DORSET BROTHERS

HE,

Please return or renew this item before the latest date shown below

HOUSEBOUND 11|17
Yule (H32)
Murray
Harbourlea

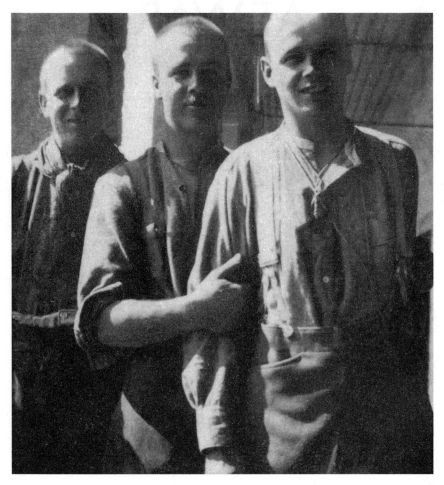

Left to right: Bertram, Roy and Stanley George, August 1915 (enlargement of plate 73).

DORSET BROTHERS AT WAR

THREE BLANDFORD YEOMEN 1914–18

JESSICA CHRISTIAN

AMBERLEY

In memory of S̶̶̶̶̶̶̶̶̶̶̶̶̶̶̶̶̶̶̶̶ ! never know

Front cover – Left to right: Roy, Stanley and Bertram George, October/November 1914.

Back cover – Cap badges: Royal Artillery (officer), Queen's Own Dorset Yeomanry, Imperial Camel Corps.

First published 2017

Amberley Publishing
The Hill, Stroud
Gloucestershire, GL5 4EP

www.amberley-books.com

British Library Cataloguing in Publication Data.
A catalogue record for this book is available from the British Library.

ISBN 978 1 4456 6684 6 (paperback)
ISBN 978 1 4456 6685 3 (ebook)

Typeset in 10pt on 12pt Sabon.
Origination by Amberley Publishing.
Printed in the UK.

Contents

	List of Abbreviations	7
	Preface	8
	Introduction	9
Chapter One	Pre-war, Mobilisation, and Invasion Scares	14
Chapter Two	Norfolk	21
Chapter Three	A Voyage with Horses	49
Chapter Four	Egypt	59
Chapter Five	Gallipoli	105
Chapter Six	Egypt Again	116
Chapter Seven	Imperial Camel Corps	126
Chapter Eight	An Officer on the Western Front	164
	Epilogue	174
	Notes	176
	Archival Sources and Bibliography	185
	Maps	188
	North-West Norfolk	188
	Egypt (Nile Valley, Western Desert)	189
	Cairo and Environs	190
	Gallipoli	191
	Palestine and Transjordan	192
	Western Front (Ypres, Arras, Mons)	193
	Biographical Index of Service Personnel	194
	General Index	218

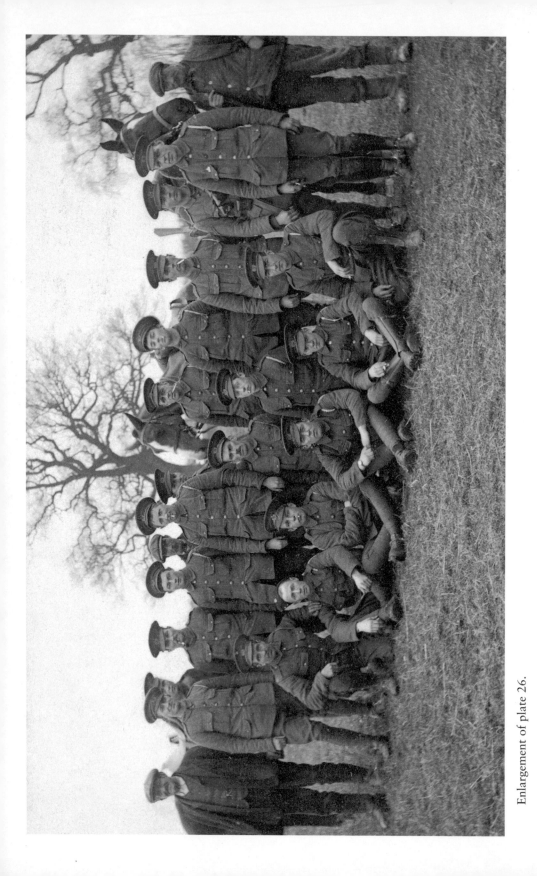

Enlargement of plate 26.

List of Abbreviations

AVC	Army Veterinary Corps
BEF	British Expeditionary Force
CB	Confined to Barracks (ch. 4); Counter Battery (ch. 8)
CO	Commanding Officer
DLOY/DLOs	Duke of Lancaster's Own Yeomanry
EEF	Egyptian Expeditionary Force
HA	Heavy Artillery
HAC	Honourable Artillery Company
HB	Heavy Battery
HE	High Explosive
HV	High Velocity
ICC	Imperial Camel Corps
KIA	Killed in Action
LMS	London Missionary Society
OC	Officer Commanding
POW	Prisoner of War
QODY	Queen's Own Dorset Yeomanry
RAMC	Royal Army Medical Corps
RE	Royal Engineers
RFA	Royal Field Artillery
RFC	Royal Flying Corps
RGA	Royal Garrison Artillery
VAD	Voluntary Aid Detachment
VPK	Vest Pocket Kodak
YMCA	Young Men's Christian Association

Preface

Both my grandfathers served in the First World War, but only one spoke to me about it. Perhaps it was listening on his knee to yarns of wartime India, Mesopotamia and Egypt that first sparked my interest in that period of history. To me these were all 'Mespot' tales. They regularly alternated with 'Jack and the Beanstalk' and the whole lot blended into a colourfully exotic and intriguing vision, with 'Fee, Fie, Fo, Fum / I smell the blood of an Englishman' as the most alarming part.

Most British families participated in one way or another in both world wars, but far more of us are likely to have lost relatives – often many – in the first. Of course families were much larger then, and it was not at all unusual to have several brothers serving simultaneously.

This is the story of just three of my numerous relatives who fought in the First World War. My maternal great-uncles Bertram, Stanley and Roy George from Blandford Forum were all volunteers in the Queen's Own Dorset Yeomanry. A book about them has been made possible by the vivid first-hand accounts contained in a diary kept by Stanley for most of 1915, and in his and Bertram's wartime letters. When I discovered these and started to match them up with their photographs, I felt it was a project that should be tackled.

Introduction

Stanley's pocket diary covers the Dorsets' time in Norfolk, training, and waiting for an invasion that never came; their voyage to the Mediterranean; four months in Egypt; and their first weeks at Gallipoli.

With the exception of a few of Stanley's, the brothers' original letters have disappeared. However, a considerable body of Stanley's and a smaller number of Bertram's were later typed up and sets distributed within the family. There are at least two top-copy sets (differing in their interpretation of punctuation and paragraphing), and multiple carbon and photocopies, some with 'improvements' and handwritten annotations. Two of Stanley's letters were published during the war and have not survived in any other form. The transcripts of Bertram's communications are particularly fragmentary and the years of their dates were often incorrectly guessed, so they were clearly typed without any input from him. Fortunately his War Office file, although heavily 'weeded' in 1933, contains enough information for the correct sequence to be reconstructed with reasonable confidence.[1]

The only George brother to remain at home was Dray, to whom Stanley addressed many of the letters quoted below. Dray typed those sent to him, but more than one machine was used, and the character of some of the obvious misreadings suggests that not all were transcribed by a family member, so maybe his secretary helped. The fate of Roy's letters and most of Bertram's is unknown. Towards the end of her very long life, their sister Margaret, finally left alone in the family home and despairing at its exceedingly cluttered state, initiated a rather indiscriminate clear-out during which many family papers were burned, perhaps including the missing letters.

Photography on active service was obviously a security risk, and was the subject of a succession of prohibitions and regulations. It was impossible to enforce these rules completely, as recognised in an order to the Dorset Yeomanry in 1916: 'The use of cameras is not forbidden but the Commander in Chief wishes it to be understood that he puts all Officers and Other Ranks on their honour not to take photographs of or in the vicinity of military works or fortifications nor of any subject likely to be of any use to the

enemy. Cameras are not to be carried in action or on patrol, nor are they to be kept in positions where they might fall into the hands of the enemy.'[2] All three brothers took photographs, many of which they sent home, and the evidence suggests that they largely complied with these regulations. Certainly Roy and Bertram seem only to have taken tourist photographs and only in Egypt (many reflecting, for instance, Roy's agricultural interests). From the time they went overseas the younger brothers each had one of the recently introduced small pocket cameras with them, and Stanley's is known to have been a Vest Pocket Kodak, very popular with the troops and advertised as 'the soldier's camera'. Both younger brothers were killed, and some of their photos taken in Egypt in the summer of 1915 before their departure for Gallipoli were rounded up and stuck into a dedicated album entitled 'With the Yeomen in Egypt'. It also contains earlier and later material, notably a few images from their period of training early in the war, and many later ones from Stanley's Imperial Camel Corps days. It is clear from mistranscribed captions that again it was put together without Bertram's help.

Stanley provided the larger part of the written material that follows. He was a gentle, kind and religious young man from a strongly Congregational background, an enthusiastic reader of poetry, prose and drama, a good vocalist and keen performer with considerable knowledge of light opera and popular songs. He enjoyed long walks in the countryside, sailing, exploring the rivers of southern England in his canoe, and botanising. Like so many patriotic and naive First World War volunteers, he was not made of natural soldiering material. With a self-confessed dislike of externally imposed discipline, he was less compliant than his brothers and therefore less adaptable to military life. He never aspired to progress beyond the rank of Private. But his bravery was second to none and he did not fear death. When he was killed in 1918 he was acting as a stretcher-bearer and attempting – in the face of heavy enemy fire and against impossible odds – to rescue the wounded, whom he was not prepared to contemplate leaving behind.

Stanley was fond of children, and befriended them wherever he stayed. He loved animals as well, especially horses. The horse he took with him to war was a bay gelding he named Itchycoo (Itchy for short) from the 1912 song 'Hitchy Koo'.[3] He was pleased to find that he would be among those detailed to look after the Dorset Yeomanry's horses during their voyage to Egypt, as a result of which he travelled separately from his brothers. His writings dispassionately describe the harsh conditions in which the horses were transported, how he tried to help the ones he was looking after, and the numbers (none of his) that died and were consigned to the deep.

Note on Editing

Editing Stanley's diary and letters has been largely a matter of eliminating undue duplication, correcting obvious transcription errors and removing a few remarks of no conceivable interest. His letter of 17 April 1915 parallels the diary entries for 7–17 April. To preserve the flow of the narrative, sections

from the two sources have been interspersed and duplicate material elided – or occasionally moved from one source to the other, as indicated by square brackets. I have also taken the liberty of amalgamating small sections of two lengthy letters of 3 and 8 July 1916 where the content overlaps almost completely, in order to keep the best descriptions from both. Misspellings, mainly of proper names (which Stanley tended to spell phonetically), have been silently corrected, but uncommon yet acceptable – sometimes archaic – alternatives (e.g. 'syren' for 'siren', 'shoot' for 'chute') have been retained; likewise obsolete usages such as 'sceptic' as an adjective. A tiny number of malapropisms and one occurrence of grammatical hypercorrectness have been amended, and I have standardised possessives to present-day forms. Stanley's old-fashioned and sometimes erratic punctuation has been simplified for maximum readability and to remove ambiguity. For example, I have not reproduced his frequent use of a dash following a comma, semicolon or full stop, instead 'choosing' one or the other – straightforward in the case of the original sources, but I have extended this policy to the transcripts when the typist seems to have 'chosen' inappropriately. Appearances suggest that the printed versions of his two published letters were based on transcripts provided by the family, and I have treated these in the same way as all the others. Paragraphing has been modified for readability and to save space. The transcripts were not faithful to his punctuation or paragraphing, and introduced spelling errors and misreadings of their own, which I have attempted to correct. Dates, times, numbers, and capitalisation of army units and ranks have all been standardised. Stanley sometimes quoted poetry from memory. His version is given in the main text, with the original in a note.

Transliteration of Arabic place names (including street names in Cairo) was far from consistent in the early twentieth century. English and French transliterations were sometimes blended, and it was not even uncommon for several spellings of a name to be used within the same publication. I have adopted a single contemporary form for each name, with a general preference for those more frequently used by Stanley. All accents have been omitted from transliterations because they were even more inconsistently applied across contemporary publications, and the brothers never used them. Personal names are less problematic, and I have used the versions most prevalent at the time.

Acknowledgements

I am particularly grateful to a small group of individuals who went out of their way to guide me in the military aspects of my researches, and provided me with hundreds of photographs to search through for relevant images: Lt-Col. Philip James, TD, retired CO of the QODY; Captain Colin Parr, MBE, former curator of The Keep Military Museum, Dorchester; and Gallipoli expert Dr John Shephard (son of the George brothers' fellow Dorset Yeoman, Arthur Shephard), who generously let me have access to much of his written and photographic research material on Gallipoli. Philip's wife Yvonne James

gave invaluable support to our little band of QODY researchers in the form of splendid lunches and hospitality. Much of Philip's correspondence relating to this project was kindly typed by Debbie Robinson.

The principal sources of research material outside the family have been: The Bodleian Library, Sackler Library, and Middle East Centre Library, University of Oxford; The Dorset History Centre, Dorchester; The National Archives at Kew; the British Newspaper Archive, British Library; and the multitudinous official records contained in the Ancestry databases, freely available in UK public libraries. The following were also helpful: The Keep Military Museum, Dorchester (Chris Copson, Helen Jones, Jean Lawson, John Murphy); Baldock Museum (Brendon King); University of Reading, Information Management & Policy Services (Lee Shailer); St Swithun's School, Winchester (Hilary Turner); Imperial War Museum, Image Sales & Licensing (Emily Dean); and Sherborne Castle Estates (Ann Smith).

My grandmother, Iris Napier, youngest of the George siblings, should be commended for her careful preservation of material relating to her two brothers who were killed, thereby enabling this account of their activities to be attempted. My mother, Rosalind Christian, and uncle, Roy Napier, aided considerably with memories, documentation and photographs. My father, Professor Reginald Christian, was the first person to scrutinise Stanley's diary in detail, making an initial transcription from often-difficult handwriting. My second cousin Miranda Gallagher showed me Stanley's Bible, containing an inscription I have quoted.

I have tried to maximise use of the brothers' own photographs to complement their writings. Numerous family albums and collections have been searched, and all images reproduced have come from these unless otherwise credited. The largest number are from (or are duplicated in) the above-mentioned 'With the Yeomen in Egypt'. Of these, the pre-Gallipoli ones of Cairo were mostly taken by the younger brothers, and principally by Roy, while the Imperial Camel Corps photos are all Stanley's. The captions separately identify images from the Bertram George collection of Cairo views, but on the whole I have avoided well-known touristic subjects.

I am extremely grateful to Mark F. Ward for permission to quote from his father Mark S. Ward's unpublished memoir 'Dear Mother', and to reproduce photographs from his father's album.

These, and many of the other images used (though credited wherever possible to copyright holders) were among those brought to my attention by Philip and Colin, as outlined above, and I am much indebted to the QODY & DG Association for permitting this. I am most grateful to the following for allowing me to reproduce photographs from their collections, assisting in identifying images, or helping in related ways: Caroline Budden (granddaughter of Arthur Budden), James Cossins (great-nephew of Harry Cossins), Stuart Gough, Derek Guppy (son of William Guppy), Margaret Leask, Keith New, Terry New, Heather Norville-Day, Paul Tory (nephew of Maurice Tory), Dr Mercedes Volait. Photographs from the wartime album of Captain F. J. B. Wingfield Digby are reproduced by kind permission of Mr K. E. Wingfield Digby, Sherborne Castle Estates, Dorset, UK. Those now in the

collections of the Imperial War Museums are reproduced courtesy of their photographic archive.

Some of the official and professional photographs used were for sale at the time and are therefore to be found in a number of family collections. This also applies to images taken by the Revd A. G. Parham, Chaplain to the 2nd Mounted Division. He was a talented amateur photographer, and sold copies of his Gallipoli photos in aid of the Church of England Children's Society. I have used four of them, and am very grateful to his daughter Philippa Bush for her permission.

Every attempt has been made to seek permission for copyright material used in this book. However, if the author and publisher have inadvertently used copyright material without permission or acknowledgement, we apologise and will make the necessary correction at the first opportunity.

This is the second book I have worked on with Brian Peart of Chromatech, Oxford, and I am once again highly indebted to him for his expert restoration of George family photographs. It is the first time I have worked with Amberley Publishing, which has been a pleasure from start to finish. I am thankful to everybody there for their kindness and efficiency, particularly my editors Alan Murphy and Jenny Stephens.

Finally, but most especially, I acknowledge with much love and enormous gratitude the continuous help, support and encouragement provided by my indefatigable research assistant – my husband, Charles Stiller – who (besides much else) compiled the biographical index and made the maps.

CHAPTER ONE

Pre-war, Mobilisation, and Invasion Scares

Bertram, Stanley and Roy were three of the eight children born to Thomas and Louisa George of The Laurels, Park Road, Blandford Forum, Dorset, between 1880 and 1894. The first was artist Winifred Ruby (Wyn), second Bertram Ilott, third Helen Margaret (always Margaret or Margot in the family) who was also a professional artist, fourth Dray (Thomas Edward Dray), fifth Dorothy (Dolly), sixth Stanley, seventh Justus Watts (known as Roy), and eighth Iris (Muriel Iris) (plates 1–3). Five of the siblings participated actively in the First World War. Wyn served as a driver on the Western Front in France, and subsequently in the Devastated Areas, Iris nursed, and three of the four brothers fought. Dray (plate 4) was the only brother to stay at home in Blandford, where he helped their father to run Markwell & Co., the family wholesale and retail grocery business in the Market Place.[1] Being seriously deaf, Dray was unfit for active service, something he felt keenly as all his brothers departed (plate 5). It was Stanley's sympathy for Dray's predicament that caused him to address so many of his most detailed and descriptive letters to Dray personally.

All four brothers began their education at a small dame school in Blandford and later attended Milton Abbas Grammar School, which despite its name was by then in Blandford (eventually becoming Blandford Grammar). When Joseph Damer, Baron Milton and later 1st Earl of Dorchester, demolished the old town of Milton or Middleton between Blandford and Dorchester to extend his park at Milton Abbey and replaced it with the model village of Milton Abbas in the 1770s, he initially allowed the school to remain. However, displeasure at the pupils' behaviour made him change his mind and, after an unsuccessful attempt to have the school moved to Dorchester in 1784, the following year he obtained the necessary Act of Parliament to transfer it to Blandford. It remained there for 142 years, though it was closed following the retirement of a particularly successful headmaster in 1877 and only reopened in 1890. (It should not be confused with the present-day Milton Abbey School, founded in 1953 at the Earl's mansion of the same name.) In Blandford, Milton Abbas School was precisely next door to the

George family's other and older business premises in East Street, known locally (but unofficially) as the Golden Canister.[2] The school moved 5 miles out of Blandford to Whatcombe House in 1928, and the old premises were demolished in 1934 to make way for a cinema.

After school, Bertram studied engineering at Hartley University College, Southampton, and by 1901 was an apprentice mechanical engineer, living at Hyde near Manchester.[3] The same year he joined the Mordey, Carney & Co. shipyard at Woolston, Southampton, where he completed his apprenticeship. The yard was taken over in 1904 by John I. Thornycroft & Co. Ltd, with whom he remained for the rest of his working life. By the outbreak of war he had risen to become assistant works manager, and was living at No. 85 Obelisk Rd, Woolston. Stanley began a career in banking. He became a clerk with the Wilts & Dorset Bank in Salisbury, which was taken over by Lloyds in 1914. There are hints that he initially lodged across the river at Harnham with John Stewart Menzies, a more senior member of the bank staff, and his wife, Eveline Emma Menzies, who remained a family friend after Stanley's death; but by 1914 he was lodging with Miss Hannah Lodder at Bridge House, Bemerton. Roy became a farming pupil with John Cossins of Tarrant Rawston, a hamlet around 3 miles east of Blandford, and went on to study Agriculture at Reading University College from 1 October 1910 to 1 July 1911. When war broke out he was running his own thriving business at Efford Farm, Everton, on the outskirts of Lymington (plate 15).

Thomas George had joined the Dorset Yeomanry in 1874, when he was in his mid-twenties.[4] Yeomanry were volunteer cavalry, historically drawn from rural areas and usually able to supply their own horses. Yeomanry regiments therefore contained a great many farmers and members of other rural trades and professions. Roy enlisted on 8 February 1909, aged eighteen, while a pupil at Tarrant Rawston. The Dorset Yeomanry was organised into four squadrons, each taking men from its local area. These were: 'A' Squadron (Dorchester), 'B' Squadron (Sherborne, also the site of regimental HQ), 'C' Squadron (Blandford), and 'D' Squadron (Gillingham). Roy naturally joined 'C' Squadron, which was under the command of Captain Castleman. Two pre-war recruits to 'C' Squadron from other prominent Blandford business families well known to the Georges were Cecil Curtis, who signed up nine days after Roy, and Leslie Cherry, who enrolled in 1912 (though Stanley's diary only mentions Leslie because Cecil transferred to the Hampshire Yeomanry and served in France). Among the many more from farming families, best known to the Georges pre-war were Harry Cossins of Tarrant Rawston and Maurice Hooper from Langton, who both enlisted in 1911, and Francis Old from Pimperne and Francis Drake from Tarrant Crawford, both in April 1913 (see Biographical Index for plates illustrating non-George soldiers). Another April 1913 recruit was Wilfrid ('Val') Watts, a first cousin of the George siblings on their mother's side and a close friend of Roy's.

Each squadron trained locally throughout the year, and the whole regiment would meet in May for an annual two-week training camp, held at a suitable location in Dorset or a neighbouring county. The 1909 camp involved the whole of the 1st South-Western and 1st South Midland Mounted Brigades,

and took place at Perham Down on Salisbury Plain (plate 10). Professional photographers attended the camps, and postcards were produced. Roy kept one of the South-Western Brigadier and his staff as a souvenir of his first camp (plate 11). He loved the training camps and would attend them all, even the one at Blandford in 1911 when he was a student at Reading (plate 8).

There was no May camp in 1912 because three regiments of the 1st South-Western Mounted Brigade, namely the Dorset, Hampshire and Wiltshire Yeomanry, had been selected to take part in what would prove to be the British Army's most important pre-war manoeuvres. The QODY travelled by train to the small town of Baldock in north Hertfordshire on 7 September, and the brigade set up camp outside the town (plate 16). The first week was devoted to the regiment's annual training, followed by two days of brigade training. The manoeuvres themselves took place over three days from 16 to 18 September, and involved a 'battle' – as realistic as possible – between two evenly matched 'armies'. The Red army was composed entirely of regular army units, and represented an invading force marching on London from Norfolk. The Blue army, mostly regulars but including the three yeomanry regiments and a territorial infantry brigade, formed a defending force based around Cambridge. The Red army was commanded by Lieutenant General Sir Douglas Haig, and the Blue by Lieutenant General Sir James Grierson. These two men would be appointed as the commanders of the First and Second Armies respectively at the outbreak of war, but the badly overweight Grierson was to succumb to a surfeit of the good life and die on 17 August 1914 on his way to take up his command. Other military leaders soon to become household names, like Allenby and French, were also involved – either as leaders or as 'umpires'.

On the first morning, the yeomanry successfully intercepted the invading force around 7 miles east of Baldock, contributing to the Blue army's eventual 'victory'. Regiments had converged from all over the United Kingdom for the manoeuvres, with over 47,000 men and 12,000 horses involved. There were fifty-one infantry battalions, thirty-three cavalry squadrons, 2,861 cyclists, 168 motorcycles, 195 artillery pieces, as well as fifteen aeroplanes and three airships. Although not nearly as sizeable as continental manoeuvres, they were large enough for realistic experience to be gained in matters such as mass troop movement and supply. A notable achievement was the movement of 30,000 troops, 120 guns, thousands of horses, and tons of munitions from Aldershot to East Anglia in a single night without disrupting the ordinary railway traffic. For the men, some aspects were probably inadequate considering the direction warfare would soon take. However, the main purpose of the manoeuvres was to prepare the leaders for command in an age of rapidly changing battlefield tactics and technology, crucially including aerial reconnaissance.[5]

The Dorsets' 1913 camp was, by comparison, felt by some to be 'too easy'.[6] It was held at Maiden Castle near Dorchester, for the first time since 1794. Roy was part of an advance party of seven who were sent to pitch more than 100 tents and prepare the horse lines. The town was decorated

with flags and bunting, a 'smoking concert' was organised for the troops, and many townspeople went to see the inspection of the horses on the opening day. Roy sent Iris one of that year's postcards, proudly reporting his section's performance in the shooting competitions and regimental sports (plate 19):

> Rear Guard, Dorset Yeomanry Camp, Maiden Castle, Dorchester. Camp is practically over now, have enjoyed it. Splendid. I am clearing up now. This is a model section, three regimental scouts, one best recruit shot in the regiment, and two in the winning team (shooting for Hambro Cup). Lovely up here. Yrs, Trooper.

The three scouts were Cecil Curtis, Val Watts and Roy, and the best recruit shot was Leslie Cherry – hence the group photograph – while 'C' Squadron won the Hambro Cup.[7]

Roy was promoted to the rank of lance-corporal on 1 November 1913.[8] The Dorsets' final pre-war camp was held jointly with the Hampshire Yeomanry at Wimborne St Giles in May 1914 (plate 17). On its final day Roy sent a card to Stanley, who he had hoped would be able to visit the camp (plate 18):

> Sorry you could not come to see us and I could not get up to you [in Salisbury]. This is my section off on manoeuvres. We have been about 100 miles in the last three days and had a splendid time. Yours, Lance Corp. George.

The Dorsets and Hampshires had been on two days of manoeuvres around Cranborne Chase (including night operations) against the Wiltshire and North Somerset Yeomanry, who had been encamped in Wiltshire.[9]

On 28 June 1914, Archduke Franz Ferdinand was assassinated. A month later Austria-Hungary declared war on Serbia, and the complex web of alliances across Europe was rapidly activated. By early August, Britain, Russia and France were at war with Germany and Austria-Hungary. On 5 August, the day after the British declaration of war, each squadron of the Dorset Yeomanry began to mobilise at its headquarters. Mobilisation was complete by the 9th and training got underway at once. 'B', 'C' and 'D' Squadrons were ordered to concentrate at Sherborne on the 11th. 'A' Squadron was assigned coastal defence duties in Dorset, patrolling from Portland to Poole Harbour.[10] The same month, 'D' Squadron was disbanded and drafted to the other three.

Stanley and Bertram both volunteered in September, and it was a natural choice for them to follow Roy into the QODY since all three brothers were excellent horsemen. Stanley, then aged twenty-five, and Bertram, aged thirty-three, signed up for foreign (as opposed to home) service at regimental headquarters in Sherborne on 7 and 29 September respectively, joining Roy in 'C' Squadron.[11] The three youngest Georges turned Stanley's enlistment day into a picnic outing, typifying the enthusiastic optimism of the early days of the war (plates 20, 21). Most recruits were new to the army, but some who

had served for a fixed term pre-war now returned. For example, Maurice Tory, who farmed at Spetisbury and was also known to the Georges, had originally joined in 1901, was discharged in 1907, and re-enlisted in early September. Bertram had himself previously served four years with the 2nd Hants Volunteer Cyclists' Corps.[12]

The First World War is often considered the first truly mechanised war and, in 1914, Britain may well have had the most mechanised army in the world. However, motor vehicles were still primitive and unsuited to difficult terrain, and in any case production could not keep up with demand. Huge numbers of horses were still required and there were nowhere near enough in Britain, so the army had to purchase a great many from overseas. At the port of Avonmouth near Bristol, 1,000 horses per week arrived from North America, and the largest Army Remount Depot was established nearby. The shortage of light draught horses was especially severe, and this led to the mass import of mules from both North and South America, the first time that they would be used in comparable numbers. Most of the horses and all of the mules were used for transport, but this was also the last war in which mounted regiments played a significant part. By the end of the war, there were almost a million horses and mules in British Army service. An estimated 484,000 had died, more than half the number of British men.[13]

By 7 August 1914, with mobilisation of the Dorset Yeomanry nearly complete, twenty-two officers and 425 other ranks had reported for duty (see plates 23 and 24, which between them show all the QODY officers mentioned by Stanley except for Captain Rickett (doctor) and Captain Druce).[14] More than half came with their own horses, to upwards of 260.[15] Because the army did not allow privately owned horses to be taken on active service overseas, all had to be bought by the state at a valuation by the Remount Department. Yeomen's horses could of course be allocated for their own use, and the army would do its best to ensure resale to their original owners after the war, but offered no guarantee.[16] Many more horses were needed than the yeomen could supply, and on 13 June the Deputy Assistant Director of Remounts, Southern Command, Salisbury had estimated that the Dorsets would need to purchase a total of 423 riding horses, twenty-two draught horses (for eleven two-wheeled carts) and ten pack horses. To meet the shortfall, many more riding horses were bought from 'all parts of the country' and 'drafted to the Regiment'.[17]

At the outbreak of war the Dorset Yeomanry still formed part of the 1st South-Western Mounted Brigade, within the Territorial Force Mounted Division. With the surge in recruitment the army rapidly grew, and in late August 1914 it was decided that another mounted division should be formed. Accordingly, on 2 September, the 2nd Mounted Division was brought into existence at Churn Camp, near Blewbury on the Berkshire Downs. The new division contained four mounted brigades, each in turn composed of three regiments. The 1st South Midland Mounted Brigade was made up of the Warwickshire Yeomanry, the Royal Gloucestershire Hussars and the Queen's Own Worcestershire Hussars. The 2nd South Midland Brigade initially comprised the Royal Buckinghamshire Hussars, the Queen's Own

Oxfordshire Hussars and the Berkshire Yeomanry. The Sherwood Rangers, South Notts Hussars and Derbyshire Yeomanry made up the Notts and Derby Brigade. Finally, there was the London Brigade, formed from three London regiments. In addition to the mounted regiments, each brigade was completed by a horse artillery battery (in the case of the 2nd South Midland, the Berkshire Royal Horse Artillery), ammunition column, signals troop, field ambulance, mobile veterinary section, and army service corps. The last of these was responsible for transport, commissariat, supplies and administration.[18] The division was so large that there was insufficient water for it at Churn camp, and each brigade needed its own training ground, so three of the brigades moved to elsewhere in the area – the 1st South Midland to Newbury, the Notts and Derby to South Stoke near Goring, and the London to Streatley – leaving only the 2nd South Midland at Churn. Soon afterwards, the Oxfordshire Hussars left for France, landing at Dunkirk on 22 September, and the Dorset Yeomanry were sent to Churn to replace them.[19] This explains why the Dorsets found themselves in the odd position, geographically, of sharing a brigade with regiments from Berkshire and Buckinghamshire.

The Service Regiment of established yeomen, including Roy, promoted to full corporal in late September,[20] proceeded to Churn on horseback by daily stages of 15 to 20 miles, billeting en route at Shaftesbury, Salisbury, Andover and Newbury. 'B' Squadron and regimental HQ left Dorset first, on 8 October, followed the next day by 'C' Squadron, and a few days later by 'A' Squadron, relieved of their coastal defence duties. Everyone had camped at Churn, but on 16 October the Dorsets handed their tents in at the Ordnance Stores and moved to billets in the Wantage area, with 'A' Squadron housed at East Lockinge, 'B' Squadron and HQ at Ardington, and 'C' Squadron in Wantage itself.[21] Shortly afterwards, on 21 October, Bertram, Stanley and sixty-three other new recruits (thirty from 'A' Squadron, twenty-five from 'B' and ten from 'C')[22] left Sherborne on the 8.50 a.m. train and arrived at Wantage Road at 1.26 p.m., having changed at Basingstoke, Reading and Didcot. The journey, by scheduled services, allowed only three minutes to change at Reading and five minutes at Didcot, so the trains must have run absolutely to time unless connections were held.[23] Wantage Road station, on the Great Western main line near Grove, was 2½ miles from Wantage. It is not recorded whether the men completed their journey on foot or took the local steam tramway.

At Wantage, the regiment undertook further practical military training. Reconnaissance, musket and bayonet work, and trench digging (by day and after dark) are all mentioned in the records; also lectures, held between 6 and 7.30 p.m. There was a programme of double inoculations against typhoid, although – unlike the smallpox vaccination – this was not compulsory. However, the Secretary of State for War, Field Marshal Lord Kitchener, had declared that only men who had been inoculated should be allowed to serve overseas and, as early as September 1914, a regimental order stated, 'The CO believes that the possibility of the Regiment being selected for service abroad will be greatly increased if every man has been inoculated against

typhoid fever. He hopes that this opportunity of taking such an invaluable precaution will not be neglected.'[24] During this time the cover photograph, with its mock backdrop on a painted scroll, was taken by Wantage and Abingdon photographer Tom Reveley.[25]

Val Watts was not among those who moved to Wantage. He was a keen pilot, and had obtained his Royal Aero Club Aviator's Certificate at the Ewen School, Hendon Airfield, on 17 September 1913. Early in 1914 he joined the recently opened Beatty School of Flying (plate 22), also at Hendon, and by the beginning of July was one of its instructors. He began a fortnight's attachment to the Royal Flying Corps on 28 September 1914, and transferred permanently on 15 October.[26] In a military flying career of just over a year, he was awarded the Croix de Guerre for distinguished conduct at Loos (September to October 1915), and commissioned as a pilot second lieutenant in 1 Squadron. He was killed on 17 January 1916 (aged twenty-two) when his Morane monoplane was shot down by German anti-aircraft fire near Wytschaete in the vicinity of Ypres while on a special reconnaissance mission. The Germans buried him with full military honours at Ledeghem, near Menin, and he is commemorated at Harelbeke New British Cemetery, Kortrijk.

On 3 November 1914, German battlecruisers bombarded Great Yarmouth, and a real fear of imminent invasion on the east coast – probably starting in East Anglia – gripped the nation. So the entire 2nd Mounted Division was moved by train to Norfolk on 16 November, the Dorsets initially billeting in the Melton Constable region, and by the 19th their new HQ was at Hindolveston.[27] In Norfolk, 'dismounted training in the defence of farms and buildings' was added to their schedule of activities,[28] along with the mounted exercises, drills, parades and war games described by Stanley in his diary. Then in December the Dorsets moved further west in the direction of King's Lynn, with 'A' Squadron going to Houghton Hall, 'B' Squadron and HQ to East Rudham, and 'C' Squadron to West Rudham.[29] Billets were found for the soldiers in a wide range of private houses. The hundreds of horses were accommodated in the stables of Houghton Hall and other, smaller houses, and on local farms. Inns could also be used short-term, but because they might 'at any time be required for small parties passing through they should not be used for standing billets for men or horses'.[30]

Over Christmas and the New Year, furlough was to have been granted for seven days – in batches of not more than 20 per cent at a time[31] – but another German bombardment on 16 December (this time on the Yorkshire coast) meant that the whole brigade remained on high alert until Christmas Day.[32] Stanley definitely had some leave in January. He was 'At Harnham' on the 15th – the first dated entry in his diary, which he only started to write in detail after returning to Norfolk. By then all three George brothers were billeted with Agnes Porter and her elderly father at a house in Nethergate Street in the small village of Harpley, near West Rudham (plate 27).

CHAPTER TWO

Norfolk

Stanley's diary was kept between 19 January and 6 September 1915, coming to an abrupt end at Gallipoli. It opens and closes with the tragically premature deaths of people very close to him. In the memoranda section at the beginning he wrote, 'Dorothy Julia Rossiter died at a quarter past twelve on the morning of December the sixteenth [1914] – a Wednesday. "Until the day break, and the shadows flee away."'[1]

Stanley had been deeply fond of Dorothy, and she may (one imagines) have become his wife had fate been kinder to them both. She had been a nurse in Salisbury and previously in London, and lodged with Mr and Mrs Menzies at Harnham. Dorothy had also been much loved by Mrs Menzies, who often spoke of her in correspondence with Stanley.

Harpley, Norfolk, Tuesday 19 January 1915

A most dull and dreary day and uneventful. I was line orderly and took care of the horses. Felt very gloomy and, as I lay in the guard-room looking out at the bare trees against the grey sky, very silently and with temerity the sparrows would fly in at the doorway. With a move of my arm they would all flutter away with a pleasant noise of moving wings.

Heard from Betty who has been ill. Wrote to Mrs Menzies and Sister Radnor [a nursing colleague of Dorothy's] down at [Harpley pub] the Rose and Crown in a room by myself. I wrote about the Death of Darling Dorothy. Had a drink with the cook and Trooper Cutler and walked home singing until I came up with one called Minchinton of Cranborne, an August recruit.

'Betty', as she was generally known in her youth, was Dorothy Betty, who had attended Stanley's recruitment-day outing and was one of Iris's closest friends from their still-recent days at Winchester Girls' School (formerly Winchester High School and renamed St Swithun's after the war). Another particular Winchester friend, although not mentioned in the diary until early

February, was Joan Buckley of Clopton Manor in Northamptonshire. The three girls had been in the same boarding house, Earls Down, and had all held responsible positions, such as House Captain, House Representative, or VI Form Representative, and had all played lacrosse for the school. Betty was especially sporty, and regularly competed at Wimbledon throughout the 1920s. She reached the quarter-finals in ladies' doubles in 1924 and 1930, and in mixed doubles in 1927, when she – by then Dorothy Hill – and Charles Kingsley beat Bunny Austin and Betty Nuthall; she also reached the fourth round in singles that year. During the war Stanley regularly corresponded with Betty and Joan (plate 7). Being still children together when their older brothers and sisters had started to grow up and be away from home, the three youngest George siblings formed a close-knit unit and had many friends in common. The Earls Down girls often stayed with each other's families, and Joan's brother Sid would become a close friend and suitor of Iris. Sid was shot down behind German lines on 30 November 1915 while on photoreconnaissance with 16 Squadron, RFC, and taken prisoner. He escaped to England in June 1917, and his exploits figure in a book by one of his fellow escapees.[2]

Wednesday 20 January

German Zeppelins attacked the English coast and destroyed property at Yarmouth, Cromer, Sheringham and King's Lynn last night. Many people in the village say they heard shakes and whirring noises overnight.

This was the first ever airship raid on Britain. Two Zeppelins reached the Norfolk coast around 9 p.m., wildly missing, as a result of cloud and mist, their intended targets in north-east England; in fact, one bombed Great Yarmouth and the other dropped its first bombs over Cromer and Sheringham, moving on to Hunstanton at 10 p.m. and King's Lynn at 11, before turning for home.

The hounds met in the Rectory garden. Several officers were riding to hounds but we troopers could only follow on foot. There was something very half-hearted about the meet. I followed as far as the football field and stayed there looking out to the hills in Hillington direction where were the hounds. There was no fun so soon returned. A good dinner at Miss Porter's – we have drawn our rations at the mess room.[3] Exercised horses as far as Massingham – the village of ponds. Peter, the horse I was leading, managed to get away from me. Night guard with Old. Cleaned kit. Windy night.

Thursday 21 January

Awoke in the guard-room at seven o'clock after a comfortable sleep. There was a regimental route march. The weather was very wet and the day dismal. We marched through Rudham to Syderstone and home through

Houghton. I enjoy route marches in new country. Coxford Heath and the fir and larch woods looked beautiful. At the time we passed the heath, the mist was rolling away and a little blue sky began to show. Cossins and I talked about Truth and Honesty. C said it was best to be shrewd and selfish in the yeomanry and that the army encourages it – not that he is. Sat around the cook's fire and talked with a fellow called Fowler, Lieut. Hoare's servant.

Had a rum and water at the Rose and Crown as I felt a cold coming on.

Friday 22 January

Weather continued wet. In the afternoon exercised horses to Massingham.

We three brothers and Serg. Dunn gave a supper at the Rose and Crown to Troopers Old and Cossins, Corp. Hooper and Serg. Tubbs. We had a couple of chickens, sausages and bacon, and plum puddings and mince pies. Excellent repast, but chicken a little tough. We drank old beer and port and Roy ordered a bottle of Red Seal [Cockburn's old tawny port]. The waitress brought in news that Zeppelins were over Cromer. I sang 'Come Cheer Up My Lads' and Roy sang 'Mandalay'. Trooper White who was also present sang 'Tarpaulin Jacket'. Roy and Bertram with Dunn wore German helmets and moustaches. They inscribed various names and pictures of Iron Crosses and Zeppelins on their helmets. They much amused the company. We attacked the night guard and had great fun with the helmets.

There was no Zeppelin raid that night. According to the contemporary press, the sounds heard over Cromer probably came from British aircraft.

Singing was very much a part of army life, especially during the early stages of the war when the soldiers were all professionals or volunteers. There were special songbooks, such as the *Camp Song Book* published by the YMCA. Each regiment also had its own songs, but Stanley had a low opinion of the Dorset Yeomanry's.

Saturday 23 January

Rode out with the troop over Harpley Common to Anmer. We had to protect an ammunition wagon in the village, and I patrolled up and down a muddy lane for an hour and saw nothing but fog.

Played football on the hill, No. 1 Troop v. No. 4 Troop. We [No. 1 Troop] won 5-2 goals. Roy and Bertram played. Roy runs like a great dreadnought heading up channel. Lonnen, known as 'Brig', is a good player – and Haim, who is an Okeford man. There were amusing episodes. Merrett, an opposing back, walked around with his hands in his waistcoat pockets saying 'they can't do anything'. He didn't do much. Bradley was most serious but suffered from indigestion.

Enjoyed a hot bath and a change of clothing. Wrote to Miss Watts at the Salisbury Infirmary [a nursing colleague of Dorothy's, who helped to look after her before she died].

Sunday 24 January

We three brothers and Cossins walked after tea to Massingham. The night was soft and still and the moon shone down through dream clouds. We went to evening service at the church and sat in a draughty side aisle. Between two pillars I could see five lighted candles on the altar and a figure of Christ on the Cross. The parson gave a sincere and simple sermon on the 'Spirit of Christ'. He remarked that 'religion is not a block of wood, but a Real [Living] Thing'. Hymn 595, 'Holy Father in Thy Mercy', is beautiful.

We had some supper at the Swan Inn and talked on the relations between farmers and their labourers. I remarked that farmers were afraid to familiarise with their men for fear of losing their respect. Bertram said he could talk easily to any of his stokers and artisans.

Monday 25 January

A beautiful morning, mild and fresh with glorious sky lights at the horizon. Two troops of the squad were ordered to attack Shernborne – defended by two troops. I went scouting with Serg. Tory and three men. There was nothing to scout. Hares on the King's estate are too numerous [to spot anything else at ground level]. While taking a message to Sir Thos. Lees at Anmer I was captured between Shernborne and Anmer by a patrol – but I think I should have killed two men as they came for me. I saw Dersingham spire, near where the [Zeppelin] bombs fell.

Cleaned my kit. Was on night guard with Cossins. Made ourselves very comfortable and read Thos. Hood's poems – 'Eugene Aram's Dream', 'The Water Lady', 'I Remember, I Remember' and some awfully funny ones. Heard from Miss Coope [Kathleen Coope, friend of all the George siblings].[4]

Tuesday 26 January

Brigade field day. The scheme was not told us but I think we, with some artillery, were out against the Berks and the HAC. Near Fakenham we came in touch with the enemy. For our troop there was little fun. I think we were 'cut up' towards the commencement. I did not fire a shot, but lay in a ploughed field for half an hour alongside Serg. Tory. At five o'clock B [Bertram] went away with four others to Swaffham to protect roads there, as a Zeppelin raid was expected. The cook gave me some sausages for a present.

Heard from Mrs Menzies. She writes, 'To me it daily gets harder, days come and go, and no Dorothy coming in. Oh, it is too cruel. Her grave shall never be forsaken as long as I am here, for I love to go there and hate

passing the churchyard without walking in, for I feel she knows it. Oh, George, isn't it too awful to think she lies there and we can't speak to her?' She writes that she has planted pale pink tulips and white hyacinths on her dear grave and, with the snowdrops, primroses and violets from her garden, it looks so nice.

Wednesday 27 January

Exercised horses by way of Little Massingham and down a green lane to King's Cottages on the [King's] Lynn road. After dinner the reg. serg.-major – Kerton – came over and drilled us with the bayonet and instructed us as to changing the guard. He came upon me rather severely for not fixing my bayonet properly. It was the first bayonet drill I had had. Walked to Rudham and drank old beer at the George. A man there from Kent told wonderful stories about horses. Can a horse trot a mile in three minutes? Read Miss Watts's letter at the inn. Heard from Owen Shittler.

Poor Watts! She writes, 'How often I seem to hear her voice along the corridor, or her merry laugh in the covered way. She was always so bright and happy, and full of life, and so I try to think of her.' Then came the account of Dorothy's death. Watts was her nurse on Tuesday, Dec. 15th. She says, 'It was such hard work to keep smiling before her, and try to comfort her mother and sister.' 'Watts' as Dorothy would call her is a good sort and very kind and sympathetic. She once fell in the river when trying to get into the canoe.

This canoe was a prize possession of Stanley's, in which he used to take Dorothy and her nursing colleagues out on the River Avon. Owen Shittler, to whom there are numerous references in Stanley's diary, was an older friend from Salisbury.

Thursday 28 January

Drilled in Houghton Park. Thick snow storm. Went a short march.
B and Roy down with colds. Slept in the sitting room.

Friday 29 January

Rode off at 8.30 to Raynham Park for a brigade drill. There were many in the squadron ill, so the troops were small. The brigadier gave us a good drilling and we finished by giving a charge with drawn swords – each regiment separately. Our troop was led by Serg. Dunn. The whole line was rather ragged but it was fun. Itchy galloped well and outpaced a good many horses. Snow fell during the greater part of the drill. Lieut. Browne rode Moke. She was clipped and looked fine.

B and Roy still unwell. We ate some of Mother's cake for tea – very nice. On night guard with Old. Slept on the hay but was a little cold.

Saturday 30 January

The horses were branded with the govt arrow mark. They do not seem to feel very much the red-hot iron. Itchy jumped a little at the time. We took the horses out for short exercise. I rode B's horse [Shamrock] and led Itchy and Roy's mare. Tried to transfer myself from B's horse to Itchy while riding; consequently B's horse got away. B's horse is very fat and wants exercise – at water she is most unruly and, as I have to take three to water, she gets away and gallops about to the amusement of the villagers.

Heard from Sister Radnor who is at Havre in a hospital. Walked down to Simpson's the baker for the milk for Roy and Bertram who are still rather unwell. Simpson's bakehouse is old and smells of flour. He had bad bronchitis and was sitting in his chair breathing very wheezily.[5]

Sunday 31 January

There are so many in the troop sick with influenza. One fellow – Minchinton – has rheumatic fever. I was the only one in No. 1 Troop that appeared on church parade, which amused the major and Lieut. Browne. The attendance of parishioners at church is very poor. Rev. Beck was absent [Henry Beck, Rector of Harpley]. A pale and tall young parson conducted the service. He did not preach a sermon. I think he was [local farmer] Mr Murfet's brother-in-law.[6] Wrote in the afternoon to Miss Watts, Owen Shittler, and Irene Gass.

Irene Gass, aged twenty-nine in 1915, was born at Bruton in Somerset (22 miles from Blandford), where her father was the Congregational minister. In 1915 Irene was a schoolteacher in Gloucestershire, but at the end of 1917 she moved to Bristol Grammar School where she taught for most of her working life. She also gave piano recitals, wrote lyrics for many songs, and published a number of books for children on music and other topics.

In the evening, called at the inn and listened attentively to a yeoman, evidently a huntsman from South Dorset, telling hunting anecdotes. He eulogised and criticised various county gentlemen, and commented on horses giving their names – Red Paint, Good Hope, Old Surrey and others. I think the fellow's name was Sturmey.

Monday 1 February

At last a day of clear sunshine and spring-like. I was line orderly and it was pleasant in the yard amongst the yellow straw and the twittering sparrows. We were instructed to go with the horses, which we intended to take to Rudham later in the day, down to the village for the major to see. At half past one I paraded, riding Itchy and leading Roy's mare. We walked to Rudham, lined up in a field, unsaddled, and led our two horses before the

veterinary and some brigade officers. Teddy Bear and Old Sam were not cast, but the former is to be used as a pack-horse.

Walked up to the football ground at nine o'clock and down the lane to the Lynn road. There was a strong moonlight and from the high ground I could see the hills folded in mist. There were no lights, and the trains were marked by the line of smoke from the engine. All seemed forsaken and deserted.

Tuesday 2 February

Brigade field day. Rode Bertram's mare, which was very fresh. The squadron moved off to Weasenham and I had to do a little advance scouting. B's mare will neigh when by herself. Operations took us to Whissonsett where we halted for half an hour and then trotted to Colkirk where the enemy was reported. Our troop under Lieut. Hoare went on in advance. In the village we were 'cut up' in the road most mercilessly by two armed motor cars driven by marines and armed with pom-poms. We had to return home. Most exciting to watch the phantom cars rush down the road while the yeomanry peppered them from the roadside.

Lecture by the doctor.

Wednesday 3 February

Five turned up to parade. Exercised horses as far as Rudham and rode bare-back. Found it hard as the lieutenant would trot. Blanket slipped off, so had to stop to adjust it. When catching up the troop Itchy, which I was riding, broke into a gallop and got away from me. I was up on his neck pulling hard and gripping like death. I was leading Roy's mare. However, I knew he would stop on reaching the troop.

Played football. Didn't feel a little like playing, as had two slices of Mother's plum pudding, but once started I enjoyed it. Night guard with Makin, who snored all the night.

Thursday 4 February

Regimental field day. 'C' Squad against 'A' and 'B' Squads. We had to fight a retreating game. After staying behind a hedge for half an hour, galloped back to a four-cross-ways and barricaded the road. Here we held the enemy for some time. The RAMC came out after the fighting and picked up some wounded who had been instructed to fall. Sir Thos. Lees gave us a little bayonet drill.

Wrote to general manager of Lloyds Bank, to Rev. Atkinson enclosing p.o. 1s 6d for his mission work, and to Mr Gordon, dentist of Salisbury, asking him for his bill. Felt a cold coming, so drank rum at the inn, where I met Makin – the snorer – whom I treated to a pint. Roy heard from Father, who said Iris had given a dance to the sailors.

Iris had wanted to become a nurse as soon as the war started, but was considered too young. Instead she busied herself with local efforts to entertain the troops and look after the wives of officers from nearby Blandford Camp, until she was accepted as a VAD in 1916.[7]

Friday 5 February

Heard from Mother. She sent me a cheque £1 18s to pay for some Lotus boots.

A glorious day and the sun rose out of a red sky over which the morning star gleamed, and the birdies sang fine. The squadron operated round Massingham. A morning of no importance.

Paraded on Mrs Cameron's lawn [at Harpley Lodge] to hear Woodrow's court martial sentence. The adjutant read the sentence while the prisoner stood with his hat off and we at attention. The affair was carried through in true military style and it was sad.

Went into the church and looked at the tomb of Sir Richard Knowles. Wrote to Mother. Bertram said during the evening that he kept hearing guns.

Saturday 6 February

I went by train to Fakenham. It is a small dull town, and gloomy in dark wet weather such as there was today. I walked to the brigade hospital and saw Andrews. He was sitting up in a chair and could talk, but looked ill and weak. Gogg's House is the name of the hospital. It is a large old house looking towards the station and the river. The RAMC keep it very clean. Had tea at the Crown Hotel in a large dining room. Enjoyed sitting solitary in front of the fire, smoking cigarettes. In the room were old photographs of famous horses and of famous meets of famous fox hounds. Walked down Oak Street and passed Dr Palin's house where Joan [Buckley] often stays.[8] Went inside the church. A young lady was having an organ lesson and playing the Nunc Dimittis. I liked looking at the plain mauve window at the west door and the coloured pictures of Christ on the Cross above the altar. Looked at the window to a Mrs Edgar, which was of the young maiden rising from sleep.

Sunday 7 February

There was a saddle inspection at eleven. It was not a satisfactory one. We are for ever being asked in the yeomanry what we want in the way of kit, and what we are short of, but shortages are replaced in a most dilatory way.

At Harpley Church in the afternoon the chaplain preached. His text was from the chapter dealing with Paul's conversion. He speaks without notes; is rather nervous, but very sincere. He wished to bring home to us the urgency of doing something for Christ, that none of us was indispensable,

that the work of God and the building of his House would always go on, and woe to us if at the time of Fulfilment we had left the work of Good for others.

Bertram and I were on night guard. I read two chapters from *Villette*, which I had bought at Fakenham. I love the easy description of the calm sweet life at Bretton. Only a woman could write so tenderly and with such instinct.

Monday 8 February

Our squadron was ordered to defend Weasenham St Peter against attack by 'B' Squadron. I believe there was some fun with No. 1 Troop in capturing six of the enemy, but this I missed as I had to guard horses. Towards the finish of operations there was a deal of absurd galloping up and down the village.

After tea I walked to Houghton stables to see Gollop, Watkins and Sansom. The stables are massive and form a square with a courtyard inside, which is reached by two wide archways, each at opposite ends of the building (plate 28). I saw Watkins and Symonds in their room – they were playing cards. The room looked dirty and uncomfortable. I made my way to the canteen and saw Hannam, who took me to see the horses. Came across Sansom writing a letter in the mess room. Gollop took me to see Mr Styles, who lives at one end of the stables in a cosy suite of rooms. I sat in his drawing room, and Miss Daisy Styles sang and he (Styles) played a mandolin. Bennett and two other troopers were there and Mr Styles's two younger daughters.

'A' Squadron were housed in the stable block at Houghton Hall. The estate had its own power station, and Mr Styles was the resident electrical engineer. Fifteen-year-old Daisy was the darling of 'A' Squadron, always happy to sing for them at their occasional concerts.[9]

Tuesday 9 February

Turned out in full marching order and paraded outside the Rose and Crown. I was two pegs and a circingle pad short. Very wet, so we went back to stables and stripped our saddles; as the weather did not improve, we unsaddled after waiting an hour. After dinner, five of No. 1 Troop walked with Serg. Tory to Little Massingham, and in the parish room practised shooting with a miniature rifle at a 'Roberts' target. I came second in the scoring – making 46 out of a possible 70. In the room was a pair of rings, and Tory made to do wonderful exercises upon them. As we went home, Ingram, Pardy, Harvey and I had shots at birds upon the roadside. Glad we did not kill any.

I wrote a letter to Mrs Menzies. She sent me a photo of the river Avon and the Infirmary, and the Door in the Wall and the Crane Bridge. How glad I was to write to her – so kind and good a woman.

Wednesday 10 February

A grand morning; the birds sing fine now and it is light at seven o'clock. We overslept a minute or two this morning and Serg. Tory came down and shouted to us, 'Come on.' It was my turn to do line orderly duty. I did not mind, for the sun was warming in a blue sky and I like hanging round farms in fine weather. Cleaned out stables and watered eight horses at the pond – two at a time. Lonnen's pony is bad with pneumonia.

I cleaned my kit in the afternoon and, while the others were at tea, went and looked at the great farm horses in their stables, and talked to an old man wearing a blue jacket and a soft felt hat.

Read *Villette*. Poor Charlotte Brontë! She was brave to venture to the Continent, and I love her ways of describing her feelings and her opinions. I'm so glad Madame Beck took her in.

Thursday 11 February

The squadron, commanded by the serg.-major, had orders to protect a company of imaginary engineers who had to destroy the railway at Massingham. The enemy, represented by two flags, appeared from Harpley and succeeded in rushing through. The serg.-major scattered his force too much. I held four horses under cover of the barn in the football ground a great part of the morning, but I had a good gallop with the troop from there down to the station, where I held horses while the troop did a little firing. After dinner we did a little dismounted drill.

Hooper, Cossins and Old returned from a week's leave. Bought a pair of 38s boots from Pitmans of B'mouth. Drew rations at the mess room – beef for three, and rashers and tea for the same number, also a pot of jam.

Itchy was beautifully fresh.

Friday 12 February

The squadron drilled in Houghton Park. The major, for the first time, gave us a deal of practice in sword drill and charging. It was quite exhilarating, what with the galloping and the shouting, and the struggle to pull up. Itchy would get away ahead of the other horses, but he goes along at a rare lick, and I think could beat any horse in the troop except perhaps Waters's mare.

Played a most strenuous game of football and enjoyed several fast runs down the field.

The day was beautiful. After breakfast I stood against the stable wall and smoked in the sun and listened to the hum of a distant thrasher. The windmill was turning slowly under the misty white clouds that made statelily across the heavens. I saw a cat cross the road with a mouse in its mouth.

On night guard. Had a most comfortable bed on hay littered with straw.

Saturday 13 February

Lonnen's little mare – Goldy – died in the night from pneumonia. She was a beautiful little creature and had such dancing feet.

There was dispatch riding at New Houghton. Eight men from each troop were told off to take messages from one officer to another. I was with those who had to exercise the horses, and a cold time we had with Tory leading, who would not trot but walked all the time although the wind was bitter and we yelled to him to t...rot.

Bertram and Roy went to Lynn by the 4.24 train. As the weather was wet, I stayed home. Drew rations, had a hot bath and sewed some yeomanry buttons on my tunic. It was rather an effort as I dislike sewing. We should always do now and again those things we don't like to do.

Sunday 14 February

After dinner, walked to Houghton. Mr Styles showed me over the great mansion. In the dancing room was a marble figure of Venus reclining on a couch. The arcade was dull and gloomy. The staircase of Spanish mahogany was fine, and there was a bronze figure of a man throwing a spear.

Stanley admired the white and green drawing rooms, the ceiling of the stone hall with its frieze of cupids ('all boys except one girl'), the Chinese hand-painted wallpaper and painted ceiling by Kent in the cabinet room, the state bedroom, and the green-velvet bedchamber. He was amused by the marble parlour with its

marble fireplace carved in bunches of grapes, and everything in the room had to do with wine. ... Saw the bed where Walpole slept and pictures of the Walpoles and their wives and of the Marquess of Cholmondeley. Went to the Library, which I liked best of all.

Had tea with three troopers and Daisy Styles. Walked home in the rain.

Monday 15 February

Out against 'A' Squadron. Acted as rearguard with Hooper and Old, so did not have a very exciting time.

I played football with a whole medley of troopers, so that there was not much of the ball to be had. What a show of waistcoats was to be seen – mustards and peppers and green and gold! Heard from Irene Gass, and May Handover sent me her photo.

May, aged twenty-one in 1915, was the daughter of George Handover of the Phillips & Handover drapery business in Sherborne.

A day of storms, and cold and cheerless. Gave my name in, also Roy's and Bertram's, for the choir that is to be formed. Have heard it rumoured that

we are to be disbanded and put in with the 1st Dorsets. Wonder if there is any truth in it? I'm afraid some of us would make rather poor infantrymen.

Tuesday 16 February

It was a grand day, after a night of sharp frost. Our troop went scouting up the Peddar's Way in search of the serg.-major, who was in hiding. I went off on my own and searched deep pits in fields, barns by wayside lanes, and woods upon the hills, but found no serg.-major. I enjoyed the sunshine on the hills and the distant valley view of the land towards Lynn. Rode up to a lonely homestead on a hillside where cattle were enjoying the warm sun as they lay upon new yellow straw in an open yard. At length reached Gayton, fell in with Hooper and returned to Harpley.

At six o'clock went on guard down at the Rose and Crown. It was a twenty-four-hour guard [the others being] Serg. Hunt, Corp. Bradley, Troopers Genge, Elsworth, Doggrell, Drake and Ford.

Wednesday 17 February

The night was wet and wild. I was on sentry-go from 2 a.m. to 4 a.m. There was a cold rain, but time went quickly. We slept on forms or on the floor of the parlour in the Rose and Crown Inn. At 7.30 we had breakfast, which [pub landlady] Mrs Darlow brought us.[10] A great part of the day, which was wet, we sang round the fire. Vic Hunt sings sentimentally in Caruso style. Ford, known as 'Puddick', is funny, and Francis Drake and Mark Genge are good fellows. I tried to write to Betty, but couldn't. Read *Villette*. On duty in afternoon from two till four. Interested spectators. Rained hard. Ate a big tea – army marmalade is very good. The new guard came at 5.30 to ask various questions. Corp. Knott was its corporal. We sang Auld Lang Syne and decided we had had a real good time.

Thursday 18 February

Our troop was sent to Great Bircham in command of Corp. Hooper, with orders to scout the ground a mile on either side of the road from Gt. Bircham to Rudham. Bertram, Old and I with Cossins scouted the right of the road. We had to locate white flags, which were placed in concealed places. Itchy and I had a pleasant time riding across fields and through woods. I investigated several pits and barns, but found nothing. Negotiated one or two jumps.

I have joined the village choir, and went to a practice in the afternoon. Bertram, Serg. Vye and Trooper Saunders were there. Six young girls faced us, and Mrs Beck [the parson's wife] leads the choir. B and I could only sing the airs of the music.

Heard from Shittler – an interesting letter. On night guard. Wrote to Betty.

Friday 19 February

The squadron rode to Lexham, and from there, representing the independent cavalry of an English army, tried to force its way through the enemy's cavalry screen represented by 'B' Squad. We hid in washpits near Rougham but the hostile scouts found us, and from there ensued a series of sharp gallops with hurried dismountings for firing at the enemy. Whether we got through or not I don't know. The day was very much like a run with the hounds. The horses were hard put to it, and the ground was heavy. We encountered hard hail storms.

I wrote a letter to Dray, who has sent us some Mexican chocolate. It is very good and goes down well on the march.

Germany commenced her blockade of the English coast yesterday. Expect her submarines will do a fair amount of damage.

Saturday 20 February

Squadron rode out in the direction of Stanhoe through G. Bircham in search of flags, which were found at the moment 'Cease Fire' sounded. There was a football match at Houghton between 'C' and 'A' Squads. The result was a draw.

The afternoon was warm and sunny. Several went to Lynn, but I sat in the sun outside the stable door and wrote a letter to May Handover. How I love to sit down and smoke in the warm sun! It is an indulgence of a very high order. Smoking can do no harm when the body is at rest, and the blue, curling, uprising smoke, the quiet contented mind and the bright sun is a 'rest cure' of five minutes, and nothing to be termed lazy.

Sunday 21 February

I sang in the church choir with Tory, Vye and Saunders. Opposite was Mrs Beck, and seven young ladies clothed in white with black velvet hats upon their heads. There was Miss Murfet, who sings very little, two Miss Woods, good-looking and dark-haired, and a plump beauty in the front pew whose eyes met mine at times, when we dropped them mutually. The parson was very poor. He read a sermon about Temptation and the Fight for the Spirit against the Flesh. There were only two hymns, and during the collection we stood doing nothing. We had 'Art Thou Weary' to Gounod's tune.

Walked along the Peddar's Way, home through Little Massingham. ... Went to the Rose and Crown. Saw Roy. Drank with the guard.

Monday 22 February

Exercised the horses. Kerton came over and gave the squadron bayonet drill. I didn't turn up, but stayed in the stable and cleaned kit. Our little

guard-room is a cosy enough place when the sun shines in. 'Nap' is played a lot inside upon a horse blanket.

Walked down to the station and found out trains to Norwich. Went into Railway Inn [by Massingham Station]. A genial crowd there. Sang songs in the front parlour with Haim, Merrett, Ford, Shepherd, Bradley and Jeans. I rendered 'Two Eyes of Grey'. Bendall the grocer was there, and some young man called 'The Honourable'. Elizabeth Mason keeps the Railway Inn.[11]

Tuesday 23 February

A brigade drill at Raynham. The weather was quiet and sunny, but snow threatened. What a long ride it seems back to Harpley! Just when the windmill comes in sight, the road to reach it seems so long. We don't like brigade drills [but] I like the village of Helhoughton. There is a little girl whom I wave to at a cottage door. I didn't see her today. My blanket slipped off as I was on advance guard. Old got hung up on a bough.

There was an inspection of men's private kit. We have Mr Druce as our officer now. He is a quiet, rather stern man, but can be pleasant. Is a little sarcastic. Not very brilliant I think, but is never excited.

Set out for Rudham but a storm came, so turned back and read two short stories by the fire. They were from *Windsor Mag.* and called 'The Cloud' and 'A Matter [Question] of Carat'.[12]

Roy went on a week's leave.

Wednesday 24 February

Thick snow storms were today. We went out to Anmer, our troop acting as advance guard to the squadron. I rode through the woods and found them warmer than the open heath. On the return, the snow came hard.

In the evening Bob [probably a local man] came up and played on the violin. He has a lot of German songs and well-known English ones. He played the Brabanconne [Belgian national anthem] and I sang it. The string on his instrument broke, so we had to stop.

Read *Villette*. It is a small world, but surely not as small as *Villette* would have it. Charlotte Brontë must have suffered a great deal. A woman of strong passion, and for such it is a tragedy to be born plain.

Thursday 25 February

The troop, under the command of Ned Smith, rode to Massingham Common and back. Smith was instructed to make notes of the country. He is a good and bold horseman, but has no gift of leadership nor any idea of reading maps. It is surprising how few troopers can read maps. Halted on the Heath. We had a nice time in the sun; the horses grazed, and two ran away as far as Massingham.

Choir practice. Beck the parson attended. I blew the organ and rang the bell for the service afterwards, and then climbed the tower and reached the bells where I listened to the music and the singing down below, and watched the sunbeams that peeped in from the narrow slits and the starlings that flew around. Wrote my name upon the belfry door.

The Allied fleets have commenced to attack the forts in the Dardanelles.

Since the nationalist Young Turk Revolution of 1908, the Ottoman Empire, although under financial constraints largely linked to the succession of Balkan Wars, had embarked on a wide-ranging programme of modernisation. In 1911 they commissioned two dreadnought battleships from Britain, which would give them superiority over both the Black Sea Fleet of their long-standing adversary Russia, and the Greek Navy. Russia not only wished to preserve its important trade route through the Dardanelles to the Mediterranean, but also had ambitions to recover Constantinople for Eastern Orthodoxy. Greece had won its war of independence from Turkey in 1830, but wished to expand its mainland territory to the north and gain fuller control of the Aegean Sea, and would achieve this by seizing three Aegean islands, including Lemnos, in the First Balkan War of 1912. The same year, Italy had conquered Libya, the Ottoman Empire's last remaining African territory, and annexed no fewer than thirteen Aegean islands in the Italo-Turkish War.

When the assassination of Franz Ferdinand in June 1914 began the inexorable slide into war across Europe, Turkey – outside the European system of alliances – thus found herself in urgent need of a strong ally to ensure the integrity of her remaining territories. France, who had only recently advanced a huge loan to Turkey, refused an approach by the Ottomans because her ally Russia would be bound to disapprove. Since the Crimean War of the 1850s, Britain had supported the Ottoman desire to protect its domains against Russian expansion by restricting Russian access to the Mediterranean. Indeed, until 1914, a British admiral had served as commander-in-chief of the Ottoman Navy. However, Britain was never approached as an ally, not least because on 1 August 1914 the government, yielding to increasing pressure from its Russian ally, requisitioned the two new Turkish battleships while they were still in dock, despite the fact that they had already been paid for. Although Turkey had no immediate wish to embark on war, the very next day the government in Istanbul entered a secret alliance with Germany, who had just declared war on Russia.

At the beginning of 1915, Russia urgently requested the British to attack Turkey so as to draw Ottoman forces away from the Caucasus. In response, an Anglo-French fleet was dispatched to force a passage through the Dardanelles, using the port of Mudros on the island of Lemnos as its base. On 19 February, the fleet began to attack the coastal forts at the southern end of the Straits. Meanwhile the Russians had defeated the Ottomans in the Caucasus, but by now the British War Council – and most particularly Kitchener – had become captivated by the possibility of a knockout blow against the Turks.

Friday 26 February

Big scheme afoot. Our brigade was out against the 1st So. Mid. Mtd. Bgd.
Our squadron started out for North Wootton to hold a station near there,
but we were attacked by the Worcesters ere we had ascended the hill out of
Harpley. All the morning we were upon the hills holding positions against
the enemy, who had rather surrounded us.

After pay – a trooper's allowance if he gets no efficiency pay is about 9*s* –
I walked to Rudham – called at the Duke's Head, an old place kept by one
Milk.[13] Entered the sitting room and played snap with the two little girls –
Brenda and Doris. Then seven troopers arrived and we had some music,
as Mrs Milk plays. I sang 'Down the Vale', 'Hearts of Oak', 'Woman's
Recruiting Song'.[14] A man with a long face sang 'Three is Company, Two is
None', and 'Can't I Come Home Again'. Quite an enjoyable evening, and
I walked back quickly in the moonlight.

Saturday 27 February

A wet morning. Exercised horses to Massingham and round by the four-
shafted windmill on the hill.

To Lynn by a special train. A number of us went. A bright afternoon –
the colours on the countryside, or rather the shades, were delightful in
the evening sun. With Cossins, after we had dined at the Globe [Hotel],
I wandered round the older side of Lynn – round the grand St Margaret's
Church and up the narrow streets to the Greenland Fishery Inn. We found
our way to the quay and walked there. The moonlight on the river and
the shore upon the further side was a sight. Looked at the Custom House.
Discovered the ferry and took a trip over and back. There were a dozen
passengers. Went into the Ferry[-boat] tavern, a snug retreat, and there
drank with the ferryman. The walls hung pictures of full-sailed ships.
The landlord was a waterman in past years. A gramophone was playing
'Tipperary'. It was a place after my heart.

Sunday 28 February

I enjoyed the service at church. In the choir I was happy, singing the
psalms and hymns. The sun shone upon the faces and vestments of
the children and ladies in the choir stalls opposite to me. A healthy
sight – young, strong lasses singing freely to the God above. Ah! Rustic
simplicity, so akin to nature. We know, although in white, they are none
too good. But what matter? They are only mortal; and we look on them
as rosy cheeked, laughing girls, and not as demure and quiet nuns.
The sun streaming, the sight of the waving boughs of the Spanish oaks
without, and the ceaseless driving of the wind did me a wonderful good,
and there was much peace.

Monday 1 March

Operations at Hillington. Measles has broken out in the squadron. Lieut. Browne and Troopers Old and Watkins have caught it.

Walked to Massingham and called at the Fox and Pheasant. The landlord – Mason – was having dinner beside his little girl, and his wife sat at the table and talked to me.[15] The little girl – Edna, a child of six dressed in blue – sang to me before the fire, and recited a short poem. I listened to the gramophone, and Edna joined in with some of the songs. Ned Smith came in for a short time...

Tuesday 2 March

The squadron is now isolated. We cannot go to a village where troops are, must not use the schoolroom, or visit a 'measly' billet.

Yesterday was very windy, but today was calm and bright. Operations (our field work is now detailed to the squadron) took us in sight of Castle Acre Church. I was in the rearguard with Smith. The lines of hills to the south, and Castle Acre Church rising in a valley and the sun upon all, moved me to march south. Oh that I could! Our work took us into a warm lambing yard. Homewards I had some jumps, and everyone admired my horse's jumping.

Heard from Mrs Menzies. The sweetness of her character is seen through her letters. Roy returned. We are highly interested in the Dardanelles attack. Read Mr Asquith's speech.

By 25 February, the Allied fleet had accomplished the first stage of its mission in the Dardanelles by destroying the southern, outer forts. The Prime Minister made a wide-ranging statement to the House of Commons on 1 March. It covered financing the war effort, the determination of Britain, the Empire and Allies, confidence in the outcome of the war, operations in the Dardanelles, the German blockade and retaliatory measures against it, labour relations during wartime, and an affirmation that now was 'not the time to talk of peace'.

Wednesday 3 March

I believe it rained from morning to night. We walked our horses as far as the windmill ... on the hill half a mile from Murfet's Farm. It is a good landmark and can be seen from Hillington. I am fond of seeing its arms dance round and round under blue and clouded skies, and in rough and light winds – the sight is a happy one. Mr Norman is the miller. He keeps his little farm and house very neat. I climbed up to the top of the windmill tower one day and looked across to the sea. Old Norman – a tall strong man with a long beard – explained things to us.

Heard from Irene Gass.

Thursday 4 March

Advance guard work from Massingham to Gayton. Roy, with Bertram, Cossins and me, took the right of the road. I was on the extreme right and missed Cossins, but made a fairly direct line. Came across a white flag (guns) in a large wood, and after some difficulty reported to main body. Advance guard work is interesting, but it is fatal to lose touch with one another, and at every bound a message <u>must</u> be sent to the main body.

The major's (not taken seriously by us) Bernhardi and French Cavalry lectures are doomed, as we cannot use the schoolroom. The major himself has the measles. I wrote to Joan Buckley, but did not finish the letter. Gave Itchy some sugar and a mangle for supper. How he loved it!

Friedrich von Bernhardi (1849–1930) was a Prussian general and military historian. His bellicose publications included *Germany and the Next War* (1911), *Britain as Germany's Vassal* (1914), and *World Power or Downfall* (1915).

Friday 5 March

Advance guard work along the Peddar's Way to Fring. I was on the right with Hooper, Cossins and Leaton. We kept well in sight of each other, and sent a message to Tory at each bound. Returned by way of Snettisham and Shernborne. From a height I saw the sea and ships upon it.

The doctor medically examined us. He looked at our teeth, our feet and hands. Not a very trying ordeal. Dr Rickett is a peculiar man: blunt, sarcastic and ugly, and rather vulgar in a professional sense, but efficient and genial enough.

Read Wm Irwin's account of the fighting at Mons, La Bassée and Ypres. They have been most glorious affairs and very critical. How little we at home know of the perils and horrors of those latter October days. Shall we ever realise how the fortunes of our island race were nearly jeopardised? Forward England!

Will Irwin, one of several prominent American journalists covering the war, wrote a long account of the First Battle of Ypres (October to November 1914) for the *New York Tribune*. His account of how the Allies held the line from the Channel coast to La Bassée, south-west of Lille, against hugely superior German numbers, was reprinted in the *Daily Mail* on 4 March 1915. Demand was so great that it was issued as a special halfpenny reprint before the end of the month. This action was 'critical' because failure would have risked handing the Channel ports to the Germans, thereby cutting off the British supply route.

Saturday 6 March

My horse – Itchy – is a bay gelding – aged – rather small, and has a white star on forehead [running into a long blaze]. He is a good jumper and will

take anything possible if he is excited. He is a handsome horse and has a true cavalry head. I can leave him anywhere and he will graze if there is grass, and there is no danger of him running away. If I move off, he will follow. Most nights I go up to the stable to see him and give him two knobs of sugar, and now and again a mangle. The oats we are supplied with are poor, but the horses look well on them and Itchy would eat a sackful I believe.

Stanley never says where Itchy was stabled, but the several references to Murfet's farm strongly suggest that he was there. Lower Farm (Murfet's) was one of the three principal farms in Harpley, and had extensive buildings with plenty of stabling.

German blockade is not proving very successful.

In fact, Britain lost more merchant shipping to enemy action in March than in January and February combined.

Sunday 7 March

No church, because of measles. The squadron paraded on Mrs Cameron's lawn at Harpley Lodge, where the officers are now living, and the Rev. Beck read to us a few prayers and a psalm from the Prayer Book. Beck is unpopular with us. The fellows think him lazy, indifferent and callous. We see him ride to hounds sometimes, and hate him for it because he neglects his parish and cares not how he preaches to us.

A football tournament was played and No. 4 Troop won. Our troop played against No. 4 Troop and lost 1 to 0.

I wrote to Mother. Miss Porter and her father much grieved at our playing football [on the Sabbath].

Monday 8 March

Squadron drill under Lieut. Bernard Lees at Rudham Grange. A thick snow storm drove us home after half an hour's drill. At the Grange is a convenient park and a pleasant farmhouse. Watching us were the farmer's daughters, and the farmer mounted on a horse, and three women in shawls. I wonder what they thought of us, passing to and fro in the snow.

Spent the evening at the Railway Inn, where I went with Robberts. Sat by the fire and talked to Mrs Mason and her son Arthur. Mrs Mason is a tight-mouthed good-natured old body.

Tuesday 9 March

Under Mr Kennaway, our troop went away to Brink Hill with three flags. The flags took up positions along the high ground, and Robberts and B and Rose and Pardy were sent out to do a little guerrilla warfare. I did some scouting. A most interesting day. It was fine and warm, and hiding with

Itchy in the gorse and woods I enjoyed. Nearly got captured, but escaped and managed to pick up the flags.

Spent all the evening writing to Joan Buckley. So hard to write in the sitting room of these billets. The lamp is so hot and the fire warm, with no window open in the room and people talking. I retired to the front parlour to write. Heard from Mother.

Wednesday 10 March

Saddles have to be given in. Special orders re measles were read to us at the Lodge. Our boundary is drawn rather tight. Cannot go to either of the Massinghams or to Houghton or Rudham because of measles. Exercised horses round by King's Cottages and Peddar's Way. Mr Druce annoyed fellows by trotting. We were bare-back; he had a saddle.

With Pardy and Harvey, tried to bring down partridges in the dark on Murfet's 100-acre field. Never seen so large a field. A very still night for March. Wrote and sent off my letter to Joan Buckley. It is an effort for me to write letters.

Good night for Zeppelins [because so still and without low cloud or a bright moon].

Thursday 11 March

There is much talk of our going away shortly to some country where it is hot. There is much talk of German East Africa, a little of the Dardanelles, and some of the Gulf of Persia or Egypt. No one thinks it possible that France is our destination. The division is evidently moving soon, as in orders it was read that the Dorsets would probably lose their chance of moving abroad with the division if measles continued. We have been measured for – pith helmets? The horses are being prepared for a long journey, and given bran and cake.

O, when will the dun brown earth and scabby stubble and bare hedge break again into life!

Friday 12 March

Spent the morning at the forge. The shoeing smiths were short-handed and old Itchy had to wait a while. I watched Mr Mountain the wheelwright make part of a wheel, and talked to old Mountain the blacksmith.[16] I should say the Mountains are a good and pious family.

Our troop drew new saddlery at Mr Beck's stables. What a mean and frugal-looking place is the Rectory! The rascal of a rector rode out on his horse with his dogs. I think only one took any note of him. Mr Kennaway superintended the giving out of saddlery. He is keen, and a good officer. A little nervous, and too explicit and perhaps not brief enough in his commands. I soaked my saddlery with neatsfoot oil.

Saturday 13 March

Bertram, Roy and I took off our coats and waistcoats after dinner, and set to and planted some potatoes and peas for Mr Porter. We dug and broke the soil, trenched, planted, covered in, and dug again, until we had sown six rows of spuds. The old man reminds me of Father in the manner in which he orders about and criticises. He and Roy disagreed as to the correct way of planting spuds. The Norfolk way is to make a trench the width of a spade and about two inches deep, and then plant. This we did. Miss Porter refreshed us with some cherry wine.

I soft-soaped my kit.

The English have been making slight progress towards Aubers and have taken the village of Neuve Chapelle.

Haig's First Army had captured Neuve Chapelle, west of Lille, on 10 March, but were unable to take the Aubers Ridge.

Sunday 14 March

Cannot go to church. Parson Beck came on to the lawn at the Lodge and read us a few prayers. I doubt if the OC can order us not to go to church or chapel. If by going to either we were neglecting other squadron duties then we might be wrong, but all the morning there were no duties, and is it possible for a commanding officer to forbid church worship under such conditions?

Wandered in the sun up to Mrs Body's house. Watched several troopers have their photos taken on horses. Went for a walk with Itchy as far as Cross's Grave. A beautiful day. Many people out.

On night guard, but Ingram took my place. Found much entertainment in Trooper Leaton.

Monday 15 March

Paraded in Wood's field – mounted, with new saddlery. Officers inspected it. My girth is too large for Itchy. Paraded in same field with our spare suits of clothes. Afterwards drill. Lieut. B. Lees in command.

Weather gorgeous. Bicycles are coming out and the girls look spring-like. A little dust on the roads. Miss Murfet's greenhouse bulb flowers looked very nice. I wrote to Shittler, a long letter in answer to two of his. Ah! I often think of Salisbury and the folk there over the river at Harnham – I mean the Menzieses – and then there is the grave in the churchyard.

Tuesday 16 March

Heard from Joan Buckley. She quarrels with me for thinking the suffrage question should be dropped in these times. I am of the opinion that the govt will be bound to recognise women's rights at the conclusion of the

war because women have proved themselves to be useful to the state in this time of war, and they have and will suffer so terribly. Joan thinks that the Suffragettes must agitate now and be sure to obtain the vote, so that at the Great Peace they shall have a say in the framing of it. Iris is going to stay with Joan on the 20th.

Joan was not the only member of her family to support votes for women. Her mother had been a founding member of the Northamptonshire Liberal Women's Suffrage Union in May 1914, and immediately became one of its vice-presidents.

Wednesday 17 March

Monotonous exercising of horses, of which we are growing entirely sick.

A dismounted march along the Anmer road to a ploughed field where we halted. Mr Kennaway ordered us to attack a wood at the far end of the plough by sharp and short advances, three troops to cover the advance of one. Running was very hard with bandolier and rifle up the slope on the rough ground. We had Xmas pudding for dinner, and it is not like rice pudding for running after!

Wrote to Mrs Menzies asking her to have my canoe.

Mrs Menzies seems to have declined the offer, but it remained in Salisbury for the time being. Iris helped to maintain it and used it as much as she could early in the war (in August 1915 she and Betty paddled down the Avon from Salisbury to Christchurch), and then Dray took it over in 1916 after Iris became a VAD.

Thursday 18 March

There was snow in the night, and we looked out in the morn to see a light sprinkling of snow upon the ground. Full marching order and inspection by the officers. I was only short of a nosebag. Itchy had his back feet shod.

Down at the Railway Inn in the evening I sat by the fire and read *The Times*. An article about Switzerland and their feeling in this war was interesting. Merrett and Richards were present. Merrett was discussing the state of being 'canned' – what makes a man 'canned' quickly, and how near a man can get to being 'canned' and yet be sensible.

Friday 19 March

So rough a night, with a heavy fall of snow. I awoke to hear the wind … and the snow was whirling earthward. We led our horses round by King's Cottages and Massingham Station. The snow had drifted deep in places. We had great fun snowballing at the stables. Percy Cutler, Robberts and Hayter bombarded some of us in the barton, and Robberts and I later in the day mounted the straw and shelled those underneath.

'Fairy' cut Itchy's mane and clipped his fetlocks.

Drew water at the well for Rose [the proprietor's daughter of a travelling show] and snowballed little Lily [one of the village children].

Saturday 20 March

A show has arrived in the village. The owner's name is Harvey. There is a moving-picture theatre and three side-shows, where woodbines can be won for hitting pipes out of people's mouths or ringing small articles of jewellery. I went to the pictures in the evening. The man Harvey was amusing. There was a tragic and a comic picture, and one or two war pictures of old date.

In the afternoon Mr Jasper Wright from Lynn came [to Houghton] to take our photos on our horses. I was on Itchy. Most of the fellows mounted themselves on Richardson's transport horses instead of their own.

Roy was among these (plate 25). Practically all the snow had disappeared overnight, since only a tiny bit is visible in his photo. None at all can be seen in a group taken by Mr Wright in which Roy's own horse appears, though it was clearly winter and apparently also on the Houghton estate (plate 26). This group shot was made into postcards (as were the horse portraits), and sent by Stanley to various members of the family. It is not mentioned in his diary, and one copy is captioned 'Yeomen 1914', so it probably dates from shortly after their arrival in December.

Sunday 21 March

Gorgeous day. Divine service on the Lodge lawn. The droning of the prayers and the warmth and dazzle of the sun affected me drowsily. O glorious sun! Why do we not pray to God and use the sun as a medium for worship?

Vaccinated in the afternoon by Dr Rickett. My brothers and several of the troop were vaccinated as well.

The soldiers made up an alphabet-poem about their officers. One of the best verses reads: 'V is the Victim of our Dr Rickett, / If you show him your arm, he is certain to prick it.'[17]

I spent most of the day writing a letter to Joan in reply to her letter. I tried to argue that this was not the time to agitate for women's suffrage.

On night guard with Cossins. Read *Villette* in the guard-room.

Monday 22 March

I rode Itchy and led Bismarck out for exercise. The squadron drilled in a stubble field near Brink Hill, and we who had led horses walked them round and round a wood until it was time to return home.

Under Mr Kennaway's charge, the squadron attacked a wood on foot. We advanced by an advance patrol, a troop extended in line, and the three

remaining troops in extended order of troop column. Very hard work running over ploughed fields, and we were done up.

Afterwards I went to the Rose and Crown and had a peppermint. Walked down to the village and looked at Harvey's Show, and was interested in the Harvey family, and Rose, the only daughter, who managed the Touch'ems stall.[18]

Tuesday 23 March

Exercised horses. For a wonder we trotted a great part of the way. We went [by] Anmer and Flitcham. Noticed several young men on the King's estate who I thought might enlist in their master's army.

Trench digging in a ploughed field belonging to Mr Fake. Cleaned my kit in preparation for tomorrow's full marching order inspection. My arm is becoming a little stiff and sore – the result of vaccination.

Gave Itchy a mangle.

Wednesday 24 March

On Harpley Common, the colonel and adjutant inspected us. We were in full marching order. Day hot and still. We rode back along the Peddar's Way. Trench digging in afternoon. I refrained from working as my arm was bad.

Heard from Father, and Wyn who is in Paris sent us each a postcard. She thinks of going to Algiers. Said Paris is sad, people in black. She slept through the recent air raid.[19]

Two Zeppelins bombed Paris on 21 March, but there were no fatalities, not much damage, and no panic among the residents.

The day closed hot, raining and humid. Visited the church and listened to choir practising. Roy played dominoes with Mr Porter. I wrote to Father.

Thursday 25 March

Bertram unwell. I rode Itchy and led Shamrock for exercise with the squadron. Many of us have painful arms – the result of vaccination – and a few show red ribbon upon their left sleeves. We were served out with a shirt and a pair of socks each. Sat some time by the stove in the stables at Harpley Lodge talking to one of Mr Kennaway's servants.

In the road met Rose, the young but very grown-up show girl. She said they had to leave tomorrow. She wore a large oval silver locket hung upon a chain at her breast.

In afternoon Roy turned 'seedy'. I heard from Mrs Menzies and Shittler, and Mother sent me a letter, and enclosed one from Wyn and one from my cousin in Egypt written to his father, Uncle William [Thomas George's younger brother].

Friday 26 March

The colonel and the adjutant came over from Rudham and inspected the mares of the squadron with a view to selecting some which would remain in England for breeding purposes.

Ruth Pooley [daughter of local farm bailiff George Pooley] is ill, and the morning papers arrived late. We look forward to seeing the papers each day. Ruth Pooley brings them at 9.30. I take the *Daily News* and Mr Porter the *Daily Mail*. Besides the papers, there is the post we look forward to very much. Roy gets most of the letters; I get a few now and again.

There were snow storms.

Saturday 27 March

A bright morning. The post brought the photos [from Jasper Wright] – they were good, and some amusing. Bower looked like a whirlwind on his horse. Aunt Don wrote me a letter and enclosed a 5s 6d postal order. Also heard from May Handover. She says she is moving from Sherborne to Berkeley in Gloucester[shire].

For many years Louisa George's younger unmarried sisters, Bertha Theodora Watts and Madonna Agnes Watts, the diminutive Aunts Bertha (Bee) and Don, lived with the George family in Blandford. Aunt Don would later be awarded the British Empire Medal for her own war work.[20]

The troop killed rats in the afternoon in a field where a rick of oats was being thrashed. In the evening, strolled round the village. Went to Morton's farm, met two children playing in the road and talked to them. Coming home saw Nora and her brother Gordon. Nora is a dark, ruddy-faced, pretty girl of fourteen. Beautiful moon, and still night.

Sunday 28 March

Church parade on Harpley Lodge lawn. This service is unpopular, I believe. Some of us think this is the last Sunday we shall spend in Harpley. Second batch were vaccinated.

Wrote to Aunt Don. I was on night guard.

I rode Robberts's mare and led Kettle's to Rudham, where there was [again] an inspection of mares. Rather silly inspection – the officers seemed to talk among themselves for the most part.

Some of the fellows' arms are very bad.

Monday 29 March

Lieut. Browne returned after being away ill with measles. He had long hair and looked very thin. He took us round Sandringham and we saw the

house and some of the grounds. I liked the stables and noted the statue of Persimmon. We passed several trees planted by royal personages.

Persimmon was a champion racehorse owned by the Prince of Wales (later Edward VII). The huge bronze statue (8½ ft high, on a 5½ ft granite pedestal) by Adrian Jones was presented to the King by the Jockey Club in 1905.

Drilled in the football field under Lieut. B. Lees. Very good view of the sea from the field.

Mumps is developed. The Rose and Crown is out of bounds. Went to the station and called at the [Railway] Inn, and talked to the donkey man and read the *Southern Times* [*and Dorset County Herald*]. Had fun round one of Murfet's ricks.

Tuesday 30 March

Gorgeous day. Exercised in drill order. Went near to Longham Hall. No afternoon parade. No. 1 Troop drew new boots and puttees. Boots very good – soft and strong.

In evening I went down to Simpson's, and asked Cossins to come for a walk. We met Old coming up from the station – he had been home. Beautiful moon. I walked up to Morton's farm and along Rudham road to the pond that is surrounded by trees. Beautiful night under the moon. Wandered over the fields to Murfet's.

Read two good chapters in *Villette*.

Wednesday 31 March

Rode with Old... Russian bayonet drill under Mr B. Lees. Packed my saddle in readiness for tomorrow's inspection. The transport men returned late – with mules in place of the horses they had harnessed to their carts when in the morning they went away. Their horses are going to France, and mules will now be their tender care.

Heard from Wyn who started for Bou-Saâda [in Algeria] yesterday. She can find no work in Paris and thinks she is better and happier painting.[21]

Thursday 1 April

Bismarck Day [the centenary of his birth].

The regiment paraded in full marching order at Rudham, and the brigadier inspected us. He and the colonel asked Roy a few questions regarding his tunic, breeches and horse.

Mr Kennaway drilled us in Russian bayonet exercise at Morton's farm.

The weather is dry and warm. Spring is showing a very little in the hedgerows, but the fields still remain dull and drear as they were when we arrived in December. The boys here call the thrush by the name mavis.

Friday 2 April

Major Castleman is returned.

Morning exercise. Afternoon there was a holiday. I started to dig Mr Porter's garden, but the rain came and I was forced to retreat indoors. Mr Porter is a man who will have things done as he wishes. Maybe he is right – he is old enough to know. I had not started to dig but a few minutes when he comes out and shows me himself how to dig. Some say I'll never be told anything, but I tried to do what he told me.

On night guard with Maiden. Maiden is the son of the huntsman of the South Dorset Foxhounds.

Saturday 3 April

On Easter eve of last year I started out from Bemerton on my tramp along the Icknield Way to Badbury Rings. How well I remember that fine afternoon! Setting out over the meadows, meeting Sam Harper, with him climbing to the Race Plain,[22] bidding him goodbye, plodding on quietly with a high heart across the Ebble and over the hills and vales to Handley. I read the life of Caesar at the inn where I stayed, and after supper walked through the village and looked up at the April moon and listened to the crying of a child in a house where a bedroom window was showing a light. That night I wrote to Margot and Dorothy [Rossiter] – Dear Dorothy, back in the big hospital working.

Like his two older brothers, who in later years tramped for miles together across Dorset, Stanley enjoyed nothing better than a long country trek. The walk he describes took him from Salisbury back home to Blandford via Sixpenny Handley and the Badbury Rings.

Sang songs – 'Vicar of Bray', 'Hearts of Oak' and 'Mandalay' – in the guard-room. Fetched bread at Mr Fake's.

Sunday 4 April

We can go to church again. I sang in the choir with Tory. There was a strong muster of ladies and their voices rather drowned ours. The parson appeared to the congregation with his arm tied to his side. He met with an accident in the week.

I walked through Houghton woods and carved my name upon a beech tree. Went to church and sang again in the choir. A very happy Easter Sunday. Walked with Bob. Visited the Devil's Pear Tree. Bob [see 24 February] told me several mysterious stories. I like Bob.

Read St John's Crucifixion to Mr Porter and sang him some hymns.

Monday 5 April

Full marching order. The major inspected us outside the Rose and Crown. Exercise to Bircham Common. Bertram found three plover's eggs.

The doctor made us all strip on the Harpley Lodge lawn and he looked to see if any of us had rashes.

Six horses came to be stabled at Murfet's. They kicked very much. I was line orderly. Sent several people the photo postcards of Itchy and myself.

We hear we are moving on Wednesday. I wonder if it is true.

Tuesday 6 April

At midday the serg.-major came to the stables and read orders which stated we are to move away tomorrow night to Fakenham, and there entrain for a port of embarkation. The afternoon sped quickly away – there was excitement and confab. Miss Porter asked Old and Cossins and Hooper to tea. We discussed our going, round the table after tea, all smoking cigarettes. At six o'clock the major read out the names of the men allotted to voyage in the 'cattle' boat and look after the horses. My name was read out. I shall now be able to look after Itchy. We were paid at Harpley Lodge. The wind was high and blew with a grey sky. The daffodils looked unhappy. The birds twittered.

All the winter here – and in the spring [his favourite season] to leave.

Their Norfolk landlady wrote to Aunt Bertha on 11 April 1915:

Dear Miss Watts

Have sent your letter on with several others that came for your three nephews. There [*sic*] address is – C Squadron, 1st Dorset Yeomanry,[23] 2nd Mounted Brigade, 2nd Mounted Division, British Mediterranean Expeditionary Force.

Words fail to express how much we miss them. Life seems gone, just like death everywhere. They were three <u>nice gentlemen</u> in every sense of the word. They made themselves quite at home and I believe were very happy here, only they felt sometimes it was a waste of time staying here so long [and] wanted to be doing something to help end this <u>dreadfull [*sic*] war</u>. I went and saw them off. It was a sight to see so many brave young men giving up all to serve there [*sic*] Country. And yet it made us feel sad, for God alone knows whether they will ever come home to dear ones again. I do hope and pray they may. For trust the war will soon be over, so no need for them to fight. If ever we valued and longed for <u>Peace it is now</u>.

I received a p.c. from Mr Roy to say they had arrived at Avonmouth and embarked. And off to somewhere, so they are on the sea miles from us all. Do hope they will have a safe voyage. We shall always think about them. Trusting you are well yours sincerely

Agnes Porter

CHAPTER THREE

A Voyage with Horses

In early March 1915, the 2nd Mounted Division was told to prepare for service abroad. Divisional HQ left Avonmouth on 3 April, and the mounted brigades sailed between the 7th and 10th. On the 7th, the Dorsets began the long journey from Norfolk to Egypt as part of the British Mediterranean Expeditionary Force. Their 498 horses and fifty-six mules travelled on the SS *Commodore* (plate 29), together with five officers and 189 other ranks of whom most, including Stanley, were to look after the animals. His brothers, as well as most of the Dorsets' officers and remaining 318 men, travelled on the SS *Karoa* (plate 30), which also transported the soldiers and around 300 horses of 'A' Battery, Honourable Artillery Company. On 17 April, Stanley wrote a long letter to Dray, beginning, 'The SS *Commodore* is nearing the island of Malta, so I take the opportunity of sending you a letter.' This – his first letter home – enlarges on his diary entries up to that point (see 'Note on Editing' in the Introduction).

Diary, Wednesday 7 April

> The squadron leaves Harpley at seven o'clock en route for Fakenham station. ... All the village are out to see us depart. They are very sorry. Miss Porter is particularly sorry to see us go. She has been so good to us. The evening is a beautiful one, clear and still. We go by way of Rudham Grange and Helhoughton to Fakenham. At Hempton Common we halt, take off our saddles and spread blankets. ... On the road I was advance guard with Cossins.

Letter

> It was a Wednesday night we ... marched away along the road to Fakenham. Our departure from Harpley was in grand style. The parson delivered a speech to us from the Post Office steps and the villagers cheered us. The major replied very politely, and called upon us for cheers for the parson and his parishioners. We then made off down through the village

with swords drawn and carried at the salute. At Fakenham the horses were entrained quickly and with little bother, and after we had refreshed ourselves at a bun and coffee stall we jumped aboard the train, which left Fakenham at eleven o'clock. We all thought our port of embarkation would be Avonmouth and we were right. All night we travelled across England, through Market Harboro', Leamington and Cheltenham, arriving down at Avonmouth about 9 a.m. on the Thursday morning.

The sixty-five recruits who had travelled from Sherborne to Wantage in October could be accommodated on regular trains, but moving entire regiments (not to mention their horses) required dedicated transport. Special troop trains became the usual method of moving large numbers of soldiers around the country, and many of them ran overnight when there was little competition for track space from timetabled passenger services. The Dorsets' journey of 236 miles took them over the lines of four different railway companies. Their route was Fakenham – King's Lynn (Midland & Great Northern Joint), King's Lynn – Peterborough (Great Eastern), Peterborough – Market Harborough – Rugby – Leamington Spa (London & North Western), Leamington Spa – Stratford-on-Avon – Cheltenham – Bristol – Avonmouth (Great Western).

Diary, Thursday 8 April

Serg. Tory, Corp. Hooper, Roy, Bert, Old, Cossins and Corp. Miller and I are in the same carriage. Our first stop is at Market Harboro'. ... I sing at times. Receive no encouragement. The country is delectable – the distant Malverns at early dawn. We reach Avonmouth at nine o'clock. Horses are detrained ... fed and then taken on board the *Commodore*, the horse boat. ... I spend the day in the mess room and looking round the docks. Come across Robson [a friend in the Berkshire Yeomanry]. He shows us his boat, and I also go over the *Karoa*, by which B and R are going. We do not leave tonight.

Read Betty's long letter on the deck of the *Commodore*.

Letter

All was ready for us. Our saddlery was placed in sacks and the sacks we packed away on board this ship. The horses were well fed and then taken aboard without any bother. They don't mind mounting the first gangway to the ship, but jib a little at the descent into the hold of the ship. Bertram had rather a trouble with his. Mine was all right when he saw some mules down below eating hay. After a look round the *Commodore* I went off to the messroom in the docks. The place is just put up, I should say, and sweets, cakes, sandwiches, coffee, tea and tobacco and books can be bought there. The place was filled with grimy navvies and perspiring soldiers. I went aboard the *Karoa*, on which the regiment is sailing. ... It is a new [1915] and large [6,631 ton] boat, but I expect they will be rather packed on it.

Diary, Friday 9 April

All day we loaf aboard the *Commodore* [watching the vessels in the docks]. Late in afternoon a tug – the *Expert* – pulls us out of dock, and we steam down the [Bristol] Channel and anchor off the small town of Clevedon. Moored near us are five cargo boats ready to enter Avonmouth, and a torpedo boat destroyer protects this little convoy of merchantmen. With darkness, the anchor is pulled up with a rattling of chains and the *Commodore* makes for the ocean under the protection of the destroyer *Lawford*. I remain on deck with the look-out man – an Irishman... The pilot is dropped off Barry. ... I wish him Good Night and he replies, 'Good Luck, *Commodore*.'

Letter

I was up in the bows during the evening and watched the green hills of Somerset grow dim and distant, and saw the long lights at Cardiff and Newport piercing the darkness away to the north. About nine o'clock we dropped the pilot. I saw him climb down a ladder and jump into a small rowing boat and pull off to a little sailing vessel anchored near us. He shouted, 'Goodbye *Commodore*.' Then I went down to my hammock and slept perfectly.

That night was amusing. Where we mess, the room is low and hot and just ventilated with portholes. The hammocks are slung on hooks all about the ceiling. I slung mine near the stairs so that it was fairly cool. Fellows were all around one sleeping; two or three just below, some on each side, and two above me. It was a comical sight. [So soundly do I sleep, although the sleeping compartment is the same as the mess room – low, dirty and crowded.]

With the morning we were up at 5.30. I had a wash in a bucket down near the cook's galley. It was a delightful wash, and there was no restraint necessary to one's movements as there is in a bedroom. One can splash all about... I had my breakfast – gravy with potatoes, a small portion of bread, salt butter and tea. The mess table I am on is very squashed. I have great difficulty in moving.

Diary, Saturday 10 April

Upon climbing the steps [after breakfast] I turn giddy and sick, and from then until the end of the day I spit my insides out and mutter, 'My God, why hast Thou forsaken me?' I wonder how I lived this day, having to descend and feed the horses. [The heat with the sickness was hard to stand.] I try to do my best. At night I sleep on some hay with the horses. The rocking of the boat makes them stamp, and I thought at times all the horses were breaking loose and stamping on me. Nearly everyone is ill – rolling and lying anywhere. I wonder how they are on the *Karoa*.

Diary, Sunday 11 April

I feel a little better, but still giddy and miserable.

A horse died in the night and it is committed to the deep today. Others are very bad, and will soon be let down in the blue sea for burial. Itchy still eats with relish and wishes for sugar. I hope he will live to see land, and once more do some jumping.

There is a [life-]boat parade in the afternoon. Capt. Fearnside will officer the boat, I assume, if there is disaster. The destroyer left us on Saturday morning. If a submarine comes, it will be goodbye.

We are in the Bay of Biscay. It is not rough. The fellows are not very happy as yet.

Letter

I felt rather better but could not face the meals down below. Towards evening I felt much better, and loafed round the cook's galley hoping he might chuck me something to eat. He was swearing horribly at someone, and with a saucepan in his hand was threatening murder. He is a bad-looking cook, but I like the smell of his galley.

Let me try and tell you something about our life, starting with the Sunday when I felt better. There was a life-belt and life-boat parade [that afternoon]. At the sound of a whistle from the Captain we all rushed below and put on life-belts, and then came up and paraded under selected officers at our respective boats. The life-belts are kept below. There are enough for every man, but I doubt if every man could get one in time in case of accident as they are in a very awkward place.

On the Sunday we cleaned out the stables. It is a hard and dirty job. The horses are each in narrow boarded partitions. They have just room to stand up and move their legs just a little. They are stabled in long lines on either side of two corridors, which run the length of the two extensive holds. The horses belonging to the regiment are here. To look after them there are about 130 men. You ought to see us cleaning out, stripped to the waist ... all the morning shovelling dung and carrying it in baskets to the decks where we deposit it in the sea. The temperature down there varies; yesterday [he was writing on the 17th] it was 62 [°F], now today it is 72. ... After morning stables we wash again and then go to dinner.

There have been great grumblings about the food. It is rather good but there is not nearly enough. We have been very angry, and our major who is in command – he is Lord Wynford – has been worried out of his wits. It is all the government's fault. [Breakfast consists of hash or porridge and a portion of bread with salt butter, and a mug full of tea.] For dinner we get two potatoes and a very small piece of meat and a little gravy. No bread or cheese. For tea, a little bread and butter [and a little jam], a cup of tea, and perhaps a bun with no currants, or a little rice. For the work we do it is not enough, and the men have been most discontented. The officers live in luxury. Hungry, we watch the cook frying the officers' mess: bacon

and eggs, fish, ducks, chicken, and other dainties. Perhaps they pay for it. You would have been amused to see the mess orderlies coming from the galley with flaked rice. [The fellows laugh at it and say they are not chicken to be given poultry food.] We all got round and whistled … as a woman does when she is feeding her poultry. Imagine the Dorsetshire Yeomanry living on rice! When we get plenty of food is when fellows fall ill with sea-sickness.

Every mess table has a mess orderly. The mess orderly at our table is named Daniells. His father is a gardener at Langton. He is a monstrosity. High tempered, swearing and greedy, with a long mouth and cunning eyes, he is a marvel – especially when he has his nose over the soup. He sits next to me. He is very funny. The fellows call him 'Danny'. He is verily in a lions' den, for the meat on the table is torn to the bone. Daniells said he would be mess orderly if we paid him 6*d* each. We did, and now Master Daniells has to lay the table, get the grub, and wash up. He is excused from all stables, and we really work harder than he. Last night he talked of 'planting a few pansies in the garden above' and pointed to the deck.

Diary, Monday 12 April

The *Commodore* is an iron-decked ship and has spacious cargo room. … This crew is new to her, but I don't know if the captain and officers have voyaged in the ship before. Lord Wynford commands the troops aboard, and with him is Lieut. Browne, Capt. Fearnside – the vet – and Lieut. Learmonth, whom they call 'Sticky'.[1] A doctor belonging to the RAMC is with us, also there are some of the RAMC men. Our mess deck is crowded at meals and at nights. The food is not sufficient. We have been short of bread and tea. The meat is very tough, and they are spare with the jam. … We have but now discovered that stable duties from which [Daniells] is free are as hard as washing up and 'slopping'. Daniells is a rum fellow. … He talks today of 'going into the garden to pick pansies' and 'taking a walk with his girl'. Fellows often ask for the 'bread cart' and the 'postman'. We are very hungry and sea air [makes] for keen appetites.

Diary, Tuesday 13 April

The *Commodore* is taking a lonely track. We have seen hardly a ship. The day is vivid with sun and the blue waters are dazzling. The horses are dying. Seven have died and been committed to the sea. They are very hot and thirsty down in the hatches. I bathe mine with a wet cloth and brush their heads with a dandy.

There is a dry canteen aboard. It reminds me of the 'guvvy' [tuck shop] at school. It opens twice a day. We can buy lemonade and soda water. This is popular – the former – just because there is no beer. The bottles have the trade motto 'Nil Desperandum' written on them, and the trade mark [above] is a hand holding up a yellow, juicy lemon.

A concert was held in the evening in the fore part of the ship. The songs were poor – they always are in the yeomanry – but with the watery deep around they sounded terrible. I sang with gusto... It was fine to sing on the rocking ship and look upwards to the God and the throbbing stars.

Letter

There was no music except when a seaman played on a banjo some of the airs he knew. Yeomanry songs are rubbish. A seaman had a good song – something about Ireland. He had a good voice. He also recited a sea poem. It was rather at the expense of this ship, the name of which he substituted in place of the name given in the poem. I clung on to the ropes and sang 'Come cheer up my lads, 'tis to glory we steer', and there was a hearty chorus. Then I sang 'Wert thou in the cauld blast' by Burns. There is a Scotchman on board and he said he liked it.

Diary, Wednesday 14 April

Last night I fell asleep in my hammock surrounded with other sleeping forms in thick cluster. Near my right ear a fellow was playing on a mouth organ. This, and the noise of the sea, soon sent me to sleep. I could look up through the hatchway to the stars in the clear sky.

Eagerly I watched our approach to the coast of Spain. The day was fine. The rugged coast and high mountains held my eyes. I thought of lonely muleteers on the rough mountain tracks, of small Spanish villages in the hills, of pleasing ladies with earrings and brightly coloured dresses. *Kedar's Tents* came back to my mind.[2]

When the *Commodore* came to the Straits, ships, some with sails and some with steam, were in view. Two troop-ships escorted by two destroyers passed us. 'Twas a grand sight, that of Gibraltar Bay and the Rock, [and] the long, irregular and rough African coast. I cannot realise I am now in the Medit. Sea with a great continent in sight – I have but been used to seeing it on maps.

Letter

On Wednesday morning we sighted land. I was hugely interested. I don't know whether it was Spain or Portugal we saw [first]. There were high rugged mountains, their sides choked with rocks and underbush. I saw a small Spanish town, a splash of red and white ... down by the blue sea. From it led roads, mule tracks as well, up and over the mountains. With glasses I could plainly see them.

The ships here were plentiful on the sea. Presently the great coast of North Africa loomed in sight and we ran along between two coasts until we came to the Rock. There it was, tall and black, capped with a white cloud. In the bay to the left we saw several ships, some for war and some for trade. A cruiser stopped us and signalled, and then we went on past Gibraltar.

Diary, Thursday 15 April

I have finished reading *Villette*. I have enjoyed the reading of it, but not overmuch. Charlotte Brontë had a neurotic temperament. Her life must have been years of mental weariness. Over sensitive, over thoughtful, highly intelligent, a weak constitution, together with a high soul. Fate made her unbecoming to the eye, and seemed to find it a delight to tease her in every turn. She was indeed a star, whose brightness could be fully seen only by other stars – and hers was Paul Carl Emanuel. I think perhaps she was purposely too cold in her nature and not warm or sentimental enough for the people she met with.

The [dry] canteen is run out except for lemonade and Nestle's Milk.

Letter

There has been such a run on it that now it is all dried up. There we could buy cheese, mixed biscuits, pickles, Nestle's Milk, sweets, cake, and [the] bottles of lemonade and soda water. Unfortunately there was not enough supply to last the voyage.... At a time when we were all ill and thirsty there was a great run on lemonade, and ... I burst out laughing when I thought of this Nil Desperandum lemonade, and saw all the fellows so ill clasping their bottles. I think the sea bottom will be covered with lemonade bottles from Avonmouth to Gibraltar. I suck Nestle's Milk and eat mixed biscuits.

Diary, Friday 16 April

A great deal of grumbling because of the insufficiency of the food. ... We are now going to have bully beef for tea.

Today we have fallen in with no ships except one tramp, which we sighted at a great distance. I like sitting in the stern of the ship, watching the churning water, the rise and fall of the waves, the setting sun and the rising crescent moon. The ship's cat – a hard looking black and brown animal – often wanders round me and will stand and look down at the water.

I do not like sleeping in the messroom with the others. It is too hot. I sleep in different places about the ship.

Diary, Saturday 17 April

In the morning our ship passed near a high headland. It was topped by a white house and tower – the latter evidently a lighthouse. I hear this is part of the Tunisian coast. One mile west of this cape we came in sight of two small island rocks – very dangerous to look upon.

Seventeen horses have died and been committed to the sea.

Letter

Poor beggars, when they droop they are brought up to the stalls on the airy deck (plate 29) where they may get better. But they mostly die after once

getting really ill. They don't die in pain, but they struggle mighty hard for their lives. When dead, they are roped and slowly let over the ship's side; the lowering is worked by means of a pulley.

Diary for the 17th continues:

Itchy continues well, has a good appetite, is greedy, and tries to bite Hooper's mare next to him. My five horses are all well. B's horse is a devil. I dislike it. They are all patient in their sufferings.

I wrote a letter to Dray. He gave me £2 before I went away. After tea I was down in the stern of the ship, reading and watching the sea. Some of the crew who were off duty came out to sing. One played many tunes on a banjo, another played a mouth organ, and a third sang well in a rich baritone. I sang 'Annie Laurie'.

Letter

Since Gibraltar we have seen no land until this morning when we ran close to a high headland on the coast of Tunis. A large white lighthouse topped this rugged cape. We see few ships; yesterday two cruisers – I think they were Spanish – passed our wake making for the coast of Africa.

Spain was neutral, but had a navy for coastal defence. The Mediterranean coast of Morocco was a Spanish possession.

It is very pleasant in the stern of the boat. It is hot and breezy. The blue sea is all around, and I like to see it best at evening. Then the seagulls seem fonder of following us. Last night a swallow was with us for five minutes, and a bird much like a cuckoo came from the south and pitched for rest on a rope high up on the ship. I sometimes think of Wyn when I see the Algerian heights. The land looks very lonely and unfriendly but perhaps behind the cold mountains that line the shore are pleasant places.

This is an old boat [1906, 4,521 tons] and rather a poor one. Her speed is 11 knots. She has a crew of thirty. She is iron-decked and has taken cargoes of cotton from New Orleans to Liverpool. She is owned by a Liverpool firm named Harrison. The *Karoa*, which boat the others are on, left a day before us and perhaps by this time has reached its destination. We don't know where that is except that we have to stop at Malta for orders.

I hope you are all well at home. I must thank you again for the £2, which I have in my breast pocket for use when I get ashore. I am looking forward to seeing Malta, and buying fruit there and hearing the news from Europe. I have given you my address. It is rather a long one. I do not put a stamp on this letter as the major says he does not think it necessary.

Itchy is still fairly well. He still eats sugar and all his food, but hangs his head now and then. Roy's mare doesn't seem any the worse. The mules aboard are standing it well. Perhaps they know these boats. Poor devils, they have only just come by sea – all from South America.

Diary, Sunday 18 April

Towards midday we sighted Malta. We were all eager to call there, and after delay the *Gleneagles* steamed out to us and ordered the captain to enter the harbour.[3]

From the sea, the town of Valetta is picturesque and imposing. On the left of the entrance to the Grand Harbour, the shore is bristling with forts and I could see large guns pointing seawards. Within, upon all sides the land is crowded with white soft stone houses seeming to rise one above the other, their many windows shuttered or balconied or flowered with plants. On the left I saw houses rising straight from the water, as one would see in Venice. All was a picture I had never contemplated. It was the first sight of the sunny Orient. The waters were busy with craft plying to and fro. Up in the harbour I saw four battleships. Maltese fruit sellers came out to us in boats to sell but the police stopped them – but at length gave up and we bought a great quantity of fruit, chocolates and cigarettes.

We left late in the afternoon. The pilot who accompanied us out of the harbour was a handsome man with a fine black moustache, dark eyes and bronzed skin.

Monday 19 April

Alas! If I could but see the fresh sweet-smelling primrose blooming 'midst the budding greens of English woods. That I might wander in the darkening light about the Bemerton meads and hear the laughing of the children and listen for the snipe, the water notes of moorhens and warblers. How I see thee, Noble Spire, Pointing Finger of the Grand Church [Salisbury Cathedral] stretching Heavenwards, yearning for a grasp within God's Hand.

The sea here is a royal blue, and the churned waters look doubly white against it. Why do not beautiful flowers grow above the ocean's surface? How grand a sight if rich and faint-hued blooms grew, flourished and drooped upon the waters! Unfathomable Mystery of the Seas' Depths. Hast thou great cathedrals illuminated with shapely windows whose glass is pink and light green? Are there silent altars, ghostly pews within their vaults? Where is the Soul of the Sea? I would find thee and learn from thee.

Tuesday 20 April

We work hard in the stables, cleaning out the manure. You should see us toiling up the steep gangways from the depth of the ship carrying buckets full of dung. We must look like the Israelites in Egypt, or the Babel Tower builders. I hope my horses will last the voyage. Itchy is fine, Bismarck is ill, Shamrock has a bad cold but eats. Minchinton's mare and Ginger are unaffected.

This implies that Stanley looked after five horses, possibly including the George brothers' own three if Ginger was Roy's mare, whose name is never

specified. War Regulations stipulated six horses per man on a voyage, but this number varied and could even be exceeded if many men were incapacitated through recent inoculation or seasickness.

> Since leaving Malta we have passed but one ship. There was a concert. I sang 'The Mermaid', 'Follow me 'ome', and 'Tom Bowling'.[4]

Wednesday 21 April

> The *Commodore* came into the Port of Alexandria. I was on the taffrail as the ship approached and drew into the harbour. The pilot boat came out to us. It was painted green, and floated prettily shaped sails. The crew wore red hats with black tassels, long, loose, coloured gowns, and baggy pantaloons. Near the harbour mouth I saw a small cargo boat. Its sails were lowered, and the network of rigging and the clean masts made it a veritable toy. As we came alongside the Quais à Bois next to the *Karoa* we crowded to the ship's side to greet our fellow yeomen.
>
> After tea we went ashore. All was bustle. The Australians and Indians were embarking for the Dardanelles. Much interested in the natives in their coloured dress. They look very dirty. Jock and Scott were busy tying the scarfs on to our helmets. They did mine for me.

These 'scarfs', known as puggarees from the Hindi *pagri*, were long strips of beige muslin folded and crossing (in the manner of a turban) round and round the helmet – and requiring considerable skill to put on correctly. They were supposed to increase the level of protection from the sun, and could also be worn hanging down behind to cover the neck. Although the *Karoa* had arrived the previous day, disembarkation did not begin from either ship in earnest until early on the 22nd.

The initial success of the Allied operation in the Dardanelles had been followed by catastrophic naval defeat on 18 March, with the sinking of two British and one French battleships, and three others disabled. Kitchener now saw no alternative to a full-scale invasion of the Turkish peninsula of Gallipoli. A force of 75,000 men – mainly from Britain, Australia, New Zealand and India, but with contingents from Newfoundland, and from France and her colonies – was given a month to prepare. The Dorsets arrived in Egypt just as the Mediterranean Expeditionary Force was leaving for the start of the land campaign.

CHAPTER FOUR

Egypt

Egypt had been a province of the Ottoman Empire since 1517, but with a growing amount of power vested in a succession of Pashas or Khedives. With the opening of the Suez Canal in 1869, its importance to Europe – and especially to Britain because of the route to India, Australia and New Zealand – increased vastly. The rise of a nationalist movement in Egypt, culminating in riots in 1882, led to British military intervention and the start of a lengthy British occupation.

With the outbreak of war in August 1914, the regulars of the occupying army were urgently needed on the Western Front. In September they began to be replaced by English territorials, followed by the Indian Expeditionary Force, which was posted to the Suez Canal Zone. At this point, Egypt was still nominally an Ottoman province under Khedive Abbas II, but when Turkey entered the war on the German side in early November, Britain declared martial law in Egypt. Six weeks later, Egypt officially ceased to be Ottoman territory and became a British Protectorate (though not part of the Empire). Abbas II was deposed in favour of his more compliant uncle, Hussein Kamel, on whom the British bestowed the title of Sultan, thereby giving him nominal parity with the head of the Ottoman Empire and helping to ensure his loyalty.

The military build-up gathered pace with the arrival of tens of thousands of Anzac troops by the end of the year, followed by numerous British yeomanry regiments. Egypt was now more important than ever to Britain, not only because of the Suez Canal, but also as a base for operations against its new enemy, Turkey. As well as protecting the Canal, the vastly increased occupying force served to prevent any possibility of uprising by the many Egyptians who resented continued domination by a western, infidel power.

Although Egypt had enjoyed considerable autonomy in the Ottoman era, and there was still a local ruler under British occupation, it had never been an independent country. Therefore the 'embassies' and 'ambassadors' referred to by Stanley were in fact consulates and consuls or consuls general. The British consulate was transformed into a High Commission when the Protectorate was declared.

Stanley's diary continues:

Thursday 22 April

Very early in the morning we commenced to disembark the horses (plate 30). They were glad to be free and to sniff the fresh air. Twenty-seven have died on the voyage, and two were shot on Alexandria quay – they were too weak to go along with us. Serg. Adlem's horse was one of these.

Early in the evening the regiment marched off to the camp. Our way was through the city, down the streets – Rue de Meuse, Rue des Soeurs, Grand Avenue – and along the tramlines to the village of El Zahria, seven miles out of Alexandria. We footed it all the way and got in very tired. There was so much to see – the disgusting shops and houses in the Rue Meuse, the large, grand and fantastic houses of the rich, the busy traffic of carts drawn by mules and donkeys decorated in bright colours, the trees along the roads through which the moon shone.

Friday 23 April

Our camp is on the sand beyond the village of El Zahria. On the north is the road from Cairo into Alexandria, and to the south stretches the desert. To the west is the village of Zahria, where the houses are poor and dirty. East, is a long belt of date palms and, beyond, a canal where boats with tall masts and large sails ply along the water [the Mahmudiyeh Canal].

Near our horse lines is a square house built of white stone. It has green shutters before the windows. Round it is a pleasant garden bounded by a wall. The sand is a nuisance and the flies a pest. The heat is fatiguing and we are told now is but the spring. Through the camp runs a railway down to Cairo. I like to see it, and see the people clear from it, and hear it whistle. At night the frogs in the canal croak very loudly and the crickets sing.

Saturday 24 April

My birthday. I am now twenty-six. The day is hot and close. We lie on the sand listless, and wonder how long we shall be the victims of the Egyptian sun.

Last night I walked to Bulkeley tram car station and took a tram to Camp de Caesar. There I met Shepherd and Munckton. We went to a refreshment house and ordered a bottle of beer each. We drank it in a pleasant garden, where grew tall plants and beautiful flowers. It was very still and quiet, and the radiant moon shone peacefully down. We then had bread, butter and coffee at a small tea shop. The proprietress was a kind little woman named Aphrodite Ieronymou. The coffee was very good. We had some difficulty with Egyptian money, but we are learning by experience.

Sunday 25 April

Yesterday was on guard over the stores. Was very sick in the night, I think because I had had a little beer.

All today I had to keep the native fruit sellers from coming into the camp. Was much interested in the traffic and pedestrians on the Cairo road. Beyond the road is a cemetery where there are many large white tombs and vaults. It is flowered with cactus – a yellow flower. The natives sell beautiful oranges to us, also small eggs, chocolates and cigarettes.

Regimental orders for this period in Egypt have not survived, but a year later there was still official concern about the risk of infection from local fruits and drinks, as shown by the following two orders. 'All men are warned against purchasing any fruit from natives except oranges, bananas & fruit which can be skinned & only small quantities of these should be eaten in order to avoid attacks of diarrhoea.' 'Troops are warned of the danger of contracting disease by drinking Aerated waters sold by native Vendors. The coloured drinks prepared from Syrups are sold in an unaerated condition & are very dangerous. Ice creams also should be avoided as they are prepared frequently under very dirty conditions.'[1]

In the evening I was in the canteen eating biscuits and drinking tea. Met Thorne and Bradley, who were eagerly discussing their experiences on the sea.

Monday 26 April

We rise here at five o'clock. At that time, the sun is just lifting over the palm trees and the air is fresh. Our ride today was through the village and out to some cultivated land where grew cucumbers, tomatoes, maize and bearded wheat. I saw a few goat herds tended by boys who seemed to be sitting upon their haunches some way off.

In the afternoon, upon the sand, we learn the Russian bayonet drill, in which are some very pretty tricks to be done with the bayonet and the butt of the rifle. Lieut. Dawson-Damer instructed us today. He has plenty of confidence and knew his work, and showed us the moves in dashing, determined style, so that I would have been sorry for a Turk, had one been there.

Tuesday 27 April

This morning I was out with the mule wagons loading forage at the stores. I had a pleasant ride behind a jolting carriage drawn by four mules through the streets. For an hour, I assisted in loading sacks of chaff and oats, trusses of hay, and wood. For a rest, I sat against the garden wall of the Villa Fortuna and ate a Jaffa orange. I was shaded by a young mulberry tree, which grew beside the iron gate. An Egyptian maiden came to the steps and viewed the camp. She was rather handsome. I heard a piano playing. Later, a small boy and girl passed out, evidently going to school, for a black boy

was in attendance carrying exercise books. In the garden were roses, red and white, wet with dew, and fresh and sweet-smelling.

Wednesday 28 April

I spent the afternoon and evening writing in the recreation tent. It is cool in there, and the good chaplain has supplied tables, chairs, lounges and writing materials. The place is well patronised, and it is quite the best place in the camp. A piano is on the stage, and all the evening reckless songs of love and war make easy my task of letter writing. The Dorsets have not much talent – at least it is not forthcoming – but the Berks are more accomplished. I wrote to Betty and thanked her for asking me down to Leatherhead. It was quite a long letter I wrote, and I hope it will reach the Homestead at Leatherhead [her parents' house]. The mail arrived bringing letters to me from Irene Gass and Aunt Bertha.

Thursday 29 April

This morn we rode through some public gardens near to the Mahmudiyeh Canal. They were artistically laid out, and the many flowers, rich in colour and fresh with the dawn, presented a scene I shall always remember. Flowers grow to full perfection in Egypt and look richer in colour. I saw many blooms common in England – roses, bush geraniums, gladioli (yellow), sweet peas, stocks, snapdragons, heliotrope, nasturtiums and anemones. Clustering over archways were purple and blue flowers; and acacia, mulberry, fig and palm trees set off the radiant colours. The season is spring now, perhaps the best time for flowers in this land.

Irene Gass has sent me a little green-bound book, *In the Footsteps of R.L.S.*[2]

Friday 30 April

The flies are a pest, and blacken the top of our tent. I sleep in the horse lines, behind Itchycoo. A saddle is an easy pillow, and I find myself warm enough with a blanket and overcoat for covering. There was a large moon shining over the waving palms in the east, and back in the town I heard the revels of a wedding festival, and the air was filled with wild delight till midnight.

Once in three days we have bacon for breakfast, and bread and jam. If no bacon, we get plenty of butter instead. I eat no meat, but drink the soup the meat is stewed in, mixing it with cabbage (when I can get it) and potatoes. We are allowed no milk in our tea.

Saturday 1 May

I am made a stretcher-bearer in place of Martin, who is gone to Cairo. An RAMC sergeant gave us lessons in picking up wounded, and Old showed us three ways of carrying wounded.

I wrote to Mrs Menzies, Miss Porter, Irene Gass, and Owen Shittler. I said to Mrs Menzies how I should love to be in the country round Sarum at this time of spring. I recollect well last May Day. It was the last day of our performing *Patience*, and, after a supper on the stage, I went home with Miss --- [*sic*], a tall, handsome, intelligent girl. Our way was through New Street and along Catherine Street. I remember bidding her goodnight at her door.

Sunday 2 May

We took our horses down to Stanley Bay and bathed them in the sea. They enjoyed the cool water, but not many would advance towards the breaking waves. Itchy would have lain down if I had allowed him. On our way back we passed by many fine houses – very varied in architecture and pleasant to look upon, being far more artistic than the red-brick, all-alike villas of an English town.

I sat without the canteen and wrote postcards to various people, and sent Aunt Bertha a letter.

Living is dear in Egypt. An English penny is more useful than an Egyptian piastre [worth slightly less than 2½d], and we have to pay a piastre for things that we can buy for less than a penny in England.

Monday 3 May

Orders came in for the brigade to strike camp and proceed to Cairo to take up garrison duties. 'C' Squadron was the last to leave. After pitching tents, loading kit bags and saddling horses, we waited until ten o'clock amidst the smoke of the refuse fires.

We rode into Alexandria along the Mahmudiyeh Canal. The moon was shining. The large lake [Mareotis] was still beneath the lights of the distant houses. The flowers smelt strongly from the gardens. There was a lot of jogging as we marched. We walked the last three miles, and felt done up when we reached the [Gabbari] station. I sat down with Shepherd in a carriage, and after eating our rations we fell asleep; the hard seats and jolting of the train could not keep us awake.

I was sorry to leave El Zahria.

Garrison duties were shared out between the regiments. The Dorsets mainly provided guards for the French and Russian Consulates, the British High Commission, and Army HQ (plates 31–33), and pickets for the Muski Police Station.

Tuesday 4 May

Towards dawn, I awoke. The train was travelling over flat country, which was well cultivated. I saw in places, clumps of trees offering shade to men and beasts. There were many men and women working in the fields. The villages, compact, clearly confined, squalid and wretched, were no better than ants' nests.

Cairo was reached about eight o'clock in the morning. When ready, we marched to Kasr el-Nil Barracks. The horses were picketed in the south square (plate 35). We sweated like fat English farmers at an August fair when we tied and shackled our horses, groomed and fed them.

After visiting the canteen, I sought our sleeping place. Bertram had occupied the window bed of our dormitory, which is No. 25 on the first landing of a line of barracks facing west over the Nile [and east over the main square].

The yeomanry regiments that had been posted to Cairo were distributed across the numerous barracks in and around the city. The Dorsets were unfortunate in having been allocated to one of the oldest and most in need of modernisation. The complex included a mid-nineteenth-century khedival palace, and was adjacent to the Egyptian Museum. Much of the area had been redeveloped within the past few decades and contained several opulent residences, such as the magnificent Villa Zogheb, built between 1898 and 1900 in the neo-Mamluk style for the Danish Consul, Count Michel de Zogheb (plate 34).

Wednesday 5 May

These barracks are dirty and want much repairing. Our bedrooms are overrun with bugs, the walls are hanging with dirt, and the lavatories disgusting. They are well situated – the front looking towards the streets of Cairo and the back facing the Nile near to the Kasr el-Nil Bridge (plates 37, 57). It is a little town here, with tailor's, grocer's and barber's shops, church, recreation room with stage, three canteens, billiard room, and shower-baths. I like the barracks in spite of the bugs. I slept out in the balcony and could see the stars and the Nile, and the lights along its banks. This was a consolation. We have poor food. Oh, the commissariat!!

It is rather hard working in the front square where the horses are. They will feel the heat severely I'm afraid (plates 39–41). The officers look very fed up. Perhaps they are pested with bugs as well.

The British Army had used the barracks at Kasr el-Nil ever since the occupation began in 1882. They had been constructed as infantry barracks without stables, and there was only the most rudimentary of shelters (plate 36). Local people were employed to assist in running all the Cairo barracks. The labourers who cleaned the horse lines and stables or shelters were known as syces (plate 43) – literally 'grooms', although the men groomed their own horses. For off-duty excursions, the soldiers themselves sometimes engaged native interpreter-guides, or dragomans (plate 44).

Thursday 6 May

We rode out early. Crossed the Kasr el-Nil Bridge and continued down a long straight road lined with handsome trees. Much traffic, of camels,

donkeys, carts filled with natives, and handsome carriages and pairs. Mr Hoare's horse John dislikes camels. We passed some rose gardens, where the natives were cutting the blooms and taking them to the city shops. We returned by way of the canal – where there was a mosque being built – and finished by crossing the Bulaq Bridge (plate 58).

The Kasr el-Nil Bridge took them across the Nile to Ghezireh (the largest of Cairo's Nile islands, commonly called Ghezireh Island by the British, although Ghezireh itself means island). They then continued in the same direction to the western shore of Ghezireh before heading north. This was only their second full day in Cairo, and what Stanley calls 'the canal' is likely to have been the straight and narrow western channel of the Nile, which separates Ghezireh from Gizeh. Finally they crossed the north of the island and returned to barracks via the relatively new Bulaq Bridge (built 1909–12).

I was mess orderly, and managed to find a good tea for No. 25 by going to the grocer's shop and buying jam, butter, bread and cakes, which cost me 20 piastres. Much appreciated.

Sat down by the riverside.

Friday 7 May

Barrack life is not so hard as I feared it. I anticipated a closed-in, tied life, monotonously timed by parades announced by bugle calls, punishment drills in the barrack square, and hours wasted in burnishing brass and cleaning saddlery. Barrack life is something of this nature, but the place is in itself such a small town that one can remain in, and spend good times at the canteen and recreation room, and read and smoke down by the Nile wall. All kinds of groceries can be bought at the grocer's shop, and sewing is done for us by the natives in a tailor's shop, and there is a barber to shave us for half a piastre. The rooms where we sleep look down upon the barrack square and upon the Kasr el-Nil street. Outside our rooms [on the Nile side] runs the long balcony where I sleep, rather than inside (plate 38).

Saturday 8 May

I sleep comfortably in the balcony upon the forms belonging to the mess table. At five o'clock reveille sounds, at 5.15 we have early tea, and then exercise our horses in the suburbs of the city. We breakfast at 8.30 and rest until ten o'clock, when we groom horses and clean saddlery. We then dismiss at eleven o'clock and rest until midday, when we water and feed horses. In the afternoons we rest, and perhaps write or clean our kit. At five o'clock we feed and water our horses, and tea is at 5.30. At six o'clock we are allowed out into Cairo.

The govt only supply us with tea, meat and bread. We are receiving 6*d* a day extra, which is spent by the quartermaster in supplying us with bacon, butter, jam, marmalade, tinned meats, and fish.

Sunday 9 May

In the evening, I walked through the streets of Cairo, through the Abdin Palace Square, until I came to the Shari Mohammed Ali, where I took a tram to the Citadel (plate 51). When I left the tram, a donkey man came and pestered me to have a donkey ride. I walked up the road to the Citadel's summit, passing two or three sentries on the way. In front of me was the Ali Pasha [or Mohammed Ali] Mosque. I paid for shoes and entered the cool spacious hall. Its walls were of alabaster and the floor of fine stone. In the centre was a holy fountain, its waters those of the Nile. In the mosque, I wondered at the mosaic work of the domes, the beautiful Carrara marble pillars, and the transparent amber, parts of the wall were made of. The guide told me two good stories about Ali Pasha. From a parapet of the Citadel, I watched the city lights.

Monday 10 May

The mail arrived. I received letters from Irene, Mother, Iris and Father. Irene sent me, besides a letter, a parcel of chocolates. They came as a great surprise, and I think she is a real good sort to send them. Father wrote describing the prosperous state of Roy's farm. Mother seems anxious about us. She has not received the letters we sent them from Malta. Her letter was dated April 21st.

I wrote in the evening to Irene Gass, and then bought biscuits and ate them on the verandah down by the Nile wall. I met Robson. He was on guard over some prisoners. He was rather fed up. Said he would like to be back at Stockham [the family farm at Wantage].

Hear of the *Lusitania*'s sinking.

The recently sunk *Lusitania* was the largest casualty of the German U-boat campaign against British merchant shipping in 1915. Her passengers included many American citizens, and her sinking provoked a strong protest from President Wilson, though the United States would not enter the war until April 1917.

Tuesday 11 May

Reveille sounded at 4.45. The regiment paraded in drill order and marched to Abbasia. At this place there are extensive barracks (plates 45, 46), and I saw a large number of horses picketed on the sand. The colonel drilled us on the sand stretches beyond Abbasia. The horses found trotting very trying, and a rough wind blew clouds of dust before it and sometimes the troop immediately before us was obliterated. Our teeth and faces were covered with fine yellow dust, and we could hardly follow the colonel's signals. Our squadron line was bad – Mr Hoare and Mr Bragge keeping too close together.

I walked into the city, down Shari Abbas, and up Shari Bulaq. In the latter street is Sault's café, where I had coffee and biscuits. I saw a Russian

restaurant [the Petrograd] where I shall go for a meal one evening. There is a large draper's shop in the Shari Bulaq [Davies, Bryan & Co., in the Continental Hotel Buildings]. The windows display beautiful, shapely gowns, and varieties of hats such as fashionable Egyptians wear.

Wednesday 12 May

Mr Browne was in command of the squadron this morning. We rode out to Roda Island [a smaller island south of Ghezireh]. The horses do not like to see the ugly camels, and start when they pass us. On the hard slippery asphalt roads we have to dismount and walk with our horses. Mr Browne treats the natives very unwisely. He hits camel boys with his stick if they do not get out of the way quickly, and he shouted and swore at a man for obstructing our passage. Mr Browne is a pleasant, fascinating man, and his frank, winsome manner is persuasive. In his treatment of the low-class natives [however] he shows himself an arrogant, quick-tempered officer. I hope one day he will get his deserts, and learn a lesson.

Today I was line orderly. A sorry task – watching horses and taking off their nosebags, and sitting down in the sun out in the hot barrack front.

Neville Champion, who is a trooper in the Herts Yeomanry [and son of family friends], came to see us.

Thursday 13 May

I do the duties of mess orderly. General Peyton inspected the barracks.

Ted Bown, the cook, gave me a large cup of tea after dinner. I sat outside the cookhouse beneath the large tree in the barrack square, and listened to music and singing that came from the recreation room. The song was irresistible, so I walked over to see its name. It was called 'In My Harem', and three cooks in their mess dress were singing it, and looking much like seaside coon singers.

I went down the town to buy a book about Cairo and Egypt. There are good bookshops here, but they are dear. I went into the large draper's shop in Shari Bulaq and looked at the silk scarves. Saw there a very handsome Egyptian girl, at whom I gazed across the coloured bazaar. But I lost her afterwards in the throng and jostle of the streets. Cowards we are! Those we could best like, we lose because of the strict formal rules of etiquette.

I went to a café and ordered iced lemon squash. They brought horrid bottled lemonade. Tried in five shops to buy straws for sucking lime juice. Had a row with a chemist. Bought a bottle of Rose's lime juice.

Heard from Dray.

Friday 14 May

We rode over the Bulaq Bridge [across the Nile to Ghezireh] and along the river bank. Through an avenue of yellow-flowering trees we rode, and came upon a garden bright with flowers. In the garden were young

people playing and laughing. I wondered who they would be, dancing beneath the trees and mixing with the flowers in so early an hour of the morning.

There was a concert outside the recreation room. The chaplain presided – a black-bearded man, pale and meek-looking, without the dash and frankness of our late chaplain, who has left us. I had to lead the programme, and sang 'Mandalay'. No accompanist, and started on too high a note. Forgot the words and became hoarse. Must have sounded very bad. During the concert I was talking to Limmer on the river wall. He is something like his brother – something of a wag – and at first might be thought an ass. But like most of these 'thought to be asses', he is indifferent to remarks, goes his own way, and enjoys himself.

Saturday 15 May

Marching order. I was ready to saddle my horse with his heavy burden, when Serg. Tubbs ordered me to be line orderly. Rather annoying – I was line orderly only three days ago. Lonnen was on with me. I bathed the legs of B's horse and those of mine with a hose at the smith's forge.

I received pay – 48 piastres.

I don't relish hot roast beef in the midday. I have bought some Lyle's Syrup, and ate it with bread. The Rose's lime juice is very good. The shower-bath I had after tea braced me, and afterwards I ordered bacon and eggs and coffee at the canteen.

In the *Egyptian Mail* of today is a thrilling article describing the glorious fight the Canadians made north of Ypres. How they breasted, and kept on against poisonous gases and withering maxim fire! They lost heavily, but how gallant they are!

Sunday 16 May

Marched with five other men under a corporal to the Nonconformist Church. It consists of one large room above a tobacco shop, at a place near to the Russian Embassy. The congregation consisted of ten soldiers and two ladies. The minister was in khaki uniform, so may be a chaplain. A youthful civilian with a fat face, blue eyes and fair hair read from the Bible and addressed us with evangelical force.

Bought a book for 12 pt. – *What to See in Egypt*, by Mrs Butcher.[3]

'C' Squad was inlying squad.[4] From the grated aperture at the top corridor, which looks out to the Kasr el-Nil, I watched the carriages, horses, motors and cycles pass. Ladies – well-dressed – with officers, driving out to Gizeh. Fine white horses, harnessed to bright dogcarts and driven by smart Egyptian grooms. Donkeys, carrying long round sacks, and in some cases their masters as well, amble along, their long ears flapping. In this land we see how useful the ass is. It is good to see so many carriages and pairs, but I wish the horses were fatter and not whipped so hard.

Monday 17 May

Rode up to the Citadel and beyond it to the large quarried levels. It was a hard climb to the summit of the stone hills, which are on the confines of the desert. Followed a stony path across a plateau, from where a fine view is obtained of Cairo, the Nile, its fertile valley, and the pyramids. The squadron drilled for a short time, and returned home. It was unique returning across the white sandy stretch, and seeing the outer fortresses of the Citadel, the Citadel itself, and the minarets and domes of the Ali Pasha Mosque before us. Old and I had a soldier's dinner for 8 pt. each at the Santi café in the [Ezbekiyeh] Gardens, and drank coffee at the Petrograd Restaurant in the Shari Bulaq. There was a band, and it played Braga's *Serenade*. The proprietor wanted to refuse us entry to the first-class room, but we persisted and sat down among officers. Old tried to sell his revolver to a young Greek. They could not come to terms.

Unauthorised disposal of military equipment has been a persistent problem for many armies, and the British in Egypt were apparently no exception. A year after this episode, the following regimental order was issued: 'All ranks should be warned of the seriousness of selling Gov. property. Cases have occurred of men disposing of their clothing to natives which practise [*sic*] must cease at once & all ranks should be informed that anyone found guilty of this offence will be most severely punished.'[5]

Fowler is full of news. He usually is. Says we have advanced in Belgium, the Essex Regiment is cut up in the Dardanelles, and the Russians are retiring from the Carpathians.

Tuesday 18 May

Rode through Old Cairo and along the [early fourteenth-century] aqueduct. I was detailed to present myself to the Chief Engineer at the Army Headquarters (plate 33) in response to a request from that quarter for a clerk. As I was not desirous to revert to clerk's work again, I stated my unwillingness to fill the post.

I managed to procure some straws at last in a large shop belonging to Fleurents [wine merchants]. Went down the Kasr el-Nil after tea and bought some Hartley's marmalade. Fell in with Eames. He was in the NP [National Provincial] Bank at Shaftesbury before the war. There was a dinner at the Italian Embassy. The dining room was brilliantly lit and the window open, and I could hear excited Italian signors conversing on the Italian crisis.

I discovered (thanks to Jock) the stairs leading to the barracks roof. From it I could see a stretch of the Nile southward, the pyramids between the desert and the Gizeh Gardens, and the city spread out around me.

Wednesday 19 May

Last night the Bishop of Jerusalem gave us an interesting lecture on Gen. Gordon, illustrated with views.[6] I enjoyed the hour and a half listening to the Bishop tell us of Gordon's life, and death in Khartoum, of the attempt to relieve the garrison, and the ultimate defeat of the Dervishes at Omdurman.

Mess orderly. Porridge for breakfast with treacle. Very good. A mail came in the evening. Serg. Tory sorted them out in our room amid excitement. Dray sent me a *Daily News* of May 3. Irene Gass wrote me, and quoted a poem she knows about a cherry tree blooming white near the woodland ride in happy Eastertide. Also heard from Emily Le Lacheur, and Father wrote to us three.

Emily and Elsie Le Lacheur were friends from an enjoyable holiday in Jersey in September 1910, when Stanley stayed at Bifrons, their house in St Helier overlooking St Aubin's Bay (plate 6).

Report in the evening paper of resignations at the Admiralty and in the cabinet. The cabinet is to be a coalition one.

Asquith, the Liberal Prime Minister, had invited the Conservatives to enter into a coalition, and some of the changes in the cabinet had been demanded by them if they were to accept. Stanley was reading on the barracks roof.

In the words of Har Dyal's love song, I was 'alone upon the housetops. I turned to watch the lightnings in the sky. Oh the glamour of her footsteps in the North. Come back to me, Beloved, or I die.'[7]

Thursday 20 May

A most uncomfortable early morning ride. I rode B's horse and led Itchy. I was hot and tired – it is a nuisance having no time to wash before we turn out of a morning. The flies irritated and Itchy pulled.

In the afternoons here, there is not often a parade, so being tired and spent I lay down and tried to sleep. I read the *Daily News* which Dray sent me – interested in Desmond's article 'Out of Doors in May'.

This article noted some effects of the unusually cold spring. Many birds' nests were easy to see because 'cold winds have kept back leafage to a phenomenal extent' and there would be 'many more flowers than usual crowded into the month of May'.

Also [interested in] opinions expressed by Hilmi Abbas Pasha, deposed Sultan of Egypt,[8] on the English rule in Egypt. Says racially, and in religion, Egyptians are closer bound to Turks than to the English, and he owes obeisance to the Sultan of Turkey.

Read Emily Le Lacheur's letter. She was glad to get my postcard and would like me to write again. She writes that there are German prisoners at St Ouen's Bay.

Les Blanches Banques prisoner of war camp, on dunes at the southern end of St Ouen's Bay on the west coast of Jersey, had opened in March 1915 with an initial capacity of 1,000 prisoners.

On the roof of the barracks I sat in the evening and talked with Adlem. Read the *Dorset Chronicle*. Interested in the Kent v. Butler case at Bingham's Melcombe.

Stanley had visited Bingham's Melcombe House, home of the Longbottom family, in order to see its famous ancient yew hedge while on one of his long hikes through Dorset before the war, and had been invited in to breakfast. The Kent v. Butler case was a cause célèbre arising from a contest in April to May 1914 for the post of churchwarden between Major Ashburnham, a friend of the Longbottom family who was supported by the rector (the Revd Pierce Butler), and Mr F. O. Kent, the outgoing churchwarden. Mr Kent had asserted that the major was ineligible on grounds of non-residence because he was not a registered householder, as his cottage in the parish was rented. For his part, Kent, who had won the election, was convicted under the Brawling Act for language he used to the rector after a service in March 1915. The case culminated in a colourful High Court action in December 1915, which ruled against the refusal of the Bishop of Salisbury to admit Kent to the office of Church Warden on grounds of gross misconduct.[9]

Friday 21 May

At six o'clock, I was on the night town picket at the Muski Police Station. The sergeant allowed me to go out and get tea. Went with Drake to Le Yildiz in Taher Street, opposite the Opera House. The waiter gave us a glass of ice-cold water each before we started tea. In the café, serving, was a fine and comely French woman who spoke to us.

Six of the guard were called off to another part of the town. We who remained had a busy time taking drunk soldiers home. Budden drove to Abbasia with a drunk Australian. We found a Lancaster man in Shari Abdin sleeping in the road, and an Australian who would not go home – both of these we took to Muski with us.

Saturday 22 May

The corporal of the picket at Muski was Cadie of Longburton.

Early in the morning, I saw the Lancaster man as far as the station for the suburb of Maadi. He was an agreeable fellow, unfit for service. We had a brandy and soda together. He was anxious about a silk h'kerchief his mother had given him, which he said he'd lost. The walk back to

Kasr el-Nil was hot and uncomfortable, and we wore our overcoats rolled over our shoulders.

I received a letter from Nurse Watts. Wrote a letter to Iris. Russian bayonet drill at four o'clock. Bought a novel – *The Spanish Jade* by Maurice Hewlett. I enjoyed the tragedy in the cork wood of Huerca.

Sunday 23 May

I wrote to Sister Radnor. I am wondering if she is still at Havre in the military hospital. Roy received a letter from Mother. Poor Mother! She misses her three sons, and writes to us often. It is very nice to read letters from home. Iris is letting bedrooms at The Laurels to officers' wives, and earning useful pocket money.

I read the *Daily News* and *The Times* of May 10, giving graphic accounts of the sinking of the *Lusitania*. I think our Admiralty were slack in not protecting the liner. Read the *Dorset County Chronicle*, which Snow lent me. Interesting account of the Dorset Dinner in London, at which glowing praises were given to Dorset and its men.

This was the eleventh annual dinner of the Society of Dorset Men in London, held after much debate despite the war. There was a message from the King, and many patriotic speeches with tributes to Dorset men in the services. There was no mention of the QODY – perhaps understandably since they had not yet been in action.

B and R [Bertram and Roy] went to the pyramids (plates 49, 50).

Monday 24 May

Up at four o'clock – regimental drill at Abbasia. The general was present, mounted on a grey horse. The regiment attacked a hill, dismounted. 'C' Squad was in reserve. I drilled with No. 2 Troop.

Ate big breakfast – excellent bacon.

Italy at last declares war on Austria, and Germany declares war on Italy. Enthusiastic crowds waved Italian flags and sang outside the Italian Ambassador's house here. I think Signor Serra gave a speech at his front door.[10] From the grating, I watched the fashionable Italians drive away from the demonstration in carriages.

Spent the evening on the roof with Robson. He is suffering with swollen feet caused from bites. Played billiards with him. He was full of the woes and troubles of the Berks, who are evidently kept hard at it.

Tuesday 25 May

Rode through the Shari el-Sadd. Mr Hoare has been in Cairo before and knows the ways.

In this room are the following – Fowler, Sansom, Bower, Robberts, Roy, Cossins, Old, Bertram, Lonnen, Watkins, Snow, Smith, Richardson, Taylor, Marsh. The first two and the last three are officers' servants and transport men, and do not do any mess orderly work.

All day [apart from the early morning exercising of the horses] I was on the main guard. For four hours, I stood in the gateway saluting officers. A deal of red tape about garrison soldiering. The volunteer rifles from Cairo came to drill in the barrack square.

With Old to the Kasr el-Nil rink [on Kasr el-Nil terrace]. Drank iced lemon squash and, upon a house roof, enjoyed the night breeze.

Wednesday 26 May

Rode down Derb el-Bazabiz [near the Citadel]. Narrow streets, quaint and small shops, old houses, mosques, and the whole place a real Sullivan opera for its jumble of peculiarities – at least to the Englishman's eye (plates 52–56 are from older parts of Cairo). The general – Maxwell – came to inspect the horse lines. He is a short, stocky man, and was wearing glasses.

Walked out to find the London Cinema, but lost my way so went to the Salonica Cinema. Saw a picture – *Ma Vie pour Toi*. A plot of force and a story strong with passion fizzled out into a weak drama. Drank coffee in Midan Suares at Stambellou Café.

Thursday 27 May

The troop rode out to some rough ground beside the Nile, and the awkward horses were broken by Corp. Waters and Trooper Courage. Two or three horses would not leave the ranks or answer easily to the rein, and Waters and Courage, with their good horsemanship, soon cured them. I liked to see the horses handled well by these men, and their riding was admirable. Itchy trotted the figure eight very steadily and well.

The 'awkward' horses were presumably some of those brought over from America, a great many of which had been wild. Generally they were broken by the Remount Department in England, but there was not always sufficient time to complete the process before they were sent on for active service.

Drove in a cab to the London Cinema. The picture, *The Retaking of Alsace*, was disappointing. I sat at the back, at a small table, and during entertainment drank iced lemon squash. The people around me were well-dressed and fascinating. Dragged myself home in the still heat.

Friday 28 May

While riding on a pathway outside the Ghezireh Sports Grounds [Sporting Club], a Berks Yeoman was thrown with his horse into a deep ditch which

ran beside the pathway. The man was pinned beneath his horse, and it was some time before he was extricated. Horse and rider were unhurt. A camel frightened the horse.

There was grim warfare in No. 25 this night. Troopers Bennett and Drake returning from the canteen attacked Lonnen in our room. Master Lonnen set about them well and, with the help of Snow, Watkins, Sansom and Fowler, the enemies were expelled. I think they were saturated with water, and the smacks they received from pillows and mattresses must have been heavy and furious.

Saturday 29 May

Every day at various times we discuss the war, commenting on the progress of the fighting in the Netherlands [i.e. Flanders; Dutch neutrality was respected throughout the Great War] and at the Dardanelles. We take turns to buy papers. The *Egyptian Gazette* is the popular journal. We wonder when we will be wanted, when Constantinople will fall, and when the German line will be broken in France.

Six of our ships have been lost in the Dardanelles. The *Queen Elizabeth* is much spoken of. The attack our ships made on the Turkish forts seems to have dwindled into desultory storming. I wonder why Winston resigned from the Admiralty. Mr Balfour holds that post now. Lloyd George is temporarily placed on a committee of munitions.

The loss of three Allied battleships in March was followed by the sinking of HMS *Goliath* by the Turks on 12 May; a German submarine sank the *Triumph* on 25 May and the *Majestic* on the 27th. The battleship *Queen Elizabeth* was the British flagship in the Dardanelles and took part in the initial attack, but was withdrawn to a safer position after the Turks sank *Goliath*. Churchill was blamed for the Navy's lack of success and heavy losses in the Dardanelles. He did not resign, but was demoted from First Lord of the Admiralty to the largely honorific post of Chancellor of the Duchy of Lancaster on the insistence of the Conservatives, whom Asquith had invited into the new Coalition government. The irony is that Kitchener, who had been the prime mover of the campaign, was not considered at fault and remained in overall charge.

Sunday 30 May

Read *Almayer's Folly* by Joseph Conrad. It is the first book I have read of his. He pens vivid pictures of the Pantai, and the dark forests about it. Almayer's was a sorry life. He was a weak fool. I envied Nina and Dain, strong, impetuous and passionate, when at the last they went in the canoe [beyond] the river to the outer waters.

Went with Cossins to the English church. It was good to look upon the congregation – fair, clean-faced English women, wearing light and white summer dresses, and tall healthy English officers and sturdy yeomen. The music was good. 'Lead Kindly Light' was sung. The sermon was about

'Peace and War'. A young and sweetly contented woman sang the hymns near me. She sang without a book. Passing out of the church, I had wished to have seen sweet English fields, high-hedged lanes and distant wooded hills, instead of the straight wide streets and gay material life of Cairo. Cossins and I ate ices and fruit, and drank coffee at the St James's Café.

Wrote to Owen Shittler.

Monday 31 May

Left Kasr el-Nil Barracks for the exhibition buildings [of the Royal Agricultural Society] on Ghezireh Island.[11] Pleasant grounds, well shaded with acacia trees, and flower beds glowing with colour. The horses are better off, having now shelters to stable them (plates 62, 63). Our squadron is to sleep in cattle pens under a tiled roof (plate 61). Very comfortable, clean and airy. Trees and shrubs help to cool our slumbers. The messing is none too pleasant, being together in a large tent. The fellows on the next table misbehave and throw bread – disgusting habit.

Went out at night to the Kasr el-Nil terrace [beside the Nile].

Heard from Shittler. Awfully interesting letter, long and sincere.

The Agricultural Society grounds were only a few hundred yards from Kasr el-Nil, at the opposite end of the bridge. The move may have been largely occasioned by the infestation at Kasr el-Nil Barracks. The bugs were regularly attacked with blowlamps, but were a long-standing feature and not to be so easily discouraged. These barracks were still notoriously poor more than twenty years later. An MP who was an old soldier asserted during a parliamentary debate that they had been 'condemned every year since the time of Lord Kitchener as being unfit to live in. Nor are the amenities of the barracks improved by the ease with which, on occasion, one can extract snakes from the walls.'[12] Even in the 1950s it was remembered by another MP who had lived at Kasr el-Nil that 'Never were there such bugs in the world as in Egypt, and never were there such intelligent bugs. ... We would [in addition to the blowlamp work] get cigarette tins into which we would put paraffin and then stand the legs of our beds in them. But the bugs were up to that. Up the walls they would go, along the mosquito netting, and down the other side.'[13]

Tuesday 1 June

Left in the morning for Kasr el-Aini Hospital, where I was on guard. Hot walk there. Did first guard. Interesting post. Native students, slim and well-dressed, go to the hospital to work. Saw Miss Traill – who is a nurse in the hospital; also three marines, one from Shroton Camp and two from Blandford Camp. Talked to various Australians and Englishmen about the Dardanelles fighting. They seemed very optimistic. Serg. Bennett was our sergeant. Rather particular. Looked at the native wards. We had a cheerful boy, like a cat, to clean our room. Very sleepy on last guard. Great temptation to sit down.

Wednesday 2 June

Our cattle pens are most comfortable. A fresh breeze from the river blows to us across the rose garden and gently stirs the acacias. Far away there are trees red with a flower, the name of which I want to know. From my bed I can see the sports grounds and watch tennis played.

Early this morning we rode out along the beautiful acacia avenues on the Ghezireh Island. Here live English people, and English nurses are to be seen with pretty English children. We passed the aquarium, and saw the ground clustered with geraniums about the trunks of some tall trees. We passed the Ghezireh Palace [Hotel, converted into a hospital], where there are many patients from the war.

Father and Mother wrote me. We hear Bert George is wounded.

Stanley's first cousins Herbert Ilott George and Harold Thomas George (plates 86, 87) were the two youngest sons of Thomas George's younger brother William, who had emigrated to Australia and lived at Bacchus Marsh, 30 miles west of Melbourne. Both had volunteered for the Australian Imperial Force and went with the Anzacs to Gallipoli, where Herbert was in fact twice wounded.

Strolled to Kasr el-Nil and talked to Signor Montini, a chemist, and drank lime juice in the Café de la Promenade.

Thursday 3 June

Holiday for the troops in Egypt [for the King's 50th birthday]. Read *Western Gazette*s and London papers sent from England.

Started out at two o'clock with Eames for pyramids. [From the Agricultural Society grounds on Ghezireh, walked across the bridge to Gizeh (plate 59) and continued south along the west bank of the Nile for a mile.] Picked up a guide at the Zoological Gardens – Ali Kriam, age twenty. The tram ride down the straight avenue of acacias to Mena delightful. Went on foot to third pyramid, grew tired and ordered mounts – Eames a donkey, I a camel. Enjoyed the Sphinx – wonderful expression, coarse and brutal. Climbed Cheops [Pyramid] with a guide – No. 146! A hard task – Eames very tired. View from summit over desert and Cairo. Saw the sun set. Inside Cheops we clambered up the limestone shoot to king's tomb – mysterious and wonderful. Wretched boys wanted half-piastres for a little water for washing the hands. Had a good tea at Mena, finishing with iced lemons. Conversed with wounded Australians. Whirled back in night singing Gaudeamus song.

Friday 4 June

Reveille at four o'clock. Away down the monotonous Shari Abbas to Abbasia. Brigade drill on the desert. We trotted over stony ground in brigade line of troop columns. Horses kept up well. Dismounted on brow of hill

and watched some infantry charge a hill, whereon was a flag, with their bayonets fixed. Dust was the very devil. How I live through these drills in the dust I can't think. While in squadron line, Cullis kept barging into me.

Letters from Mrs Menzies, Owen Shittler and May Handover. Met Taylor at the cook's fire; we talked about Worbarrow, Tyneham and Egliston. Heard that Old Stickland is dead.[14] Taylor says he was worth a good sum of money. Teddy Bown is ill. Met him and he said he'd had an attack of bronchitis, but Doctor gave him medicine and he was cured at once.

Lord Wynford has left us for England to train artillery, and Dr Rickett has gone to the Dardanelles.

Saturday 5 June

On guard at Russian Embassy. Why don't they look after the guards' breakfasts? Kerton reprimanded me for bad drill – told Serg. Bradley to drill me one afternoon. Devilish hot tramp to embassy. The guard occupy the house top, where are two small rooms and a wash-basin and shower-bath. Had dinner in kitchen. On guard from two till four. Very hot. I am too impatient for a sentry. Induced a native to bring me iced water.

Wrote to Emily Le Lacheur. Great pleasure to do this. Dear old Jersey, and what a time they gave me at Bifrons. I helped Daniells write a letter to the Rev. Salmon [Rector of Langton Long, Daniells's home village].

On sentry duty from 10 to 12 p.m. Streets lively. Flash ladies driving to the Kursaal [variety theatre], in some cases attended by English officers. Saluted the Russian Ambassador. Serg. Horsey commanded the guard.

Sunday 6 June

Shittler in his letter describes his walk from Seaton to [blank in original], the church in that village, and the sight of returning fishing boats off Beer. … Poor May [Handover] has had scarlet fever. Sweet May! So patient and restful in all her sufferings! I loved reading Mrs Menzies' letter. She enjoyed my letter, and wants much to see Itchycoo. There is no woman more fond of animals. She will miss Dorothy in her garden at evening when the light falls to darkness, and fondling winds breathe among the roses.

And I too would fly far away in the night sky, riding the canoe-like crescent moon between the stars, until I came to those far-off lilied waters, where are grass glades and howling pines.

Monday 7 June

Rode round Ghezireh Island. It is an Eden, compared with the heat, dust and hard roads in other parts of Cairo. On Ghezireh, live English people in pleasant houses; and the gardens are green and cool, and the roads tree-lined. The garden approaching the Anglo-American Hospital is bright with iris.

Read the *Western Gazette*. I find home news very interesting; never cared about it before.

I sleep on the ground under a tree a few yards from the cattle pens; the fellows make such a row all night, guffawing – Haim, Ingram and Kettle. I find Irene's little book [about] RLS very good to read in the evening. How he dreamt of Edinburgh from abroad: 'The tropics vanish, and meseems that I, from Halkerside and steep Caerketton, dreaming gaze again. The town I see spring gallant from the shallows of her smoke, cragged, spired, turreted, her virgin fort beflagged.'[15]

Tuesday 8 June

Mess orderly. May it never come again. There was a great confusion over a pot of jam which was emptied by the guard. I tossed with other mess orderlies who should go short, and lost. A riot among my fellows at the table – very wroth were they; but eventually the tossing-up story I told them made them laugh heartily, and they wondered if I was going to toss breakfast, table and all. Afraid I left little food for the transport. They really should mess separately.

Letter from Irene Gass, and *Punch* and *Daily News* from Dray. Enjoyed the American cartoons in American papers relating to the *Lusitania* affair.

Mr Bernard Lees fell from his horse, Schoolgirl, and badly hurt himself. Conversed with Limmer; he _is_ a wag.

Stanley's sister Margaret, who was in the United States during the war, kept him supplied with selections from the American press.

Towards the end of 1917, Limmer would be taken prisoner in Palestine and interned by the Turks until the end of the war. His 'waggishness' and capacity for enjoyment served him well as Secretary to the Amusements Committee in the camp at Bore. When he was repatriated after the war, he published a booklet, *Reminiscences of a Year's Captivity in the Hands of the Turks*.[16]

Wednesday 9 June

Our mess here at Ghezireh is unclean and not conducive to good appetites. We got porridge and eggs for breakfast at Kasr el-Nil, but now too much tinned brawn is served out to us. The grab game is once more in force, as it was at Wantage. The other table belonging to our troop are at enmity against us. They are too fond of throwing bread about.

Some of the troopers have bought mongrel puppies, and are keeping them behind their horses or in their pens. Met a Sherborne man who was in Ffooks & Douglas's office.[17] I forget his name, think he is in 'B' Squadron.

Night cool and pleasant.

Thursday 10 June

Divisional field day. The regiment rode away at 2.30 p.m. to Abbasia.

I was on night picket at Muski and arrived back at Ghezireh early in morning. No police work to do. Night very quiet. Slept in peace. Before going on duty, I looked round the Ezbekiyeh Gardens and watched the

people rinking. Interested in an Egyptian 'bint' [young woman], who skated well but made wry faces. Had a good strawberry ice. Interested in the trees in the gardens. Had tea at the shop in Taher Street, where is the little French girl.

Roller-skating was popular in Cairo. The rink in the Ezbekiyeh Gardens was managed by the YMCA, and it was 'no uncommon thing in the evening to see three or four hundred men gathered together under the sign of the Red Triangle'.[18]

Friday 11 June

Mother wrote to say she had sent a parcel for me, so went down to the Post Office after dinner and claimed it. Too hot and tiring for me in Cairo in the daytime. I slunk into Groppi's [in Shari el-Manakh], and ate an omelette and a fruit salad. Took the tram back [to Ghezireh] by way of Bulaq Bridge. I enjoy the tram rides. They run frequently and are very cheap.

In a city with not many motor vehicles – in 1914 there were fewer than 600 cars, only ninety-seven taxis and no buses – the comprehensive system of fifteen electric tram routes provided the only fast way of traversing Cairo.[19]

Wrote postcards to many acquaintances.
 I burnt my foot with some porridge at Kasr el-Nil and the wound will not heal, so I go to the hospital in the mornings and have it bandaged. Festers have broken out elsewhere on my feet. A great many fellows are suffering from sores and blains. The new doctor [Lieut. Dominy] will be fairly successful as regimental doctor.

Saturday 12 June

Went to the hospital to have my foot bandaged. Doctor gave me light duties. Near the hospital is a neglected garden, and I found in a bush there two small birds' nests. The eggs were white with black spots and the nests were made with fine twigs and wool. The birds were on the nests, and they are very small.
 Took a tram ride to the pyramids (plate 48). Fresh air lovely. Talked to a little Egyptian girl – pretty – dressed in black and white. Spoke broken English very sweetly with her hands clasped. Went to the restaurant and drank cocoa, and lemon squash with soda water. Talked to a drunken Australian.

Sunday 13 June

Open-air church parade. I did not attend, but had a shower-bath instead.
 A large parcel from home arrived. Contained cake – iced with cherries on it – made by Iris, Mexican chocolate, Petit Beurre biscuits, Eau de Cologne,

Oil of Citron, Wright's Coal Tar Soap, various vestments, and a letter from Iris. Very kind and thoughtful of Mother. The opening ceremony reminded me of school-days.

I don't eat dinners here – can't raise an appetite at midday. Breakfast and tea I indulge in.

Read a few pages of *Richard Carvel* by Winston Churchill.[20]

Monday 14 June

How miserable we must look, waiting outside hospital for our turns to be bandaged!

Mr Hoare said I didn't groom B's horse properly. Had to do it again.

Had some of Iris's cake for dinner.

Very hot. Was restless all the afternoon. Ashford lent me the *Salisbury Journal*. Bayonet exercise at four o'clock. Mr Browne slopes in and makes desultory criticisms. At tea-time Kettle's table was annoying. I offered to fight Kettle for throwing bread. There was some boxing afterwards between Watkins and Norman, and Watkins and Harvey.

Major lectured to us on the infantry attack.

Tuesday 15 June

Temperature 115 °F in the shade. The papers say this was the hottest day known for years. The scorching khamsin wind blew all day. Lay in my pen and sweated. I wonder we stand it as we do. Robberts is ill, and Daniells has had a slight stroke. Getting tired of bandaging of my foot. Asked the doctor if I couldn't do it myself.

There has been no news in the papers for a long time.

Cossins played the piano and I sang 'Ye Banks and Braes'. Tory sang 'Lucky Jim'. Drank beer at the canteen. Horrible stuff.

Wednesday 16 June

Mess orderly. Our quartermaster, Vye, is very slow. Tiring waiting for him to give us the bread. Complained to Lieut. Hoare that no cleaning materials were given the mess orderlies with which they could clean the tables. Tomatoes and cucumbers for tea. Sansom and Marsh collared all the vinegar.

Went with Teddy Bown, the cook, to the pyramids. He was dressed in clean white duck suit. At the Mena café, he drank whisky and soda, and I, iced lemon squash, and then coffee (essence) with milk (condensed). Talked with a guide, who wanted us to give him Egyptian money for an English florin. Home by tram down the long avenue. I very tired – late in turning in.

Thursday 17 June

A mail arrived. It brought me two LMS magazines from Miss Dyer. I like reading the news from the mission fields of other lands, and stories of the

strange habits of distant peoples. Amused with the story of the Indian who, to atone for his sins, floated on a raft down the Ganges, from the Himalayas to the sea. He never put to shore except at night, when he kept close in to avoid the crocodiles. The sun blistered him by day, and the nights were shivery with cold.

Cossins is transferred to the brigade headquarters as a policeman. A few criticisms as to his suitability for the post.

Friday 18 June

I went on stable guard last night with 'B' Squad guard. Was cold in the night and had to walk around to get warm. On guard from two till four. The light breaks very quickly in Egypt. At four o'clock, reveille sounded from the bandstand where the buglers stay. By five o'clock the regiment was off to Abbasia for brigade drill. I was glad to escape the drill. I bathed, bandaged my foot, and ate eggs and bacon at the canteen. The others did not arrive in till 10.30. Tinned salmon for breakfast.

Saturday 19 June

Walked with [Leslie] Cherry as far as the Kasr el-Nil Barracks, where I took a tram to the Muski Police Station. I drank a lemon squash at a café in Taher Street. It was at the café where I previously met the French girl who is employed there. Bought some good chocolates of her. In the [Ezbekiyeh] Gardens, I lay upon a seat under some trees and listened to the band playing on the terrace at Shepheard's Hotel [a popular haunt of officers]. It played selections from *Princess Ida*.[21] Returning on the tram, I talked with a Derbyshire Yeoman who is stationed at the Gizeh wireless depot.

The mail brought letters from Dorothy Betty, Irene Gass and May Handover, a *Punch* from Dolly, and a letter from Miss Lodder with a little poem called 'The Bluebell'.

Sunday 20 June

I wrote to Miss Lodder. Went over to the Gizeh Zoological Gardens [in the park of the old Gizeh Palace]. With difficulty found the tea house – a delightful place, shady and cool, near a lake on which pelicans swam. After tea I lazily smoked a cigarette and read my letters. Irene's was written on the heath at Coniston. She enclosed a view of Tarn Hows, and some wild thyme. Betty – stolid, solid Betty – has gone into an insurance office for 'duration of the war'. May is convalescent after scarlet fever and wrote to me sitting under a tree in the garden. She suggests Oil of Lavender for flies. Father wrote that Poole Harbour was full of minesweepers ready for the Dardanelles, that the pottery factories were used for munitions, that a pier at Parkstone on Sea was used for shipping munitions, that the heather around Arnecliffe had been burnt, and that the Admiralty yacht *Enchantress* had stuck on a sand hook outside Poole Harbour.

British intelligence suggested that the Turks had heavily mined the whole of the Dardanelles, though in fact they had concentrated on the narrower, northern half. The Allies therefore wasted a good deal of time and resources sweeping the southern half. Initially, converted trawlers were used for minesweeping, but purpose-built vessels began to be delivered by British shipyards in May 1915.

Arnecliffe was the George family's holiday house overlooking Poole Harbour (plate 12). As the children grew up they sometimes stayed there independently and entertained their friends. Aunts Bee and Don often used it, and periodically it was let.

The enormous steam yacht HMS *Enchantress*, with a crew of almost 200, was Churchill's much-loved and much-used official transport when he was First Lord of the Admiralty. In 1914 it was converted into a floating hospital for officers.

Wandered round the zoo – saw some eagles, a zebra, five giraffes, and best of all the lion and lioness from Kordofan. How I love looking at lions! I love their savagery, and yet at times they look so docile. The white lotus flowers were blossoming on the water, and the mango trees were shedding their leaves. A fresh wind blew on the lakes and stirred the poplar-like trees growing by the water's edges.

One of the more recent and unexpected exhibits was a couple of galvanised iron pontoons used by the Turks in a failed attempt to seize the Suez Canal in early February. All twenty-five pontoons were destroyed by British machine guns and warships, and two were displayed in the gardens complete with shell and bullet holes (plate 60).

Monday 21 June

Took a tram to [central] Cairo. Had dinner at Sault's. Poor dinner – 18 pt. There were Australian officers around me dining, and two English music-hall artistes with a grey-haired actor; a pale woman sat at a table by herself. A Christian Egyptian talked to me as I came home in the tram.

Tuesday 22 June

Now I see the longest day is reached in England. And now slowly backward into darkness will the evenings slip. I wonder how long before we see an English spring. I would love a glimpse before my eyes of some wooded height in England, where the strong west wind blew and howled, and where the storm clouds raced, and a tearful sun shone now and then. Can I not dream of this? I think of it often; it is on my mind, but never at night.

I received a parcel of chocolate from Irene Gass.

I feel rather weak and sleepy. Think my stomach is out of order.

Wednesday 23 June

On guard at the Kasr el-Aini Hospital. The guard was under Serg. Burrow and Corp. Waters. Hot walking there – could not tram as Kerton was behind us. I don't like this hospital. Our guard-room is near the native wards, and the place does not look clean and there are smells. Interested in the wailing women, waiting for the body of a man to be brought out for burial. Saw Miss Traill, but she had forgotten me. At night I sat on the seat in the porch and talked to Waters about Woodyates and the country round his home. The guard was composed of Genge, Leaton, Loader, Maiden, Drake and myself.

Thursday 24 June

Marched back from the hospital to find the camp rather deserted. Last night the regiment left for Abbasia, where it bivouacked the night, ready for operations today. At eleven o'clock they came back, very dusty and tired and hungry. The Cool Shady Bower rode my horse because he said his own was bad. Cheek! Poor Itchy! He was rather lame with the desert's rough surface. I believe the squadron made a charge against orders and their line was bad, whereupon the adjutant – an excellent man – was very wroth.

We read in the papers that Lemberg[22] is fallen and the Russians are in full retreat.

Friday 25 June

This night the moon was near full, so I decided to take a tram over to Mena, and there go to see the Sphinx in moonlight. Glorious ride – a fresh blowing air, and the moon looked fine over the Nile flats. With a guide and a camel – called Mena – I rode to the Sphinx. How grand she looks in the soft moonlight! The background of the three pyramids pointing into the blue starlit night sky is fine. I was much impressed. Went down to the Sphinx Temple, which showed ghostly in the moonlight. I dismissed the guide and the camel man at the Cheops, and there stayed to admire the flat land around me in the direction of Cairo, with the few lights of Mena village pricking here and there in the half darkness.

Saturday 26 June

Bertram, Roy and Hooper left in the evening for Minia, a hundred miles upriver, where they will stay with a friend of Roy's he met at Reading.

They were going to the parental home of Shafik Fahmy Mina, who had been in the second year of a two-year course in the Faculty of Letters at Reading when Roy was there, and had stayed with the George family in Blandford

(plates 65–68). Reading University College was popular with Egyptians. Of the twenty-seven students from eleven overseas countries represented in 1912, no fewer than eleven were from Egypt.[23] Shafik had gone on to become a teacher at a French Jesuit school in Minia. Some of the best schools in Egypt were run by French and American missionaries.[24]

An Englishman, I think his name was McNeile,[25] lectured to us on Old Cairo, with lantern slides. Hope he will come again, for he proved most interesting. I must see the mosques he mentioned, and the old Egyptian house, and the native bazaar.

Heard from Sister Radnor and Shittler. Sister is nursing a man with spotted fever, and has left her first hospital at Havre. Shittler was very glad to get my letter. He reminded me of our little exploration one evening in the Bemerton meadows.

Sunday 27 June

On guard at the High Commissioner's House with Corporal Bennett, Daniells and Churchill. The guard-room is a shady bower at one end of the garden path. Gen. Maxwell lives in the house with Lady Maxwell – and Prince Alexander of Battenberg, [the] Marquis of Anglesey, and Capt. Walford, who are the general's aides-de-camp. I saw them all pass in and out in their motors. The prince and Capt. Walford are small, rather dissipated, unintelligent-looking men, while Lady Maxwell looks like a pink doll. I think they call Capt. Walford 'Joe'.

Could not sleep for insects. Tried at the kitchen to get milk for the tea, but no good. On guard from twelve midnight to two in the morning. The moonlight looked very pretty in the garden.

Monday 28 June

At eight o'clock we were relieved by the new guard. Back in time for breakfast. Hungry, and ate bread and butter with strawberry jam, and two eggs and tea with relish.

Lay on my bed all the morning, and read the *Salisbury Journal* and the *Dorset Chronicle*. In the afternoon I finished René Bazin's book *The Children of Alsace*. Have been most interested in this book. It is written so quietly and modestly, and the descriptions of the Alsatian country and the Vosges, and of the people, are so gentle and soft. How soulful the French seem to appear against the solid, brutal, overbearing Germans! So many times I felt like hitting out at Von Farnow. Let us hope Jean will win his Odile – and France her Alsace-Lorraine.

Tuesday 29 June

With Major Castleman at the head, the squadron exercised the horses through the Gizeh Gardens.

Miller (of 'B' Squad) and I walked over the fields to the YMCA playing-grounds. Played a game of tennis – soon gave up – too hot. Watched a cricket match – Berks Yeo. v. a team of Australians at Ghezireh Hospital. We saw the Berks complete their innings and make 96. The lime juice and soda bought at the YMCA pavilion was cold and delicious. Walked back through a rose garden, where on a wide grass path two black men were eating melon.

There was an 'episode' at tea – Corp. Hooper threw a little rice at Fowler for being greedy.

Irene Gass has sent me a tin of Rowntree's chocolate, and a plum cake.

Wednesday 30 June

Small tin of potted meat (between two) for breakfast, three melons for the table at tea. I complained to the orderly officer, Mr Bragge. There is such a greedy scramble at meals – Roy went short of bread.

Exercised in the cool green avenues of Ghezireh Island – Mr Browne was out.

Mr Hoare inspects our horses after we have groomed them. Lonnen and Roy were sent back to re-groom theirs.

Read the *Observer* in my bunk. England must rouse now. The Russians are driven back, and the French and English are I think sitting down before Achi Baba [settled into trenches facing the strategic Achi Baba heights on Gallipoli]. There is little doubt the Allies are short of munitions, and the German gas is too dangerous for a general advance.

Played draughts with Leslie Cherry. Was beaten. All the old hatred and jealousies I felt in school-days against him found tonight a place in my heart.

Thursday 1 July

Mess orderly. Porridge for breakfast, first time since we have been at Ghezireh. Stew for dinner. This means a real mess when washing up; however, managed to get hot water. At tea-time I complained to the quartermaster because no jam was served out. He will think me a great grouser, as yesterday I complained that we had not received our 8*d* worth of food.

Started to write Betty, but tore the letter up. Letters arrived from Father, Aunt Don, Aunt Kate [his father's younger sister, Mrs Catherine Burden] and Joan Buckley. Joan is busy at various things – sec. of a swimming club, helping Sylvia Pankhurst in the East End, and learning motor driving. ... Iris and Aunt [Don] are trying to take in convalescent officers at Arncliffe.[26]

Sylvia Pankhurst and the East London Federation of Suffragettes not only continued to campaign for votes for women, but also did relief and social work. In the East End during the first half of 1915, they set up a toy factory to provide jobs for unemployed women, founded the League of Rights for

Soldiers' and Sailors' Wives and Relatives, and converted a disused pub into 'The Mothers' Arms', a nursery school incorporating a doctor's surgery, nursery and Montessori school. Joan Buckley could have been involved with any of these activities, but before long she started work as a Junior Administrative Assistant at the War Office, and in 1920 would be awarded the MBE for her wartime services.

Thirty men left for Maadi to look after prisoners for a month – Bower and Pardy from our troop.

Went with Old to the Kasr el-Nil rink.

Friday 2 July

Reveille sounded at four o'clock. The regiment left for Abbasia. I rode with Watkins. A fine sight in the Shari Abbas to see the troops moving, and the sun climbing in the eastern sky. At the barracks, Itchy became lame and I had to return home. I saw the funeral of Hadiqa Hassan, widow of Prince Hassan Pasha. The procession passed the gate of our camp. First marched a company of Egyptian Infantry, second some cavalry in blue breeches and white tunics, third an Egyptian band, and fourth the coffin. Behind were some Egyptian coastguards. The music was impressive.

Bought a book by [E. Phillips] Oppenheim, *The Long Arm*.

We cheered Major Souter as he drove away. He is gone back to France [to be attached to the Scottish Horse]. Men rather furious because Lieut. Browne went off without paying them – they were late.

The mail brought a letter from Irene Gass, a paper from Aunt Don and a p.c. from Aunt Kate. B heard from Mother and Father.

Saturday 3 July

Again on guard at General Maxwell's house – Corp. Miller, and Ptes Meaden and Leaton. The general lives in a fine house. The garden must have been pleasant at one time, but now it is neglected; there are roses and sunflowers blooming. In the kitchen, a native servant gave me coffee and toast. Saw other delectables brought out from the dining room. In the stables are three motors and five horses. The two best motors were made by Lanchesters, and P&L.[27] Two of the horses are named Cronstadt, and Flying Vixen. The stablemen speak English; also I found the interpreter an interesting man, and he made my sentry guard pass the more quickly by talking to me about Cairo. A stableman went out and bought some Morton's marmalade – it was bad – and a melon. Could not sleep for mosquitoes. How fine the Union Jack looked flying on the roof of the general's house!

Sunday 4 July

At last we are served out with our drill tunics, which are thin and light. On sentry guard at midday wearing the thick khaki material is unbearable.

After dinner I took a tram to the zoo. Very hot and uncomfortable walking. Watched the lioness and the handsome leopards. Saw, and envied, the hippopotamus under the water. Visited the grotto, where upon a sea-rock seat I listened to trickling water, and looked out on the hot dazzling gardens through a hole in the rock. Had tea on the island, and talked to three Irish soldiers back from Gallipoli. They were drinking Munich beer. In the Gizeh Gardens I met two nurses, and they told me they had come from transport wounded work at Lemnos, and were sorry to be in Cairo with so many of the amateur nurses, who are a nuisance at times. I went with them back to the hospital.

Monday 5 July

Our squadron exercised around the Island of Ghezireh. The island roads are very pleasant. They are lined with lubbuk trees.[28] Comfortable houses, white with green window shutters, peep out between the delicate foliage of trees. I love seeing these houses, which belong to English residents. They are snuggled away in such quiet corners. At the far end of the island is a large convent [and boarding school]. It is called the Convent of the Mother of God – a large white building with a bell tower. A tall plastered wall surrounds it, and inside grow tall banana plants. Around the convent are fields of maize and long grasses, and far off across the river one can see the city mistily through the morning haze. I rode Hooper's mare.

Wrote to Irene Gass and Dorothy Betty.

Tuesday 6 July

The vet – Capt. Fearnside – looked at Itchy. Said he was lame in the hock, told me to feed him on bran mash, and foment the leg. (Adlem says he is lame in the fetlock.) He gave him a pill, a large, long black bomb sort of thing, which Itchy wouldn't take, so the balling-iron had to be used.

I wrote to Mrs Menzies, and sent a photo of Eames and me on Cheops. There was a lecture by Mr McNeile about Egyptian customs. He told us funny stories about Egyptian justice, the easy way by which a man can divorce his wife, and the wonderful doings of an old Egyptian 'saint'.

We are getting desperate for good definite war news. Russia are being pushed back on Warsaw and there is little progress in Gallipoli.

Wednesday 7 July

Itchy is [still] lame and suffering from the effects of the ball. I rode Hooper's mare out for exercise.

I wrote a letter to Joan Buckley.

There was a concert held in the drill-square at Kasr el-Nil Barracks. It was an excellent concert. A sergeant-major from the Westminsters sang 'The Old Brigade' and 'My Old Shako'.[29] His was a fine voice. A Berks man sang 'The Rosary' and 'I Know a Lovely Garden'. A violinist from

the Herts played that well-known air of Verdi's [from *Il Trovatore*], 'Ah, I have sighed to rest me'. As an encore he played 'Violets'. It was good to hear a violin again – so tremulously the music fell on the still air. I drove back, as I felt very tired. Lonnen is taken to hospital with a very bad throat.

Thursday 8 – Friday 9 July (spanning both pages)

Early in afternoon the regiment started out for Abbasia. Horses were watered at the large, round and deep cement basins, which are under a lubbuk tree. We had tea (awfully good) in the Westminsters' mess room. Rode away over the desert, Heliopolis on the left, and halted after sunset near a watch-tower on the Suez Canal road. What a sight – the troops riding in extended order, the westering sun streaming along our way, and the dust, golden with the light, choking our path. And then darkness, and stillness, with stars in heaven and lights on earth twinkling. All night until two o'clock we dug trenches, with intervals of rest for refreshment – a cart with beer had crawled up over the desert. I slept in my trench – much like an open grave.

In the early morning [of 9th] we were ready for an attack, which came not. Gen. Peyton and staff rode round to inspect the trenches, and then rode off up the hillside in a cloud of dust and clatter of small stones. At seven o'clock we unlinked horses and rode home. I was very dusty and tired. Tom Snow's horse is such a puller, and trotting with marching order up is a terrible jolting. Arrived back to find sardines for breakfast – which were not served until we had finished.

Letters arrived from … [Aunt Don] and Miss Lodder. Aunt Don sent a *Tatler*. All is much the same at Bemerton. … The rector is giving up the living in September, but will [continue to] live in the Rectory.

Bought a bouquet of roses from a boy over the railing – they were encircled with the scented wild geranium leaf.

Saturday 10 July

Mess orderly. While carrying out these duties, Serg. Tory came and told me I was to go to Maadi to guard prisoners. Pike, Hewlett, Hibbs, another trooper and I took train from Bab el-Luk for Maadi. No wagon to take our kit, so we waited at station. Drank at the café there kept by a Greek who speaks English well. At one o'clock, leaving Hewlett to watch kit, we set out on foot for Tura.

The prison camp is an old Egyptian gun factory beside the Nile. I thought the place looked very comfortable. We reported ourselves to Serg. Hellyar, and then went to see our other fellows who had come up previously. Our beds – mattress and two gaudy blankets – were given us. We have to sleep in a room within the gate. Round us in other rooms are the noisy Manchesters and Lancashires. It appears there will not be much to do here.

Went inside the old Coptic church at Tura.

Sunday 11 July

In our room are six Westminster Dragoons, sent up from Abbasia on the same job as us. There are fellows from the Notts, DLOs and Herts here, besides the Manchesters and Lancashires. We feed well. I had plenty of bacon in fat and fried tomatoes for breakfast. For dinner there was very good stew, and rice to follow. This shows up the Dorset Yeomanry. The North Country men make a great row at meals and <u>appear</u> to quarrel violently, but I think it is only their way. The canteen is small. Plenty of beer is drunk by the northmen.

Watched the guard parade. Gen. Maxwell arrived to inspect the camp. The prisoners appear contented. … Their shirts are of bright colours. They all wear the fez. I strolled down the road to the Bord du Nil Café, where I had poor coffee.

Slept in the balcony with a little terrier.

Monday 12 July

On rear guard today. The orderly officer rather smart. Some of us, including myself, bungled a little at the parade. Our corporal was a Manchester man – noisy, but good-hearted. On No. 6 post from twelve to two. Prisoners interesting. Turks are sturdy, strong and healthy – heads square, faces full, eyes deep-set and fierce; not clever faces. Saw an officer walking up and down like a tiger imprisoned. He was handsome and young.

Guard-room very hot. Hardly knew what to do for discomfort. At night-time we boiled some tea, and the corporal took me in the prison to the Turkish cook, who gave us some delicious coffee.

The night commenced the Ramadan month. During the night the Turks prayed, when they were not eating.

Tuesday 13 July

Glad to finish guard at eight o'clock. Breakfast good – bacon again with tomatoes. The six Westminster Dragoons in our room are six gentlemen as far as outside manners and appearances go; then Sieling, another dragoon, who takes the lead at our mess table, is so energetic, good-natured and good-humoured. The Notts and the Herts men are above the standard of the Dorsets.

Bertram came over with Hooper and Watkins, having escorted three Turkish sailors to the prison. They stopped to look round the prison and have some tea – great scramble for tea, little food forthcoming. Down in the vinery we sat under the long archway and ate grapes.

Walked to the Australian camp with Eames. Very quiet there. How clear the bugle sounded! Saw the guard changed. Had ices at the Greek café. Discussed the impossible ignorance and humour of the Dorsets.

Wednesday 14 July

A day of discomfort. Wrote a poor letter to Father and Mother. It is so hot writing, and I'm afraid my writing is too often illegible.

There was a great outcry at tea-time. We were served out with large tins of blackcurrant jam of Egyptian make. It was nothing more than dried currants in sweet syrup. The North Country men said, 'Take it away' and began to sing, 'Nobody knows how fed up we are.'

Walked to Maadi with Stroud. His home is at Sydling St Nicholas. I bought Thomas Hardy's book, *Under the Greenwood Tree*. Perhaps I shall now feel cool. Over our ices at Maadi we discoursed on Dear Old Dorset, eulogising the Blackmore country, the Lulworth coast and the Frome Valley.

Thursday 15 July

The Westminsters, and Hewlett and one of the other Dorset men, have gone into the tents. I was looking to singing songs in bed while Hewlett accompanied on the mouth organ. I must now go round to his tent.

Sergeant-Major Rochester of the Essex Regiment has arrived, and gave us a speech this morning on discipline. He said, 'If you are told to do a thing out of your turn, do it, and then grumble afterwards.'

Wrote to Shittler a long letter, which I shall copy out again and post tomorrow. Strolled round Maadi. Admired the houses. Looked across the cotton fields to the desert and the hills. How strong and eternal the desert looks at night – much like the boundless ocean. After deliberation, bought some Colgate's Shaving Soap for 6 pt., and also some magnesia for medicine.

Friday 16 July

On main guard. No. 1 post, third relief. Acted as escort to two defaulters and a score of Turkish prisoners during their trial before the colonel. Oh, the ass of a sergeant-major, who whisked me about as though I was a ventriloquist's doll! With unsheathed bayonet in my hand, I stood at attention in the room during the courts martial. Colonel Whittingham Bey is a big, blunt-speaking, confident man. He dealt with prisoners quickly and well. He himself questioned the Arabs; an interpreter spoke for the Turks. The adjutant – Mr Simpson of the Manchesters – stood by looking very important. Major Halstead was the only man who didn't annoy me. He was writing letters at the table, just like a quiet, contented, shrewd business man – which he is. The remands were for fighting, slovenliness, falling out of rank, and swimming in the Nile.

Wrote all day to Shittler.

Saturday 17 July

From six to eight on sentry post. Confound the slowness of the new guard parading. Four men of the DLOY arrived and are sleeping in our room. Like us, and the Westminsters, and all the yeomanry regiments, they are very fed up with Egypt.

Finished and sent off my letter to Shittler – a fifteen-page one. Watched the prisoners: sergeant dealing round rice, some bowing over big books, which perhaps were Korans. Walked in the dusk to the village up the Helwan road. Sat beside the Nile under a eucalyptus tree and watched a sandstorm blowing, so that Helwan was closed from view.

Heard from Mother and Dray. Slept in verandah.

Sunday 18 July

Caught the 2.38 train at Maadi for Cairo. Drove in a hired cab to Ghezireh. Found them most asleep. Lonnen had gone to Port Said to recuperate after mumps. Roy showed me a letter he had received from Pat Irwin. Had tea with troop at mess table, then went to see Itchy. Looked the same; badly groomed. I think he knew me. Adlem says he is better and Old will ride him out tomorrow. Went to Gizeh Gardens. Called at hospital there on pretence to find some marines; really to find a nurse I met a fortnight back. In a ward I talked to Cook of the Plymouth Battn. Next him was Robinson, RFA – hit in the back with shrapnel. Cabbed to Bab el-Luk. Went home in train with an Armenian.

Monday 19 July

Wrote a letter to Margot and enclosed two photos of myself – one with Itchy at Kasr el-Nil (plate 40), and the other of Eames and me mounted respectively upon a donkey and a camel beneath a pyramid.

The moonlight is so beautiful upon the river. I watch the ships cross the silver path and listen to the wavelets breaking on the bank, and am reminded of Arnecliffe and the Harbour of Poole beneath.

The Germans are advancing on Warsaw. We English do not seem to mind. *Punch* in a cartoon represents Russia as the gladiator retiring to throw the net once more about the attacking warrior.[30] Achi Baba is not captured yet and Italy is not moving fast. In France nothing appears to happen of importance.

The letter to Margaret reads:

I am now at the Maadi prisoner of war camp, doing sentry duty. There are 2,000 Turks interned here in a large, dismantled Egyptian gun factory. A dozen men from every regiment of yeomanry in Egypt have been sent here to guard the prisoners. The prisoners seem quite happy and really have nothing to grumble about. They are fed three times a day with the flat, round, native bread and stew, and once a day with tea, rice and aloes. Soap, tobacco and writing paper given once a week. The prison is cool and open. They look very sturdy and strong; some look very fierce, but I'm afraid there isn't much fight or patriotism in these men, and they tell us they hate Germans and say the Turks can't hold out long.

It is now the Moslem month of Ramadan. Good Moslems eat nothing all the days of this month – save at night, when they more than make up

for the day's fasting. Two nights ago I was on sentry post outside the prison at ten o'clock in the evening. At that time a gun is fired during the month of Ramadan from the famous Cairo Citadel. This is the signal that the fast is ended for the day. All was utterly still around me where I stood until the gun was fired – and then, like a city suddenly awakened, up rose all the sleeping prisoners and set to and gorged all the food they had saved during the day. You may laugh – but these Moslems, during the days of Ramadan, are afraid even to swallow their own saliva. One day I was escort to some Turks who had to be court-martialled before the colonel. Several were brought up for spitting in the prison and the colonel let them off because (as I heard him explain to the warden) they are almost forced to spit, as their religion forbids them to swallow anything in the daytime.

It is a most impressive and solemn sight to see three or four hundred of these Turks at prayer. A leader will call them to prayer and they all line up in long rows. At first they stand erect and quiet, hands in front and faces very solemn. Then, following the leader, they fall on their knees, emitting weird chants – now high, now low. Then they will smother their noses in the ground and get up with a start and lift their hands to heaven (and then all over again). It is really a wonderful sight – all the movements are done together with much dignity. I should love to see them at prayer in their mosques – those cool, white, vast-domed, alabaster-pillared churches.

And the colours – the Turks have been given the blue suits the French onion men wear, but there is a variety of others. Red shirts patterned with white leaves, crimson and purple ones, bright blue sashes, and the red, black-tasselled fezes they all wear. These gaudy garments make the prison look quite gay, and such a relief from the eternal drab-khaki.

Outside the prison the roads are lined with oleander, blooming red and white, tall eucalyptus and lubbuk trees, and here and there an Aleppo pine. The fields are green with waving maize and white with the soft cotton flower. Down below runs the Nile, and away beyond I can clearly see the pyramids.

And when the moment comes between sunset and darkness, Egypt is marvellous – soft winds blow, livening the water and speeding the sailing boats that ply on the Nile. Across the river, the men and women in the fields return with their donkeys to their boats in which, donkeys and all, they return to their homes this side. The black-draped women move by in the road, carrying cargoes on their heads – so stately and bold (plate 69). Camels, ugly and silent, walk in single file, ridden by tall, handsome, treacherous Bedouins [or bringing home the harvest, plate 70].

We sleep in the open under a tile roof – the wind blows in upon us, but the mosquitoes are the devil.

Hospitals and every building here are filled with wounded from the Dardanelles; Achi Baba still untaken, but must fall this week. Thousands of K's Army have come here.

In describing the Bedouin as 'treacherous', Stanley may well have had in mind the Battle of Shaiba in Mesopotamia three months earlier, in which

Bedouin irregulars initially formed three-quarters of the Ottoman force, but harried the Turkish infantry – who had been defeated by an Anglo-Indian force – throughout their lengthy retreat. Many tribes understandably felt no particular loyalty to either side.[31]

The Gallipoli campaign had developed into a costly stalemate of trench warfare. The British and French had lost more than 15,000 men in three unsuccessful attacks on Achi Baba, and the Anzacs had suffered heavy losses in attempting to secure other high ground on the peninsula. The Dardanelles Committee (successor to the disbanded War Council) decided to send reinforcements, including divisions from the New Army, commonly known as Kitchener's Army, which had been formed from masses of new recruits to the regular army in the early part of the war.

> Thanks for American papers. I am always interested in them. Someone is playing some soft, melancholy air on the piano (I am on the balcony) with the Nile reeds shimmering in the soft, night air. Makes me homesick for green grass – tall, waving grass, you know – and cows, and peaceful England. The moon rises over the barrack wall, turning the Nile to silver.
>
> This is grim warfare – mostly at night with mosquitoes and bugs in these barracks! It is not all beer and skittles, though, as you would find if you were doing damned manoeuvres in the desert under a blazing sun, while sweat runs down your face in a continuous trickle and you can't open your eyes for sand – but as yet it is only 100 °F. Even now the only cool place is the shower-bath – or [the] wet canteen, where there are many large and luscious-looking barrels of beer and cool pewter mugs to be seen.
>
> I suppose we go to the Dardanelles soon. I am glad we shall see the end of guard duties and all the nonsense attached thereto.

The diary continues:

Tuesday 20 July

> On rear guard – Corp. Carter. Very good post – No. 9 – breezy, good site, out of the way of meddling officers. Orderly officer – Slaughter.
>
> So hot in the afternoon. Sieling of the Westminster Dragoons is musical and is the conductor of the orchestra which plays for one of London's best amateur operatic societies. We sang together various songs out of Sullivan operas – favouring 'Yeomen of the Guard'. He has been in yeomanry for four years.

In contrast to the predominantly rural backgrounds of the Dorset, Bucks and Berks Yeomanry, the Westminster Dragoons were 'absolutely City of London types, sons of stockbrokers, accountants and Bankers. There was also a couple of actors with them.'[32] Carl Sieling, the son of German immigrants, was a pianist as well as a conductor. In December 1915 his fluency in German led to his being moved to General Maxwell's

headquarters as a receptionist, translator and interpreter, though his musical abilities meant that he remained in demand as a performer at social functions.[33]

> Read *Collier's Magazine*, sent by Margot. Awfully interested in article 'German Thoughts Behind the War'. Dr Harnack, Herr Ballin and Dr Südekum seem rather inflated with the pride of the everlasting enduring of the Germans.

'German Thought Back of the War' was one of a series of reports from Germany by former US senator Albert J. Beveridge, written before America entered the war. His eminent interviewees included theologian Professor Adolf von Harnack, General Director Albert Ballin of the Hamburg-American shipping line, and Dr Albert Südekum, leader of the Social Democratic Party. Not the least remarkable feature of this article is the repeated assertion by eminent Germans that Bernhardi's book *Germany and the Next War*, which had gone through at least six editions, was scarcely read in Germany.[34] Beveridge's articles and the book he developed from them were widely criticised for their pro-German viewpoint.

Wednesday 21 July

> Early in the morning, watched the sun rise over the desert hills. I waited, wrapt in a blanket, while Pike stood near me as sentry. Daylight came at four in the morning; the sun did not rise until 5.15.
> Parcel of cigarettes from Mrs Menzies and Kathleen Rossiter [Dorothy's younger sister]. Mrs Menzies is staying at Red House, Bridport, with Mrs Rossiter. Mrs M says Kathleen has Dorothy's voice. From the letter, she has Dorothy's merriment and humour. She [Kathleen] speaks of 'Dear Old Dorrie'. Says she is going to Salisbury, where she will picture Dorothy in the garden and on the river. She regretted I did not come over from B [Blandford] when home. How I wish now I had! But as Kathleen writes, 'Years and years hence after the war, you must come. We should love to see you, and feel as if we'd known you for years.' May God at some distant time take me to West Bay; then I will see face to face Dear Dorrie's Spanish sister, and hear Her voice speaking again in Kathleen's.[35]

The bulk of the regiment was relieved of its garrison duties and moved to the modern Abbas Hilmi Barracks at Abbasia on 21 July (plates 45, 46, 75, 76). Although there had been military barracks on this site since the time of Napoleon, the complex had very recently been vastly enlarged, and had become the biggest and best of the British barracks in Egypt, complete with magnificent stables. Being out of the city centre, it had even more reason to be self-contained than Kasr el-Nil. Its bookstall (plate 47) would have pleased Stanley, but he remained on guard duty at Maadi and did not move with the others.

Thursday 22 July

Towards tea-time 130 Turks arrived, escorted by a troop of South Notts Hussars. Turks in khaki uniforms, dusty and stained – saw some spattered with blood. The warders searched them – unwound their puttees and their long body protectors. They had in their pockets plenty of bully beef and biscuits.

Bought the little *Handy Pocket Atlas*,[36] because I love seeing the world by maps, studying continents and running the eye along the coastlines, and learning the names of big cities on the great rivers. A DLO man told me today that Dorset was on the Welsh Border. His friend knew better and said, 'No, it is up in the Midlands.'

Sailed across the Nile with an Egyptian boy, and a man with a bundle who got out on the other side and disappeared in the maize fields.

Friday 23 July

Main guard – No. 3 post – Lieut. Brabazon orderly officer.

Sat on window sill and wrote to Kathleen Rossiter. I hope one day I shall see her. In mentioning Dorrie's Death I quoted the old song:

Not for long, not for long,
Blush the fair, or bloom the strong.
Though the cheek with health be glowing –
Roses 'mid the lilies blowing –
Roses die the snows among.[37]

Sweet, smiling Dorrie, I see you now standing in the summer garden of flowers, where behind, the Avon flowed in its pastures, the grey Cathedral spire leapt Heavenward, and on the Plain, the light dream-clouds sailed over the corn!

'Until the day break', Dorrie, 'and the shadows flee away.'

Saturday 24 July

A letter from Emily Le Lacheur. Such a pretty letter, as coming from a pure and simple soul, and a homely and sincere heart. She had been to see a friend leave for France and said she felt sad. Joe the dog is well. The parrot died a year ago. The potatoes are good in the garden, and the currants, and the gooseberries are ripening. How I remember Mr Le Lacheur's pears! They hope to see me one day in Jersey. Elsie and Emily are sending some chocolates.

I wrote to Mrs Menzies and thanked her for the cigs – and the smiling snaps of herself in the punt, of Sonny and her in Grovely Wood [near Wilton, west of Salisbury], and of the dogs Boyo and Toyo, and the cat Chummer.

Ate a solitary supper at the Maadi [Bord du Nil] café – eggs, ham and chips. Drank a bottle of Pyramides Beer.[38]

Sunday 25 July

General Maxwell arrived at eight o'clock to inspect the prison. In consequence reveille was at five, and breakfast at 6.30. Every room had to be spotlessly clean, beds laid, and equipment ready, in case the general should walk through our quarters.

Some of the fellows are suffering from low fever, which keeps them weak and feverish a day or two. Amusing to see the tattoos displayed on some of the men's chests and arms. Coiling serpents, girls in tights, Buffalo Bills beneath the American flag, and lovers' hands clasping amidst the ocean's roar. A Notts Hussar has a portrait of the King and Queen, robed in state, upon his heaving chest.

Monday 26 July

On rear guard. No. 8 post – Corporal Williams. The rear guard-room is a disgrace. The prisoners are better off. The place steams with heat and is choked with smells, and yet we are made to have meals there.

I don't like the Notts fellows at all – i.e. collectively. They are a greedy, swearing, bumptious lot. Millhouse, a Yorkshireman, I like. He is honest, modest, healthy and humorous. Not many men are thus.

At my post early in the morning I watched the sun rise statelily in red and gold from off the hills, and with the dawn I saw the men and women go to work in the fields, the camels pass down the road, the sailing boats start out from Helwan, and the herds of goats moving on the opposite Nile bank.

The same day, Bertram wrote a brief letter home from Abbas Hilmi Barracks, referring to his meeting with Stanley at Maadi on the 13th:

It is full moon of the month of Ramadan. I can hear the natives out on the desert enjoying a little music after their evening orgy – 'Oh, the brave music of the distant drum'[39] – I'm very glad it is <u>distant</u> anyhow, for it merely throbs and throbs continuously. Terribly monotonous.

Thanks for your hints on darning. I darned all my socks one day and wasn't very satisfied with the result – but compared them with other men's efforts and was happy to find mine better than anyone's (plate 76)!

I took some prisoners down to the Turkish camp at Maadi and saw Stanley there. He took us through the prison buildings – quite against the rules. I never met anyone who cared less for rules and regulations than he does! Afterwards we went through the large vineyards, where a large bunch of grapes costs 1¼*d*.

It is night, and a delicious cool breeze is blowing from the north – from England.

'Lights out!' So it's Goodnight.

Stanley's diary continues:

Tuesday 27 July

Came off guard to find the four DLOs gone with the Westminsters, and others from the same regiments taking their places. Heard from Aunt Bertha. She says Iris sings and plays [the piano] with a Lieut. Stocks, and that Pocock [a family friend who would attend a séance with the George family in Blandford after Stanley's death] arrived to tea one day.

Very tired. Read *Under the Greenwood Tree*. I delight in it. It is so simply and truly written. It depicts the typical life of the country – simple, hard, harmonious, happy, and moral. The only great and dramatic time in Fancy's life was when the vicar proposed to her in the schoolroom; and many, in fact nearly all, live the ordinary happy life of a flower that springs and blows and droops and dies among its fellows, shedding a little radiance – and then forgotten. *Under the Greenwood Tree* will live with me. What names of melody – Mellstock and Yalbury!

Wednesday 28 July

Commenced a letter to Mother. Studied my geography book. Lay in a tent and talked to Meech. He is from Tyneham of Sweet Memory. He fishes with his half-brother in Worbarrow Bay – knows Everett and his children, the Sticklands, and South Egliston Cottage where we lived. How I delighted to talk to him about Kimmeridge Ledges, the caves, Gad Cliff, Worbarrow Bay, Old Stickland and his son, and many other things. What we called the Wild, he calls the Gwile or Guile. He told me a big ship ran on the rocks just round the Tout and plenty of brass fittings are to be got from it at low tide. Of course he wishes to get home very badly to see to his boat and tackle. Says he and his brother make their own beer, and I have promised myself to take some of it after I set foot in England.

Meech's half-brother was Bertie Taylor (see diary entry 4 June). John Everett was a keen sailor, marine artist, and a friend and Slade contemporary of Stanley's eldest sister, Wyn.[40] Louis Stickland ('Old Stickland', whose death Stanley mentioned on 4 June) and his son Will were fishermen who also built boats. Their home, Sticklands Cottage, South Egliston, was on the western Purbeck coast, very close to where the George family had spent a memorable holiday in 1907 (plates 13, 14). The three gwyles – Egliston Gwyle, Lutton Gwyle and Tyneham Gwyle – are distinctive, wooded valleys near the Tyneham coast. Worbarrow Tout is a large promontory at the south-eastern end of Worbarrow Bay. A considerable part of the area, including South Egliston and Tyneham, has been an army firing range ever since the Second World War.

Thursday 29 July

> Russia is holding Germany before Warsaw. They have retired in splendid
> order, and it does not matter how far they fall back; when they are
> strengthened again with munitions, they will fall on the Austrians and
> Germans like a horde of wolves.
> Discovered a tennis court, and native burying ground out behind the
> prison, hidden by Aleppo pines. Sat on a seat and watched Australians playing
> tennis with English girls. Bought S. Baring-Gould's book, *The Broom-Squire*.
> What true types of Dorset are Meech, Mitchell and Cross! Mitchell from
> Piddletrenthide way, and Cross from Ansty. Read in the *Dorset Chronicle*
> that a Belgian of Malines is to ring a carillon at Cattistock Church.

The Dorset village of Cattistock was famous for having the first carillon
in England, and the only one in an English village. It consisted of thirty-
five bells, cast at Louvain. People came from all around to hear it played by
leading British and Continental carillonneurs. The Belgian exponent on this
occasion was Monsieur Jos. Denyn. The carillon was destroyed by fire in
1940 (not war-related).

Friday 30 July

> Rear guard again. Corp. Williams in charge. Same post as before – No. 8.
> About 9.45 the colonel with the adjutant and a large following were going
> through the prison, and the colonel saw me leaning against the rail and he
> shouted 'Sentry'. The rest of my guardsmen when I told them said I'd be certain
> to get cells at the Citadel. The rear guard is depressing. The sight of the Turks,
> the smells, the tiring work of sentry duty; all these tend to make one sick.
> In the evening we sang songs from my *Camp Song Book*.

The *Camp Song Book for use by the Y.M.C.A. with H.M. Forces* was widely
available in the 'Recreation Huts' run by the YMCA at home and abroad,
which were greatly valued by the troops during the First World War. By 1916,
fifty-two YMCA centres had been established in Egypt, ranging from their
major club in Ezbekiyeh Gardens to 'Huts' in the desert and marquees along
the Nile. The Huts in Egypt were usually constructed from grass matting
on a wooden framework, and in the desert 'the only cool place in camp is
the Y.M.C.A. Mat Hut, and the only place to get anything decent and cool
to drink is the Y.M.C.A.'[41] Some Huts were very large: No. 2 Hut at Mena
Camp, for instance, was 132 feet long. They were used for all types of leisure
activity, from reading and letter-writing to sports and concerts.

Thought of a limerick during my guard:

The sentry of 'Eight' is no more
He's gone to a happier shore.

A terrible Turk
With a double-edged dirk
Chopped him up into pieces of four.

Saturday 31 July

In the morning Serg. Greenwood detailed me to appear as a defaulter before the colonel for irregular conduct on guard. I went in with an escort. He told me I should try to do my work in a proper way, especially as I get three nights in bed. I contradicted him, as we often get only two nights between duties. So he looked at a book and consulted the orderly officer, and then awarded me four days CB. If this is soldiering as in the regular army, then the Devil take it. They say I am lucky to escape detention. Men here for slight offences get cells, and I hate this talk of crimes and cells. One would think us to be felons going to some damp deep-down prisons in the Tower of London.

Sunday 1 August

Answered the 'Defaulters' Call' [by reporting to the guard-room]. It is known as the 'Angel's Whisper'.

We are hearing rumours from Abbasia that the yeomanry are moving to the Dardanelles within the week. There is general excitement; but we are rather sceptic.

All the Herts men were moved from the tents to the barracks, and Pike and I were ousted and had to occupy a tent. The adjutant told me personally to see that some prisoners thoroughly cleaned out the rooms into which the Herts were coming. He is a smart-looking man; wears civvies in evenings, has a bull terrier following him.

Sat by the Nile with Millhouse and talked to the young man who lives at the Coptic church.

Monday 2 August

Bank Holiday! and on rear guard. I remember last year on this holiday I was at Arnecliffe. We were buying papers upon papers and waiting expectantly for dramatic developments. I remember Dray and Leonard [Cherry] were staying at the Bee Hive, and I went up to them with papers and then we went into the road and discussed the news.[42]

We were expecting to be relieved on the rear guard every hour, as we thought we were leaving Maadi. No relief came.

There is a little dog here called Bess. She is petted by everyone and belonged to a man who was killed in the Dardanelles. One man possesses a rabbit, and a Notts Hussar has a monkey. A Lancs man has two owls in a cage. He took them from the nest.

Read *The Broom-Squire*.

Tuesday 3 August

On dismissing from guard, found two parcels for me – cake from Irene Gass, enclosing a little book of Mrs Browning's poems, and a box containing Suchard chocolate from Emily and Elsie Le Lacheur.

At four o'clock a squadron of Australians arrived to relieve us. Packed our kit bags at once, and waited orders. All the yeomanry – Herts, Westminsters, DLOs, Notts, and Dorsets – formed up in the prison quad, and Adjutant Simpson wished us good luck wherever we should go. We left amid cheers from the northmen and marched, singing, to the station. We crowded the train. At Bab el-Luk we waited for a tram. I drank some tamarine. Sat next to Dudley Roberts in the tram. He told me he was from Bridport, was late in joining the Dorsets, spent a happy winter at Sherborne, but missed his old Bridport friends.

Marched to the Dorsets' quarters in the [Abbasia] barracks.

Wednesday 4 August

Awoke to hear that all orders to move to the Dardanelles were cancelled. Preparations had been made, men had been medically examined, kits ordered, bayonets sharpened, and we were excited except for a few sceptics. We are now downcast. The reason for our staying in Egypt is that Gen. Maxwell does not wish Egypt and the Egyptians to be at the mercy of the Australian horde.

In April, and again in July, drunken Australian troops had rioted in the infamous 'red blind' quarter to the north of Ezbekiyeh Gardens, with several houses being burnt down on each occasion.

I bathed with B and R in the plunge-bath. It was delightful. I just wallowed in water like a pig in dirt. B took me round to the King George's House. A grand building for soldiers. It is conducted by a Scotch woman – Mrs Russell. We call it the 'Cavalry Club'. Watched Roy play chess with Old. They each won a game.

Returned to hear that Dudley Roberts had fallen from banisters to the cement floor and had gravely injured himself.

Thursday 5 August

Dudley Roberts died in the night at the Citadel. How deep a mystery is Death! To leave England to fight against the Turk, and then to die of a broken skull at the bottom of stairs!

Hear that Swatridge and Lockstone are killed in France. In peaceful, sunny, quiet days of Salisbury life a year agone, why was it not brought home to them that <u>there</u>, in that spot, on a certain day, the fullness of their young lives would speed away to the Heavenly Eternals?[43]

During last night I had to guard Corp. Moore who is arrested for theft. How stupid to leave him in the barracks amongst us of his troop!

Went down to the stables and saw Itchy, and sat down on some fodder and talked to the night guard, looked round on the far and near Abbasia lights, and listened to the coming back of 'A' Squadron from Trooper Roberts's funeral. 'Follow me 'ome ... follow me 'ome!'[44]

Friday 6 August

We had an interesting morning on the desert. The squadron acted as the advance guard to a main body, and rode away south-east. I was one of the flank patrols. I rather like drilling and riding over the desert in the early morning. The breeze is fresh and I like to see the distant hills.

These barracks are most conveniently built. There are hot and cold baths, splendid canteens, and a regimental institute. I went to a brigade concert at the C. of E. Soldiers' Institute. Quite a good programme, including 'The Bedouin Love Song', 'I Hear You Calling Me', 'My Dreams', and Tosti's 'Goodbye'. A trooper recited 'The Green Eye of the Yellow God'.

Saturday 7 August

We are fed better here than at Ghezireh. We don't get bacon and tomatoes, excellent roast stew, and rice as we did at Maadi, but the quartermaster is really generous now and supplies us with 2 lbs of the good Australian Nile Cold Storage butter; there is plenty of jam, and the tinned fish and meat are plentifully given.

The major asked me if I would take the post of quartermaster sergeant of the remount depot. I declined.

This might have been an ideal post for someone so fond of and kind to horses, but Stanley was still keen to experience action and reluctant to return to administrative work; and he did not want to be separated from his brothers (plates 73, 74).

Went to the swimming baths which are in the [Citadel] barracks where the Berks and Bucks are quartered. Tried diving for half-piastres, but could not see them at the bottom of the water. Hooper, who has been at the Citadel [hospital], came back. He has had a touch of dysentery and looks thin. Don't think he should have come out, but he says the slightly ill are soon hurried out of the Citadel, as the wounded are crowded in there.

Sunday 8 August

The regiment paraded for divine service in the Garrison Chapel. We paraded in tunics and slacks, wearing bandoliers. The colonel and the adjutant were present. On the way, passed the Herts, Westminsters and DLOs coming

back from service headed by a band playing 'Then he'd row, row, row'.[45] The church is large and pleasant. The choir was full and consisted of soldiers in flowing surplices. The chaplain, before giving the sermon, said, 'Well, we must carry on. It is hard.' The chaplain is a man very keen and sincere, and lays before us the duties of a Christian very plainly; but he is also one who has in his motives first and foremost the strengthening and building-up of the Church of England. He insists on Confirmation. In these times, and when speaking to a congregation of men who do not emphasise sects and creeds, he should be more general in his preaching.

I wrote to Dray, Irene Gass, and Emily and Elsie Le Lacheur. Went to see Robson. His father, he says, is very unwell.

On one of his visits to Robson, Stanley was introduced to Dinky, the Berkshire Yeomanry's little donkey mascot (plate 42).

Monday 9 August

The adjutant drilled us. We expected a gruelling time but, except for a little close drill, the morning's work resembled a route march over the desert. Returning, each troop was ordered to extend and, at the signal, wheel round and gallop towards a hill occupied by artillery. Itchy and I found ourselves galloping over rough ground and we came to a deep trench, which Itchy leapt with ease and delight. We are all fond of the adjutant. He is an efficient soldier and has a gentleman's manner. It is quite refreshing to have him drill us, and to hear him rap out commands and gallop up and down to keep us up to our drill.

Went to the wet canteen, filled with Australians and yeomen, and had a shandy.

Tuesday 10 August

Line orderly in the afternoon. Was talking to Hannam in the canteen. He told me his experiences in Canada, and thought little of the ways and means of doing things in the yeomanry.

News came in the afternoon that we were to prepare to move at any time. We received this news coolly and with doubtings – there have been so many rumours. However the regimental orders read, 'Dismounted parade at seven o'clock.'

After tea Cossins and his brother came in to see us. We went to the Camel Corps Canteen and had supper and shandy. A good canteen, but rather hot. It was filled with Herts, Westminster and DLO men. We sat in a gloomy hall, from the ceiling of which hung an oil lamp. The Westminsters have received orders to move.

Abbasia was the Cairo headquarters of the Egyptian Army Camel Corps, but nearly all of them were on duty in Sudan from the start of the war, so their facilities were naturally used by the British regiments posted to

Abbasia. The Hertfordshire Yeomanry, Westminster Dragoons and DLOs were the first mounted regiments to reach Egypt, and had been based at Abbasia since September 1914. They seem to have adopted the Camel Corps canteen. Cossins's brother George (who had moved to London) was in the Westminster Dragoons, which is why they went to this canteen – the first time Stanley had been there.

Wednesday 11 August

Dismounted parade – sections arranged and troops counted. I am in Roy's section of eight men. Each eight is divided into fours, and an efficient soldier put at the head of a section of four men. Bertram commands a section. Mr George Dammers was placed at the head of us [all].

Packed our saddles and stored them away. Bathed in the swimming bath and walked back with Swatridge. Read *The Broom-Squire*. Good book. Poor Mehetabel! That blackguard Kink! What some women are born to suffer! B and R wrote home to say we were likely to be going overseas at any time. Went to the CCC [Camel Corps Canteen] with B and R and Old and Hooper. Discussed the yeomanry, its officers, and chances at the front. Amused at the frightened native boy.

Thursday 12 August

Our infantry kit arrived. A Kitchener's man who had been to the Dardanelles helped me with mine. Drew 120 rounds of ammunition – found the pack very heavy – we are wondering how we will carry it.

Finished reading *The Broom-Squire*. Am glad Mehetabel did not die.

Went down to stables. Some few men are left behind – Pike, Adlem, Snow, Maiden, Wareham – and a great many, including the shoeing smiths, and fellows who are ill or not very strong. Strolled round the barracks with Old. Sometimes in the evenings when I wander round and see the lighted blocks of buildings and the men walking here and there [I imagine] that I am in a university.

The 'few men' named by Stanley were from his squadron. Overall, around 30 per cent of the Dorsets stayed behind, among them professional grooms as well as shoeing smiths, but it is not known how many remained because they were unfit. Stanley's diary entries from their time in Norfolk make it clear how ill-prepared the war games there had left the mounted troops for warfare as it actually transpired – even to never having carried the full weight of pack and additional equipment needed for foot-soldiering (unlike the infantry, who were given plenty of practice). On 12 August he alluded to this again in a letter to his mother:

I have just received your letter. There has been plenty to do lately. A fortnight [ago] we had an order to prepare to leave Egypt, but the order was cancelled. Two days ago the old order was renewed, and we are

now preparing to move. We are told we are 'proceeding overseas' – the destination is unknown, probably it is Gallipoli – to a base for some time.

Today we experienced carrying the infantryman's kit – we have to foot it now – it was rather heavy, but expect it gets lighter as time goes on because one gets used to it, and I'm told infantrymen fling away their things one after the other, as ballast is flung from a balloon to lighten it.

We hardly like to write and say we are leaving Egypt because we have so often been fooled. Even now a great many – including Major Castleman – think we shall not be fighting. The major does not like the idea of our going as infantrymen. They are keeping a good number of fellows back who are well; of course the horses have to be looked after, but if we were going to the firing line I should have thought they would have sent as many as possible.

About the parcel: Bertram says he does not wish for anything as he has plenty of underwear; Roy would like a pair of thin woollen pants reaching just below the knee; I should like a thick pair of pants please. The nights may be getting chill soon. Also a pair of socks would be useful, and a tin of sweets that can be sucked – say glycerine or b'currant jujubes, if you can get same.

I am glad Aunt Don managed to get a house at Efford after all. [Don and Iris had gone to check up on the running of Roy's farm.] Roy wants Iris to be firm and severe with Joc, or there will be trouble. Remember Old Leo and the sheep!

CHAPTER FIVE

Gallipoli

The reinforcements sent by the Dardanelles Committee reached Gallipoli in early August. They included two New Army divisions, who arrived at a new landing site – Suvla Bay – 5 miles north of Anzac Cove. Difficulties in landing the infantry and delays in getting their artillery and supplies ashore gave the Ottomans time to bring up reinforcements, and the offensive quickly failed. In a final bid to gain the upper hand, Sir Ian Hamilton, commander-in-chief of the Mediterranean Expeditionary Force, urgently requested 95,000 more reinforcements, but the cabinet had already allocated nearly all available troops for the forthcoming battle of Loos. Furthermore, while for the Ottomans the Dardanelles were of prime importance, for the Allies the Western Front always had top priority. All Hamilton was allowed was 5,000 men from the 2nd Mounted Division. After weeks of rumour and uncertainty, the yeomanry would be off to Gallipoli.

Stanley's diary, Friday 13 August

> The regiment paraded in full marching order. I only saw one officer with his pack – Capt. Reeves. All day parts of the division were leaving Cairo. The Herts and Westminsters are going. There are persistent rumours that Achi Baba has fallen.
>
> At ten o'clock p.m. we paraded, ready to move. All the officers had their packs – but carried no rifles or ammunition, but ash sticks – and wore the loose knee bags. We went off singing – our troop to the front. There were many of our fellows to bid us goodbye. It was a three-mile march to Heliopolis [Qubba Palace] station. No men fell out, but we couldn't have gone much further. I found a comfortable place in the train. Bown had given me some tea, which I found good.

Saturday 14 August

> I awoke with early morning to find the train nearing Alexandria. Egypt – the fields, the towns with churches, houses and weird cemeteries – looked

beautiful. It was fine to think we were leaving hot Cairo and approaching the sea. The train drew up at the dock where the *Lake Michigan* was waiting for us.[1] We were soon put aboard, and then began the embarking of the baggage.

Bathed at the lighthouse with Hooper and three seamen of the *Lake Michigan*. Had tea with the seamen down in the fo'c's'le. Good tea – horrible butter. Put on fatigue, putting potatoes in sacks and sending them up on deck. We left port about seven o'clock. It was a grand evening. So clear, so serene, so fresh a wind. There was no cheering; all very quiet. Very tired, so went off to bed early. Slept on deck.

Sunday 15 August

At three in the morning we had to clear off the decks because they had to be washed. At nights the ship is covered with sleeping forms. It is hard to move. Iron rations were served out. A tin of corned beef, some tea and some wholemeal biscuits to every man. I slept upon the bo'sun's sprung mattress up in the bows. Read a book by Dr Miller on 'Cheerfulness'.[2] There was divine service at 6.30. We sang several hymns – all the best. The chaplain read something from the Apocrypha about Judas Maccabeus – how he was a great soldier.

I slept in the bows beside a seaman in a hammock who told me about cables in the deep seas.

Monday 16 August

Our ship continues steaming through seas set with small bare mountain islands. The sea air is delightful. Down below, where we mess, we are awfully cramped – rather amusing. I am squashed against the side of the ship and it is with much difficulty I can get food. We have coffee for breakfast and porridge and good bread – and butter like cart-grease. The 2nd Brigade [i.e. also the Bucks Hussars and Berkshire Yeomanry] is on this ship. I selected a seat on the deck where I could obtain a good view of the port and starboard sides. A French troop-ship crossed our track, and the French soldiers sang 'Tipperary' and we sang the Marseillaise.

Swatridge and I sat together in the evening, and smoked and talked and slept and looked at the ships. We are told to be ready for Lemnos tomorrow.

Tuesday 17 August

Lemnos in sight – a distant haven it looked – like a paradise. We could see many ships. There is a pretty red and white lighthouse on the hill of a small island outside Lemnos. Anchored in the harbour near battleships and troop-ships, I saw the little *Cornwall*, the *Agamemnon* and the *Cornwallis*. Tried to get in touch with S. Cooke, but could not.

The battleships *Agamemnon* and *Cornwallis* had taken part in the bombardments of the Turkish forts at Gallipoli. The 'little' *Cornwall* was a

large cruiser of almost 10,000 tons. Stanley Cooke was an engineer lieutenant commander with the Naval Ordnance Department, and was related to the George brothers on their mother's side.

> Orders were read to be ready to leave for Gallipoli ... within an hour. Extra fifty rounds were served to us, and another iron ration apiece. We cheered the Bucks as they left quietly ... and after dark and much waiting, the Dorsets and Berks left Lemnos in [the *Sarnia*]. All was darkness. We were huddled closely together. Our ship made great speed in the night.

Eleven days earlier, infantry had been moved to Gallipoli in motor-lighters (armoured landing craft) towed by destroyers, but the yeomanry went variously on light passenger steamers and the old light cruiser HMS *Doris*. The Dorsets started to board the 1,500-ton Channel Islands railway steamer *Sarnia* (plate 77) at 7 p.m., leaving at 9.[3]

Wednesday 18 August

> The [*Sarnia*] reached a bay on the Gallipoli coast before dawn, and we waited for the light before we left in boats for the shore. While in the boats a few shells from a distant gun fell around us in the sea [but without casualties]. Mr Browne met us on shore. The coast we arrived on is rocky, hilly and green, and silver rock shrubs grow. There were plenty of soldiers here. We soon got into dug-outs, for the shells were pitching.
>
> I was feeling bad. I developed dysentery on board the [*Sarnia*] and I went under the care of the Red Cross until the reg. moved higher up the hill [on 19th – this written a day or two later], when I carried my pack (Bertram helping) to the new camp and fell asleep. Very bad in the night. I could hear the firing on the long hill inland.

Thursday 19 August

> Went down to the 2nd South Mid. Hospital and stayed in a dug-out all day and was fed on Nestle's Milk. Still, I was very comfortable watching the doctors and the Red Cross orderlies. They are nice fellows, and the doctors – being more doctors than officers – seemed very nice. Several fellows who had been hit by shells were treated.
>
> From my dug-out I could look down on to the sea and see the three warships which are forever firing at the distant Turkish trenches and at the gun that keeps annoying us. I think it must be on an armoured train. It is good to hear our own guns firing. I see lucky fellows going down to bathe. I wish I were with them.

The identity of the 'three warships' that Stanley saw, and mentions again on the 21st, is not entirely certain. Henry Day, who was present as Catholic chaplain to the yeomanry, names the battleships *Swiftsure* and *Canopus*, and the cruiser *Bacchante*, 'supported by gunboats and monitors',[4] but the

battleship *Venerable* also took part in the Suvla operations between 14 and 21 August.

Whereas troops on the Western Front could at least enjoy brief spells of respite in reasonable safety away from the battle zone, at Gallipoli there was no escape. Even swimming in the sea, soldiers could be hit by shells.

Friday 20 August

The armoured train gun still fires and the ships reply, but they don't seem to be able to locate it.

I hear our brigade is moving to the trenches. The hospital is packing up, so I have to clear out. The doctor is sending me down to the clearing hospital.

At the clearing hospital the doctor detained me instead of sending me to Lemnos... I slept next a Red Cross man who was ill. All night the firing was terrific, and the wounded were continually arriving. I wonder how Roy and Bertram are. I would like to have been with the Dorsets.

Saturday 21 August

Dismissed from the clearing hospital as convalescent. Returned to the regiment's headquarters on the hill [Lala Baba]. Found Mr Dammers left with the two quartermasters and a few men ill. Felt very weak with dysentery. Sat down all day and looked down on the ships and away to the firing. In the afternoon there was a big bombardment by the three ships in the harbour. All afternoon, reports came in as to how our fellows were doing. An enemy's gun fires at us at intervals but does little damage. The fellows left behind in our squadron are Routledge, Knott, Harrold and Osmond.[5]

This is something like being on a desert island – washed ashore with a pile of packs – only there are plenty of ships to rescue us.

The brigade, having landed at 'A' Beach on 18 August (plate 78), bivouacked beneath the Karakol Dagh ridge overlooking the north of Suvla Bay (plate 79), moving further up on the night of 19th–20th (plate 80). On the evening of the 20th they marched south, and camped on the sand south-west of the hill Lala Baba. At 2.30 p.m. the following day, leaving their packs behind and supported by a naval and artillery bombardment of the Turkish trenches, the entire 2nd Mounted Division assembled on the plateau of Lala Baba (plate 81) and paraded in troop columns. After half an hour they started to advance towards Chocolate Hill (as the Allies called it because of its soil colour). The Berkshire Yeomanry set off first, followed by the Dorsets at 3.15 p.m. Chocolate Hill was 2 miles inland on the Allied front line and, as they marched through the open scrubland and dried salt flats along the edge of the seasonal Salt Lake, they came under shell fire, which not only inflicted casualties – minimised by their spaced-out attack formation – but set the scrub alight.

The Allies were attempting to gain control of the high ground to the east of their front line, and the ultimate objective for 21 August was the capture of Scimitar Hill, also called Hill 70 after its 70-metre height, around 1½ miles north-east of Chocolate Hill. (Maps used by the Allies were based on captured Turkish maps, and consequently heights were in metres.) The brigade waited in reserve for about twenty minutes in the lee of Chocolate Hill during an initial attack on Scimitar Hill by two other divisions.

At 4.30 p.m., the Dorsets, under Lieutenant Colonel Troyte-Bullock, received the order to advance on Scimitar Hill. As they made a bayonet charge on the Turkish trench system at the summit, they came under ferocious machine-gun fire from the north and south. The map provided to the regimental commanders showing the positions of the Turkish trenches had proved to be inaccurate.[6] 'It was reported by survivors that the Brigadier, all his Staff, [Captain] Nigel Learmonth, [Lieut.] Fred Gray, and some fifty Dorsets, including, amongst others, Sergeant W. Pike, [Sergeant] Finlay, Privates J. Philipps, S. Adams, E. Hooper, [G.] Parsons, E. Perry, and [Corporal] George, together with some Berks Yeomanry, had assembled in the rocky shelter of the hillside ... and from there made a dash into the enemy trench [on the hill]; they gained a momentary success, and drove the Turks along it, but, unluckily, a machine-gun came into action from behind a traverse, and killed and wounded nearly everyone in the trench, Turks included. ... Out of eight officers, I was the only one who escaped unhurt. We lost 119 other ranks out of 301 who went into action [on that day] ... in all, the Brigade's casualties amounted to over one-third of its strength.'[7]

The Dorset Yeomanry alone lost 126 killed or wounded. Roy (aged twenty-four) was one of the forty-one who died, but in the chaos of the failed offensive his body was not recovered and so he was initially reported as 'missing'. His death was eventually recorded by the War Office on 19 July 1916.[8] The brigade's other two regiments suffered even heavier casualties, and the Dorsets would certainly have lost more men had a detachment not veered off course in the maze of goat tracks through the scrub.

Sunday 22 August

> Gollop came back from the firing line. After him came some 'B' and 'A' Squadron fellows. They all tell tales rather black of heavy casualties. We listen to nothing. We hear the brigadier is killed, also nearly all the officers except Bragge and the colonel.
>
> Went down to the beach to get some water with Harrold. Had to wait a long time. Washed in the sea. Slept at night upon fifteen blankets with Routledge. Very comfortable. Feel rather better today, but still very weak.

The provision of water was one of the Allies' greatest problems at Gallipoli. Rivers were seasonal and some wells and springs dried up in the summer, while others were contaminated by proximity to dead soldiers. Local supplies had to be supplemented by bulk shipments from Malta and Egypt, which were pumped into tanks on the beaches. Wherever it was to be collected

from, fetching water was hazardous because of the ever-present risks of snipers and artillery fire.

Monday 23 August

Reports come in of the losses sustained by the 2nd Division. Stragglers from the Bucks, Berks, Dorsets come in telling black stories.

Life on this hillside is rather dull. I should like to be with the other fellows, but perhaps Providence willed differently. There is plenty to do. We had to take out the overcoats from the packs. I had to fetch officers' valises up from the beach. There has not been much firing. Harrold, Routledge and I sang songs down in our little shelter.

Tuesday 24 August

Thunderstorm in the afternoon. There was plenty of water afterwards to wash with.

The Indians with their mules came up to take the cloaks to the fellows.

The Indian Army Mule Corps provided vital transport throughout the Gallipoli campaign. The mules served as pack animals and drew carts. Their drivers were all Indian; there were both Indian and British officers, and British interpreters.

About six, eight of us with four officers started out to join with the brigade. Before starting I wrote home and to Betty, and made my will.[9] Our way was along the beach, and then across the swamps of Salt Lake. Ahead we could see the lights of our camp on Chocolate Hill. Without mishap we reached the camp and I came across Bertram, but no Roy. Slept in some dug-out near Bertram.

Wednesday 25 August

Bertram told me the stories of the fighting – how the advance took place. It seems to have been a grim affair. He told me about Roy, and about Cossins and Old.

Roy and Old were both among those initially reported as 'missing', though both had been killed. Francis Old was only twenty-one. Harry Cossins was wounded in the arm, evacuated to Mudros and then invalided to England, where he would return to work on the family farm.

Our camp is on the seaward [south-western] side of Chocolate Hill, overlooking the sea. We live in dug-outs. Water is very scarce. We haven't got our packs, and most of us have long growths and are very dirty. I live with Kettle, Bertram and Robberts.

Tea is grand, also the bacon. The biscuits and bully one gets rather tired of. In the evenings we are shelled with shrapnel.

Thursday 26 August

I hear different versions of the brigade's charge.

There is no news of Roy, but we must not give up hope.

There are snipers around the camp. The shrapnel comes in the mornings and evenings; it now and then kills one or two men.

Snipers, who infiltrated behind Allied lines and were often camouflaged with green face-paint, were a persistent danger at Gallipoli. Some of the most accurate and prolific were women.

Robberts left us for the machine gun section. Lee has taken his place.

Rum was given us in the evening. It went down well. Kettle is a good man to live with. It is surprising how well fellows get on together in these times. War has good effects on us. Slept well.

Friday 27 August

[Blank page in diary.]

Saturday 28 August

Orders to move up to the reserve trenches. We started out at dusk – marching in single file, well apart, to avoid snipers. Some fellow fainted, no wonder with so much to carry – 200 rounds, rifle, and pick and spade. It was an eerie march. Passed a group of kneeling soldiers – a chaplain was praying in their midst. Fell in with some Irish soldiers sitting in their dug-outs behind the firing line.

Reached at last some half-dug trenches and we set to work to deepen them, working near to morning. I felt very tired. Bertram and I brought along the dixie between us; it would rattle, much to the annoyance of some sergeant behind.

Welcome sleep at the bottom of my dug trench (plate 82), where looking up I could see a narrow line of stars.

Dixies were large iron cooking vessels (resembling vertical-sided cinder bins with lids and bucket-type handles) in which the soldiers made soup, stew, etc., and also brewed tea. For this reason the tea would often taste of onions! The lids could double as frying pans.[10]

Sunday 29 August

With light we could see where we were – one hundred yards to our front, the firing trenches, and beyond them on the hill, but unseen, the Turkish trenches. Behind, the country is flat as far as the sea. To our left lie the Turkish hills, and the English trenches can be seen cut up the hillside. These hills are very beautiful in the morning and evening light, and the country reminds of England – the oaks, the wild hedgerows, the open fields, burnt

and neglected. During the morning we improved our trenches, digging for ourselves sleeping caves and seats.

Bennett is the corporal in our section. I live in the trench with Bennett, Drake, Courage, Bertram and Bower. I have never spent a Sunday like this before. Rejoiced in a mess tin full of tea.

Monday 30 August

Last night we crept out to dig a communication trench – have to be careful of snipers. I would rather pick than shovel – there is more rhythm in picking.

Twice a day water has to be fetched. The walk is a little risky, especially if one goes to the fountain – across the flat a mile away. I went down there with Eames and Cutler. A bullet whizzed between us as we neared the fountain. But what a stream of life! Never shall I forget that liberal flow of spring water gushing from an old stone wall! I bathed my face and hands and filled the dixie in a few seconds. Arrived back safe. We dug a little in the day – my hands are getting harder.

The sun is very hot and burns down in the trench, and the flies swarm around us. I cannot sleep in the day. Reread my letters from Wyn and Mother. I lost my LMS magazine on the way from Chocolate Hill.

Even for men who had spent time in Egypt, the flies at Gallipoli were horrific. Earlier in the campaign there had been periodic ceasefires to allow the dead to be buried, but these were discontinued when each side suspected the other of using them as an opportunity for espionage. From then on the dead littered the battlefield, providing ideal breeding conditions for flies, and leading to epidemics of dysentery and other illnesses.

Tuesday 31 August

This is a tramp's life. No washing, or shaving, or changing of clothes. Each of us gathers his firewood – difficult to obtain – and cooks his breakfast on his own fire. I make a mess tin full of tea – very good it is – and fry my large fat rasher and fry some biscuit. There is a joy in lighting a wood fire, boiling the water – so valuable – and cooking the scanty rations. Some fellows are enterprising and save their bacon fat to fry bully beef in it.

I feel restless and impatient in the heat, but with tea-time and a cigarette, and the last of the sun, my spirits rise – we all feel brighter, and talk about our homes and the people we know at home. Growing above this part of our trench is an oak tree, and the wind blows tenderly around its leaves so that the sound is like the whisperings of the English oak.

Wednesday 1 September

Went off down to the well with a dixie, a rifle and fifty rounds. Felt rather afraid of snipers – no bullets came within sound. Bathed my face and hands. Returning, I spilt most of the water – hurrying in fear of snipers.

Letters arrived. Heard from Irene – she sent me some Dorset lavender and heather.

I resumed my postman's duties – sorted the casualty letters, and collected the outgoing mail. While waiting for Mr Digby to censor the letters, Gen. Peyton arrived. We hear that Gen. Kenna is killed – hit in the shoulder while looking through a trench aperture.

We hear no news of Roy. I do not for the world think he is dead.

That night, 150 men from the regiment, under orders of absolute silence, worked at a communication trench up to the front line.[11] As Stanley does not mention it, he may well not have been among them this time.

Thursday 2 September

Percy Courage is unwell. The life is bearable before and after the heat of the day. At breakfast we are happy and at tea we are happy. It is the evenings when we talk about the war – how long it will last, and when good news is coming.

Horace Miller was shot in the leg this morning while outside the trench gathering wood. Harvey has given me a book by Chas Garvice, *Staunch as a Woman*, which is the first by that 'written out' writer I have ever tried to read. We read anything here. Bertram has read through a *Salisbury Journal* and a *Western Gazette*. Bertram got a shave somehow.

Towards night, firing becomes louder and sometimes attacks are made by the English or by the Turks. We have to stand to arms in the evenings. The rum they serve us out with is much appreciated.

Friday 3 September

Sometimes an aeroplane flies overhead, high and safe in the clear blue. Shrapnel is fired at them, but we have seen none come down yet.

After tea I went to fetch water at the filter cart. Waited so long under an oak tree while the Inniskillings filled their bottles. The place is in little danger, but stray bullets or snipers' bullets sometimes whiz by us. Filled twenty bottles on my knees in the mud, fearful lest I should lose a bottle.

A mail came in. It brought me a box of fruit from Irene Gass. Most of the day I was marking the casualty letters, and distributing the parcels of those missing and wounded to the sections in which they belonged, as their friends or comrades have to open them.

Bennett had his cheek hit by a shrapnel bullet.

Saturday 4 September

In the evening we had orders to prepare to move.

The Dorsets were to be relieved by the Dublin Fusiliers. They were to be ready with all their equipment by 9.30 p.m.[12]

After preparing everything, I lay down and slept. At one o'clock in the morning the order came to move. I carried the mail bag, so was excused pick and shovel. Marched in single file to Chocolate Hill – fellows tired and weak – at Chocolate Hill thirteen men fell sick. I helped Meech to the hospital.

After a short rest, we drew rations and ammunition and started out along the trenches for a place on the left of the right flank. Mr Dammers called me back when a little way out to guard the rations that could not be brought on. I was glad to stay. It was a quiet rest, and I ate biscuits, drank water and smoked a cigarette, and watched the dawn break to reveal the warships on the sea.

Sunday 5 September

Went off with the fatigue party to our new trenches. Found Corp. Bennett and our happy family cosily installed on the right end of our line, next to the Herts Yeomanry. We are in reserve trenches. In front of us are the Bucks Yeomanry and on our left the Berks Yeomanry.

Hard work here. Two guards on the look-out every night – two to a bay. One guard to a bay during the day, and a lot of digging, and fatigues to Chocolate Hill for rations.

I went to fetch some water at the well which is past the Westminsters' lines. There is a little well in our trench where we dip for water, but it has to be boiled.

Monday 6 September

Tiring night on guard. I slept as much as I could in my little dug-out. Rather dangerous on sentry, as snipers aim at your head through the aperture. It is a pretty view before our trench; the long grass is dotted with trees, which run to the foot of the hills. Before us is a Turkish barn and around it are a few fruit trees. English flowers grow here and English birds thrive. I saw a hawk in the sky hovering, and Bennett saw a curlew and a bird like a shrike. Scabious, 'old woman's nightcap' [Greater Bindweed] and [blank space] I have seen growing.

Went to Choc. Hill for sandbags – thought I should never get back, they were so heavy.

Hurrah, we make our tea in the dixie!

Stanley's diary here comes to an abrupt end. This is probably because the likely fate of Roy – still optimistically spoken of five days earlier – was by now borne in upon him. Stanley was able not only to confront death relatively fearlessly, but to write about it eloquently, as in the case of his 'Darling Dorothy'. Yet perhaps the suspected death of his youngest brother temporarily defeated his desire to record his own experiences.

From this point, Stanley and most of the surviving Dorsets spent roughly alternating fortnights in reserve trenches and on the front line until the night of 20 October, when they were relieved by the Scottish Horse (also

unmounted). On the 31st – with the exception of the machine-gun sections – the brigade was ordered to move back to Lala Baba above Suvla Bay for embarkation that night.[13] By the following day they were on Lemnos, where they were scheduled to rest for a few weeks in camp at Portiana before returning to Gallipoli. Meanwhile, however, it had been decided to evacuate the Peninsula. The Allies' attempt to drive the Ottoman Empire out of the war had failed miserably, with the loss of 47,000 lives.[14] On the afternoon of 27 November, the Dorsets boarded HMS *Hannibal* and sailed back to Alexandria, where they arrived on the 30th. The next day they proceeded to Cairo by train, and were soon established at Mena Camp (plate 83). Bertram had returned to Cairo well ahead of Stanley because of illness, and been admitted to hospital on 26 September.[15]

CHAPTER SIX

Egypt Again

The two surviving brothers were back in Egypt before the end of 1915. The first post-Gallipoli letter is from Bertram while in hospital at Bulaq el-Dakrur, near Cairo, dated 7 December 1915:

I was up on the Peninsula about seven weeks – that seems to be the average time out there – and was only in one fight, the advance on August 21. We got absolute hell that day from the Turks – but drove 'em out of their trenches and into the valley beyond, and could have held the hill, I am convinced, if we had had proper support from the other brigades on our right. They couldn't help it I suppose – got lost in the dark I guess.

The remainder of the time I spent there was in trenches at various points on the front. Once for a fortnight we had the end of a sap to look after and, tho' the Turks never looked dangerous, I didn't care for that corner at all! We had dead buried in our parapets and unburied dead lying everywhere. The sap was 150 yards from the Turkish trenches, but we could only bury – or rather cover 'em up – occasionally on dark nights. One gully three yards to our right was packed with 'em – staring white and black faces and bared teeth. I think they were worse in the moonlight than any other time.

I have been in hospital – first with septic poisoning, and later with jaundice (a very common trouble out here – Stanley has had it too), ever since Oct. 2 – nine weeks – and have grown very tired of the peace and quiet. This hospital is one of the ex-Khedive's palaces just outside Cairo: a huge thing – ugly as sin outside, but tastefully decorated inside with white and gold, quite plain. Ceilings 30 ft high and rooms immense. We are very comfy – glorious roses and palms everywhere. The reverse picture is not so good, as there is a 25 ft wall all round the grounds and armed guards at the gate. We cannot get out! Of course that is the only thing all of us want to do! I haven't seen the outside world for nine weeks and feel a Rip Van Winkle.

The bugle blows for lunch, so adieu.

On 12 December, Stanley received letters from his mother and from Dray, which had been posted almost a month earlier. The same day he wrote to his mother from Mena Camp:

We left Gallipoli, Nov. 1 after three months there [in fact almost eleven weeks] – just in time, as I hear some snow storms have been blowing over the Peninsula and many soldiers are frost-bitten. Mostly, the weather we had was good. We experienced, often, storms, which came upon us quick, heavy and short-lived, but – as the trenches were of clay – a few minutes rain would give us a devil of a time until it slowly drained away.

We were all right – rations good – bread fresh, meat, bacon, jam, tea – and rum now and then. We were all cooks for ourselves, unless we preferred to combine, and – if you had passed along the trenches before dinner – to right and left little fires smouldered in odd corners, and frizzlings of steaks, bakings of stews and such delectable smells would have greeted you all the way along.

I always meant to walk right through the trenches – from the centre, which we held, as far as Anzac on the right – passing the Gurkhas in their trenches. But I had little spare energy, and my postal duties gave me walking enough.

On our way back to Egypt we stayed at Lemnos for three weeks – a fair-sized brown mountainous island with a good harbour, which has been of good use to the English. I enjoyed going into the small Greek villages and buying all kinds of good things in the little shops. Every cottage had been turned into a temporary shop as there are so many troops training on the island, but things were so dear – as all stores have to be brought along on mules along rough roads from Castra. Eggs were in great demand, and I used to go around begging at private houses of the Greek women to sell their eggs. But I caught jaundice and was in an English tent hospital for ten days. Terrific winds were blowing over the island and near blew down our tent several times. Dysentery was our greatest enemy in Gallipoli, as well as jaundice, septic wounds and enteric.

We sailed from Lemnos in the twenty-one-year-old battleship *Hannibal*, mounted with four guns and only used now for carrying troops. It was good to move south into the blue sea and glowing warmth, from the cold Lemnos winds.

Here in camp I go up to the native supper tent at Mena where I get omelette, fried potatoes and fresh fruit – all for 9½d, 4 piastres.

He wrote to Dray the next day, 13 December 1915:

Your parcel of biscuits and pot of honey arrived yesterday. Bertram also rejoined us yesterday from hospital. We are both enjoying the biscuits, which are awfully nice and so temptingly packed; we have them for lunch and supper. They arrived in very good condition. It is jolly good of you; I remember now I wrote you from Gallipoli during a fit of hunger, and asked you to send on biscuits and honey.

A letter from you yesterday, dated Nov. 14, and one from Mother, dated Nov. 16. It was quick of you to read beneath the censor's erasure. You were quite right, I wrote that a strong rumour was prevalent we were leaving for Egypt. I have always written what I liked in my letters, and have wondered if they were ever censored.

Do you know, when I was in the hospital at Lemnos I wrote a letter to a friend one afternoon. I jocularly wrote that I was supposed to have stout for dinner, but that it was never forthcoming, and perhaps the quartermaster swigged it. The colonel who censored the letters sent for me and very seriously demanded what right I had to accuse an honest quartermaster, of nine years' service, of swigging the patients' stout? Who was I? Did I know I was liable to be shot for such an offence, and that it was a crime? He wished to know what they would think at home of that quartermaster. Of course I was rather taken by surprise, and told him I only wrote in a jocular vein, and everyone, if there is a shortage of rations, points his finger at the quartermaster. He made me tear the letter up, and called for the quartermaster and asked him if he had anything to say. Amusing, wasn't it? I believe he was pulling my leg; he looked very serious all through his talking, but fancy he smiled as I saluted and marched away. Imagine me being shot at dawn for accusing a man of swigging stout! Untimely end!

We left Gallipoli in time to escape deluges of rain and bitterly cold weather. The trenches have been swilled with water, officers' baggage and men's packs submerged, dug-outs washed in, and men's toes frost-bitten. It is said they will evacuate Suvla, but hold on to Helles Cape.

I should like to see the swirling waters of the Stour coming down from the Cliff Woods, and from the grey bridge look down beyond the Tumbling Bay to the dark yew at the point of Penny's Island.

This refers to Blandford. The Cliff Woods are on the Bryanston estate. Tumbling Bay appears to be a George family name for part of the River Stour to the east of Blandford Bridge, and Penny's Island is in the Stour further east, on the Wimborne side of the weir.

How funny about our hundred-years-old gardener! Please thank Aunt for pad and pencil. I hope you'll get rid of the sciatica quick. You can sleep easy in bed now, for I guess we are as comfortably off as yourself at night. I am glad Mother is getting better now; tell her young Francis Drake is corporal of our troop. Sorry to hear Father is unwell, but I hope a stay in bed will cure him.

All cheer for Xmas. I shall miss you and the annual Xmas walk, with return to The Dinner.

On 17 January 1916, the Dorsets left Mena Camp and travelled west by train from Abbasia to El Hammam, arriving just after midnight. They were to form part of the Western Frontier Force in a campaign against the Senussi close to the border with Libya. The Senussi were a Libyan Moslem sect who had conducted a guerrilla campaign against Italy in 1911–12, and were

persuaded by the Turks and Germans to invade western Egypt when Italy joined the Allies in 1915. Stanley wrote home on 21 January 1916:

> We are settled in El Hammam – to the south is the desert, also stretching east and west. Five miles northward is the sea coast, forty miles west of Alexandria. This place is on the railway that runs along the coast of Egypt. We are out against the Arabs, but don't think we shall see any here; they are further west toward Matruh, some 500 miles.
>
> It is very much like an English April day here – warm and spring-like. It makes me think of the Dorset woods and primroses and violets. This morning we rode out through a long narrow valley somewhere near the sea, where we drilled, and charged with drawn swords. There is a flying station here and two aeroplanes circling over our heads, doing useful work.
>
> We have been rather short of rations for the past week, but in the village we have been able to buy native bread – v. good, like hot teacakes – also butter and eggs, so we are all right. The horses are wobbly – rather poor – the journey from Cairo didn't do them any good. Bertram rode out yesterday with twenty other men some sixteen miles into the desert, but they sighted no hostile tribes. We have an armoured train to protect the railway.
>
> Parcels from home have come. Don't send any plum and apple jam – got sick of it, and in fact of any jam. In Gallipoli we barricaded a trench with apricot jam and named it Apricot Street.
>
> I carry *Martin Chuzzlewit* in my kit bag to read at odd moments.

The next day, Lieutenant Colonel Souter (as he now was) returned to take over command of the Dorsets. On the 26th they were on the move again, first by train to Dhabba, where the railway terminated (plate 123). They then marched in five daily stages, halting successively at Galala, Bir Faka, Bacush and Bir Jerawalah, arriving at Matruh on 1 February. Stanley described their journey in a letter to his father dated 11 February, of which extracts (with place names censored) were printed a month later in the *Western Gazette*.[1]

> We come to many camping grounds. Now we are between the desert and the sea on the coast of Egypt. Our camp is upon sand-dunes, overlooking a lagoon, and the village of [Matruh]'s a mile away. A fair-sized camp this, with our brigade, and some South African, New Zealand, and Scotch infantry. The village has been swept clear of all natives, and the houses are used for officers and stores of this camp. Ships of light draught come into the harbour, and the shore is piled with provisions which they have brought with them from Alexandria. We are protected from the sea by a monitor ship.
>
> There have been fights with the enemy before we arrived. On Christmas Day there was a fight. The Senussi keep off at a respectful distance, and there is no prospect at present of our meeting them. But they are always on the move, and our aeroplanes are busy every day scouting their whereabouts. They are said to live in caves; are very wily and dirty, and badly horsed. Around us on the desert there are isolated houses where the Arabs have lately lived, and which the English have burnt.

I think I wrote from [Dhabba] to you. It was a fine trek we made from [Dhabba] to this place. It is a four days' march across the desert with the sight of the sea all the way. There was a long procession on the move. We were protection to the hundreds of camels which carried water and stores, and before us were other mounted troops, infantry, and a long line of transport wagons. The weather was perfect. With night the whole force halted and formed a circular camp, from which flared the camp fires of the Australian transport men, who know how to live under the stars. Each man slept behind his horse, and we got down to sleep early, after grooming the horses and eating our rations – excellent tinned Maconochie [stew], with biscuits and cheese, and of course the tea. What scrambles we have about the dixie of tea!

Our night camps were always near the wells. We found it hard sometimes to find water at midday. Our noonday halts at the wells were looked forward to by us, and horses. The wells must be very old, because around them all are thousands of pieces of pottery – fragments, I suppose, of water pitchers ... broken by the carriers of many generations. At one camp we arrived early, and Bertram and I bathed from the white silvery sand-dunes. It was here we saw a large patch of spring-green grass growing round the wells.

The horses did very well over the rough, stony ground which we encountered in places, and we finished without one horse ill in our squadron. Last night it rained hard, and this morning strong winds blew in from the sea, and the desert plants smelt sweet as we drilled on the plain. ... You make a grand mistake if you think there is any swashbuckling with us. We work real hard, parades morning and afternoon, and no time after breakfast, not even for a cigarette!

P.S. A daily paper and a *Western Gazette* now and then is all I wish for in the paper line.

On 8 February 1916, while at Matruh, Bertram was promoted from private to corporal,[2] though neither brother mentions this in any surviving letter.

The Dorsets stayed at Matruh until the morning of 20 February, when they set off with several other units on a four-day march to Shammas, via Um Rakhum (plate 84), Bir Abdin and Unjeila. On the 23rd one troop, which included Stanley, continued from Shammas on a patrol to accompany an intelligence officer to the area of Wadi Maktil, though the men were not told the reason. The rest of the force joined them at Wadi Maktil on 25 February, where Colonel Souter prepared them for the next day's action against the Senussi. This would become famous as the Battle of Agagia, culminating in one of the last effective cavalry charges by the British Army. On the 29th, Bertram wrote a short note to his mother:

We were in action again all day Feb. 26, and after giving these Senussi a real good hiding and chasing them for about ten miles, we finished with a charge, and then camped on the field. Stan and I are both quite safe and

fit. I don't think there will be any more fighting here. We are now in camp again within fifty yards of the sea. Had a lot of rain this morning, so the day is cool. Shall cable you if possible, otherwise this must do. In great haste.

Stanley's more detailed account begins at Matruh and covers the reconnaissance patrol from Shammas. He wrote home on 4 March while encamped for a week at Unjeila:

I can tell you plenty of news now.

Our regiment left Matruh about twelve days ago to seek for the Senussi. With us was a regiment of infantry (South Africans). We trekked for three days, taking a bee-line within sight of the sea all the way – a fine life that. The desert is in places very beautiful. So green and fresh and hundreds of little flowers there are. Think of us riding up a valley in this desert all green and growing! Here and there spaces covered with beautiful anemones [of] all colours – enormous ones, far larger than are grown in English gardens – I have pressed some to keep. There are long deep silent gullies in this desert. One day I was doing flank-scouting, and we came on one so deep it was impossible to cross and we had to follow along it for miles before we found a crossing. The gullies are choked with rocks and gay with all kinds of plants and flowers. In places the ground we marched over was very bad, so rocky, but the horses have done marvellously.

It is good getting into camp early, and after the work is done, to stroll over to the sea for a bathe – the breakers are fine. In the evenings we light fires and cook what we can and sing a few songs. You see, just for the moment we have come back to the story-book kind of war. We sleep behind our horses, and one or two break loose at night and trample around us but never <u>on</u> us.

We got in touch with the enemy four days out from Matruh. The main party rested one night at a camp and our small troop were sent on twelve miles for some reason I can't discover. At nightfall we found ourselves dangerously placed as we could plainly see the fires of the enemy – a few miles off. Our horses were too done up to return, so we camped behind a hill, lit a fire, and passed the night. Great wonder the enemy did not see us and cut our small troop up. Next day the main party came and camped with us. The same night the colonel gave us a talk as to what he wanted us to do on the morrow. 'Plenty of ginger and jam ahead boys,' he said. That same night the enemy shelled us with good range but did very little damage. All night we lay with our horses; and saddling up at dawn, we moved inland in search of the enemy.

A fortnight ago I was made a stretcher-bearer with three others of our squadron. We had a fat strong-pulling mule to carry the two stretchers. Our duty was to ride behind the squadron, and when our men dismounted for action, get up into the firing line with the stretchers. I shan't forget that mule in a hurry, and the way he pulled us around as we galloped over the plain. We each had a turn with him – it <u>was</u> a doing, the stretchers kept

slipping sideways as the beast was so fat and round. However we managed to keep up, and put in appearance duly at two actions. Very fortunately there wasn't much for us to do. We carried off one man shot through the shoulder.

I will tell you of our next dismounted action. We were on a ridge firing away hard and two maxim guns helping us on each flank – then we mounted and galloped about four miles to get near to the enemy. We came up with them where they lined a low ridge, a <u>large</u> number of them and they were ready for us. I could see the charge was going to come and it did, and away went the Dorsets led by Colonel Souter. Bullets came in thick before the word 'Charge' was given. We stretcher-bearers soon had work on our hands. A sergeant fell wounded but he had a bullet through the heart and died in a few minutes. We had barely left him before we came to another man on the ground – he also was hit near the heart. Poor fellow, we did what we could but he very soon died.

By this time the fight was over, and our men were retiring – with the enemy coming at us again. We made a slow retreat, I helping a man on a stretcher along until we got to a gathering of our men. After about half an hour – within which time the enemy must have come up and taken away all their wounded and dead and stripped stark naked all our dead – a party of us went out to look for our wounded and to set fire to ammunition. The enemy were still popping at us, so we had to be wary.

That night we camped near the field, all of us, the South Africans and ourselves. We had captured a number of camels laden with dates, so we had plenty to eat. Our thirst was awful, my throat was caked. Oh, didn't we drink that night – any sort of water we could get.

Next day we looked for our dead, and found and buried them all together. The enemy had taken all their clothes, but there was no mutilation of any sort. That burial was impressive. A colonial chaplain said the prayers. It is a high mile-after-mile plain, about the centre of which our men lie buried. When the sun isn't sweltering there, a sweet wind blows in from the sea ten miles away.

So it's battle and death and burial all down the ages. Our own dear Dorset Downs have their mound-memorials of same strife and pain a thousand years ago.

We are now resting by the sea at a place called Unjeila, a deserted spot where there are two burnt Arab houses. Mails have come to us from Matruh by camels. We are glad to know parcels are on the way, as bully beef and biscuits are a slur on a seaside appetite.

Bertram is well. He had a narrow escape – a bullet through his saddle and his horse was hit on the shoulder. Lucky isn't he? Itchy (my steed) had a little clipped off his left ear. He is a wonderful horse and lasting better than any. We are letting them graze in the mornings.

The campaign finished with the occupation of Sidi Barrani on 10 March and the capture of Sollum, on the Libyan frontier, on the 14th. On the morning of 18 March the Dorsets began the long march back to Alexandria, covering

the 25 miles from Sollum to Baqbaq in the first day. They arrived at Sidi Bishr Camp, Alexandria, on the afternoon of 6 April. Stanley's next letter home is undated, but must have been written between 16 and 20 April because Sir Randolf Baker had returned and Major Castleman was still awaited:[3]

We marched to this camp (near Alexandria) and so finished our long trek from Sollum – a distance of over 400 miles. We were nineteen days on the way, and three days were taken for resting the horses. The desert, as we call it, is really a beautiful garden that is along the sea margin. The rich red of large anemones floods the valleys, and there are acres choked with bright marigolds and yellow-petalled daisies. Very pretty is a small, four-petalled, greyish-blue flower something similar to the lilac bloom, which grows thick and low over the plains. Where in places the anemones mingle with these little flowers, the sight is as bright as a bed of red tulips and blue forget-me-nots in an English garden. I saw many other flowers growing, common enough, but not thick enough to show a carpet of colour.

On our way back we saw numbers of Arab families camped in their dirty ragged tents. With them were camels and flocks of sheep and goats; but not a few must have been starving, because when we left our camps they would come in from all sides looking like scraggy moulting birds of prey, and scratch in our horse lines for grains of corn, and pick up all the half-eaten tins of bully beef and fragments of biscuits on the sand. They love bully beef, and we gave them tins and tins of it in return for wood they would bring us. I don't know how the poorest of the Arabs live all the year round in the desert. I saw a man catching birds by means of a net and a long string, after the style of the sieve trap which we have used at home and worked with a string behind the stable door. It is the quail they catch. We caught one or two, and roasted them over the camp fire. I think that some of the desert vegetation is good eating. I saw an Arab picking stems from a plant and eating them, and one of our troopers discovered a root that tastes like celery. Patches of land are sown thinly with wheat and barley, and in places far from any habitation; evidently a moving family will sow in the spring and come back miles and miles in the autumn to harvest. We used to graze our horses in these places. I do not know if these desert people joined willingly with the Senussi to fight against us. On our way to Sollum we came across none, and I understood that the Senussi have driven them with their sheep and goats away, I suppose with an idea to reinforcing their larders and adding to the numbers of their fighting men.

The Arab women wear handsome earrings, bead necklaces, wristlets and anklets; they look heavy compared with the English women's jewellery, but are cleverly and artistically wrought in metal. They decorate their children with these adornments, and two I saw with nose rings. The men are not the story-book type of Arab. A few are tall, fierce, black-bearded, gleaming-eyed men, but most of them are poor-looking, and their raiments are not white and flowing as one reads.

Looking at it straight, it is a fine life on the march. If there are any hardships, the joys of breathing purest air, washing, and feeling clean after

feeling dirty, bathing in unbathed seas, sleeping 'neath a starry blanket, and with a keen appetite realising the full enjoyment of a bare meal – these outweigh hardships. After Gallipoli the feeling that every day would find us in new places was good; and for our huntings for wood, bathing on lonely sands, searching for rubber and wreckage on the shore, night fires and amateur cookings, we might have been the Swiss Family Robinson.

To be coarse in the way of Charles Reade when he said that the Venetian ladies suffered from itch,[4] the lice well-nigh maddened us. They grew and fattened on our shirts, and a man's first duty when he had a moment to spare was to turn his shirt inside out and begin the 'hunt'. Very amusing the way the men talk about it. They will say, looking up from a garment, 'Just discovered a few stragglers', or 'Found the advance guard of the main column', or 'Just picked off a small party moving in open order.' The sea saved us, otherwise we should have been eaten alive. I think that the eggs hatch out in the night in the seams of the clothes, and it is when lying down the demons begin to creep and crawl.

On our return some of the men went inland to Agagia, the scene of the charge, where are the two graves of our thirty-two dead.[5] They placed large stones round the graves and erected a cross (plate 85). Flowers had sprung up about the place since February 26th. The flowers must come very quickly in the desert, because when we went to Sollum only the tall desert lily(?) flourished.

It is good to be back in Alex, as everyone calls it. I like Alex. It is a breezy town just now with north winds from the sea blowing across our camp. Cairo is like a closed oven full of perspiring English, but down here the sea gives one a sense of freedom from war, army red tape, and this third-rate land of Egypt. It is fine to see the many ships in the harbour – black transports, white hospital ships, a few grey fighting vessels and, flitting here and there, small boats with coloured sails, like bees amongst the large proud flowers. I like to see the sailors in the streets, hear the ships' syrens, and to know that we are beside a great port in line with the great East and West route.

Bertram is now a full sergeant. He was taken ill with dysentery at Dhabba and returned to Alexandria by train. He is in the 21st General Hospital, Ward 14. I was down to see him on Saturday and found him better, with a good appetite, no temperature, and the dysentery gone. I gave him various letters which had come for him, and the tin packed with clothes from home. He said that he hoped to be back with the regiment in a few days. His ward looks out upon the harbour, and beyond to the outer sea. After tea we watched the sunset from an open window at the end of a long windy corridor.

Bertram's promotion to sergeant came on 27 March 1916.[6] He and four other men were sent to hospital on 31 March, the day they arrived at Dhabba. Despite Bertram's prediction, it would be more than a month before he left hospital. He was eventually discharged on 27 May, and rejoined 'C' Squadron on the 28th.[7]

Sir Randolf Baker has come back to us, and I understand that Major Castleman is arriving some time. A number of the time-expired men have left us, and a few of the wounded from our desert scrap have sailed for England. Francis Drake of Tarrant Crawford is among them.

We have no idea where our next move will be. It was a year ago last Saturday, on April 8th, that I left England, and I landed on the quay down in the port of Alexandria on April 23rd. My horse is still fit, though rather thin after the hard work he has done. He carried me well, especially on February 26th when he was put to a hard test. But at Baqbaq, on the return, I discovered that he had two sores on his back – we had had a long ride that day – and so I had to lead him back all the way, and I rode another horse. We raised three or four rabbits (some say that they were hares) in places on the desert. One fellow says that he saw a cuckoo, perhaps flying to England, and I saw a number of swallows on the telegraph wires pondering before the long flight north.

CHAPTER SEVEN

Imperial Camel Corps

By now, it had become clear that the army's cavalry horses were unsuited to lengthy patrols in the desert. In the spring of 1916, the Imperial Camel Corps was therefore formed as part of the Egyptian Expeditionary Force. In essence they were mobile infantry who, having been transported by camel, would go into action on foot. Recruits were drawn from mounted regiments. Three of the four battalions came from Australian and New Zealand regiments, but the 2nd Battalion largely comprised volunteers from British yeomanry regiments. Stanley was one of the first group of thirty-one (one officer and thirty other ranks) to join from the Dorsets, and from this time on the two surviving George brothers would go their separate ways in the war. On 24 April 1916, the volunteers officially became the 1st Dorset Yeomanry Section, No. 8 Company, 2nd Battalion, Imperial Camel Corps,[1] under the command of the popular Captain Mason-Macfarlane. No. 8 Company comprised, as well as Dorset Yeomen, volunteers from the Royal Bucks Hussars, the Berkshire Yeomanry, and the Westminster Dragoons. In instalments between 9 May 1916 and 25 February 1917, the Dorsets' contribution was augmented by further volunteers to a total of fifty or fifty-one (plates 88–90).[2] They moved from Alexandria to Abbasia during early May, and immediately began training with the single-humped Arabian trotting or running camels (dromedaries), from the Sudan that had been allocated to them.

These camels, depicted on their cap badge (produced in Egypt and cast in desert sand – plate 91 and back cover), could move at between 4 and 10 mph when fully laden. A smooth trot was the only motion comfortable for the rider, though if necessary they could gallop considerably faster. Nearly all the companies used the stronger bull camels, although one company favoured the lighter and reputedly faster cow camels. The bulls did have the drawback of being temperamental and potentially dangerous in the rutting season.[3] Camels generally had to be watered every three to five days, when they could drink up to 30 gallons. Their principal load consisted on one side of a 50-lb bag of dhurra,[4] which in this context usually meant a kind of millet

(*Andropogon sorghum*). The feed was sometimes a mixture, with millet predominating but including pulses, crushed barley, and around 1 per cent salt. The dhurra bag was balanced on the other side by a fantasse (plural fanatis, Arabic words adopted by the army), a 5-gallon water container made of galvanised iron or copper, with a screw top for filling and a tap at the bottom for emptying. The saddles were made of wood and padded with blankets. A sheepskin apron offered protection from the rider's boots (see plates 95, 104, 120). Two canvas saddlebags completed the standard load, excluding the rider.

Each of No. 8 Company's four sections (i.e. Dorsets, Bucks, Berks and Westminsters) had three spare baggage camels – of the same species, but specially selected for their strength. When away from base, the men were further divided into self-sufficient groups of four. Each had one man in charge, and groups were responsible for their own cooking and for feeding their own camels. The company set off on their first trek in mid-June, and Stanley wrote to Dray from Shusha on 3 July. Five days later a letter to Margaret covered much of the same ground (see 'Note on Editing' in the Introduction):

I should like to tell you of the journey our company made with the camels from Cairo to this camp of Shusha.

We left Abbasia barracks on Friday afternoon, June 16th, and passed through the main streets of Cairo on our way to Gizeh. Every camel was abundantly 'cargoed'; dhurra bags and fanatis filled, saddle-bags bulging with each man's rations for a week and the clothes necessary for a long stay on the desert. Behind each of the four sections came the three baggage camels, loaded with ammunition and picketing gear.

I don't know what impression we gave to the people in Cairo who saw us. Our pace was slow and stately, and we looked down as from a height; but the fact that we were soldiers with rifles might have been forgotten, as there was much of the picnic suggestion in our procession, many saddles being decorated behind with cooking-pans, mugs, firewood, ropes and spare boots.

It was a glorious afternoon. The sun streamed down the long length of the Shari Abbas, and a cool breeze flowed in from behind us, swelling the trees overhead and tucking the flags of England, France and Italy flying from distant housetops. Fashionable ladies with sleepy faces and flash dresses waved to us from the balconies of tall houses, the schoolboys – weak-legged, sallow-faced, grown up before time – laughed at us, and officers out for the afternoon with the nurses photographed us from the pavements with hand cameras.

We crossed the Nile by the Kasr el-Nil Bridge (a photo of which Roy sent you) where the four bold lions sit on their haunches fierce and defiant (plate 57), and went by the road which goes to the pyramids. At Gizeh we turned left and followed a track beside a canal close to the Nile.

The road was so narrow, we could only ride two abreast. I was with Foyle, who is from Fontmell. His skin is the colour of red brick dust and

he speaks the broad 'Dosset', finishing his remarks with the words 'you' or 'like'. In front of us were Mark Ward and Budden, the two other members of our group of four. Mark Ward is rather a fine type of yeoman – big in body, and quiet and easy in manner. He is the leader of our little group. Budden is entertaining – his manner in swearing is quite his own, and his sympathy with anyone who meets with bad luck on the way is expressed in the words 'Ah, you shouldn't have joined.' He used to work for Mr Sharp, the florist at Blandford, but his home is in Bridport.

At about eight o'clock, when it was quite dark, we reached a village called El Bedrashein [near Sakkara]. It is across the river from Helwan and Maadi, where is the large Turkish prison. Our camp was in a small field of stubble, near to some palms. Across the road were the mud houses of the village, set down in close and miserable disorder with loathsome alleys pushed in between them. A rising moon lighted a round space where the houses squatted drunkenly upon a steep bank and stared blindly down to a stagnant pond. Three palm trees with tufted foliage crooked their backs over the houses and looked into the pond. Above, the sky – mooned and starred – swam clear and serene. The cries of the children broke from the darkness, the wandering scavenger dogs barked, and the mumbled conversation of the natives continued till I fell asleep. It all reminded me of a drawing of Heath Robinson's.

Next morning we were off at 4.30, continuing along the canal. The green of the cotton field extended on either side of the way, with here and there patches of the tall waving sugar cane. Date palms grew in plenty, and now and again we'd pass a squalid village within a circle of trees, and all the inhabitants upon the roadside to watch us.

At about nine o'clock, when the sun came in hot, we camped in a palm grove near to a place called Mazghuna. Our method of trekking with camels is to cover a number of miles very early in the morning, rest during the heat of the day, and then jog on to our night camp at five in the evening.

Foyle soon had the fire well in hand – he had gathered some dry maize stalks – and while I looked to the camels' feeding, I watched as well the preparing of Quaker Oats (government issue), bacon and eggs (the eggs we bought in the village – nine for a piastre) and coffee, which we had brought with us.

After breakfast we went down to the steep muddy banks of the canal and washed our bodies. I had great temptations to bathe in the deep flowing water as others did. The water in these irrigation canals is from the Nile and every native drinks it, scooping it up in his hands from the dirtiest places. We fought shy of drinking it, and when we wanted our fanatis filled, a native would direct us to a village pump – sometimes in a farmer's courtyard or on the threshold of a mosque – where the water was less dirty, although very brackish.

The water and sugar melons are ripe now, and our Captain (Macfarlane is his name) kindly allowed each man 1 pt. a day to buy fruit. Most of this day we sucked huge slices of the batsekh, which is the round water melon. They are very refreshing and juicy, and I can imagine how well the pink

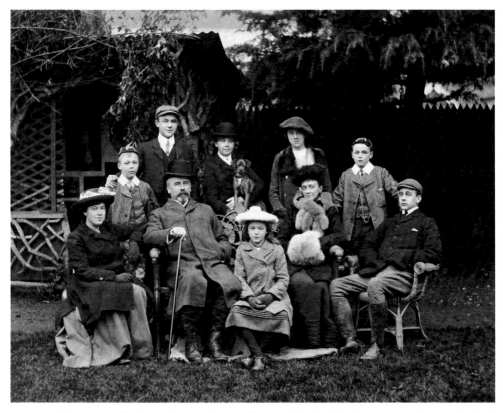

1. The George family in their garden at The Laurels, Blandford, *c.* 1902. Left to right, back row: Stanley, Dray, Wyn, Dorothy, Roy. Front row: Margaret, Thomas, Iris, Louisa, Bertram.

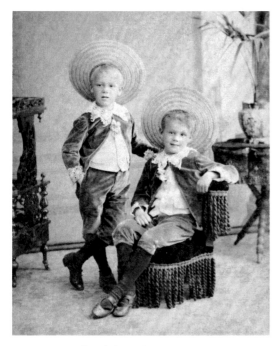

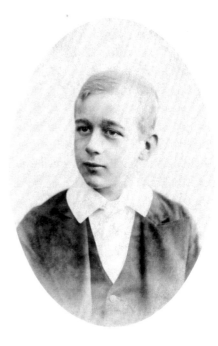

2. Stanley (left) and Roy, *c.* 1896.

3. Bertram, *c.* 1891.

Left: 4. Studio portrait of Dray by Lambert & Lambert, Bath, *c.* 1905–08.

Below: 5. Left to right: Bertram, Dray, Stanley, and Roy outside The Laurels, Christmas 1910.

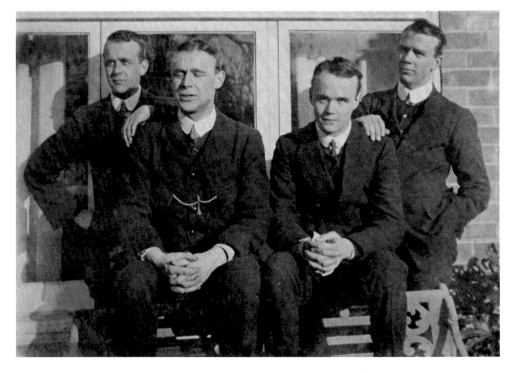

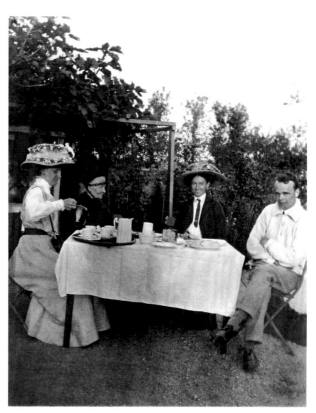

Right: 6. Stanley with Emily and Elsie Le Lacheur and their mother having tea in the garden at Bifrons, Jersey, September 1910.

Below: 7. Clopton Amateur Theatrical Society members, including Sid Buckley (third from left of the men, and highest), Dorothy Betty and Joan Buckley (second and first from right of the girls), July 1914.

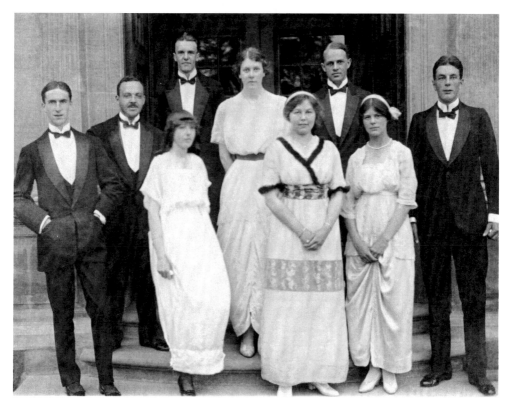

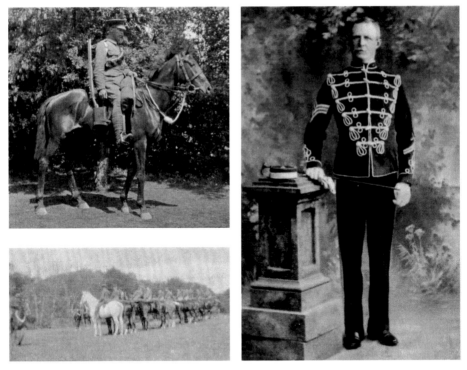

Top left: 8. Roy ready for QODY annual training fortnight at Blandford Camp, outside The Laurels, May 1911.

Above right: 9. Sergeant Maurice Tory in QODY full dress uniform. (Courtesy Paul Tory)

Above left: 10. Local Dorset Yeomanry parading on Milldown, near Blandford, prior to departure by train for brigade camp on Salisbury Plain, May 1909.

Below: 11. Brigadier and staff of the 1st South-Western Mounted Brigade (QODY officer front row, extreme left). Roy's postcard from brigade camp, May 1909.

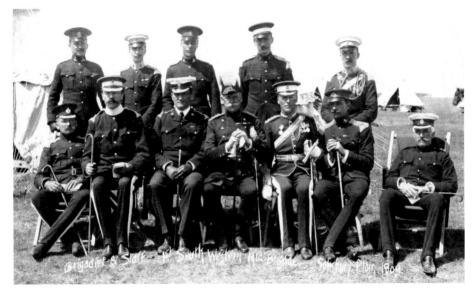

12. Arnecliffe. 13. 'Old Stickland and Iris with the boats', summer 1907.

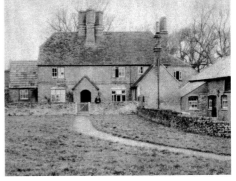

14. South Egliston Cottage, summer 1907. 15. Efford Farmhouse, 1915.

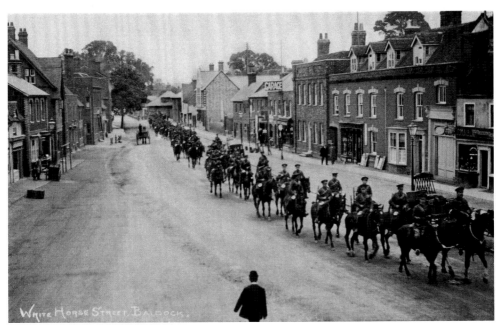

16. Roy's postcard of a troop of yeomanry riding through Baldock at the time of the 1912 British Army manoeuvres.

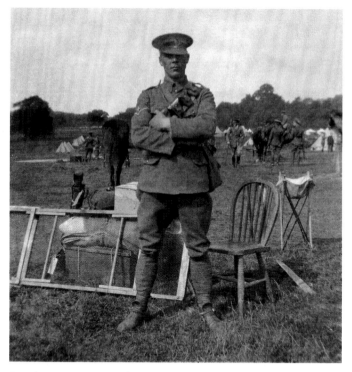

Above: 17. Roy having just arrived at QODY annual training camp, Wimborne St Giles, late May 1914. Note the camp bed, and the luggage labels tied to each piece of equipment, because heavier baggage was transported separately.

Below: 18. Left to right: Ernest Cossins (who remained at home during the war to help run the family farm), Harry Cossins, Roy George (riding the mare he would soon take to war), Leslie Cherry. Roy's postcard from QODY annual training camp, Wimborne St Giles, late May 1914.

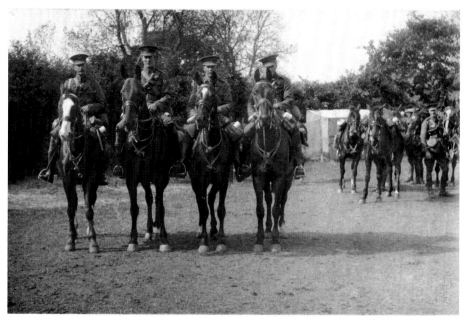

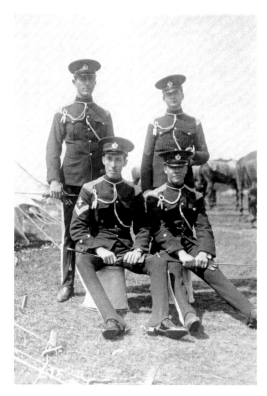

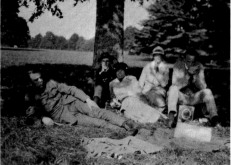

Above: 19. Left to right, standing: Val Watts, Leslie Cherry. Sitting: Cecil Curtis, Roy George. Roy's postcard from QODY annual training camp, Maiden Castle, Dorchester, late May 1913.

Top right: 20. Stanley's enlistment day outing, 7 September 1914. Left to right: Iris, her friend Dorothy Betty, Roy, Stanley.

Above right: 21. Stanley's enlistment day outing and picnic with friends and youngest sister, Sherborne, 7 September 1914. Left to right: Roy, an older friend of Stanley's, Dorothy Betty, Iris, Stanley.

Right: 22. Val Watts at the controls of a Wright biplane, Beatty School of Flying, Hendon Aerodrome, 1914.

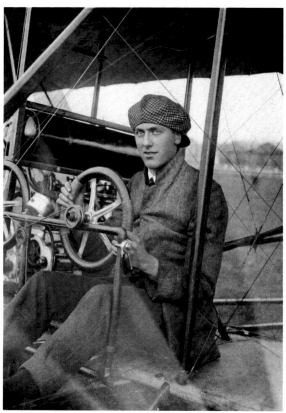

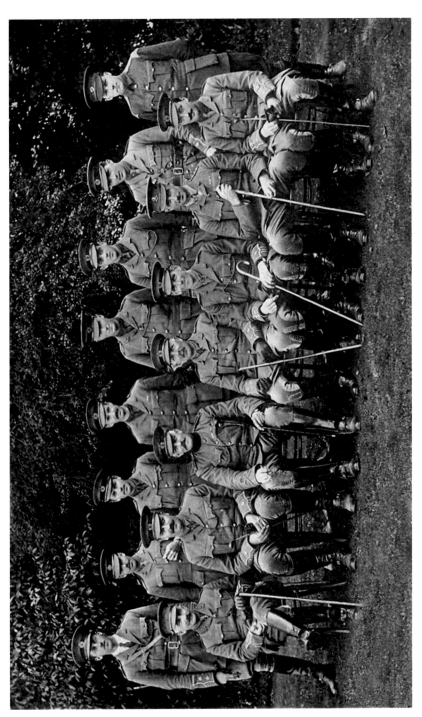

23. Fifteen QODY officers at Sherborne, August 1914 just after mobilisation. Left to right, standing: Lt Browne, 2nd Lt Sir T. Lees, 2nd Lt Kennaway, Capt. (from 26.8.14) Gordon, 2nd Lt L. Livingstone-Learmonth, 2nd Lt Dawson-Damer, 2nd Lt B. Lees, 2nd Lt Blaksley. Sitting: Capt. Golledge, Major Sir R. Baker, Major Batley, Lt-Col. Troyte-Bullock, Major Goodden, Capt. N. Livingstone-Learmonth, Capt. Reeves. (Arthur Shephard collection, courtesy John Shephard)

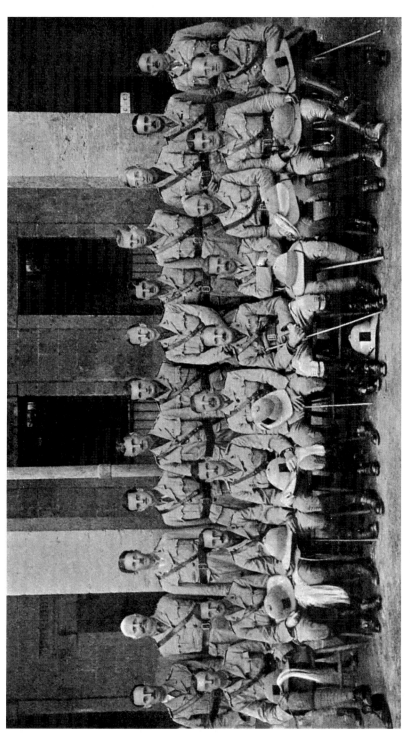

24. Twenty-two QODY officers at Kasr el-Nil Barracks, Cairo, between 5 May and 3 June 1915 (Lord Wynford left on 4 June). Left to right, standing: Lt Pass, Capt. and Quartermaster Parsons, Lt Browne, 2nd Lt Dawson-Damer, Capt. and Adjutant N. Livingstone-Learmonth, 2nd Lt Hoare, Lt Carter, 2nd Lt B. Lees, Lt Busk, 2nd Lt L. Livingstone-Learmonth, 2nd Lt Gray, Lt Dammers. Seated: Capt. Wingfield Digby, Capt. Alexander, Capt. Reeves, Major Goodden, Lt-Col. Troyte-Bullock, Lt-Col. Souter, Major Lord Wynford, Major Castleman, Lt Fearnside, 2nd Lt Bragge. Press photo from the *Tatler*, 1 September 1915. Officer group photos, often taken many months before publication, were a regular weekly feature. The magazine would not have known that, by the time of publication, three of the above (Browne, Gray, and N. Livingstone-Learmonth) had been killed at Gallipoli.

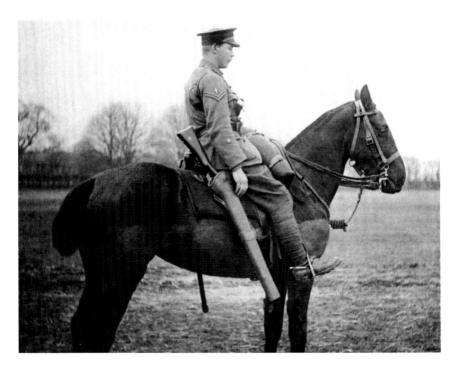

Above: 25. Roy on one of the transport horses in the grounds of Houghton Hall, taken by Jasper J. Wright of King's Lynn, 20 March 1915.

Below: 26. Stanley's postcard of 'Dorset Boys' in Norfolk. In uniform, left to right, back row: Rose, Stanley George (partly concealed), Bower, Leaton, Snow, Marsh (partly concealed), Bertram George, Cutler, Harvey, Roy George (with his mare beside him), Ingram. Middle: Norman, Maiden. Front: Richardson, Hine, Hayter, Robberts, Minchinton, Pardy. The older civilians could be Houghton estate staff, but are unidentified. By Jasper J. Wright of King's Lynn, probably December 1914 (see also page 6).

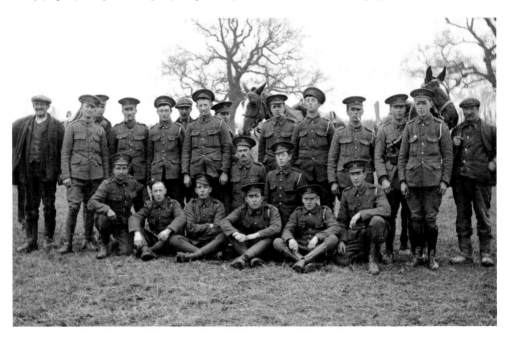

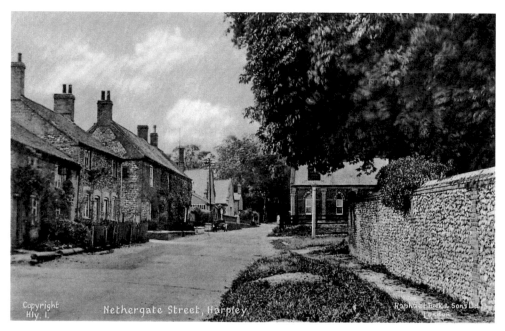

Above: 27. Nethergate Street, Harpley. (Postcard, courtesy TuckDB)

Below: 28. The stable yard, Houghton Hall, early 1915. Note the lantern with cables running to it from an upper storey window, presumably rigged up by Styles, the electrician. (Mark S. Ward album, courtesy Mark F. Ward)

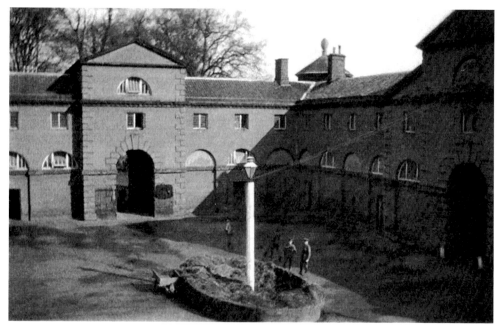

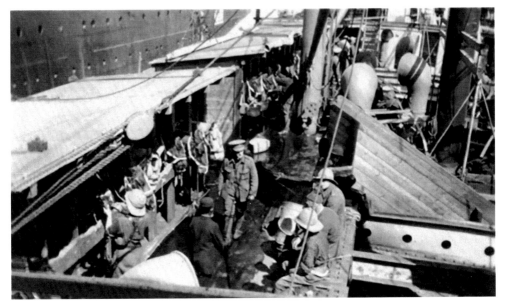

Above: 29. QODY horses in the deck stalls of the *Commodore*. (Capt. F. J. B. Wingfield Digby album, © Sherborne Castle Estates)

Below: 30. *Karoa* disembarking at Alexandria, 22 April 1915. (Capt. F. J. B. Wingfield Digby album, © Sherborne Castle Estates)

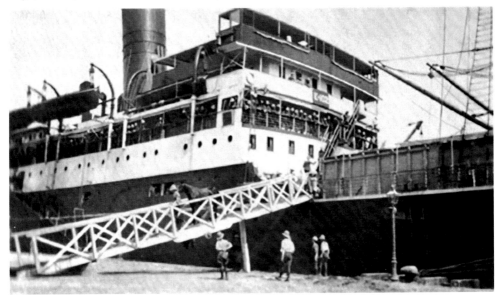

Right: 31. The French Consulate, Cairo, July 1915. The sumptuous Villa Saint-Maurice, corner of Shari Kasr el-Nil and Shari el-Madabegh, former home of Comte Charles Gaston Esmangard de Bournonville de Saint-Maurice, equerry to Khedive Ismail.

Below right: 32. Off-duty guards at the French Consulate: Francis Old on form and Bertram on chair under tree, summer 1915.

Bottom left: 33. British Army Headquarters, 45 Shari Kasr el-Nil, summer 1915.

Bottom right: 34. Villa Zogheb, Shari Kasr el-Nil, May 1915.

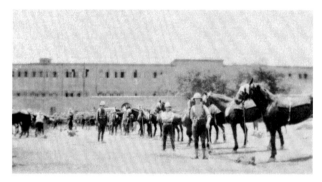

35. Horse lines in the south-facing front square of Kasr el-Nil Barracks, May 1915.

36. Rudimentary shelters for horses at Kasr el-Nil, May 1915.

37. Back of Kasr el-Nil Barracks overlooking Nile with bridge on right, May 1915.

38. Part of Kasr el-Nil Barracks – central part of the back (Nile side) of the block in which the brothers' No. 25 dormitory was (first floor), showing the long balcony in which Stanley preferred to sleep, May 1915.

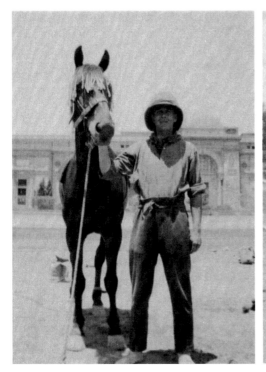

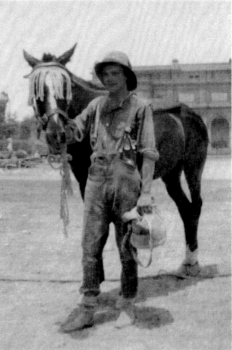

Above left: 39. Bertram with Shamrock at horse lines, Kasr el-Nil (Egyptian Museum behind), May 1915.

Above right: 40. Stanley with Itchycoo at horse lines, Kasr el-Nil, May 1915.

Left: 41. Roy with his mare at horse lines, Kasr el-Nil, May 1915.

Below: 42. Dinky and (probably) Private Robson, summer 1915.

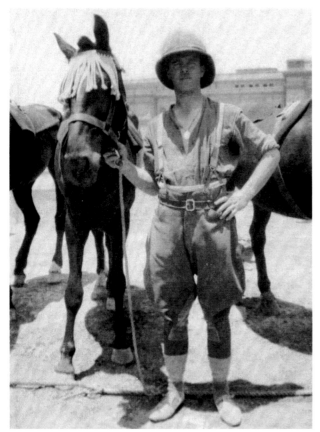

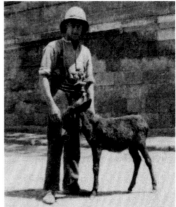

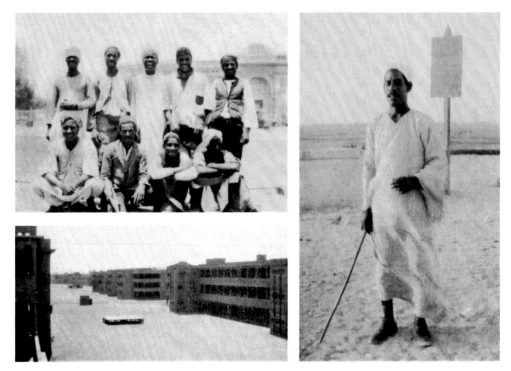

Top left: 43. Syces at Kasr el-Nil Barracks (Egyptian Museum behind), May 1915.

Above right: 44. 'Ibrahim el-Shar – our dragoman and one of the best (J.W.G. [Roy])', summer 1915.

Above left; right:
45, 46. Abbas Hilmi
Barracks, Abbasia, July/
August 1915.

Left: 47. Bookstall at the Abbasia
barracks (Francis Old on right),
July/August 1915.

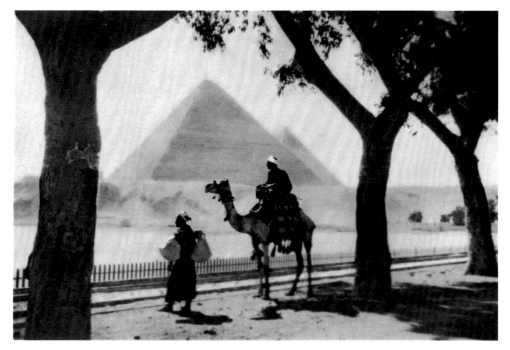

Above: 48. 'Gizeh Pyramids from the tram route'. (Bertram George collection)

Below left: 49. 'Roy half-way up Cheops Pyramid', May 1915.

Below right: 50. 'Bertram half-way up Cheops Pyramid', May 1915.

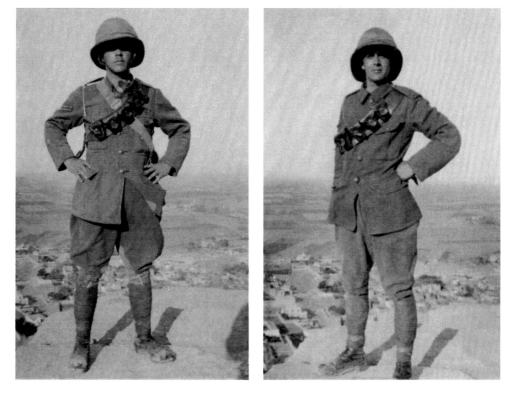

Opposite, top left: 51. Citadel and Ali Pasha Mosque, Cairo. (Bertram George collection)

Opposite, top right: 52. 'Ancient gate, Cairo'. (Bertram George collection)

Opposite, centre left: 53. Flatbreads.

Opposite, centre right: 54. 'Arabic coffee shop'. (Bertram George collection)

Opposite, bottom left: 55. Water sellers waiting to fill goat skins at a pump.

Opposite, bottom right: 56. Water seller with full skin in barrow.

Above: 57. Kasr el-Nil Bridge, May 1915.

Left: 58. Bulaq Bridge, summer 1915.

Above: 59. 'Opening Bridge at Ghezireh' – the recently completed (October 1914) Gizeh Bridge, also known as English Bridge, summer 1915.

Left: 60. Turkish pontoons destroyed in February 1915. On display in Gizeh Zoological Gardens, summer 1915.

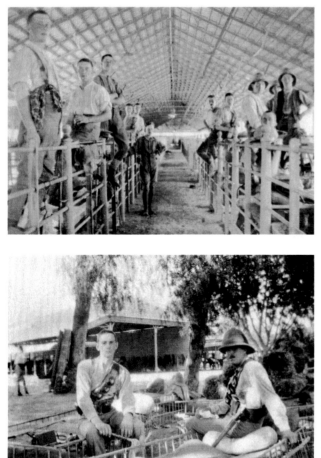

61. 'C' Squadron in their cattle-pen sleeping quarters, Ghezireh, June/July 1915.

62. Two of main guard off-duty at Ghezireh. Left to right: Francis Old, Harry Cossins, June/July 1915.

Below left: 63. Private Robberts at the entrance to one of the horse shelters, Ghezireh, June/July 1915.

Below right: 64. 'Death of Corporal Hooper [right] by hand of Trooper B.I.G. [Bertram]', Ghezireh, June/July 1915.

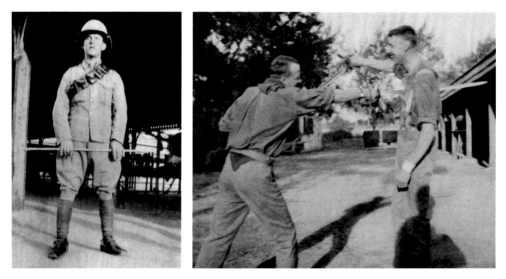

Above left: 65. Shafik
Mina at Blandford, 1911.

Above right: 66. Shafik's
parents' house at Minia,
June 1915.

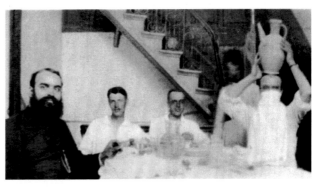

Above: 67. After lunch on the
balcony at Minia, taken by Shafik.
Left to right: Père Josef, Maurice
Hooper, Bertram, Roy, June 1915.

Left: 68. Shafik, Père Josef and three
pupils, Minia, June 1915.

69. 'Fetching the water at eventide'. (Bertram George collection)

Right: 70. 'Late evening – the hay harvest'. (Bertram George collection)

Below left: 71. Winnowing the corn, summer 1915.

Below right: 72. The norag (thresher), drawn by oxen, summer 1915.

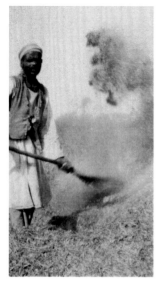

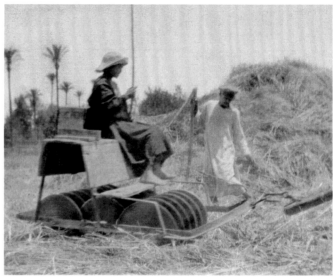

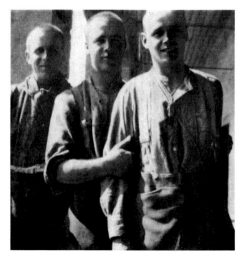

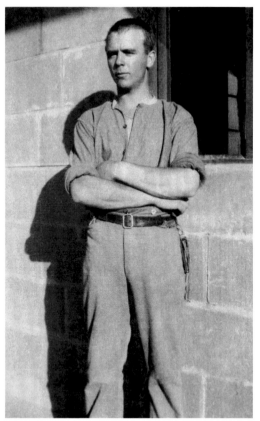

Above: 73. The three brothers off-duty at the Abbasia barracks, early August 1915. Left to right: Bertram, Roy, Stanley. The last-known photograph of Roy (also frontispiece).

Right: 74. Stanley at the Abbasia barracks, early August 1915.

Left: 75. Some of No. 1 Troop, 'C' Squadron, off-duty in their barrack room at Abbasia, July/August 1915.

Below: 76. 'C' Squadron men off-duty in their barrack room at Abbasia, July/August 1915. Bertram lower right, darning a sock; Francis Old top row, second from left.

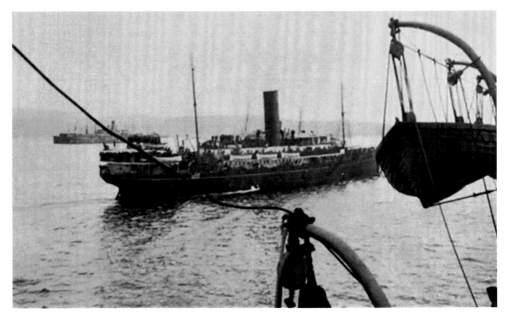

Above: 77. *Sarnia*, August 1915. (Capt. F. J. B. Wingfield Digby album, © Sherborne Castle Estates)

Below: 78. Arriving at 'A' Beach, Suvla Bay, Gallipoli, 18 August 1915. (Revd A. G. Parham collection, courtesy Philippa Bush)

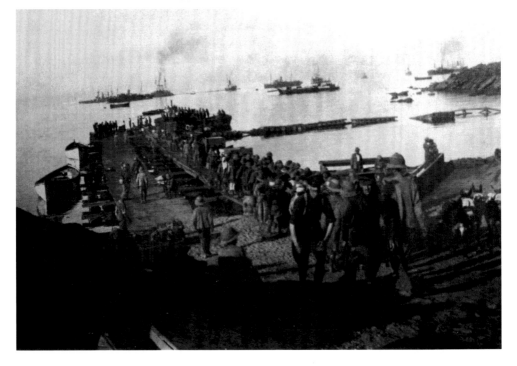

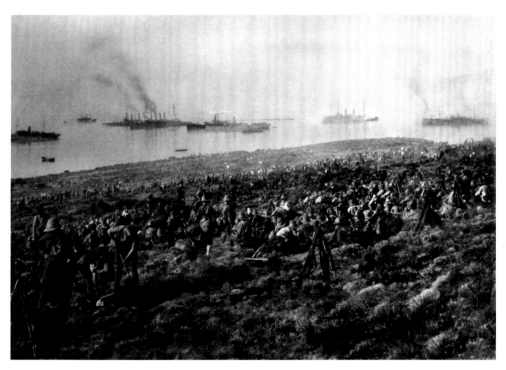

Above: 79. Digging shallow shell-scrapes on arrival, 18 August. (Revd A. G. Parham collection, courtesy Philippa Bush)

Below: 80. Bivouac area 19–20 August higher up the hill. (Revd A. G. Parham collection, courtesy Philippa Bush)

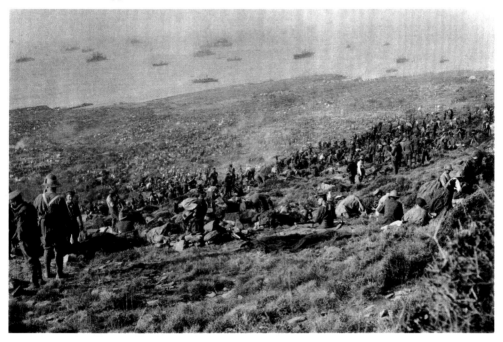

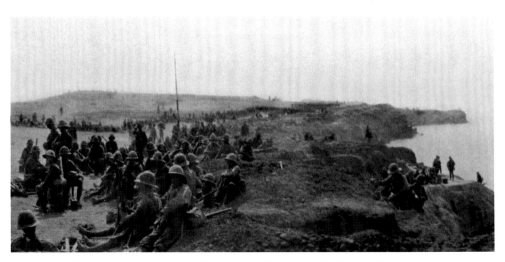

Above: 81. Waiting to go into action, 21 August. (Revd A. G. Parham collection, courtesy Philippa Bush)

Below: 82. Asleep in a yeomanry trench at Gallipoli, away from the front line. (Capt. F. J. B. Wingfield Digby album, © Sherborne Castle Estates)

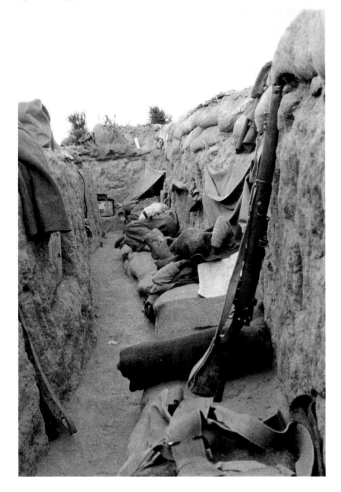

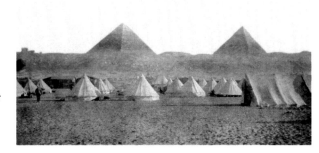

83. Mena Camp, December 1915 or January 1916. (Courtesy QODY & DG Association)

84. Um Rakhum, 20–21 February, 1916. (Courtesy QODY & DG Association)

Right: 85. The QODY's mass-grave cairn at Agagia. Official photo, July 1916. (Mark S. Ward album, courtesy Mark F. Ward)

Below left: 86. Herbert George, 1915/16.

Below right: 87. Harold George, 1915/17.

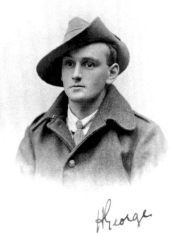

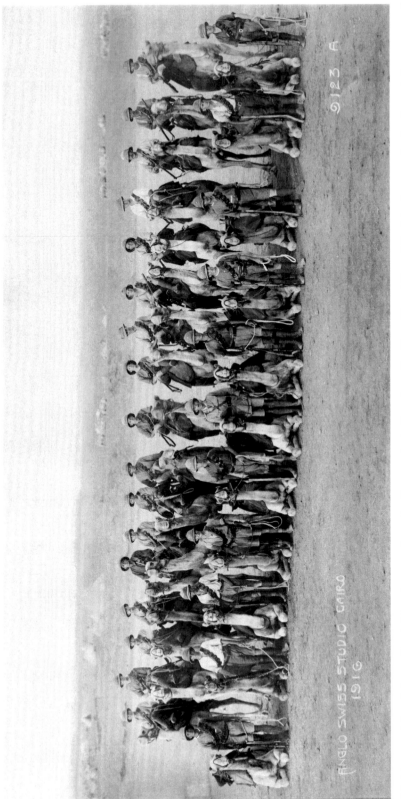

88. Twenty-eight of the earliest ICC volunteers from the Dorsets, including three (Budden, Churchill and Foyle) who were in the first reinforcements of 9 May. Stanley's copy of a photograph by the Anglo-Swiss Studio, Cairo. All Privates unless otherwise stated. Left to right, mounted: L/Cpl Gould, O'Reilly, Greening, Strickland, Ward, Tett, Banfield, George, Guy, Maiden, Wells, Nethercott, Foyle, Meaker, Sadler, Purchase, Beams. Standing: L/Cpl Webb, Bolt, Hallett, Budden, Cpl Vye, 2nd Lt Ryan, Cpl Guppy, Churchill, Woolner, Marsh, Drury. Abbasia, June 1916.

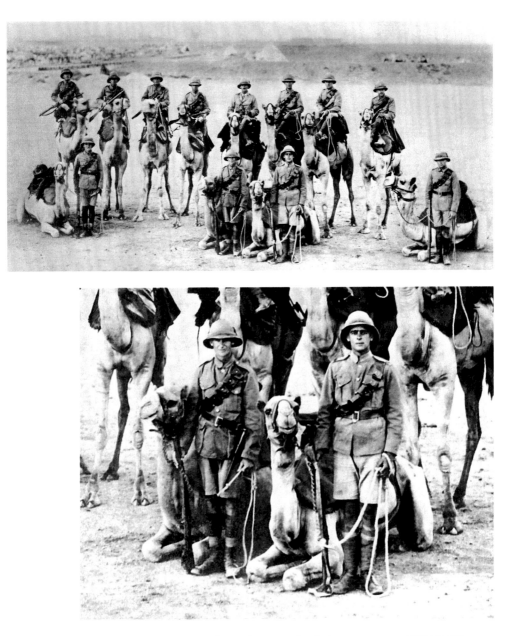

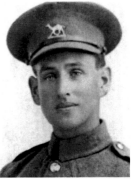

Top: 89. All the 'A' Squadron men from plate 88, plus Cpl Vye ('B') and 2nd Lt Ryan. Left to right, mounted: Drury, Bolt, Webb, Vye, Ryan, Guppy, Meaker, Greening. Standing: Gould, Budden, Ward, Tett. Anglo-Swiss Studio, Cairo; Abbasia, June 1916. (Mark S. Ward collection, courtesy Mark F. Ward)

Above: 90. Detail of 89: Arthur Budden (left) and Mark Ward.

Right: 91. No. 8 Company Sergeant-Major William Guppy wearing ICC cap badge. (Courtesy Derek Guppy)

Above: 92. 'Stan leads Solomon in the desert', June/July 1916.

Below left: 93. In the sand-hills, June/July 1916.

Below right: 94. Hagar Mashguk ('split rock'), a huge outcrop near the Fayum, overlooking the caravan route to the Baharia Oasis where the Senussi were at the time of Stanley's letter of September 1916. Used as a lookout post in the Western Desert campaigns of 1916–17.

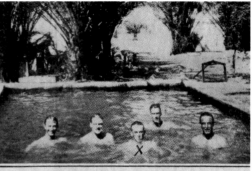

WISH **OUR** CLIMATE WERE LIKE THIS!
British soldiers enjoy an open-air bath in Western Egypt

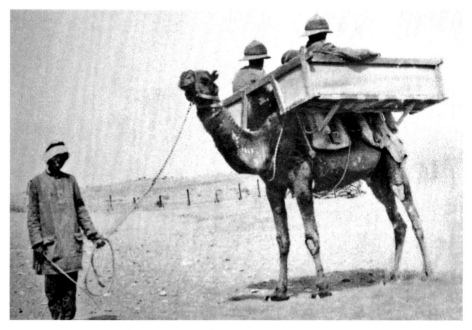

Above: 96. Stanley (marked with a cross) in the 'plunge-bath' at Shusha, probably taken when they returned there in late 1916. Published in *The Bystander*, February 7, 1917.

Above left: 95. Arthur Budden, 1917/18 (wearing QODY rather than ICC cap badge). His camel seems to be roaring, as they often did when barracking or getting up. When this happened en masse, the noise was deafening. (Courtesy Caroline Budden)

Above right: 97. Captain Mason-Macfarlane, obituary press photo. (Mark S. Ward album, courtesy Mark F. Ward)

98. Baggage camel with cacolet (litter for carrying sick or wounded, one on either side). (Courtesy QODY & DG Association)

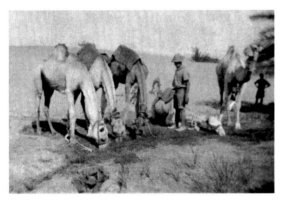

99. Watering camels in the Fayum, September 1916.

100. 'Cooking brekker' in the Fayum, September 1916.

101. Privates Coultas, Harper, Murray and Hooker (ICC friends from the Berks and Bucks Yeomanry) in the Fayum, September 1916.

102. Privates Murray and Coultas 'in sulphur bath', Fayum, September 1916.

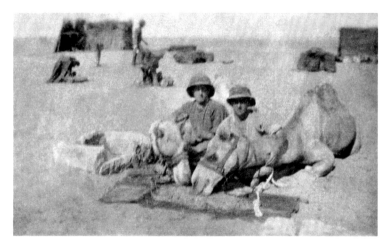

103. Privates Maiden (left) and Guy, resting and feeding camels while on patrol from Fayum, September 1916.

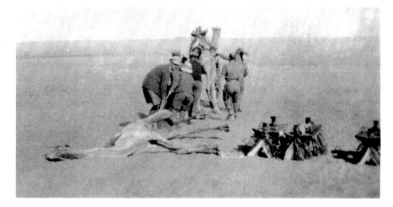

104. Dragging poor Granfer to a burial place with the help of another camel. An 'unlucky' early morning (note jackets) in September 1916.

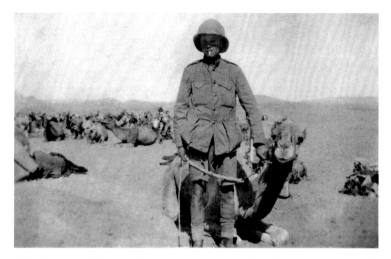

105. 'Stan and his camel', the replacement for Granfer (name not stated), autumn 1916.

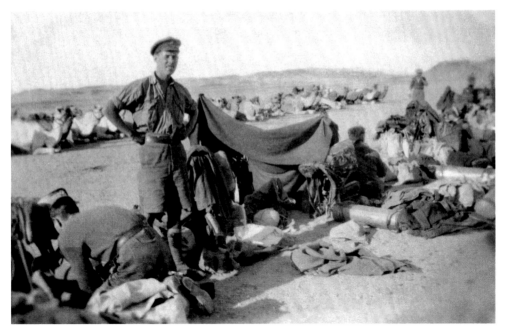

106. 'In from a trek', with 'bivvy' as described by Stanley. Private Priddle standing, autumn 1916.

107. 'Headland in Libyan Desert', winter 1916/17.

108. Rugged camels in the camel lines at Abbasia, February 1917.

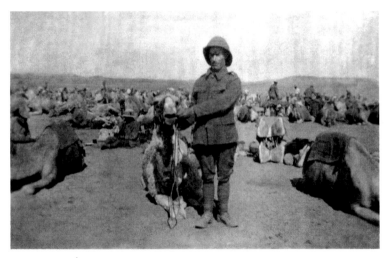

109. 'Pat O'Reilly, our vet man', inspecting Stanley's camel, winter 1916/17.

110. 'Camels kissing', showing camel rug with hole for hump, winter 1916/17.

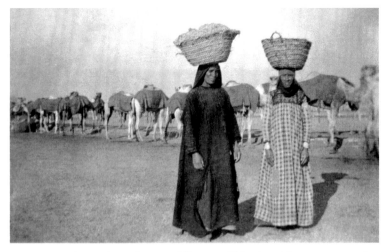

111. Rugged camels in the camel lines at Abbasia with women carrying baskets, February 1917.

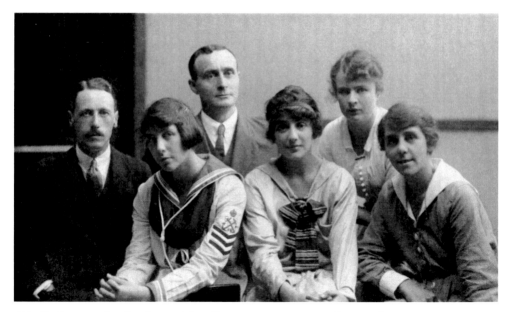

112. Performers in the Lena Ashwell concert party seen by Stanley in Cairo in early February 1917. Left to right, back row: Bret Hayden (humorist), Marjorie Ffrangcon-Davies (soprano). Front row: Theodore Flint (pianist), Yvette Pienne (reciter), Sylvia de Gay (violinist), Grace Ivell (contralto). Postcard by Alban-Studio, Alexandria. (Courtesy Stuart Gough)

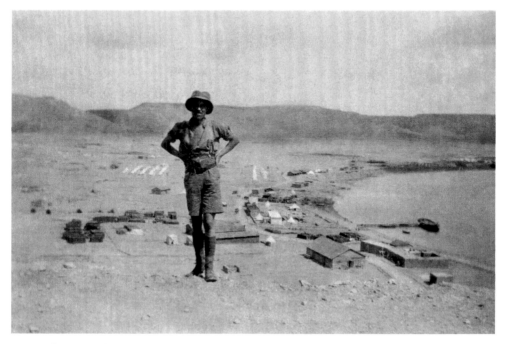

113. Sollum Heights, looking down to the camp and the shore. Private Priddle in foreground, spring 1917.

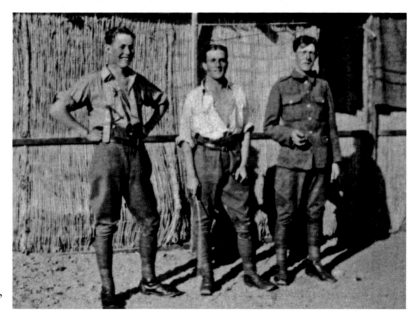

114. Left to right: Privates Priddle, Foyle and Maiden in camp at Sollum, spring 1917.

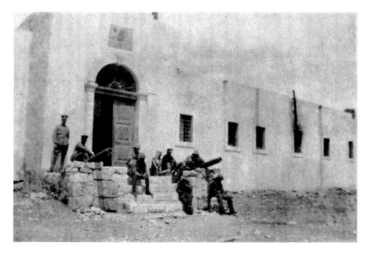

115. Exterior of Fort Abbas, Sollum, spring 1917.

116. Interior of Fort Abbas, Sollum, with cars from the Light Car Patrols, spring 1917.

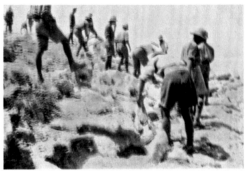

Above: 118. Road-making in the hills, Sollum, May 1917.

Left: 117. Tug in camp at Sollum, spring 1917.

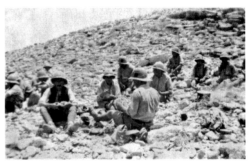

Right: 119. 'Dinner time' for road-makers, Sollum, May 1917.

Below: 120. Ready for a trek (Private Hallet in foreground), May 1917.

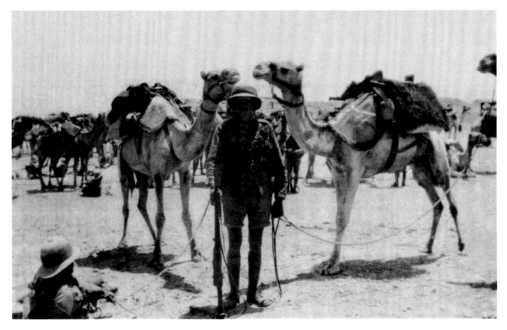

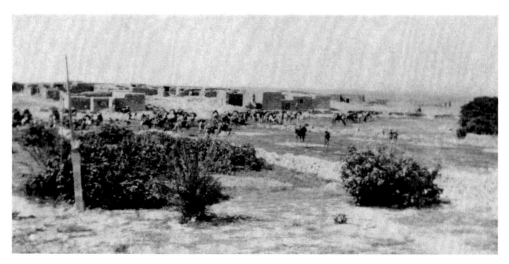

Above: 121. Unjeila, May 1917.

Below: 122. 'Our company on trek. A halt before Um Rakhum', May 1917.

123. Dhabba, May 1917.

124. 'Greek house at Matruh', May 1917.

125. 'Great wire road at El Arish', June 1917.

126. El Arish from the south. (© Imperial War Museums, Q 57886)

127. Wadi el-Arish, 1917, showing the palm trees with the army tents and huts visible between them as Stanley describes. He was writing from a position higher up in the sand-dunes. (© Imperial War Museums, Q 57751)

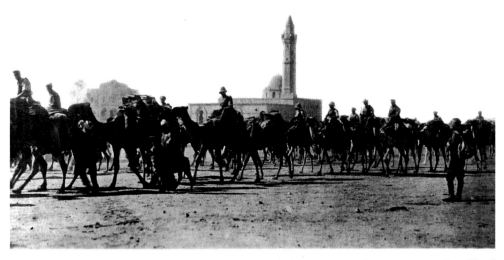

128. 'The Imperial Camel Corps enter Beersheba', 1 November 1917. British Official Photograph No. 142, Cairo. (Postcard, Mark S. Ward album, courtesy Mark F. Ward)

129. The Jewish colony of Rishon-le-Zion, First World War. View from the roof of the wine cellars. (© Imperial War Museums, Q 15792)

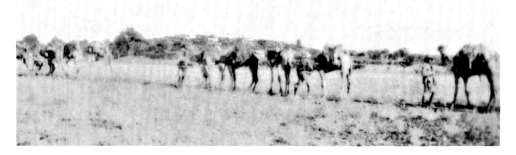

Above: 130. Yebna (village on hillside), early December 1917.

Left: 131. Iris as VAD, 1916/18.

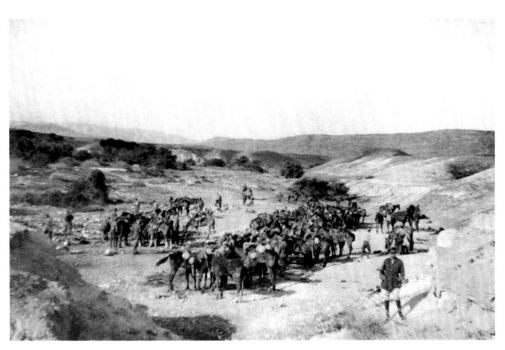

132. Wadi el-Auja, Jordan Valley (with a squadron of Westminster Dragoons), Easter 1918. The stream runs from left to right through the bushes in the middle distance. (© Imperial War Museums, Q 50585)

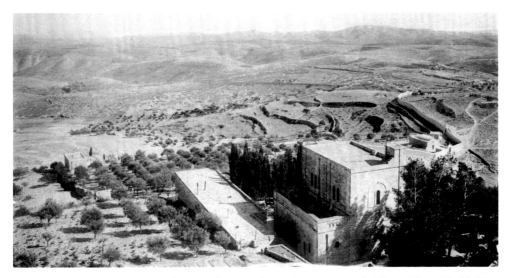

133. Panoramic view of part of Judea from the Mount of Olives, First World War. Bethlehem and Jerusalem behind the photographer; Jericho in middle distance with Dead Sea and River Jordan beyond; Mountains of Moab in far distance with Hills of Gilead to their left. (© Imperial War Museums, Q 33885)

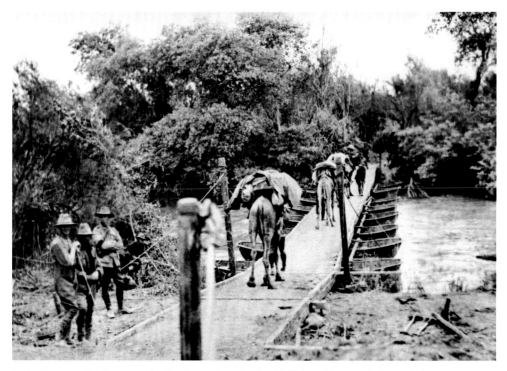

134. Pontoon bridge over the Jordan at Makhadet Hajlah, with camels being led across. (© Imperial War Museums, Q 105661)

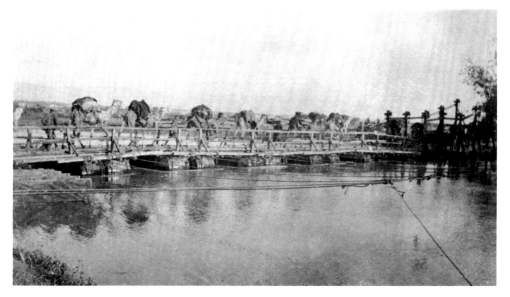

135. ICC troops recrossing the Jordan by the barrel-pier bridge at El Ghoraniyeh after the Amman Raid, evening of 2 April 1918. (© Imperial War Museums, Q 23477 detail)

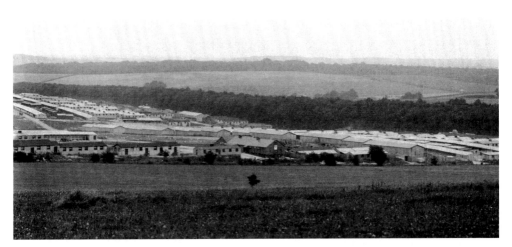

136. Avington Park during the First World War. (© Imperial War Museums, Q 30108 detail)

137. Studio portrait of Bertram, Bournemouth, July 1917.

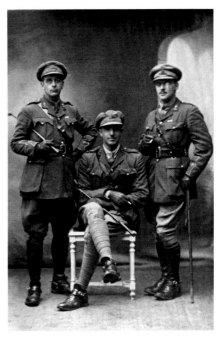

138. Bertram's joke monocle photo, November 1917 (see letter of 12 December). He is standing on the left, MC medal ribbon above his left-hand breast pocket.

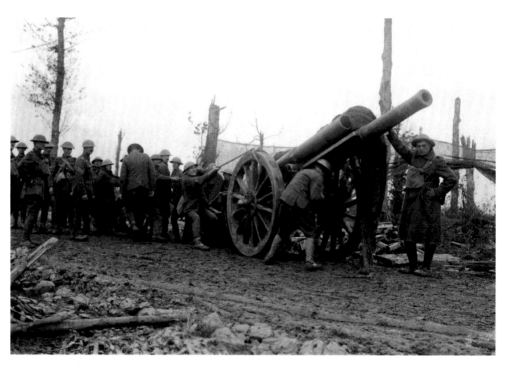

139. RGA gun crew taking a 60-pounder gun out of its emplacement to move it forward, Wieltje, 5 September 1917. Note camouflage netting. (© Imperial War Museums, Q 3020)

140. RGA troops moving a 60-pounder gun on its horse-drawn limber, Flanders, 22 August 1918. (© Imperial War Museums, Q 6996)

141. RGA gunners having a meal outside a shelter amidst the ruins of St-Elooi, 11 August 1917. (© Imperial War Museums, Q 5876)

142. RGA gunners pushing a light railway truck filled with shells. Behind Zillebeke, 1 October 1917. (© Imperial War Museums, Q 6032)

143. British 60-pounder guns of the RGA firing near Langemarck, 12 October 1917. (©
Imperial War Museums, Q 3140)

144. Panorama of Passchendaele battlefield, with the ridge in the distance, November
1917. (© Imperial War Museums, CO 2265)

slices of this fruit would look on an English dinner table with cream and gooseberry tart and other cold viands for a summer meal.

Late in the afternoon we went on to a small town called Ayat. On the way one of the baggage camels fell into the canal. It was got out after some delay, and it was dark when Ayat was reached. I recollect I slept well this night, feeling very tired, and old Solomon looked done. It is hard work riding my camel. He is the slowest in the company, and my beating him is for no good – whips don't frighten camels.

In the morning on our way out of the town we crossed the Egyptian State Railway; there was the neat little station, quiet and shady, twittering sparrows all about it, the name Ayat painted in English and Arabic upon the boards. The main railway ran with us all the way to Samalut, and we used to see the fast trains down from Khartoum and the long white sleeping-cars.

Our halt for the day was much like the day previous – beneath date palms, beside the canal, and near to a village. This was Sunday. We had watered the camels on the Friday at Abbasia, yet they were looking thin and thirsty and wouldn't eat their dhurra and tibbin [chopped straw]. We led them to the canal, but they were so afraid of overbalancing down the steep banks they wouldn't get down well to it.

Sunday night we reached Wasta – marched straight into the town square and camped. It reminded me of how the artillery would march down the Dorchester hill and into our own Market Place at home. I only wanted Markwells to be across the way, with hams, mixed biscuits, and chocolates.

Wasta is a fair-sized town – the line to the Fayum Oasis starts there. After some porridge and tea, I found my way to a street alongside the river where there were some shops and cafés. I drank a bottle of India Pale Ale beneath a verandah overgrown with vines, and watched the respectable Egyptians of Wasta pass up and down. There were a few Englishmen I saw – I think they have good berths as inspectors of irrigation and directors of the cotton-growing industry.

From Wasta, three mounted police with an officer – Egyptians in khaki and fez, mounted on lively Arab ponies – accompanied us to the boundary of their district, where others took over their duties. These police are very absurd – except the officers, who are very civil and usually speak English – for they gallop up to the bridges where the natives talk in groups, and hustle them off by spurring their horses into them and brandishing long whips. I think mounted police look horridly aggressive.

It must have been market day in Wasta, because there was a deal of traffic on the road: the long-eared, long-headed donkeys, their eyes looking downward, each one laden with a large sack of grain; a man riding an ass which had a saddle-bag over its back, and out of each pocket protruded the long neck of a fat goose; there were flocks of brown and white goats, grey-black bullocks, brown cows something like the Jersey kind; and hand-carts filled with marrows and melons. Over the railway to the left, across the fields, were the white and graceful triangular sails of the Nile boats flitting up and down the blue water.

The Nile valley all the way up is only a narrow thread of green, say fifteen miles in width, and beyond this on each side the desert. The water, and the green of trees and plants, look all the more refreshing because of the thirsty desert so near. We halted on a grass plot outside a garden of pomegranates. The owner gave us permission to sleep beneath the hanging fruit where 'twas green and shady, but most of us lay down in the grass, having rigged up shelters from the sun with our blankets, using saddles and rifles and bayonets as supports. Here was a deep stream below some hatches, and banks of spongy grass. Churchill of Langton, who has bathed many a time at the head of Withy Bed, defied the military rule and plunged. I stripped upon the bank and washed – an apology for a bathe.

In the evening we rode on to Beni Suef – an important town in Upper Egypt. We entered the town through what looked like public gardens. There were plantations of bushes and trees kept in prim order, and grass paths lined the road, along which were placed public seats of the dirty sort – like that owned by the Blandford Town Council, which has been for years a few yards beyond the Cottage Hospital. The police directed us to a large yard covered with a fine black dust, and the wind that was blowing covered us with it and – as our faces were sweated – the moisture and dirt mixed and ran down our cheeks in dirty streams. Part of the night I was on guard over the camels. I was entertained with the music of a distant band, which was made up of a flute (I think in Egypt it is called a 'ney') and a persistent drum.

We rested the camels all the next day. A strong wind blew from morning to night. In the afternoon I sought refuge in the town from the wind and the black dust. I found a grocer's shop owned by a Greek. It was very fatly stocked with good things: two walls displayed bottles of various –ades and –ines tastefully labelled, and behind the counter I saw ranged on the shelves tinned fruits, and jams galore. I bought three tins of Ideal Milk – 4 piastres a tin – and 1lb of cream crackers.

It is a poor, dirty place, Beni Suef, with no comfort there for an English soldier. Various shops advertised 'English teas', 'chop and pudding' and 'English beer', but they looked disappointing places, and as they couldn't spell 'chop' and 'pudding' correctly, I guessed they didn't know how to serve them.

In a house named the Beni Suef Club, I ordered of a Frenchman, the proprietor, bread and butter, fried eggs and tea. The butter he put in with the eggs as it was too liquid to spread. I had the nearest to an English tea I've yet had in Egypt. There was a tea-room upstairs furnished with tables and chairs, and a French window opening to a verandah which overlooked a garden. On the wall there was a large picture advertisement of Mackinlay's whisky; and two racing pictures showing an English racecourse, excited crowds of people in old-time attire, and six blood-steeds at the stretch. I enjoyed eggs and tea, smoked two cigarettes, forgot I was khaki, and looked down on the garden wondering [about] the times it has been, and will be, a quiet garden of shade and sleep.

Next morning reveille was at two o'clock, and we were soon away out of Beni Suef on the road to Beba. I don't care for reveille at two in the

morning. Saddling up in half darkness and riding until nine o'clock with only a cup of tea to drink is hard, yet when we were on the way I saw it was the best time to take the road in Egypt.

It was a perfect love-night, the palm foliage swished in the light wind and waved against the starry sky, and a waning moon shone down on white houses, running waters, and wide fields where slept the fellahin amid the scenes of their labour. Through such a world of slumber the camels trotted loosely and ungainly, their serpent heads and long necks stretched out. Uncanny – no noise of motion as would be with a troop of horse, but very quiet, such pin-cushion pads have camels to their feet.

Soon after sunrise we reached Beba. Outside the government dispensary, tables, chairs and forms were ranged. On the tables were tins of biscuits and bottles of Pyramides Beer and lemonade. An old Egyptian, dressed in European clothes and holding a sunshade, greeted us – someone said he was a judge. He invited the officers in to a breakfast, and to us he distributed the biscuits and beer. We sat down anyhow beneath some large trees in front of the dispensary and drank – hardly caroused, because it was early morning and we have a saying, 'It takes a <u>man</u> to sing in the morning, any fool can sing at night.' If you had seen us – tanned, dusty, khakied – beneath the trees, you might have said it was the drinking chorus in some old play – *Old Heidelberg.*[5]

This was Midsummer Day. It was Mark Ward's [twentieth] birthday. He was taken ill here with a sickness and had to take train to Beni Suef where he entered the hospital.

In Mark Ward's own account, he became ill during the dust storm. He 'was taken to Egyptian police station by W. Guppy, who held me on a donkey as I was too ill to ride a camel. The police arranged for me to be taken to the hospital at Beni Suef. ... I was well looked after in Beni Suef Hospital by an elderly English sister and an Egyptian doctor, and soon recovered and rejoined the Company, who were [by then] camped on the desert just off the Nile Valley, near Mynia.'[6]

When the officers returned from breakfast, which might have been in the garden for the roses that they had, we went away to Sods [el-Umara]. At Sods there is a kindly farmer who lives in a handsome house in among the poor hovels of the village. He asked us all to dinner. The day was intensely hot, and pending the arrival of dinner we sat – near on 100 of us – about the hall and in the rooms adjoining it, while servants brought us water poured from brass ewers.

Soon a swarthy man – like a beardless Othello – in white flowing robes, with suave manner and soft voice, beckoned us to dinner. There was not room for all of us in the two rooms, so we fed in batches. I fell in with the first party and sat with ten others upon the floor around a large circular tray of copper, which stood upon a piece of stout polished wood. Bread cakes, shaped flat and round, were served to us, and then came two large ducks roasted in butter, [and] other small dishes containing marrows stuffed with rice, minced meat and garlic, spinach in gravy, and rissoles.

No knives and forks were used except by the carver, who executed with a long fierce blade. For plates we used large pieces of the bread, and with our thumbs and fingers we ate the meat, dipping it in the soup with small pieces of bread – the Egyptian style – and the soft vegetables we picked up upon pieces of bread.

After the bones of the birds were taken away, there descended into our midst – from the hands of a tall Egyptian – a large portion of sheep, surrounded by hard-boiled eggs. Trooper Meaker, one-time valet to a naval commander, carved this with zest. I didn't touch this, but ate two hard-boiled eggs.

Unfortunately there was no pudding – no suet with blackberry jam, or spotted dick. Dessert closed the meal – luscious red ripe water melons cut in small pieces were brought in, and figs floating in their own thick juice – and we moved to make place for others.

During the meal the old farmer, who reminded me of that disciple who cast nets, was here and there seeing to our wants. He couldn't speak English. His generosity was unbounded, and after we had all cleared out he sat down to dinner with the men who had waited on us.

Afterwards, standing in the hall, I noticed two servants struggling to get the huge copper table out of the dining room door. The space was not wide enough to get it through without tilting the table, so they readily did it, scattering the bones and mess of the meal upon the stone floor. I thought of Mother.

In the verandah I saw the swarthy Othello, and he told me he learnt his English in the American Mission College at Assiut. I asked him if the very poor people of the village knew anything of the war, because although they are near to towns and railways their lives seem so apart from ours; he said they all know of it. He spoke highly of Lord Kitchener, and looked very sorry when we mentioned his death.

On our return to the camels we saddled up, ready for leaving. About this time a terrific storm burst upon Sods and over the fields. The wind came roaring, and the stinging rain descended in great violence. We were all wet through in a minute. Out in the fields the men were running for shelter, and the sky was dark with a low grey curtain out of which the rain fell in sheets. To us the storm was a joy; not before in Egypt have I felt the hard rain or heard the rushing song of the high wind out with the rain – here the sun is the splendid tyrant of the sky. A water-cloud up here is as welcome as a white sail to a wrecked and thirsty crew.

Thunder belched, lightning flared, a palm tree fell like a man bullet-struck, branches broke and crashed, and the green dates from above showered down on us. The camels didn't worry at all, but stood still with their tails to the wind.

When the rain subsided a hot wind blew, which dried our saturated clothes in short time. The children came out and gathered the dates that had fallen. I asked a native boy who could speak English whether they weren't afraid of the lightning – I noticed they were calmer under trees than most English during lightning flashes. He said, 'We Egyptians fear nothing.'

When we started on our way to Fashn, where we were to stay the night, the road was so slippery with wet mud that we had to walk. Camels are good animals to lead – they keep a few feet behind one and walk on evenly for hours; and they are a good change after horses, because at a halt they can be left 'barracked'[7] with no fear of accidents.

At Fashn we slept the night in a station yard. A lighted lamp lit the place where Foyle, Budden and I slept. We cooked porridge and made cocoa, and remarked on the excellence thereof. All along, everything we made was good – especially the tea, cocoa and coffee. The government rations consisted of biscuits, bully beef, porridge, jam, tea and sugar, but we lived on porridge and tea, with coffee for breakfast and cocoa late at night.

Again reveille was at two in the morning (I was fed up with this) and we crept out of Fashn as though we were ashamed of daylight and recognition. We rode on till late after the sunrise. It was good to see the slow growing of the light of day, to hear the warblings of water birds, and to feel the fresh breeze upon the face. The sun rose very bold across the desert, and we passed various travellers on the road. A section of the Egyptian Camel Corps, looking very smart, passed us with shouts of 'sa'idah' [greetings].

I saw two men irrigating a field of cotton by means of the shadoof, singing as they worked. The shadoof looks a rustic, antiquated affair. It consists of two upright posts, crossed at their tops by a horizontal piece of wood from which is hung a slender lever formed of the branch of a tree, having at one end a weight and at the other – attached to two long palm sticks – a large bowl with which the water is thrown up to the height of a trough into which it is poured.

There were children watching the heavy black oxen that bathed in the canal, seeming to sleep with but their heads above the water. Some men were swimming across the water with their clothes wrapped round their heads, making I suppose for the opposite bank and work in the fields beyond.

There were numbers of women in the water up to their knees, filling their large earthen pitchers. Some of the younger ones were very pretty – oval faces, black almond-shaped eyes graced with long dark lashes, and beautiful thick-lipped (yet not of the negro kind) mouths. It is a pity they hide themselves so, with long face veils and black, mournful loose gowns – but the girls dress in bright colours, and I like the sham pearl and blue bead necklaces they wear, and the anklets round their brown ankles. They tattoo themselves on the chin and hands, and their well-kept nails are red with the henna.

Our halt for the day was at Aba el-Waqf. Here was a field of birseem [clover] high grown, and a vine and pomegranate garden. The sun came in stinking hot – 120 in the shade, as our officer told us. I lay all day beneath a palm in the birseem, a mosquito net around me and a large water melon ready at hand.

Two Egyptian boys came out of the garden and across the field of birseem to where I lay. They both wore the fez and were dressed as bespoke the sons of a farmer. I had with me a book – *The Arabic Language*[8] – with

words and sentences in Arabic and the English equivalents. They were very keen to learn more English – they both spoke it fairly well – and as they offered to teach me some Arabic, we formed a class, eating the melon between us. Their names were Ahmed and Fahmy; they learnt English in the school at Beba. They had a hazy idea of geography, and although they knew a war was on they didn't know anything about the Allies. Ahmed said he would sing with his brother a song in English about Egypt, so they started off with a duet – words 'Egypt our Fatherland, happy and free'. They asked me to sing, so I sang 'Songs of Araby',[9] but as they didn't catch the words and the tune was foreign to them, the song didn't take. Then they leapt up and said, 'We will bring a boy from the village who will sing very sweetly unto you.' They brought a sturdy boy, with hair very thick and curly of a yellow colour, and he sang a song about the norag. It takes time to understand the lilt of Egyptian tunes and the beauties of the music. They say it is equal to the English, but I can't see this; certainly the people are as fond of singing as the Welsh, and relieve the monotony of their work with chantings and singings. I have heard them – the men working the shadoof, and the boatmen on the Nile.

That evening we went on to Beni Mazar, where we camped on some bare ground beside a large field of cotton. I don't remember much of this place – we were late in, and off again at 2 a.m. I know the officer put me on guard for riding irregularly on my saddle. I had to throw my two legs over one side instead of crossing them in front over the camel's withers, to counteract the tilt of the saddle caused by the fantasse being heavier than the dhurra bag, which was nearly empty – but we were all very tired and cross.

All night the village ghaffirs [watchmen], armed with staves, stationed themselves at intervals around the camp and guarded our sleep. I noticed they coughed one to the other at every half hour or so, an arrangement to see that all were awake. Two Greek brothers (always so enterprising in business) had rigged up a refreshment booth for the few hours we were there, and now and then during the guard over the camels I was down there drinking pomegranate grenadine – wonderful red stuff.

I don't know how we saddled up and got away in the dark at two o'clock – we were all dog tired. This was our last day on trek; by evening we were to arrive at Shusha, our destination. Solomon was hopeless for anything but walking, and Budden's camel was done. We found it impossible to keep up with the line, so we came on as best we could. A sulky camel will drive a man into a bad temper, and the look of them is sometimes so obstinate and indifferent, and they seem to say, 'You just carry on by yourself.' Budden's camel – he calls it Henry[10] – is a very rough ride, so rough that Budden was taken ill with pains and lay on the canal bank. We sent on for the baggage camel with the cacolet[11] to return at once (plate 98), and when it arrived we hoisted Budden thereon and took him to the next station, where he went to Minia by train. Two of our group were now ill; Foyle was on ahead with Mark Ward's camel. I decided to walk into camp. A boy coming along with a white donkey offered me a ride and

carried my rifle, so we went along together, the camels walking on ahead one behind the other. It was a funny way to arrive in camp; the others thought Budden and I had drowned ourselves in the canal out of despair when they saw the riderless camels wandering in, but the sight of me on the donkey reassured them. I offered the boy ½ pt. for his trouble, but he didn't want any money – the first case I have seen where an Egyptian has refused payment, but this was a country boy.

Qolosua is a heap of mud brick houses huddled upon a rising ground… It is a large village, the houses [are] crested with waving palm foliage and peep out between the straight bare trunks of trees. The main Egyptian State Railway from Khartoum runs nearby. A Coptic church with three mud domes, each surmounted by a cross, rises above the meaner dwellings, and a farmer's dilapidated white house stands on the outskirts of the village.

An officer of police was with us to direct the way to the market-place, where we were to stay. We filed through the labyrinth of narrow streets. The people thronged the side alleys and doorways to see us, their faces brimming with interest and surprise. The houses appear to be of the one-room kind, in which live together fowls, dogs, goats, with the women and children – the latter very dirty and fly covered, especially about the eyes. I believe the mothers will not wash their children till six months after birth. The sanitation must be filthy in such a place and the smells were strong, but I think the hot sun acts as a cleanser.

In an open space we came across the village burial-ground. I had often wondered on the way from Cairo where the burial-places were, and here we found this one in the heart of the village. It was a high, irregular earth mound, built up of grave upon grave, shallow and half open, so that the long-gone dead seemed to have been forced out of their first positions by the weight of the bodies buried later. Skulls and bones and fragments of coffins were littered around shelving gaps [and] about the base of the burial-place – perhaps the pariah dogs had meddled with them.

The market-place was also a playing-ground for the children. Two women with a wooden apparatus were making macaroni and placing the tubes on a mat to harden, and a man was making bricks with black mud and straw. The son of the Coptic priest came down to see us and, as he spoke English, there was much he wanted to know. I shall always remember a bathe I snatched in the wide canal at Qolosua. He showed me to a good bathing place on the clean grass bank of the canal below a bridge. I had decided to bathe and risk the consequences. For bathing in Nile water we get No. 1 Field Punishment, which is very stiff. The water is said to give us some kind of disease of a bad nature, but the water looked so tempting, and 'twas infernally hot. Half a dozen boys were delighting in the water, jumping off the bridge into the swift current and swimming good over-hand strokes across from bank to bank, battling strongly with the fast flow of the water. I wanted them to follow me and dive in head first, but they didn't appear to be used to diving, and jibbed. The priest's son took me to see the Coptic church, and introduced me to his father, and he asked questions about London and England on the way there. He much

wanted to go to London but had little money. He seemed very intelligent and happy in spite of – what I thought – his cramped existence in a dull village. He had seen Kitchener at Minia, and he said, 'His eyes were as the sun, for no man could look into them.' He expressed great admiration for England, and was very sad that the Egyptians would not make fighters of themselves, that they might help us in defending their country from Turk and Senussi. I dare say the Khedive would lend us his soldiers, but I guess the War Office would rather be without them – they have little heart.

We went into the church, where it was very cool. On the walls were pictures of the Crucifixion and of St George killing the dragon (I've seen this picture before in Coptic churches, but don't know what it has to do with the Coptic faith). Up in the gallery there was a school for boys, so we went up the stairs and watched them writing English. Egyptian boys are very quick and intelligent, good linguists, and write English fairly well – I mean those who attend the schools. A boy showed me his copy-book, which was very neat, the English writing quite legible. I asked a boy to read from a school primer I saw on a desk, so he commenced to read from the Pied Piper story, intoning like a parson and paying no heed to commas and full stops. The priest asked me to dinner, but I thought I ought to get back to camp.

Most of the afternoon I sucked watermelon and watched a norag going round and round, drawn by two oxen. It takes the place of a thresher at home, and is a chair which moves on small sharp-edged wheels fixed to three axle trees (plate 72). A man usually drives it, but often children sit in the chair and yell out 'ahh' to the oxen, and two of our men had a trial on it. The cut corn is thrown beneath the wheels, and the sharp edges thresh the grain and cut the straw into fine tibbin. The grain is separated from the tibbin by throwing both into the air, and the grain falls while the chaff is scattered further afield (plate 71).

From Qolosua we rode to Samalut, where we turned our backs on the canal. This was very depressing and, as the land became barer and the desert nearer the further we went, I felt rather gloomy. By dark we arrived at this camp of Shusha, which is on the edge of the desert. First impressions weren't very bright, but we were tired and I hoped for the morning to show cheerfully. Thank God there are no flies here. They cannot work us hard because of the heat, and we keep well in our double canvas tents until evening, when we bathe in the small plunge-bath that has been rigged up (plate 96).

On reading this letter myself, I think it will bore you. There is not a great deal to do, so I whiled away time writing you. Thank you for your letter of June 6th written at Arnecliffe. I'm glad you get weekends down there, guess you deserve them. I should have enjoyed the sail with you round the Brownsea Isle to the Haven, where dinner was taken in the hotel. I'm glad you like the canoe – can't one rush through the water with it! Wouldn't you like to voyage down an English river, say the Warwickshire Avon, in it? ... When I tell others your prophecy of the war's ending they look rather gloomy, but brighten up when I say you think we shall be home in September.

Last night came in news of an advance in France. Yes, I expect Douglas and Leonard [Cherry] are good officers – I hope they will come through well.[12] All glory to those who die in the great advance made for the safety of our island home. What is Blandford like since the influx of soldiers?[13] I suppose the birth-rate keeps up. You mention the Institute as a place to see the lively throng in the Market Place. Are there still the spectacled readers in the front room there? I should love to get home to village publics or reading institutes and listen to war opinions.

Please thank Dorothy for the letter and Aunty Bertha for the *Daily News*, which are very welcome as we get no news here to speak of. Could Mother send on two pairs of thick strong socks and half a dozen khaki handkerchiefs? I brought several here with me, but have missed them.

Hoping you are fit, and making the best of summer weather and garden fruit.

P.S. Whoever it is, I don't want any of my letters in the papers, although the last one didn't read so bad.

On 8 July, Stanley wrote to Margaret. Descriptions already given in the above letter, notably of the meal at Sods el-Umara and of the Coptic church at Qolosua, are omitted here:

You see I have joined the Camel Corps. I joined with several others of the Dorset Yeomanry in April, after returning from the Western Frontier Expedition. We trained at Abbasia, near Cairo, for six weeks and then trekked up the Nile Valley to this little desert camp, by name Shusha. It was a novel trek. We made the distance about 130 miles, and we covered it in a week – not too fast travelling. Our method was to be up and away from the night's camp at 4.30 in the morning, continuing until eight o'clock when the sun becomes too hot. All the day until the evening we'd be lazing in the palm groves beside the water, and then on to the next camp.

It is so refreshing in this hot climate to pass through the green of cotton fields, sugar canes and palms, and the many watered ways that break from the Nile and irrigate the land. Villages – built of mud – huddle in circles to left and right, the white superior house of a farmer glistens in the strong sunlight. In the spaces under the trees, yoked oxen pull the norag round and round ceaselessly, threshing the corn, while natives scatter the chaff from the grain as they did in the Bible days.

I would not have missed this journey for anything. So many and interesting things to see. It gave me a fine idea of rural Egypt and a good opinion of the Egyptian – but then we were in the country, and people are always nicer there.

This camp is on the verge of the Libyan Desert and within tantalising sight of the Nile and its fertile valley – yet we don't go down there. Our work lies in the opposite direction, over the sand-hills that ridge the skyline where the sun sinks red at evening (plate 93). The Senussi are somewhere beyond them, planning with devilish cunning fresh attacks. We live in bell-tents on the

sand – it is very hot but breezes blow, and often too hard with smotherings of sand. Water is plentiful and a plunge-bath has been rigged up in which we sport.

Our camels are fit. Mine is going to be cast, as he is too slow (plate 92). Very fascinating animals – interesting to watch.

Bertram is now sergeant. The Dorsets are in Upper Egypt ... at Sohag. June was full of events wasn't it? What do the Americans think of the Battle of Jutland? Kitchener dead? Oh well, perhaps the secret silent desert that he loved will win his spirit back to the places of his hardest labour.

The Dorsets had left Alexandria for Upper Egypt on 10 May 1916, and would stay there until the end of October. 'C' Squadron was based at Sohag, while 'A' Squadron was at Manfalut, and 'B' and HQ at Deirut. Bertram wrote home from a YMCA Hut at Sohag on 25 July:

I hope when I get leave it will be when Arnecliffe is free again. Looking over the Nile here, I have only to shut my eyes to imagine I see the quiet water with the tide-swirls in the distance, and the sunset glow over the pines at Branksea Castle.

At present I am sitting at a home-made table, on a home-made (very hard) bench, clothed in a shirt and a pair of shoes; guess I look remotely like a bride, as I have a small mosquito net over my head and another large one draped around me to keep off flies. I've deluged everything with cheap eau de Cologne, and behind me our old megaphone is grinding out the Wedding March.

Regarding leave, my application is still on the knees of the Gods – the colonel – and I hope it won't slip off 'em. My energy is not sufficient for more than one letter a day, although it is much cooler here now, and a fine north breeze.

This morning we had a long ride at dawn out of the valley into the hills (you know the Nile is hundreds of feet below the desert level). Terrible hills they are too – just a waste of sandstone, sand, limestone and other rock formations. Not even so much as a fly or a wheeling vulture to show that life exists in the world – you might be alone, the only living thing on the earth. Sometimes we find caves, and old, old trails leading to them from the monasteries in the valley – I think they must have been made and lived in by some old Coptic saints.

How I hate the desert! It is refreshing to at least be able to give orders to the men to turn homewards, and to see the cool green of the doura (maize)[14] and the long, silver ribbon of the Nile sweeping away north and south until lost in the morning mists.

On reading over this scribble, I find I am getting slightly hysterical. It must be the love-songs this damned gramophone is singing; please don't think it is an attempt to get into print in some local paper, as I see so many chaps do. I couldn't stand that – far better death on some lonely battlefield!

This emphatic aversion to any of his letters appearing in the press contrasts with Stanley's less dramatic request only three weeks earlier that it not

happen again with his. Whatever the reason, none of Bertram's letters appears to have been published in his lifetime.

> Old Father Nile is rising higher each day, and is now lapping the edge of the great [Sohagia irrigation] canal. All the fellahin are busy hooking the hard baked earth into little holes – they use a very heavy adze to do it. They then parcel off the ground into little squares, about six yards square with earth banks between, so that they can flood each one in turn, and – as the water fills the little holes – it softens all the surrounding earth. Incredibly hard work, but well rewarded.
>
> There are three sounds in Egypt which never cease – the creaking of the waterwheels, the song of the frogs, and the buzz of flies – night and day, one hears them always. Letter writing is an impossibility in the evening, for as soon as the sun goes down – if a lamp is lighted – the air all round is thick with little grey sand-flies, which bite disgustingly. Several of our men are down with sand-fly fever – not in the least dangerous, but causing a high temperature and lack of energy.
>
> I finished my course at Zeitun – passing with 246 marks out of 250, thus getting Distinction.
>
> The bugle has just sounded for afternoon stables, so I must go. Glad you got my photographs of the Graves of Agagia.

While some of the men had taken their own photographs of the grave cairn, the following official notice was issued on 11 July: 'A large photo of the grave at Agagia may be obtained at 7 pt. per copy (plate 85). A copy of the photo may be seen in the Orderly Room & numbers of photos required must be given in there.'[15]

Bertram not only hated the desert, but was well aware that his particular knowledge and skills could be better employed in a different part of the army. He had been on Stokes Gun (trench mortar) Course 16B. Only two Dorsets were on this course, and both were awarded Distinction.[16] On 8 August he applied for admission to an officer cadet unit to prepare him for a temporary commission in the regular army. His first choice was to serve with the Royal Artillery (preferably Royal Field Artillery) or, if not the RA, then with the Royal Engineers or Army Service Corps. Four days later he received the necessary recommendation from his commanding officer, Lt-Col. Troyte-Bullock,[17] and before leaving Egypt he sent home a brief message:

> I have been recommended for a commission – so am getting my transportation papers to Blighty – am going in the Royal Artillery.[18]

On 3 September 1916 he embarked for England on the *Royal George*, and was accordingly removed from the strength of the QODY.[19] Meanwhile, Stanley wrote to Dray on 2 September:

> The import of goods to Egypt must be tremendous as nothing we eat is Egyptian, save fruit (dates and figs). To see the plenteous stock of tinned

fruits and fish you'd think a ship-load arrived every day. Sugar is hard to get outside the towns. Egyptian cigs are very unpopular with us, but I smoke very little – only enough to keep off the flies. The luscious melons are now over, but the fruit man brings ripe figs just picked from the trees. Fine! Do they ever ripen perfectly in England? We used to grab for them on that tree that leans over the Rectory wall on our way down Sheep Market Hill to school.

I used to laugh at people who hankered for their cup o' tea, yet I drink enough of it now – about four pints a day – for breakfast, dinner and tea.

The Egyptian black coffee is delicious. In Cairo the cafés are crowded with Egyptians. They spend all evening sipping at tiny cups of this coffee, eating small salads and other fairy dishes and playing chance games. In these cafés are varieties of small sickly sorts of cakes, and the many elderly, flabby, soft Egyptians delight in forking their delicious morsel of cake. Their complexions are very much similar to the cakes – floury, sugary and bilious. I speak of the rich indolent Europeanised Egyptian in Cairo.

With their defeat at Agagia and the capture of Sollum by the British, the Senussi had been dislodged from the fertile coastal plain and were considerably weakened. However, they had disappeared into the desert and still posed a threat to the British war effort against the Ottoman Empire. Initially the men of the Camel Corps were not told the purpose of their trek into Upper Egypt, but once they were at Shusha it was clear that their mission was to protect the Nile Valley from attacks by the Senussi, and preferably to flush them out and neutralise them once and for all. Regular patrols into the desert made no contact with them, but it was believed that they had concentrated at Baharia Oasis. Captain Mason-Macfarlane led two reconnaissance expeditions to Baharia, during the second of which, on 5 September 1916, he and Lieutenant Ryan were ambushed and killed by a group of Senussi.

During this period, part of the Camel Corps would be based for a few weeks at a time in the Fayum, a large fertile area west of the Nile and around 70 miles north of Shusha (plates 99–103). Stanley wrote to Dray from there on 22 September:

I am sorry that Mother writes the business is giving you a hard time, and that Rolfe the Rover is acting after the manner of his illustrious ancestor, Old 1066, and become high handed [referring to two of Dray's vehicles, probably Markwells delivery vans]. Your place is not to be envied. The good ship Markwell is in wintry seas – however bright her gilded letters show – with a depleted crew. Storms are out, and more than one seaman has gone overboard, but the ship holds tight and stays to her course. The skipper is at the wheel, and Fuzzard encourages with gentle oaths the fierce and swarthy crew of 'Italian warehousemen', while the sticky stokers 'out behind' answer readily to their officer's 'shout' for 'another sack of Demerara – waiting'. She is sure to win home, is the Markwell. Her cargo is sugar and flour and tea and bacons and hams for the common good, and sweets and almonds and crystallised fruits for the rich. Good luck to her.

My last patrol into the desert was an unlucky one. The camel I was riding – Granfer was his name because of the goat's beard he grew – stumbled and put his shoulder out. This happened early in the morning, twenty-five miles from camp. I shot the camel with a bullet through his poll, because he was unable to stand and we couldn't pull the shoulder bone back into position (plate 104). The place we were in was a three-mile-wide valley overlooked by high precipitous cliffs, and we had come into it by crossing lines of sand-hills, which abound in this part of the desert. Around us grew thick, coarse bushes, and tall and beautiful grasses, where the sand was marked with the tracks of foxes and gazelles. We lit a fire in the shade of a high bush and cooked a porridge and bacon breakfast (plate 100), and afterwards two men were sent back to camp for another camel to take the place of Granfer (plate 105). This did not arrive till evening, and the time being too late to start for home, we camped out in the valley.

At dusk I went looking for gazelles, but although their tracks went away in all directions I did not sight any. Night falls quickly under these hills. For a time I stayed to watch the golden evening steal into darkness along the cliffs and about the silent desert valley, while yet the Hagar Mashguk out in the plain was glowing in sunlight (plate 94). I returned to camp to find a fine stew ready cooked. It really was a most appetising mess that our 'Curly' had made. It consisted of bully beef, oatmeal, pea flour, curry powder and sage, and any hotel manager would be pleased to have the recipe. Then it was a sweet wood fire we sat around, while the camels, tied to fanatis behind us, chewed their cud and gazed upon us indifferently, their outlines in the flickering light making a grotesque picture against the darkness beyond.

I enjoyed this night very much, and when we stretched ourselves round the smouldering fire to sleep, there were no mosquitoes to bite us as there are here – a camp beside the water. A moon rose about midnight over the sand ridges, and at four o'clock, when there was a faint gleaming of dawn, I got up and prowled around with a rifle and hopes of killing some animal. There was nothing living to be seen. I would like to know just when the gazelles come out of their shady nooks in the surrounding hills for food.

After tea and 'slingers'[20] we returned homeward. It was one of the pleasantest mornings I have known in Egypt. The wind streamed past us merrily, and white clouds, like the English clouds, snowed up in thick array from the east, so that the desert was chequered with shadows flitting on, such as one does not often see in this land of clear skies.

This district of Fayum is very rich in soil. There is no choicer land in Egypt. Mr Hichens writes in *Bella Donna* (just read it) that it is a land to delight the heart of an Egyptian – a land of milk and honey – the Fayum.[21] It certainly has a charm. The tall cotton fields, the high yet lately sown dhurra, and the paths between; the full streams that thread the land, and the scented bushes about their banks; the evening sun glowing red on the water, and over the fields the rich light, like gold in the air, and the brightening of stars in a heavy blue sky; and in the mornings the crested larks singing, and the fellahin calling one another from field to field.

I think the heat is gone now. The nights are cold. The flies will soon perish.

The large, coal-black beetles would interest you very much. They are powerful things, and can dig themselves in very fast, and can carry to their holes loads twenty times their own size. Didn't the Egyptians deify the beetle, and place artificial ones inside the hearts of their mummies? The large ants too race along and attack the ponderous beetle right and left, and if they bite between his fine pieces of armoured plating – then Farewell, O Beetle! ...

I was glad to get Mother's letter dated Aug. 30th; a long and interesting one it was. I am sorry if a month passed between the comings of my letters. I write very irregularly, but never allow a fortnight to pass bare of a letter for home.

I have not heard a piano for a long time – say four months. Sometimes we spend evenings round a fire, drinking (a little) beer and singing many songs. I always lend my aid – the fellows laugh at me for my unexpected outbursts at odd moments of the day. It is a good habit for strengthening the lungs. I hope Kathleen Coope enjoyed her holiday. Life was different when she used to come down to supper, and to play for us the Indian Lyrics.[22]

Yesterday I received Father's letter, and the news of cousin Herbert's death. I am very sorry. I hoped he would be able to see England, and he deserved a good time back in Australia. It seems his father had a pet affection for him.

Stanley's Australian cousins Herbert and Harold George both moved to the Western Front with the Australian Imperial Force after Gallipoli. Lance-Corporal Herbert George was killed on 25 July 1916 while serving with the 5th Battalion during the taking of Pozières, part of the Battle of the Somme.

I see Edward Butler is wounded. Life is nearer to death in France, isn't it?

All congratulations to Father on having come into sixty-eight! And going strong like Johnnie Walker – yet never takes it! It seemeth to me an artificial drink to give a strong body.

It would be rather nice to obtain one of the booklets printed for the Commemoration Service of the Dorsets at Suvla Battle [Gallipoli], which was held at Sherborne. Perhaps the stationer there (F. Bennett) has some left.

I hope you are brisk and fit, although harassed (as Father is) with business. My love to parents, sisters, aunts.

By early October 1916, the company had returned from Fayum to Shusha, and for the time being patrols would once again start from there (plate 106). At this time, the officers were planning the final capture of Baharia. However, Stanley appears still to have been expecting to be rotated back to Fayum when he wrote home from Shusha on 18 October:

Thank you for two parcels – which came in the last mail – a cake, pot of jelly, vest, pants; also cigs, café au lait, sugar and films. I made a pot of

coffee the same night and, with the cake, we had a supper in the tent. I'm so glad you sent gay coloured hankies. Colours look so well out here, when the Bedouins and Egyptians dress in such bright array.

We have trekked to Shusha before going on to Fayum. The floods are out, the water spread wide – right up to the desert's edge.

A couple of sentences written by Bertram on this letter when he was at home that autumn have been typed up with Stanley's account: 'Indeed, away up country, the Nile this year has risen extraordinarily high and is very early. Some of the natives have been caught napping; but a high and early Nile means prosperity to everyone, generally.'

In the evenings I bathe in the flood and swim away out into 'staring darkness'.[23]

Some of the men are standing out against inoculation, but of course it is very hard to resist the doctor and military authorities as they will do everything to make you give in, except force.

No. 8 Company spent Christmas 1916 at Baharia Oasis, and Stanley wrote to his father from there on 2 January 1917:

Just got Mother's Christmas pudding, and we each had one from the *Daily Telegraph* Fund. Fine!

The *Daily Telegraph* Shilling Fund opened at the beginning of October, aiming to collect £60,000 so that 'none of our gallant soldiers should go short of their plum pudding on Christmas Day'. A single shilling donation would provide for two men. On 1 December, the paper announced that over £50,000 had been raised, puddings for East Africa and Mesopotamia had left the country some time ago, and the consignment for Egypt had just been despatched. By Christmas, more than £70,000 had been donated, and puddings had also travelled to France, Flanders, Salonika, Cyprus, Malta and Gibraltar; to wounded soldiers in hospital in Britain, to a large part of the Navy, and to 20,000 Belgian soldiers!

Our new camp is 150 miles west from the Nile on the Libyan Desert – hard crumbling hills and deep valleys (plate 107) – beneath us a large oasis where waters spring and date palms grow. Here we go grazing our camels. We enjoy green. There are orange plantations and palm groves over against the village of Mandisha.[24] The Senussi have been here – in fact we came out intent on fighting them, but they retreated further into the desert. Perhaps it's lucky our enemy is so evasive [being fierce fighters with a reputation for barbarity towards captives]!

We depend on the pack camels, large, strong, worthy animals, for bringing up our stores – tended by Egyptians, who do much work for us, officered by Englishmen; and the natives are uniformed in a long, loose, blue robe.

The days come on cold and windy now, and we and the camels are in for colds, but our camels from the Sudan are rugged at night [thick rugs with a waterproof outer layer and a hole for the hump, plate 110][25] – and they need it, for mine has a bad chill and is on the sick lines, though he is the hugest of the lot (plate 109).[26]

I wonder how you would like a trotting camel? If you get a good one – fast and comfortable – riding is fine.

The people of Queensland have just sent us each a gift – beer, and a box containing soap, cigs, tobacco, toffee, chocs, chewing gum, safety-pins, and sundry neat and useful things.

Also on 2 January, Stanley wrote to Margaret:

We are out after the Senussi as usual, and they recently occupied this place. We set out from the Nile intent to fight, but they retreated back to Siwa. They are the same Senussi the Dorset Yeomanry charged with their horses last year. That was up near Sollum and the sea, on the Tripoli frontier. They are splendid fighters – have some trained men and a few Turkish officers. We think they are paid to show this threatening attitude against England. They can never invade Egypt, but – as we have to send troops against them – their hostility helps the Huns.

We had a jolly Christmas. Mails came in on time and we had port, sausage, and puddings in tins – and plenty of milk and porridge, of which we eat a great deal. We had an impromptu concert in this bell-tent Christmas eve. About twenty of us crowded in and managed to stand around the tent-pole to sing 'Auld Land Syne' for a finish.

No, there are no wild beasts in the desert. There are jackals and foxes in plenty, but they stay in the hills all day and roam about after camels' carcasses at night. When on guard at night near the camels, I have heard their weird howlings. The foxes are just the same as old Reynard in England. Gazelles are shot sometimes – very pretty to look at, and very good to eat. We have killed snakes as long as two feet, but I doubt if they are poisonous. The real black vulture is seen on the desert, near the Nile cultivation. We can watch them tearing our dead horses, which are dragged out to a far place and left in the sand.

Stanley to Dray, 9 February 1917 from Abbasia, where they returned earlier that month and stayed a few weeks (plates 108, 110, 111):

A day's holiday for me – inoculated yesterday against typhoid. Not a few are standing out against it, as they are getting a little tired of having serum circulated through their systems so often.

Am writing this letter in the Church Army 'Bournemouth' hut. A comfortable place – green baize on the tables, easy chairs, and reproductions of war and peace pictures on the walls. Sparrows twitter outside in the trees. Egypt is a great place for sparrows and pigeons. On a hot day, you lie down under a deep tree and the twitterings and cooings sound very peaceful.

I've been down to Cairo a few times since we came in from the desert. It is a place worth exploring if you have the time and inclination and energy. I have not even been to the tombs of the Mamelukes or the City of the Dead[27] – and the Bazaar in the Muski, the Mosque of el-Azhar and the huge Moslem university of the same name, I have not seen.

European Cairo is fine. The streets and bridges, the houses and shops, the trams and privately owned horses and carriages, are splendid. The Ezbekiyeh Gardens in the Opera Square is a popular place for the soldiers. A tea pavilion is there, where English ladies of the high society serve out cakes and tea with much delicacy and grace to the admiring soldiery. A book is there for us to write our names in, and to remark on the comfort of the accommodation. This 'remarks' column is full of opinions of Egypt, the desert, the war, and the ladies. An artillery man writes of Egypt, 'I came, I saw, and was more than satisfied', and an infantryman, 'Doomed to wander over the desert until the war ends.'

The English soldiers are very keen on smartness of appearance in Cairo. Even if they are only wearing issue clothing and have not bought tunics and breeches made to fit at their own expense, they look well. All buttons, hat badges and shoulder brasses shining, boots wonderfully glazed so that they have ever beneath their gaze the reflections of their solid countenances, and long burnished spurs that clank and clink. A few carry whips. Let us hope they are drivers – at any rate I don't understand why a man promenades with a whip.

The little boys do a big trade in soldiers' sticks, and boot cleaning. The latter juvenile merchants will commence operating even if you look at them, and it is as much as one can do to dismiss them. One cannot give them sympathy or encouragement; they are rascals, and possess none of the grand boyhood spirit. It is so in Egypt – as soon as a poor boy is ten years old he is grown up, and the material commercial mind dominates him.

Smartness in appearance pleases the Egyptian, I think ever so much. They are a flash, either sleek or podgy, well-dressed race – I mean the higher classes – and superficial smartness not only gratifies them, but increases their respect for the English soldiers. I guess they don't have much for me. I usually promenade Cairo's streets with the dust of the Egyptian desert on my boots, so that the lynx-eyed boys have seen and pounced upon my boots even in the darkness, shouting, 'Boots clean, Johnny – baksheesh rub, half piastre.' To flatter, they usually address a soldier as 'Corporal', irrespective of his not being one, and if that won't 'fetch', it is 'Sergeant', or 'Sergeant-Major'.

Some months ago two enemy aeroplanes flew over Cairo and dropped bombs on the unsuspecting inhabitants. I'm told there was much excitement. Since then the lights in the streets and over the shops, which made Cairo a dazzling city, have been cut off or subdued.

On Saturday night I went to the Opera House to hear Lena Ashwell's Concert Party. It is a bright building inside, and the walls and ceiling are moulded and festooned with complicated designs and flash colouring. Around the galleries, looking on to the stage, there were plastered reliefs

in head and shoulders of great musicians. Beethoven was the only German name I saw. I thought there looked to be a great number of box sittings. These were all inhabited by officers and nurses, elderly colonels and matrons, and subalterns of the abominable Gillette-advertisement kind, with pretty VADs. How sweet and clean the uniforms and head-pieces of nurses! It seems to me a nurse should be a saint out of respect for her ascetic, religious, virginal, not-of-this-world apparel; and the soldier in rough, earth-coloured khaki – what must he be?

The concert party were worth seeing (plate 112). They came on to the stage very leisurely and sat down on lounges – four ladies and two men. A duet was rendered first – by a soprano in pink and contralto in emerald green. It was 'Allan Water' they sang. There was a girl with the party who sat demurely on the sofa next to the humorist who told jokes. Very plain she was and plainly dressed, with no pretensions to stage affectation at all. I wondered – she was the last of the party to perform – what was her accomplishment. She was a reciter, and she had such a spirit that made her at once a pet with the soldiers. 'Mandalay', 'A Fairy Story', and 'Say Hullo!' were fine to hear her recite. The violinist looked like a plump gipsy girl, and stood while executing upon the violin as if she was bullying off at a hockey match. The humorist impersonated a coster at a music hall. Have you heard it? I believe it is called 'Slow, ain't it?' I noticed that the soldiers' songs had deafening applause and encores came again and again, but when songs of a high, educated order were trilled out, the appreciative boxes – with dignified clapping and no idea of letting themselves go like the pit and galleries – often lost an encore.

Lena Ashwell was an actress and theatre manager, a very active promoter of women's suffrage in the early years of the century, and a wartime fundraiser. She is now best remembered for channelling much of her immense energy into organising – in co-operation with the Ladies' Auxiliary Committee of the YMCA – 'Concert Parties' for the entertainment of British and Empire troops overseas, from the Western Front to the Mediterranean. The Party that Stanley saw arrived in Egypt in October 1916 and stayed until the end of the war. By February 1917 they had performed in Alexandria and Cairo, up the Nile as far as Luxor, and along the length of the Suez Canal. They then went back to Cairo, where Stanley saw them, before returning to Ismailia. Where there was no grand city opera house or theatre, they performed in YMCA Huts or in the open air.[28]

> Young Shafik Mina is [now teaching] at a school in Cairo. I'm going round to see him one afternoon. In reply to my letter he wrote, 'Your letter was a source of perpetual happiness to all my family.'

Presumably Stanley had spoken of how much Roy valued their friendship, and what a good time he had with Shafik's family in Minia less than two months before his death.

I enjoyed your letter dated Dec. 16th. Your true and humorous account of the domestic upheaval occasioned by the 'busting' of a pipe amused me much. I loved yours about the [gardener] Great Walters's successor – his being like a gnarled old plum tree. Poor old man! All dried and withered, I suppose! What a sad state the world is in, when such old men have to dig the soil in place of younger men gone to fight! What of Walters?

Moan the trees for his return?
Weep the flowers, timid fern
For his coming back?

I think I acknowledged in a short letter your very useful parcel to me. It came at a time when all the contents were soon devoured – we were just on trek. Early this week I had a letter from Mother dated Jan. 7th – a long delay somewhere; yesterday a letter from Mother dated Jan. 23rd. Mother says she has heard indirectly that Neville Champion was near to Roy when he fell. I don't know if Mother has written to Mrs Champion about it, but I expect the word 'close' is wrongly used. Neville was in the Herts Yeomanry, which regiment was [not] in the advance.[29]

The campaign against the Senussi was by now in its closing stages, and on 24 February 1917, No. 8 Company set off from Abbasia for Sollum, by way of Alexandria, Dhabba, Matruh, Um Rakhum, Bir Abdin, Unjeila, Shammas, Sidi Barrani, and Baqbaq, retracing most of the route he had followed with the yeomanry the previous year. Stanley wrote home from Sollum on 18 March:

Now we are in a camp by the sea – with violent sandstorms. The white, fine sand is hurled round our tents and drifted outside, so that we have to shovel it away, as Margaret says they do snow in Colorado. An old ship named *Borulos* brings our mails.[30]

No, we [No. 8 Company] were not in that scrap against the Senussi of which you speak [the taking of Siwa in February], so there is no need for you to be anxious, for it seems we are quite side-tracked for the summer. Inactive under the Egyptian sun. If we only had our old Captain [Mason-Macfarlane] here who was killed last summer by the Senussi, we shouldn't be inactive.

I'm going down now to wash some clothes at the palm tree well. I dislike washing intensely! I am looking forward to some day patronising Mrs S. (the laundress) if she be still existent and not quite dissolved in the steams of the hundreds of washing days at home.

On 20 April, Stanley found himself in trouble again. He was awarded three days of Field Punishment No. 2 (involving confinement in some form) by Captain Paterson of the Westminster Dragoons, who had succeeded Mason-Macfarlane in command of No. 8 Company. His latest offences, not mentioned in surviving letters home, were officially recorded as follows:

'When on Active Service, conduct to the prejudice of march discipline on the line of march.

1. Leaving his rifle on the saddle in dismounting.
2. Allowing his helmet to blow off through neglecting to put down his chin strap.
3. Falling out without permission in the line of march.'[31]

No. 8 Company spent around two months at Sollum in the spring of 1917 (plates 113, 114). The fort there – Fort Abbas (plates 115, 116) – was one of the bases of the Light Car Patrols, formed in spring 1916 for operations against the Senussi. The Patrols were equipped with Model T Fords, some of them mounted with machine guns. The Fords were able to move fairly easily across the sand and rock of the Western Desert, unlike the heavy Rolls-Royces of the armoured car brigades. Stanley wrote to his mother from Sollum on 10 May 1917:

> Just to let you know I'm fit. Yesterday we were out road-making on the hills (plates 118, 119) – shifting great boulders from their old beds; finding under them snakes and scorpions, the latter strangely shaped with stinging tails.
>
> I have found a chameleon, and keep him in the tent on the pole. He will catch flies now from my hand. At first he used to bite in his small way, but could make no impression on our fingers. It is a great entertainment to watch him stalking, looking round and about and behind with his turret eyes. He gets his flies in finely, and they crack in his mouth.
>
> I bought a half pound of butter at canteen yesterday, price 4½ piastres. When we came, we got it as a ration – Australian, and very good. They don't export it now. This is the first I've had for ages; once I thought I could never do without it.
>
> There is an officer here has two young gazelles for pets – the Bedouin gave them to him. They will feed out of his tobacco pouch, and seem to like the tobacco.
>
> The sea is a deep blue today, and I've just had a fine bathe. The ship has just arrived with mail – a letter from you among others, but your parcel has not materialised yet.

Ten days later, near Sidi Barrani, the sea was less benign. No. 8 Company had started the return journey along the coast to the railway terminus at Dhabba, en route for the Suez Canal. On 20 May, Mark Ward and his close friend, the recently promoted Lance-Corporal Robert (Bob) Tett, went for a swim, and were overcome by heavy seas and swept away from land. Someone in camp raised the alarm and Stanley, who was an experienced and powerful swimmer, joined the other strongest swimmers in a rescue attempt. Mark Ward was lucky, but Bob Tett was beyond resuscitation when they brought him ashore.[32]

As they continued their trek to Dhabba, Stanley took several photos (plates 120–24). Before the end of the month, the company arrived by train

at Kantara on the Suez Canal, the principal base for military operations in Palestine. Stanley wrote home from there on 28 May 1917:

We are back from the peaceful plains of Libya, going hard all the time. The Nile is behind us, and the green flash of Egypt (glowing in the soft light of the evening sun) as fresh as our own June countryside. I saw it all but for an hour as our train rushed along.

Our tracks are now upon another desert. Our enemy is no longer the Senussi, hiding in the remotenesses of Western Egypt – but the Turk, who watches upon the hills that are lit by the dawn. I am sheltered from the sun by my little 'bivvy', put together with saddle, two blankets, rifle and bayonet (plate 106). The camels – amusing to watch – are all asprawl on the hot sand.

The air of a waltz from the canteen gives a poetic intensity to evening sounds about the busy camp; and the ships in the canal are shouting of other lands, for we are beside the waterway that ships the steamers from one sea to another.

Stanley to Dray from Kantara, 1 June:

This first day of June finds us camped in a genial place on the Syrian Desert. Beneath a sky the colour of a hedge-sparrow's egg, a glistening tract of white sand, planted with low, wide-spreading fig trees, slopes back to the irregular confines of a desert town; a garden of eddying breezes, a playing-ground for Bedouin children, who swing on the trusted, clean-barked boughs of the trees and gambol in the deep shade; a place for an English picnic – delicate cucumber sandwiches, cooling juice of the lime, and the laughing ring of feminine faces.

We have no tents. By night I sleep, by day I lie, under a fig tree's canopy, my head upon his rounded bowl; my arms – to find his old green soul – are clasped about the stem. My eyes towards the dancing green of whisperings and sighs – old leaves that once hid Adam's nakedness, and now peep-hole the skies!!!

The guns are sounding far away – yes, very far away. A Taube [a German reconnaissance aircraft used by the Ottoman Air Branch] comes gaily every morning, a target for our guns. The stealthy, staring anti-aircraft guns that search the sky, and shoot out their shells after wandering Taubes, remind me of the action of the chameleon feeding on flies – except that the chameleon's is a more direct shot. There seems little likelihood of any fighting for us.

I got your letter of April 29th. What said the Medical Board? You say 'spud' is on the lips (but not in the mouth, worse luck) 'of everyone'. Aunt said you liked to see the old vase [planter] in the garden clean and white! Still the same sensible, practical modern! Plant a crimson geranium therein, to show it up – or else a spud.

From Kantara, they trekked for more than 100 miles – on a wire-mesh 'road' (plate 125) laid on the sand beside the railway – to El Arish on the

Sinai coast (plate 126), arriving in mid-June. Stanley wrote to his father on 16 June 1917, soon after reaching El Arish:

> I hope you are keeping fit and still hopeful about beating the German.
>
> I think my last letter I wrote under a fig tree. Since then we have been some way inland – followed the course of a narrow wadi, which brought us to the foot of some blue-looking mountains. For a few days I was with the heliographers up in the fastnesses of these mountains. Very nice it was too, up there near to the mist, and to watch one or two columns far below moving slowly across the wide desert. It was a noble head of mountain we were upon; probably we saw the poor children of Israel returning back to their own land.
>
> For two days we stayed at a place recently taken from the Turks – the graves of the Englishmen were there. War is an unfair game; there were we, walking into the place after others had fought and bled and died to take it.
>
> The heat is striking hard now. It is the better way to fight it and not lie down – water is plenteous, and thank God for it. I have a real good camel. I call him Tug because he pulls all the time. His neck is very powerful and he breaks loose if I don't tie him down very securely (plate 117).
>
> I see various friends are getting killed – it seems quite the thing now. Well, pass on brave men!
>
> Perhaps this letter is not up to standard. There are a few fatigues on just now – fetching water and fodder and rations.

While No. 8 Company were at Sollum, the rest of the ICC had been involved in the First and Second Battles of Gaza in March and April, in which the EEF, under General Sir Archibald Murray, was defeated by the Ottoman forces and suffered heavy losses. As a result, Murray was relieved of his command in July and replaced by General Sir Edmund Allenby, who was under instructions to drive the Turks out of Jerusalem by Christmas.

Despite what Stanley had said to Dray the previous year, in the November 1917 issue of the *Congregational Messenger* – newsletter of the local Congregational church – another of his letters appeared in print, from an original written at El Arish in September 1917:

> I am in an outpost 'bivvy', perched on the high curve of a sand-dune. The time is 6.30 a.m. Our party has come up from the valley where we spent the night at the crossroads on the look-out for hostile Bedouin parties. Breakfast is being cooked – tea, bacon, and eggs which we bought of a Bedouin for a half-piastre each.
>
> I enjoy camping down in the wadi (plate 127). We reach there from the [main] camp in the evening, when the sun falls in a rich glow upon the sand-dunes, and the first star mounts steady to his post. Bewitching then is our valley of soft lights, fresh colours and sea wind, and the distance puts on that romantic garb of blue I know so well in England. In the dark, foxes sometimes prowl round and we are tempted to shoot – and do so at times, and miss.

One can't go to sleep early. I wandered round the camels and rubbed the nose of my animal; a thin, refined nose he has, beautifully sensitive to the touch. I gave him a bull's-eye peppermint, and a large piece of very stale bread I had by me. Camels are no faddists, they are willing to share any of our rations with us – even to bully beef. Camels are as interesting as dogs to watch; a dog when angry hasn't the dignified expression that a wrathful camel can command, and no retriever can look so sad as a camel in the dumps. When one is angry with another, he drops his head, bulges his eyes, wrinkles his eyebrows, shoots out his lower lip to a point, and swells his gorge, which shows in his mouth like a bladder covered with froth.

Their ways of fighting are rather terrible and they inflict deep flesh wounds on each other's humps; they are snake-like with their necks, twisting and turning them wonderfully in the fight. Strong necks they have – I tied my animal to an ammunition box, and he lifted his head and swung the box round on the halter rope, and then dragged it away with him. He can easily lift me in the air as I hang on the rope.

The sun is high in the sky now, and the wind blows sand around me. A blue line of sea is in the north. Compact palm groves blot the desert shore – from here they resemble pine woods. The tents belonging to a part of the Palestine Army can be seen between the trees; there is the dust of moving cavalry, and the close smoke from a railway engine is blown by the breeze into shreds. The Sinai Police – Bedouins in government service, attired in breeches and blue puttees, and the flowing Arabic headgear – will soon ride swiftly by on their dainty cow camels caparisoned with coloured cloths and strings of black tassels.

I should like to tell you how we eat our meals in the sand, how the meat is cut up by the corporal on pieces of paper, how we balance plates of army stew on the uneven face of the sand and eat from the ground, and how sticky the jam tins get after ten men have dipped [the] 'posser' as they call it![33]

The principal duty of the Sinai Police was to prevent the smuggling of hashish from Palestine to Egypt. By the time this letter was published, the EEF – referred to above as 'the Palestine Army' – had begun its successful advance into Palestine. The ICC left El Arish at the end of September 1917 and took part in the capture of Beersheba on 31 October (plate 128), to be followed a week later by the Third – and this time successful – Battle of Gaza. Allied forces then advanced swiftly northwards. The ICC and yeomanry together captured the village of Yebna on 12 November, followed by the Russian Jewish settlement of Rishon-le-Zion, principal centre of the wine industry in Palestine (plate 129). The important seaport of Jaffa was taken without a fight on the 16th. Stanley wrote to his mother from the ICC's camp 5 miles inland on 21 November:

I'm well up in Canaan now, near to the sea, amid delightful orange groves. I'm fit, and everything is all right. Army rations very good, now we are advancing.

This is a delectable land – soil red and rich – olives, almonds, oranges, lemons and grapes are grown. The villages are very pretty. Large white, red-roofed houses – owned I think by Jewish colonists – show between the eucalyptus and mulberry trees. The people come out with bread to sell us – brown it is, 1s a loaf. Sweet wine they also bring, and a few cakes.

I got a letter yesterday. It is a pity the autumn affects you gloomily – I suppose it is the November days. After the wilderness, I rejoice to see the yellowing leaves and cloudy rainy skies one sees here.

Could you send me an Old Testament.

Stanley to his mother, 30 November 1917:

To tell you I'm fit, enjoying our wanderings over Sunny Palestine. The skies are free of rain-clouds now, and the lands glow under the autumn sun. Recently we watered our camels in a village where a colony of Russian Jews lived. A pretty place of red and white houses set on a hill, looking towards the Hills of Judah – neat vineyards in autumn leaf, almond tree plantations, orange groves nodding the yellow fruit, and the silvery wave of the dark-hued olives, we rejoiced to look on as we rode up the sand lane hedged with the cactus – and the rustic peace of the settlement, where the people seemed indifferent to war and followed their daily pursuits. I saw a child dressing a doll with white dress and red sash, an old man descending from a loft with gardening tools, and a sailor-man – perhaps from Jaffa – conversing casually with a demure girl of sweet seventeen. These Jews – especially the Jewesses – are very European in dress – tight skirts and high-heeled shoes. The poor Arabs look to be outcasts.

We can buy bread and wine and nothing else. Sugar, they have none; honey was offered – at 5s a bottle!!

The ICC remained on the front line near Jaffa, under intermittent Turkish artillery fire, while Allenby moved more troops into position for his planned attack on Jerusalem from the west. However, their camels were by now in very poor condition, so on the night of 4–5 December they were relieved by the New Zealand Mounted Rifles Brigade. Their return trek southwards took them back through Yebna (plate 130), and when Jerusalem was captured on 9 December they had almost reached Gaza. By the 12th they were at Shellal (around 15 miles south of Gaza) from where Stanley wrote to his mother on the 14th, fearing his news would not arrive in time for Christmas:

I meant to write you a Christmas letter, but it was impossible. Recently we have been moving night and day, and – while our camels stayed under the shelter of hills – we have been digging hard and spending exhausting hours in the trenches.

Now we are in for a rest after eight weeks of the going. The camels have had a bad time – we were trekking three nights in pouring rain. The fertile Philistine Plain was a quagmire in which poor animals sunk down, many of them to die of mange and misery. My camel Scissors became so ill for lack

of sun and sand, I had to shoot him where he lay helpless in the mud on a murky night.

The nights are bitter with cold – never have I known it so cold, the frost was plain on the ground – but I am well-clothed, and looking and feeling as fit as the round red holly berry.

Canaan is beautiful. The soil is reddish and fine to dig – fruit abounds. What a sight for children the orange groves round Jaffa! The European Jewish settlements are pretty, but they spoil one's imaginative picture of the Holy Land which we take with us from the Sunday School. I prefer to see the man in Eastern raiment mounted on an ass – there are plenty – than old bearded Jews in low, black, round-brimmed hats. They remind one of Shylock, and little of the good Abraham.

Well, I'd rather be in Dorset this Christmas than in Judea. Whether snow and red berry, frosted earth and clear cold sky, or warm sun and the hounds out – 'twould be better than the Plains of Philistinia.

A fine parcel has come in from you containing two pots of jam, biscuits, cigarettes, and sardines and cocoa. Don't worry about the parcels; one very occasionally will do me, and the things you send do me well.

By Christmas, the ICC were resting at Rafa, between Gaza and El Arish, where they would spend two and a half months. They needed to recuperate after their arduous campaign, and they were awaiting remount camels. Christmas was celebrated with a sports day and concert, but there was no special fare because the men's Christmas parcels did not arrive until early January.[34] Stanley wrote to Iris from Rafa on 12 January 1918:

The happiest of years to you. I see you are sticking well to the nursing (plate 131). I suppose you're about in love with it.

Your letter of November 20 came to me when on the Palestine 'stunt'. Not a bad stunt either – interesting – but we did no fighting, though our battalion was often ready, dismounted for action. The cavalry (light horse and yeomanry) swept the ridges and we, ponderous and stately, followed in their rear. We were ever on the move – mostly at night, eerie work in the darkness – over rough, stony ground. We often sat on our camels, half asleep, wondering sadly why the Camel Corps was ever formed, and where the colonel was leading us. Sick camels fall out, the packs on led camels fall off, the unwieldy ... boxes of ammunition charge into obstacles and are 'put out', unintelligible messages come up from far away back, breaks in the column are made; and then, perhaps, your own most valuable bundle of firewood drops – and no time to pick it up.

We had a long ride one afternoon, from Deir el-Belah to Tell esh-Sheriah. The land is quite a wilderness there, and the recent fighting made the road a sickening sight – dead Turks, stark dead horses, scattered ammunition, shell cases, blood-stained bandages and rags of soldiers' clothing strewed the way; and the sand, blowing in a warm wind, drifted and eddied around the dead things. We had then but just come down from the hills around Belah and felt filthy – the sand caking in our beards and the sweat oiling our dirty bodies.

One night a thunderstorm broke over us. The camels 'barrack' at once, noses down-wind, and refuse to move till the storm subsides. I don't blame them, poor things, they love the sunshine and the azure sky.

I rejoiced to come on the bright country that leads up to Jaffa – so fertile and rich. There was Ramleh in the distance, white, alluring; the square, decorated tower of some religious house rising over the town, which is planted round with bushy groves of fruit trees. A huge granary was at Ramleh, filled with dhurra, which gratified our camels not a little. But the place itself is festering with dirt and rotten with stench.

The modern Jewish settlements surprised me. From Ramleh – which is, in all things, Eastern – we came to Rishon-le-Zion on a hill, embowered in trees, where cosy, red-roofed houses peeped through, and white-winged pigeons fluttered on the warm roofs. The children were out from school. I saw a small girl with a fine, fair doll dressed in white and encircled with a red sash. Beautiful Rebeccas and Rachaels – half in and half out of doors and windows – eyed us, but in no saucy manner. Women sold us bread and wine, and a dishonest old man sold us 'bread' made up in the semblance of 'cakes'. There were shops down the street, and people shopping. I saw a lady dressed in the French style, paying an afternoon call. There was a man gardening. But it was so quiet that it reminded one of the rustic peace of a small English village. We walked our camels at Rishon-le-Zion. Our animals filled the narrow roadway, the people staring as though they didn't know that the English army went in for camels.

I was rather sorry when the order came for us to return, although glad enough at the time to get out of some very insecure trenches. I never enjoyed bully beef so much as on the Palestine stunt, and the daily issue of dried raisins was useful. No one, however, had any tobacco. Fellows used to obtain a little from the Arabs for money, but it was very strong stuff.

Our camp is now on the Egypt-Palestine frontier line, by the sea. Great dunes lie between us and the shore and the green-springing plain, and in the shelter of the dunes we abide. Today I have been with the camels to graze – plenty of green blades now for them. I got wet through in a hail storm. Sounds English, doesn't it?

I visited a Bedouin family to buy eggs, and obtained ten large, new-laid ones for 1 piastre each. The extensive family lived in two warm, beaver-like huts made of brush-wood. The 'bint' who sold the eggs had her hair streaming with small coins, and a length of [silver] 20-piastre pieces around her neck. Her nose was ringed, also ears and wrists and ankles were encircled with heavy ornaments. Her husband and son were eating a mess of potage out of a bowl with their fingers. A kid in the beaver-hut was trying to swallow an egg. I asked the 'bint' to give me one over for luck, but she said 'la finish' – but brought out a broken one, which I guessed was that the kid had stuffed in her mouth.

The Bedouin are busy ploughing just now.

How are you faring through the winter? What do you get pay per day? 1s 5d, like me?

Stanley to Aunt Bertha from Rafa, 6 February 1918:

Thank you for the *Telegraph*s you sent me. The last mail brought those dated January 3 and 4. I hope you are keeping well this winter – no rheumatism or bad colds.

A rain-wind is blowing today which reminds me of our own sweet and mild south-westerlies, which bring up so close to us at home the sound of the Rolling Bay and the church bells and clock.

We have a few 'mad' camels just now. They foam all day and bite at their chains. I heard someone call us 'Allenby's Lion Tamers'. I lost my old camel, Scissors, on the last stunt, but I have had given me another which looks to be good. He is young, handsome and white-coated – a smooth ride and fast on his legs. I'm glad he is a smooth ride – very glad – a rough-trotting camel is terrible. Think of this if you ever intend buying one.

What a lot we hear of War Aims – not a word about that Aim which I suppose is now too boastful to strive for. I mean the Aim to prove by Victory that our grand old English stock is superior to the Enemy's in physical fighting, courage and endurance.

Last Sunday [3 February] I rode away [to see] the Dorset Yeomanry, nine miles distant. A glorious morning, the sea in merry movement flashed, the sky arched clear, and fluttering larks sent joyous songs to earth. At the camp I saw a number of the 'old boys', and many I missed who were killed in Palestine. Old Bown, the cook, I saw busy with the dinner. He rides a donkey now, and has a second ass to carry the dishes when the regiment is on the move.

The Dorsets had been at Deir el-Belah, 14 miles south of Gaza, for a month. The day after Stanley's visit they moved to Gaza under orders to salvage materials that had been left in the British trenches there and were now urgently required at the front line, notably corrugated iron sheets, brass and copper (including ammunition), good wood, iron pickets, and coils of barbed wire.[35]

Stanley wrote to Dray from Rafa on 27 February 1918:

How are things going with you? That was a fine parcel you packed for me – I acknowledged it in a recent letter.

There is nothing exciting in our doings at present. This morning one of our 'mad' camels broke loose and held the arena against us; any attempts to trap him with ropes were futile – he chased all intruders up the steep dunes. Eventually the officer shot him with his sporting rifle. Dangerous beasts they are.

A few days ago I went up the [railway] line as far as El Mejdel to fetch back remount camels. We had a good trek back. The country is looking fine – the plains are green, the gardens flowered with almond blossom, and the hedge-banks down the village lanes bright with blood-red anemones. Large purple iris and the small pheasant-eye narcissus grow common out here. We rode by famous Gaza and halted for some grub outside the

Turkish wire entanglements; the rusty old tank is still 'on the rocks' a few yards from the trenches – he must have been hit just as his nose was sniffing the Turks.

There are thousands of starlings out on these dunes. They come in swarms round about the camel lines; it's fine to see them flying en masse. They close, extend, and wheel in wondrous fashion. Yesterday I saw two hawks chasing a few hundred through the sky. I fancy they must fluster them till they are tired – I saw one starling drop dead beat to the ground, and the hawk sank like a stone after him.

Thanks for your letter of Jan. 6th. I was glad you reported 'very fit'. Should like to see the 'violent check' suit; does one receive a 'violent check' on looking upon it? Who was the girl you tried to tack on to Bertram [when he was on leave]?

Before Christmas I wrote a letter home a little descriptive of the Palestine stunt, but it don't seem to have arrived. Mother's latest letter is dated Jan. 28th. I hope she does not worry about not hearing from me. I write, but the sea must choke over a letter now and then.

I enclose you some snaps. One or two VPK rolls of film would be welcome if you think to send them.

Stanley, still at Rafa, wrote to his mother on 9 March 1918:

We have left the sand-dunes, and are come out on the plains to graze our camels. We are out with them from reveille till nightfall. The land is green with barley. Last year with the fighting, much of it fell to seed unharvested, and now the plains laugh and sing, they stand so thick with it.

Last August this part was dry, hard and dusty under the blazing sun, and there was little water down in the great wadi. The recent heavy rains have lifted the grass and wild flowers, and broken the dried springs at Esh Shellaleh. Red tulips and anemones are growing in the green waves of grass, and the wild hyacinth and stock, the small Spanish iris and purple antirrhinum flourish in places. Marigolds, white scillas, marguerites, and a beautiful mauve shrub are in array, and I have found some large purple Japanese iris and pheasant-eyed narcissi.

Beautiful days we are living in. The sun is a happy jewel in the blue sky, the wind trickles like fresh, cool water past us from the spicy East, great prey birds swim and float all day above us, and the larks flutter and sing like toy birds freshly wound. Geese in their hundreds pass in strong lazy flight my 'upwondering' eyes.[36] I cannot think these are of the earth. Spirits from the Unknown, they fly to us in semblance of swans and geese, and pass again into the mystery of space.

The Bedouins are happy now their tents are over the plains, their hearth fires signalled by the blue twists of smoke. Their flocks are fleecy white as summer clouds, and their cows and goats set off the pastures.

My camel is going fine – he comes in every night, his belly full of barley. He looks at me enquiringly, with pupils tender brown and eyebrows wrinkled.

I am looking forward to a mail. I hope everything is well at home. The papers don't speak 'rosy' of England just now. Are the daffs out? These days I seem to smell the English copses breaking in primroses and bluebells.

'Lights out' is being called. My fondest love to you and Father.

After a pause of two months following the capture of Jerusalem, Allenby's Palestine campaign had resumed with the taking of Jericho on 21 February, and the entire west bank of the Jordan from there to the Dead Sea was safely in Allied hands by the end of the month. The day after Stanley wrote the above letter, the Camel Corps, now well rested and equipped with new camels, was ordered to move to the Jordan Valley for the next phase of the campaign – an invasion of Transjordan (corresponding approximately to the present-day Kingdom of Jordan). Their route took them through Beersheba, Hebron, Bethlehem and Jerusalem, down through the Judaean Hills to just north of the Dead Sea. The Turks had destroyed the stone road bridge at El Ghoraniyeh, and the Jordan was unfordable at this time of year. Therefore engineers had to construct new bridges. By the end of 23 March, despite strong currents and enemy fire, they had made a footbridge for infantry, a pontoon bridge and a heavy barrel-pier bridge, all at the El Ghoraniyeh ford, and two pontoon bridges at Makhadet Hajlah (the pilgrim ford). The Camel Corps crossed by one of the Hajlah bridges on 24 March (plate 134).[37] They then struggled over the Mountains of Moab in torrential rain and, after three nights on the move without pause, were able to shelter in a large cave on the eastern slopes. The raid on Amman began on 27 March. The Turks put up stiff resistance and, although the Allies succeeded in causing some damage to the strategically important railway system, they were forced to withdraw. A second attack on Amman began in the early hours of the 30th, and the Camel Corps captured two lines of trenches but were unable to advance any further. The following night the EEF started to retreat, and the Camel Corps took a slightly more northerly route to regain the west bank of the Jordan by the barrel-pier bridge at El Ghoraniyeh (plate 135) on 2 April. They would remain in the Jordan Valley until near the end of the month. The last letter Stanley addressed to his mother was written from there on 5 April 1918:

Have been unable to write lately. Trust this will reach you.

We are in most sacred places, and our camels away behind us for a few days. I'll have plenty to tell you later when we get away for a rest, which time will be soon.

Our latest stunt has been a unique one. We pulled our camels over the gloomy mountain by a narrow mule track – the rain incessant, the mud deep – and we waded over torrents that foamed and raced between our camels' legs. Three nights we trekked in the land beyond the River; a night's sleep, and then a fray in which we lost good men. For a while we dwelt in a great cave of the kind which sheltered the Levi kings at Makkedah. It was like a brigand-life, but no loot, or wild animals to kill.

I have seen Solomon's Baths near to Bethlehem, and the pretty town of the Nativity. Jerusalem we rode through in the moonlight – a sweet clock

note struck the ninth hour. It is indeed an aesthetic city, high on the hills, commanding great views (plate 133). The winding Eastern road looks out on white and delicately spired churches, strong stone buildings and dark groves. The Roman walls look grim. It is like a dream city one would see in sleep. One becomes silent. The forceful drama that darkened, and then brightened forever our Jerusalem still hangs over the city.

Stanley's final letter home was addressed to his father on 25 April 1918. It was also written from the Jordan Valley, on the day after his twenty-ninth and final birthday with only five full days left to live, and contains an eerily prescient passage. It again records his appreciation of seeing the Biblical lands of Palestine, known to his imagination since Sunday school days and which were to be his final resting place.

It was nice to get your letter that was written on Hayward Bridge[38] while you awaited the 6.41 train. I am reminded of the pre-war timetable of trains to and from Blandford sometimes, when I hear certain numbers read in army orders – 7.54, 10.19 and 6.34!

Roy and I used to go with you to Corfe Mullen when you spooned for jack from Adam's field. Ah! those lush meadows and placid waters! I'm glad you and Dray are fishing again. There is something very reassuring and confident in the fact that two men of business can ignore the war, the war's effects and the stress of the time, to saunter off to fish in our Dorset streams. It is delightfully contemptible. I think if everyone took to fishing rods instead of rifles, the Hun – on arrival in England intent on conquest – would turn about again when he saw every stone bridge and meadow bank dotted with silent, smoking, philosophic fishermen, and take to it himself!

We are camped near to a mountain stream [the Wadi el-Auja, plate 132] which runs through bushes and rocks to the Bible River. It is a God-send to us now we are back from the front line, which we are holding.

The front line ran south-eastwards from the coast to the Jordan. No. 8 Company took its turn at defending the strongpoint of Musellabeh, a hill 10 miles to the north of Jericho.

Our Eastern trenches may be quieter than those of Flanders, but lack of washing water, innumerable flies by day and 'quitoes by night, and hot sun and flying dust, do not make this life more genial. I speak for the infantrymen – I reckon some of those Gaza trenches at Samson Ridge must have been frightful to live in. Here, our cover is rock, not trench, and we view the enemy from low, steep, bouldered bluffs.

We have been here three weeks – we had then returned from a most interesting stunt to Amman beyond Jordan. You can guess what our objective was if you see the map [the destruction of the railway line]. Bethlehem and Jerusalem we rode through under the moon, and the famous road to Jericho we passed along at dead of night – a muffled, noiseless column of patient, philosophic camels and tired, irritable men.

It was Palm Sunday [24 March] when we sighted the Dead Sea and crossed the River – what a lively flow of water! – about twenty-five yards wide, the banks overgrown with willowy trees that reached out over the water. Some of us bathed in the ford beside the pontoon, and the engineers were diving from the boats. The valley is luxuriant with flowers and shrubs; nature seems to possess tropical strength in this oppressive valley.

We went over the Mountains of Moab against pouring rain, thick mud and rushing torrents. A grey curtain of rain-cloud closed on those heights where we climbed, and refused to lift for forty-eight hours. Think of our poor camels rolling over and over down greasy slopes, and others down in the deep mud unable to rise. Palestine is a rain-sodden, mud-plastered land for many days in winter.

We scrapped with the Turk on the 27th March. I lost something of a pal when Harvey was killed – hit in the stomach while looking for wounded. He was a stretcher-bearer, but I had my rifle this fray. Harvey was a rare man. He joined us from the West Kent Yeomanry – a keen botanist and photographer, with a high taste for everything good and beautiful. He certainly had the right to live – more so than many of us – but 'o' course 'e went an' died'.[39]

On the night of the 27th a large party of us took shelter in a great cave, whither our captain [Tredinnick] led us. There we remained, except for the guards and outposts that were sent out, for two nights. I enjoyed the experience – a gathering of ragged, dirty, unshaven Englishmen sleeping against the walls of this ancient Moab cave; and if not sleeping we were cleaning our rifles or conversing on those more amusing incidents of the 'scrap'. We had one more 'go in' at the Turk, which took place two o'clock of the morning. Our company was in reserve, and had nought to do but lie prostrate on the rocks with our bayonets fixed and watch the chill, miserable dawn break to the accompaniment of that burning, tearing noise of flying shell. 'Johnny' (we call him 'Johnny' in a most endearing way) never fires his guns at night.

When we did get away back with our camels, it was night. A damp, silent night, mystic with the light from a piece of broken moon and a long shroud of mist that hung over the enemy ground. I shall not forget that scene. The Turks watching and listening, ourselves watching and listening, and waiting for the soft, padded tread of our camels.

We rode back and over to Jordan in brilliant weather. Through the village of Ain es Sir [on Easter Sunday, 31 March],[40] where Circassians and Arabs live – a resolute, fierce lot of men.

The 'resolute, fierce' Circassians were a Moslem mountain people from the Caucasus who were expelled from their lands by the Russians from the early 1860s and underwent forced mass migration to the Ottoman Empire. Those who settled in the Jordan Valley included 365 who arrived at Jaffa in 1883, but were debarred by the Russian consul from settling too close to sites of Christian pilgrimage.

[Then we rode] down a narrow valley [the Wadi Jeria] clothed with grasses, flowers and tall, thin trees. A beautiful stream rushed, and stayed in deep pools, and rushed again between the white rocks. Many miles away beyond the hills we were riding, beyond Jordan and the Valley. Far back in the [Judean] hills that encircle Jerusalem we could see a tower, which I know is built in Jerusalem and is a landmark for wanderers in Moab.

It was a gusty, gloomy night when we rode over Jordan.[41] I shivered when my camel struck the ford. Perhaps the dark, the wind, and the croaking of the frogs made me think of Jordan as the river that runs in the Valley of Shadow, through which the dead pass.

Then to Jericho, where we camped for two days beneath the Cliff of Temptation, on the face of which is built a Greek monastery.

It is a fine photo you sent me of yourself. When was it taken? These three war-shadowed years seem to have flown over you. I have not heard how the East Street trouble ended. I hope your manager was able to remain. Mothers must find it hard to feed their children, but no one ought to miss meat – it can be well done without. I should miss sugar, butter and tea most; dripping and lard with a pinch of salt is good.

Australia feeds us quite a lot – Nestle's Australian Milk, Hobart Jam, Queensland Bully Beef, and Australian rabbits we have had. We are getting army biscuits, too, that are made in Egypt. Our ration of tea is getting short. If it comes here from the East direct, this ought not to be.

The flies are very troublesome. We are given fly-paper, but the Egyptian fly is too wary – or else the papers are no good.

Have you seen Cousin Harold since he left hospital at Oxford? Does it depress him much? Very hard luck it is for him. [Harold survived the war and would eventually return to Australia, but had lost a leg.]

I hope Bertram is safe through the gigantic fighting in France. You at home must be very anxious. I hope he is all right. They have pushed us back there – we expected it – but never mind; England bides her time confidently.

Thank you for paying my L/P [Life Policy] premium to Lloyds Bank. One does not want money as a private in the army. Our pay is now 2s a day and, on stunts such as the present, we save money, which is paid us when we get accessible to canteens. I should like to put that deposit money of mine into the war. I suppose I had better send a written and signed authority to the bank. Would you do it for me? War Saving Certificates would be best, as I wish to be able to redeem it at any time.

I did not get that book you sent, *The Open Road*.[42] I am reading a book that Shittler sent me, *A Shepherd's Life* by W. H. Hudson, published by Methuen. I feel sure you would like its pastoral quiet, and recollections of the old Wiltshire days of the seventeenth century.

I long for Bemerton meads now and again, and hope for the time when I can set out again on foot over the downs and valleys.

Ever your affectionate son,
Stanley.

Will you ask Mother to send on a couple of thin summer khaki shirts, a little pen-knife for sharpening pencils, and writing paper with pencils.

Meanwhile, the Allies had suffered a major setback on the Western Front with the start of the German Spring Offensive. Allenby had been ordered to prepare to send his infantry to France, and he wanted to make one last attempt to take Amman before they left. His plan was to retake the town of Es Salt in the Hills of Gilead, which the British gave up as they retreated from Transjordan following the Amman raid. The Camel Corps's role was, at dawn on 1 May, to destroy a Turkish pontoon bridge over the Jordan at Mafid Jozele, around 11 miles north of El Ghoraniyeh and near the front line, thereby cutting the Ottoman supply route from northern Palestine. The company commander felt he was given insufficient time to prepare, they arrived at the front line an hour late because their guides lost the way, and their supporting artillery failed to materialise. The Turks probably knew of the planned attack in advance as a result of treachery on the part of a Bedouin tribe of characteristic divided loyalty who had agreed to assist, or German interception of British wireless traffic, or possibly both. The Camel Corps were subjected to heavy fire as soon as they emerged on to the open ground around half a mile from the bridge.[43]

Reminiscent of 21 August 1915 at Gallipoli when Roy lost his life, the mission was chaotic and a total failure. One third of No. 8 Company were killed or wounded, and several were taken prisoner. Stanley fell while acting as a stretcher-bearer, ironically on the third anniversary of the day when, in Egypt, he had been trained for this job. Because the company was forced out of the area, not all the dead could be retrieved. Stanley was recorded as missing, and initially it was hoped that he had been taken prisoner. The events are outlined in the following letter of 16 August 1918 from the Enquiry Department for Wounded and Missing, run by the British Red Cross and Order of St John. This organisation was directed by the Earl of Lucan and manned by about 150 volunteers who dealt with correspondence and sought out eyewitness statements. The letter was addressed to one of the volunteers, Mrs Adams of Orchard Poyle, Taplow, who was a lady-in-waiting to Queen Victoria's daughter Helena, Princess Christian of Schleswig-Holstein:

Trooper Stanley George. 50092. Imp. Camel Corps.

Dear Madam,

This last mail has brought us the full reply from Signaller Knight for which we have been hoping. I am afraid it is not any more encouraging than the other report that we have sent, but it is more valuable as being the evidence of an eye-witness.

The one hopeful sign that we can mention is that a card has been received from Reynolds, which has come via Germany, and if he, who was supposed to have been fatally wounded is alive as a prisoner there seems to be a

very faint chance that the others may also have been captured. Signaller Knight's letter is as follows:-

'May 1st, about 6 a.m. we commenced the attack. Being a Signaller, I was in the reserve wave 200 yards or more behind the firing line. The Turkish machine gun post, which was our objective, was 900 yds in front of our newly established line. The first 400 yds or so was ground cut by wadis, and so offered cover. The remainder was flat and without cover of any description. By the time our wave reached the last piece of cover, our boys were getting it hot out on the flat. Two stretcher-bearers went out, but one was hit only a few yards out. The other stretcher-bearer, who was S. George, then called for a volunteer. I said I would give him a hand and was just getting ready when an order came back to say the Company would retire. I asked S. George if it was well for us to go and he replied "we must fetch in the poor wounded". We started to double up the flat and rested half-way. During that run the stretcher was hit many times, so obviously the enemy was not respecting the Red Cross. We jumped up again and ran on. After a few minutes I felt a bump, but kept on. At the same time I looked back and saw S. George lying on the ground. I did not go back because it was madness to stand about; also someone could come out from the reserve and render aid. I reached the line; bullets were coming everywhere. I called out who wanted the stretcher-bearer. Reynolds shouted to me to get back out of it, as it was no good trying to get anyone away under such a heavy fire. I dropped down close to Finch, who was I might mention, the heaviest chap in the Company. He was lying on his chest full length, and apparently badly hit. I called for help and Reynolds who was near started to crawl towards me. Then he was hit and lay on his chest. He did not say another word. I then called again, and another fellow, whom I afterwards learned was Calvert, commenced to make towards me on his hands and knees. He got within five or six yards of me when I heard a "plonk" and saw water running from his water bottle which had slipped round in front of his body as he crawled. Well, here I was left with a big chap very badly hit, in fact I should say mortally, for he lay very still. It was out of the question to think of hoisting him on my back and there was no one near to give me help, because this section was the most advanced and really isolated. My only hope was to return and get help as soon as possible. I jumped up and ran and hadn't gone many yards before they had me through the forearm and side. By the time I reached the first bit of cover, the enemy had advanced and were coming on, so it was a case of getting back to our position as soon as possible. I did not see S. George as I came in. Some of the fellows saw the enemy take in some of our fellows, so it is probable that Finch was one of them. The other two, I really don't believe could have lived. All the fellows I have mentioned were well known to me. Poor old Calvert came from my Regiment and was in the trenches with me at Jaffa. S. George knew my home very well. He was a man known for his pluck. On one occasion on the Western Frontier he showed great pluck and endurance

in a drowning incident, when he rendered great assistance [see 20 May 1917]. You might convey my deepest sympathy and condolence to all the relatives. If it had been possible to get them in, we should have done it.'

Trooper George evidently behaved in a most gallant way, and we can only trust that he may be safe, though I am afraid there are very serious signs to the contrary.

Please convey our deep sympathy to the family.

In his own later account of the action on 1 May, Mark Ward recorded Stanley's death alongside that of one of the others involved in the rescue operation on the day of Bob Tett's drowning:

Our Sergeant Major W. Guppy was wounded, also the chap who pulled me out of the water at Sidi Barrani, little Jimmy Harding from Weymouth who had just joined us, was badly wounded. We carried him carefully back to Red Cross, but he died the same night. Another one who lost his life was Stanley George from Blandford. He was different from the rest of us, while we were card playing he would be reading Shakespeare or books of poems. He was a good soldier and nobody thought it strange that he did not join in with the rest.[44]

An Officer on the Western Front

Bertram was back in England on 18 September 1916. He was transferred to QODY reserves and subsequently to the 2nd Reserve Cavalry Regiment, to which the QODY became affiliated. Initially he was on home leave, as he had hoped. On 29 December he joined RA Officer Cadet Unit, Topsham Barracks, Exeter, to begin his training.[1] Parts of the four-month course, such as observation, range-finding and gunnery (including live firing), took place on the ranges at Okehampton, Dartmoor. The Royal Artillery had expanded enormously since the start of the war, and by the end of 1916 the strength of this largest of regiments was approaching 500,000 men.[2] The preceding two years had also seen major technical advances. Bertram's period at Exeter coincided with a reorganisation and expansion of officer training for the Royal Artillery, with dedicated cadet schools being set up in February 1917 for the RGA and RFA. He completed his course at what had become No. 2 RFA Officer Cadet School, Exeter, on 21 April 1917.

The following day, Bertram was appointed to a temporary commission as 2nd lieutenant in the Royal Garrison Artillery (Special Reserves), and posted to the 2nd Reserve Brigade for Heavy Batteries, RGA at Avington Park, Winchester (plate 136),[3] established during the 1917 reorganisation as the training centre for 60-pounder guns.[4] In July, after embarkation leave during which a couple of studio portraits were taken (plate 137), he was posted to 23rd Heavy Battery on the Western Front.

The RGA was organised into groups (renamed brigades at the end of 1917). Some groups consisted of two heavy batteries equipped with 60-pounder guns (so-called because they fired 60-lb shells), plus two or four siege batteries with even larger guns. Others consisted of four siege batteries alone. Batteries often moved from one group to another. Groups or brigades themselves were not autonomous, being attached to the army corps whose infantry they supported, and would from time to time be transferred from one corps to another. These moves were sometimes purely administrative, without a battery changing location, although its precise role might be modified. Heavy artillery operated from well behind the front line.

Their main roles were to provide bombardments preparatory to an infantry advance, covering fire during an attack, counter-battery work to neutralise or destroy enemy artillery, and 'harassing fire', often at night. The gunners themselves were generally too far back to see their targets, and were guided by reports sent from forward observation posts by field telephone, or from RFC or balloon reconnaissance.

At the start of the war, a heavy battery had four 60-pounders, but by early 1917 this had been increased to six. A 60-lb shell was propelled by a 9¾-lb cordite charge, giving it a range of up to 7 miles. The gun and its carriage together weighed 5 tons. When a gun was to be moved, its carriage was attached to a limber – which was also used for carrying ammunition to the gun once it was in position – and the complete, four-wheeled assembly was drawn by a team of eight to twelve horses according to local conditions (plates 139, 140). At this time, only the heavier siege battery guns were routinely hauled by tractors. A typical heavy battery was manned by five officers and over 100 other ranks, and equipped with almost 100 horses.[5] The officers comprised a major in overall charge, a captain responsible for administration and transport, and three lieutenants, each of whom commanded a section of two guns with their men and horses. In Flanders the army was served by an extensive railway network, and ammunition was often delivered to the guns on railway trucks propelled by the men themselves (plate 142).

No letters have survived from Bertram's time at Cadet School or at Winchester. His communications home from the Western Front are brief, some clearly just postcard or telegram messages whose only real purpose was to reassure the family. They seldom give any clue as to precisely where he was, but when Bertram received his commission, 23 HB was in action in Flanders as part of 60th Heavy Artillery Group. It would remain there for most of the long-drawn-out Third Battle of Ypres (July to November 1917), the whole of which became popularly known as Passchendaele after the village taken during its final offensive. This campaign encompassed eight separately named battles over small pieces of territory, but for the gunners it was an almost continuous duel with the opposing artillery.

The British preliminary bombardment in preparation for Third Ypres began on 22 July, and it was about this time that Bertram joined 23 HB. By then, 60th Heavy Artillery Group was attached to II Corps in General Sir Hubert Gough's Fifth Army, just south of Ypres. Conditions were difficult from the outset. Some of the group's batteries were unable to operate on 23 and 24 July because enemy artillery had cut a railway line and hit the train that would have delivered their ammunition. Then on 26 July, 'Two of 23 HB's guns were condemned for wear and were drawn out of position and taken to workshops.' The group also remained short of ammunition, and by 2 August '23 HB had only three guns in action'.[6]

The artillery supported a successful advance on Pilckem Ridge to the north of Ypres on 31 July, but the next day was too wet for the planned further advance to the Gheluvelt Plateau. The rain continued incessantly for three days, and indeed total rainfall in August 1917 was five times that for the same month in each of the previous two years, with only three completely

dry days. Moreover, years of shelling had disrupted the natural drainage and created an almost impenetrable marsh (plate 143), making Passchendaele one of the muddiest – as well as one of the bloodiest – of all Great War battles. Bertram's first letter from the Western Front was written on Monday, 6 August 1917, between the Battles of Pilckem and Langemarck:

It is Bank Holiday, and in those far off, happy, halcyon days we would have been sailing round Poole Harbour in the *Beloved Vagabond*. Here things are not as comfortable as at 127 [Avington Park], but we are happy, and manage to keep fairly dry. The rain has been pouring down for three days, and everything is deep in mud – knee deep in places.

I am at present with the wagon lines, but go up alternate days to the battery position about 3,000 yards from the front line. Here, we are several miles behind. It's quite exciting up there at times, when shells come over, and a real bombardment fairly shakes the ground, and deafens one like a huge drum.

Up there we live in a tunnel about thirty feet below ground, with little rooms branching off from the main way. The major calls it a medieval oubliette, and it certainly is a noisome dungeon, with streams of water running down the walls and off the roof, but it's quite safe – anyhow, no shell would ever come through it. There we live, move, and have our being, and from there we – by telephone and other instruments – direct the battery fire.

The number of troops here is enormous, all living in holes in the ground or roofless houses. Where our battery is now was at one time the front line before we advanced, and the country is awful – bare, blasted tree trunks, a few blighted grass blades, acres of docks and nettles, and the whole a tumbled sea of water-logged shell-holes (plate 144), with just a few little mounds of brick-dust to indicate where was once the thriving little village of St-Elooi [St --- in original] (plate 141).

We get very good food – better bread than yours at home – and the canteens are able to supply nearly anything – at most exorbitant rates.

This may sound a terrible picture to you, but I assure you that I'm well and happy, and there's a gramophone going most of the day to cheer us – also a cricket match tomorrow evening if the mud dries enough.

Despite the weather, intense artillery activity continued, leading up to the Battle of Langemarck on 16 August, and subsequent local operations forming part of Gough's preparations for the final advance to Passchendaele Ridge. On 19 August, 23 HB was 'heavily shelled with HV gun'. The battery lost three dead, but the following day 'engage[d] HV gun which harassed them yesterday'.[7] The group's war diary continues to note 'successful shoots' by 23 HB into early September.[8] Then on the 7th, by which time the battery was near Zillebeke, it was transferred to the 11th Heavy Artillery Group under X Corps.[9]

Over the next month, the Allies made a succession of small advances north-eastwards – in the Battles of the Menin Road on 20 September, Polygon Wood

on 26 September, Broodseinde on 4 October, and Poelcappelle on 9 October – bringing them to just a mile from the village of Passchendaele. Throughout this period artillery fire continued to be exchanged, often heavily; for instance, 23 HB fired over 900 rounds of shrapnel, high explosive and gas in an 'attack barrage' on 20 September.[10] At Zillebeke on 1 October, a day when 23 HB and eight of the group's other batteries 'were engaged on harassing fire, barrage, counter battery work, and in general bombardments of areas',[11] Bertram's 'section came into action under heavy enemy shell fire, but in spite of continuous fire, which caused casualties among his men, he kept his guns in action until "Cease fire" was ordered'.[12] For this deed of 'conspicuous gallantry and devotion to duty' he would be awarded the Military Cross, and the description is from the official citation.[13] For the next week, the whole group took part in preparations for the attack on Poelcappelle, with gas shelling of hostile batteries throughout the night of 8–9 October. It then supported the attack on the 9th, including taking up 'many calls received from aeroplanes', which played an essential part in directing fire on to targets that were invisible to observers at ground level. Poelcappelle was followed by the First Battle of Passchendaele on 12 October, resulting in minimal advance at the cost of more than 10,000 casualties. A fortnight later the Second Battle of Passchendaele began (26 October to 10 November), with the group again supporting the initial attack. This time the village and its ridge would finally be taken at a cost of 30,000 further casualties (plate 144).

'During the month of Oct. the casualties in [11th] Group were very severe, and in consequence batteries were very hard pressed in carrying out the work required of them.'[14] Those suffered by 23 HB were so great that it was withdrawn for 'rest and refitting' on 29 October.[15] By this time, Bertram had been moved away from the immediate vicinity of his guns and their horses, as he explained on 25 October:

> I am keeping pretty fit, though the weather is fierce – rain, rain, rain. I have been transferred to the Headquarters party, so have given up my horses, worse luck.
>
> At present I am spending my time baling out my dug-out and wrestling with a smoky stove – and heartily cursing both. You haven't seen real mud until you've been in the front line – it's six foot deep in parts; soft, slushy, brown mud as sticky as treacle. For trees – there are no real ones here – what remains of the ones we have taken is just the trunk and broken branches, but it is surprising how soon the country recovers. At the back the German prisoners are working – filling in the shell holes and mending roads so that it looks almost normal again, barring the towns of course.

The November 1917 issue of the *Congregational Messenger* containing Stanley's letter from Palestine also carried this brief item: 'We have just heard that Lieut. Bertram George has been awarded the coveted distinction of the Military Cross. Warm congratulations to him!'

The award had been gazetted (officially announced) on 19 November, although the citation quoted above would only be published four months

later, still with no indication of date or place.[16] Bertram's own account is dated 12 December, four days after 23 HB returned to active service. They had been transferred to 16th Heavy Artillery Group in support of the Canadian Corps at Thélus near Arras.[17]

> I have been down at a gunnery school in the back areas, and had a good time for a month after a very hard time in Flanders. Since then we have moved about a good deal, and I'm now with two other officers and a section (two guns) detached from the rest of the battery on a very quiet front. We do one day on duty at the guns, one day on duty at the observation post nearer the front line, and then one day off duty in a village (ruined of course). I am at present off duty in a cellar. One of my men – an ex-bricklayer – has built us a fine open fireplace where the logs burn merrily. The table on which I write is made – and is a real good table – from coffin lids, old and black with age. We didn't have to disturb anyone's dust to get 'em, the Boche did that years ago when he dug up the cemetery with his shells. The old church and cemetery are just behind me, or what is left of them – only a heap of rubbish with beams and broken pews, coffins, and the Virgin standing unharmed above all.
>
> I cannot tell you much about the life out here. Many of the incidents are really very horrible, but a part of our daily existence at times. I enclose a photo (not a serious one as you'll see) which I and two pals had taken down at the gunnery school (plate 138). There was a Portuguese officer about there who wore a monocle and used to annoy us greatly by his supercilious airs, so we all bought monocles also, and used to fix 'em by numbers when he passed by. 'Attention! Eyes right! Monocle!' Eventually he used to cross the road to avoid us I think, as after that we seldom saw him.
>
> Also you see by the photo, His Majesty King George has been pleased to honour me with an MC, for what I don't know exactly [citations being confidential until published]; anyway they are fairly common around here – a pretty flower but common.[18] I hope to get a VC, a DSO and The Order of the Bath before this war is over, but am much more likely to get what I saw this morning out on a lonely shell-swept plain behind our lines, i.e. a little grave with a cross at the head, giving name, no., rank, regiment of the chap inside. On the top was a bayonet and part of a broken rifle stuck in the ground, his helmet, part of his web equipment, and an inverted bottle. An inscription at the foot said he was a good soldier and a true comrade – hence the inverted bottle, I suppose!
>
> I am very fit and quite happy, though the weather is cold and frosty – but we still have most of the old church and village to burn for firewood. So Cheerio.

Portugal had fought off German attacks on her southern African colonies as early as 1914 but without any declaration of war, and had remained neutral until 1916. At the outbreak of war, she had interned thirty-six German cargo ships at Lisbon. Britain, keen to secure Portugal's more active involvement, offered to buy the German ships and have them refitted in Portuguese

shipyards if Portugal would commandeer them. Portugal complied in February 1916 and, predictably, Germany declared war a fortnight later. The British requested a Portuguese force to be sent to the Western Front in July, but training was needed and shortage of transport caused further delay, so the Portuguese Expeditionary Corps only arrived in February 1917. The French requested a separate heavy artillery force in November 1916, but its establishment, organisation and deployment to the Front also took the better part of a year. The unfortunate officer teased by Bertram and his comrades would have been a member of this Portuguese Artillery Corps, which started to arrive in October 1917.[19]

On 20 December, 16th Group was handed over to XIII Corps, but did not change its location, and on New Year's Day it became known as No. 16 Brigade, RGA (Mobile). On Christmas Day, Bertram sent a card home (received 16 January 1918), with a brief and typically droll message:

> No. 348565, Somewhere in France. Christmas Day – great times here – rain, mud, bully-beef. Very thrilling!

Brigade headquarters moved from Neuville-Saint-Vaast to Roclincourt, 3 miles north of Arras, on 15 January 1918, but 23 HB remained at Thélus. 'During this month artillery activity was slight – daily CB shoots when visibility allowed and registration of SOS points.'[20] By this time Bertram was on the battery commander's staff, and therefore at Roclincourt. He wrote home from there on the 20th:

> There are only two officers here just now at the battery position [at Thélus], so you can imagine we are busy. However, we get some others up on Tuesday, which will make things easier – the others were on leave, or gunnery courses. Things up here are normally quiet. The weather is soft, and smells of spring after a slight rain this morning. I can see every stone in the cathedral [at Arras], three miles behind. It looks a fine old place, though I have never been there.
>
> The war on rats is proceeding merrily. The major and I went for a drive last week into the back areas and bought some traps, which have proved very successful.
>
> My terrier has wandered away and got lost or stolen. I am almost inconsolable.

One section of 23 HB moved to Farbus, around a mile to the east of Thélus, on 7 February. This section was heavily shelled on 21 February, putting one gun out of action, and again on 6 March.[21] Whether Bertram was involved in this temporary move is unknown, and there is no clue in his only communication from this time, on 5 March 1918:

> I am sorry I can't give you any war news – it's absolutely forbidden. Of course we only know the small bit we happen to take part in. The whole business is very sordid and depressing.

From mid-March, 16th Brigade supported Allied raids and countered enemy attacks in the area to the east of Farbus during Operation Michael (21 March to 4 April), the first of the German Spring Offensives. The Germans took no territory in the area covered by the brigade, but further south they advanced more than 45 miles, bringing them to within 10 miles of the city of Amiens. During this time, the brigade was transferred back and forth between XIII Corps and Canadian Corps, with which it remained from 29 March until 7 May. It was maybe while it was attached to Canadian Corps that Bertram wrote the following undated note:

> Hurray – we had rabbits for dinner yesterday. After months and months of mutton and bully-beef they were delightful – and being on the battery commander's staff, we have a cook of our own. Well, anyway, we have one swell cook – used to be on a log camp in Canada – so we had one swell meal, and just to celebrate the event we bought a petrol can of champagne and white wine mixed – and we all were very happy. Started the old gramophones and quite overlooked their many faults. There are times when it would take a brave man to put on a record.

The 1918 Spring Offensives were marked by extensive use of gas on both sides; for example, a twelve-hour gas bombardment by 16th Brigade during the night of 5–6 April consisted of '55 lethal, 150 lachrymatory and 42 HE on each enemy battery'.[22] The effects of gas were not limited to where the shells landed and where it happened to be carried by the wind. In a test of gas protection arrangements, it was noted that, 'Difficulty [was] found in arranging for keeping protected dugouts clear of gas owing to men with possibly gassy clothing going down on relief. Decided that all men from outside must be considered as gas carriers and must take off outer clothing at top of dugout.'[23]

For two months, artillery activity continued relentlessly in support of periodic Allied raids and against a wide range of enemy targets. In return, hostile shelling, including further gas attacks, also persisted. On 7 and 8 May the brigade HQ moved, first to Berthonval Farm and then to Château d'Acq near Villers-au-Bois. This was only 6 miles from its previous position at Roclincourt, and the batteries remained in the Thélus area.[24]

At Thélus on 7 June, Bertram suddenly developed a high fever with severe abdominal pains and vomiting, and was immediately sent to a casualty clearing station. He was then moved to the British Red Cross Hospital, Wimereux, on the coast north of Boulogne, where at one point his temperature exceeded 107 °F. On the 15th he was evacuated to England from Boulogne and admitted the same evening to the Acheson Hospital for Officers in London. The Acheson, in Albert Road (since renamed Prince Albert Road), Regent's Park, was one of many private houses to become a temporary hospital during the war, and functioned as an auxiliary to Queen Alexandra's Military Hospital, Millbank. Bertram remained at the Acheson until a War Office telegram of 27 June sanctioned a month's convalescent

leave at home in Blandford. His next Medical Board examination, on 29 July, passed him as fit for home service. He was duly posted back to 2nd Reserve Battery at Avington Park on 9 August, where this time he would have been instructing new recruits. Following a further Medical Board on 3 September, he was 'directed to return to his unit' overseas.[25]

A fortnight after Bertram was taken ill, 16th Brigade was relieved by 2nd Canadian Garrison Artillery Brigade and went into the First Army Reserve, moving to camps and billets at Gouy Servins. Bertram was never given a specific diagnosis, only 'PUO' (pyrexia of unknown origin). When the brigade arrived at its new base, however, 'The Corps Q [Quartermaster] was unable to supply any tents or bivouac shelters so 50% of the men have to bivouac under paulins, ground sheets etc. This is necessary to prevent overcrowding of the huts in view of danger of bombs and also infection from the sudden attacks of fever – popularly called Spanish Fever which is rife in these areas.'[26] This was the first phase of the 1918–19 influenza pandemic, highly infectious but usually self-limiting – unlike the second strain that emerged towards the end of the year and would kill tens of millions.[27] The outbreak appears to have been over by the end of the month, since the last time it is mentioned in the brigade war diary was on the 28th: 'Fever getting better. 23 HB now practically the only battery with many cases, but all Battery Commanders except Major Cobb are down with it.'[28]

Bertram missed an enthusiastic inspection of the whole brigade by HRH the Duke of Connaught on 1 July. This was followed by several days of tactical exercises, and then, after four weeks in reserve, 16th Brigade in turn began its relief of 2nd Canadian Brigade on 18 July, returning to its old positions and old routine of nightly (and sometimes daily) harassing fire, with periodic bombardments and targeted shoots. August saw the King's annual visit to the Western Front, and he passed by 16th Brigade HQ en route from Mont-Saint-Éloi to Villers-au-Bois during the afternoon of the 8th, cheered on by the HQ personnel. Enemy artillery in this region was relatively quiet during August, but there were air raids on the brigade's back areas. Bertram would have been especially sorry to have missed the Corps Heavy Artillery horse show at Château de la Haie on 19 August, at which 23 HB was awarded second prize for 'best turned out man and horse' and third prize for 'best turned out gun team'.[29]

By the time Bertram returned to France, the tide of the war had turned, beginning with the Allied victory in the Second Battle of the Marne during July and early August. After this, the Germans were pushed back almost continuously, though still only giving up defensive positions after heavy fighting. At some point in the two months following his return to France, Bertram was transferred from 23rd to 115th Heavy Battery, part of 7th Brigade. No letter home from 115 HB has been traced, and his severely weeded War Office file does not explicitly mention this move. Furthermore, the 1918 war diaries of these two batteries have apparently not survived, and the brigade war diaries seldom mention individuals by name. What is certain is that in September he went back to the Arras area; 23 HB was still positioned near Thélus, and 115 HB had just finished supporting the taking

of the Drocourt-Quéant Line to the east of Arras, part of the northern section of the Hindenburg Line. Both batteries were part of the First Army under the command of General Henry Horne. For the next two months, they covered separate eastward advances, converging on Mons. The more northerly route was taken by 23 HB. Still in the vicinity of Arras in early October, it reached Esquerchin just outside Douai on the 15th[30] and crossed the River Scarpe at St Amand-les-Eaux on the 28th.[31] Meanwhile, 115 HB started to take up positions around 15 miles south-east of Arras on 22 September, and at the beginning of October was at Bourlon, 5 miles west of Cambrai.[32] After the Battle of Cambrai, culminating in its recapture by the 3rd Canadian Division on 9 October, 115 HB moved north-eastwards, and reached Villers-en-Cauchies on the 13th.[33]

Bertram was promoted to full lieutenant on 22 October, and it may well have been then that he was posted to 115 HB; it seems unlikely to have happened much later. On the 25th, this battery was temporarily attached to 42nd Brigade.[34] Two of its guns were put into reserve or workshops, and the remaining four were positioned at Verchain-Maugré south of Valenciennes, where they contributed to the massive bombardment leading up to the Battle of Valenciennes on 1–2 November. After this, they moved steadily north-eastwards in support of the next stage of the advance, and were in action, often subjected to hostile shelling, successively at Quérénaing, Artres, Préseau, Curgies and Sebourg, close to the Belgian border.[35] At this point, on 6 November, they rejoined 7th Brigade and continued to advance behind the infantry. Since the beginning of October, the First Army's front line had moved forward on average ¾ mile per day. The Germans were still resisting the Allies, but their morale was falling. In early November, there was widespread civil unrest in Germany, Bolshevik revolution broke out in several major cities, and a naval mutiny that began at Kiel rapidly spread to other ports. Negotiations for an armistice began on 8 November, and on the 9th the Kaiser abdicated.[36] The Allied advance then accelerated dramatically, and the First Army moved almost as far in two days as it had in the preceding six weeks. By 10 November, 115 HB had reached Quévy-le-Petit in the suburbs of Mons.[37]

At 11 a.m. on 11 November, the war ended. That day and the next, 115 HB stayed at Quévy cleaning guns and other equipment.[38] On the afternoon of the 12th, a 'beautifully fine and sunny' day, the brigade commander, with some officers of 115 HB, quite likely including Bertram, attended at the State Entry into Mons.[39] The entire brigade assembled at Genly, just south of Mons, on the 13th, and two days later, two guns from each of 115 and 125 HB took part in a march-past at Mons in honour of General Horne of the First Army and the burgomasters of the city.[40] On 28 November, after a period of looking for suitable billets, brigade HQ and the two heavy batteries moved back over the French border to Quiévrechain, as the brigade began its journey west. Two days later the brigade moved 15 miles further west to Marchiennes, where it would remain until midsummer 1919. The first half of December 1918 was taken up with further cleaning of guns, inspections, and daily football matches. Halfway through the month, regular

entertainments began in the YMCA cinema, initially by army concert parties. Carol singing on Christmas Eve was organised by the YMCA. Christmas Day began with yet another football match in the morning. 'Men's Xmas dinners at mid-day. All successful, supplies having arrived in time.'[41] On New Year's Eve a Corps Heavy Artillery Theatre was opened, and Lena Ashwell concert parties – which continued to perform for troops in the Devastated Areas after the Armistice – presented shows there on 24–25 January and 27–28 February 1919.[42]

At last, on 22 January, the commanding officer of 158th Siege Battery gave a lecture on demobilisation in the YMCA hall, which was attended by the brigade commander. Demobilisation was a slow and gradual process. As far as 7th Brigade was concerned, it started the following day, when the first batch of eighty horses was dispatched to Boulogne for transportation to the UK, followed two days later by the dispatch of thirty-six men. It gathered pace during February, with more than 300 men demobilised. On 27 March 1919, Bertram and six other officers began their journey home.[43] Eight days later – and almost five months after the end of the war – Bertram was officially demobilised from 115 HB at No. 1 Dispersal Unit, Fovant, Wiltshire. He then returned to his pre-war position at Thornycrofts, but remained on the Special Reserves with an order to rejoin at Plymouth in case of emergency.[44]

Epilogue

Neither Roy's nor Stanley's body was recovered, so there are no graves. Roy is among the more than 21,000 commemorated on the Helles Memorial at the tip of the Gallipoli Peninsula, and Stanley's name is one of the 3,300 on the Jerusalem Memorial. Very soon after Stanley's death the ICC started to be broken up. The larger part once more became cavalry and took part in Allenby's continued advance through northern Palestine and into Lebanon and Syria, through the sort of country that had already been found unsuitable for camels. A substantial remnant was transferred to the command of Colonel T. E. Lawrence for his operations in northern Arabia. In July 1921 the Imperial Camel Corps Memorial was unveiled in Victoria Embankment Gardens, and Stanley's name can also be found there.

Following demobilisation and his return to Thornycrofts, Bertram lodged with the parents of his friend and by then brother-in-law Malcolm Napier in Southampton. From there he wrote in December 1919 to the Secretary of the War Office: 'As I am going abroad shortly for a period of three years or more, I wish to resign my commission.' He was quickly told that there would be no objection to his going abroad as a civilian. In January 1920 he received a letter of official approval for his resignation, in which he was told he could retain his rank of lieutenant, 'but such grant does not confer the right to wear uniform except on appropriate occasions of a military nature'.[1]

Thornycrofts sent Bertram to Brazil as engineering manager on a contract to convert the maintenance shipyard of the Costeira shipping line on Ilha do Vianna, an island in Rio de Janeiro harbour, into a shipbuilding enterprise. He started work there in February 1920, but an economic crisis in Brazil meant there were hardly any orders, and the Thornycrofts team were sent home the following year. Bertram arrived back at Southampton on 22 January 1921, having been away from England for barely a year rather than the expected 'three years or more'.[2] Five years later, in 1926–27, he returned to Egypt to oversee the construction of King Fuad's shallow-draught river yacht *Kassed Kheir*.

During the Second World War, by which time Bertram had become works manager, he carried out important, classified work always described by his siblings (and in his obituary) as 'hush-hush'. The Admiralty placed large orders for various types of landing craft developed by Thornycrofts, who supplied plans and some mechanical parts to subcontracting yards around the country. Bertram was one of their principal travelling supervisors and, as such, received a full petrol allowance for his Morris 12 throughout the war.

Bertram always worked extremely long hours and had difficulty in adjusting to retirement. The traumas of the First World War – and in particular a sense of guilt at having returned when his two youngest brothers did not – would haunt him until his own death in 1959. He was always private, reticent and self-effacing, though with a keen awareness of the ridiculous and a considerable, if sometimes sarcastic, sense of humour. He was a great reader – John Buchan was an especial favourite – and an energetic walker, but his surviving writings are so few that it is hard to get to know him through them. Even in the family he was a shadowy figure. He was devoted to his parents and very close to Dray, but his technical background and orderly mind set him apart from their two talented but somewhat disorganised and undomesticated artist sisters with whom he also, to some extent, shared the family home in later years. Not one member of the next generation of the extended family who is old enough to remember him claims to have known him well.

The same fate has befallen Roy, though he died before any of the next generation was born. He was much more outgoing and, as testified by Stanley in his diary, received and wrote many letters. That none survives is probably in part because he died so soon – three years before Stanley's death, the end of the war and Bertram's return – so his letters home are likely to have been kept separately.

So, of the three brothers of this tragic tale, the only one it is possible to come away with much sense of having known is Stanley, its principal contributor. After his death in 1918, his Bible was given to Margaret, who inscribed the following:

He had Vision, Understanding
A keen love of the Beautiful –
The Heart of a Poet.

Notes

Introduction

1. The brief summary in Christian, *Wyn George*, p. 87 of Bertram's service after he left Egypt was based on the dates given on the transcripts of his letters, before it was realised that these were unreliable.
2. D-DOY/A/1/1/22, 13 Nov 1916, 3: 'Photography'.
3. Words by L. Wolfe Gilbert, with music by Lewis F. Muir and Maurice Abrahams. The lyrics of this song, popular with soldiers, are reproduced in Max Arthur, *When This Bloody War is Over: Soldiers' Songs of the First World War* (London: Piatkus, 2001), pp. 22-23. Stanley picked up many tunes and songs he heard without necessarily seeing them written down.

Chapter One

1. For more information on the George family history, including the war service of Wyn and Iris, see Christian, *Wyn George*.
2. Christian, *Wyn George*, Chapter One and fig. 2.
3. 1901 census.
4. C. W. Thompson, *Records of the Dorset Yeomanry ("Queen's Own")* (Dorchester: Dorset County Chronicle, 1894), p. xxi.
5. *Western Gazette*, 13 and 20 September 1912; Simon Batten, '"A School for the Leaders": What did the British Army learn from the 1912 Army Manoeuvres?', *Journal of the Society for Army Historical Research*, 93 (2015), 25-47.
6. *Western Gazette*, 30 May 1913, p. 10.
7. The 1913 camp was extensively reported by the *Western Gazette* on 16, 23 and 30 May.
8. D-DOY/A/1/1/15, 19 Mar 1914, 25: 'Promotions and Appointments'.
9. *Western Gazette*, 29 May 1914, p. 6.
10. D-DOY/A/10/3, telegrams 5 and 9 (August 1914); Thompson, *Records 1914-1919*, pp. 3-4.
11. D-DOY/A/1/1/16, 8 Sep 1914, 188: 'Recruits Joined'; ibid., 30 Sep 1914, 342: 'Recruits Joined'.

12. WO 339/70738.
13. The official number of war dead from the UK and Colonies (excluding Dominions) was 886,000.
14. D-DOY/A/10/3.
15. Ibid.
16. D-DOY/A/1/1/17, 30 Oct 1914, 127: 'Horses: Officers' Chargers'. It is clear from Stanley's diary that this was general policy.
17. D-DOY/A/10/3; Thompson, *Records 1914-1919*, p. 2.
18. Becke, *Order of Battle 2A*, p. 12.
19. Becke, *Order of Battle 2A*, p. 14.
20. D-DOY/A/1/1/16, 30 Sep 1914, 370: "C' Squadron promotions'.
21. D-DOY/A/1/1/16, 7 Oct 1914, 388: 'Parade'; ibid., 16 Oct 1914, 428: 'Parade'.
22. D-DOY/A/3/11/5, telegrams 40 and 43.
23. 'Time Table, Sherborne dep. 8.50 a.m., Basingstoke arr. 11.2 a.m., do. dep. 11.40 a.m., Reading arr. 12.15 p.m., do. dep. 12.18 p.m., Wantage Rd arr. 1.26 p.m.' (D-DOY/A/1/1/17, 20 Oct 1914, 67: 'Parade'). There was also a change at Didcot, arr. 1.02 p.m. and dep. 1.07 p.m. (*Bradshaw's Guide*, October 1914).
24. D-DOY/A/1/1/16, 17 Sep 1914, 246: 'Inoculation'.
25. In Christian, *Wyn George*, this photograph was captioned 'early 1915' because that is inscribed on the back of the original, but it must in fact have been taken in October or November 1914 (apparently before Bertram, the last to enlist, had been issued with his QODY cap badge).
26. D-DOY/A/1/1/16, 26 Sep 1914, 310: 'Royal Flying Corps (Military Wing)'; D-DOY/A/1/1/17, 14 Oct 1914, 37: 'Discharge'.
27. D-DOY/A/3/11/5, telegram 95; Thompson, *Records 1914-1919*, pp. 5-6; D-DOY/A/1/1/16, 19 Nov 1914, 649.
28. D-DOY/A/1/1/16, 24 Nov 1914, 681.
29. D-DOY/A/1/1/16, 8 Dec 1914 [wrongly dated 8 Feb 1915], 746.
30. D-DOY/A/1/1/16, 19 Dec 1914, 807.
31. D-DOY/A/1/1/16, 4 Dec 1914, 731.
32. Thompson, *Records 1914-1919*, p. 6.

Chapter Two

1. *Song of Solomon*, 2:17.
2. A. J. Evans, *The Escaping Club* (London: John Lane the Bodley Head, 1921).
3. Stanley usually calls the midday meal 'dinner'.
4. See Christian, *Wyn George*, pp. 181-2.
5. Alfred Simpson, baker and farmer, Harpley (*Kelly's Directory*).
6. Joseph Morton Murfet, farmer, Harpley (*Kelly's Directory*).
7. See Christian, *Wyn George*, Chapter Three.
8. Dr Edward Palin, general practitioner, was grandfather of television presenter Michael Palin.
9. See Ward, 'Dear Mother', p. 9.
10. William Darlow, Rose and Crown, Harpley (*Kelly's Directory*).
11. Mrs Elizabeth Mason, Railway Inn, Little Massingham (*Kelly's Directory*).
12. *Windsor Magazine*, February 1915 (Vol. 41, No. 242): 'The Cloud' by Alan J. Thompson, pp. 413-19; 'A Question of Carat' by Mrs Francis Bailey, pp. 425-31.

13. William S. Milk, Duke's Head, West Rudham (*Kelly's Directory*).
14. 'Your King and Country Want You' (words & music Paul A. Rubens, 1914); refrain 'We don't want to lose you but we think you ought to go'; subtitle 'A Woman's Recruiting Song'. All profits to 'Queen Mary's Work for Women Fund'.
15. William Ernest Mason, landlord of the Fox and Pheasant, Great Massingham, was the son of Elizabeth Mason, widow, who kept the Railway Inn, Little Massingham.
16. Charles Mountain, blacksmith, and John G. Mountain, van and cart builder, Harpley (*Kelly's Directory*).
17. 'England's Last Hope, or the Dare-Devils of Dorset', D-DOY/A/3/12/4.
18. A fairground game like skittles.
19. See Christian, *Wyn George*, p. 84.
20. Ibid., Chapters One and Three and illustrations.
21. For Wyn's time in Algeria, see ibid., Chapter Three.
22. At Netherhampton, where Salisbury Racecourse is.
23. In March the brothers' regiment had officially become the 1st/1st Queen's Own Dorset Yeomanry; the reserve or 2nd-line regiment, formed in September 1914, became the 2nd/1st, and a 3rd-line regiment was raised, called the 3rd/1st. These were usually simplified to 1st, 2nd and 3rd. Only the 1st was sent overseas.

Chapter Three

1. Lestock 'Sticky' Learmonth also appears in 'England's Last Hope', D-DOY/A/3/12/4.
2. *In Kedar's Tents* (1897), novel by Henry Seton Merriman.
3. *Gleneagles* was a local ferry steamer taken over by the Admiralty in 1914.
4. 'Follow me 'ome' was a setting of Rudyard Kipling's poem.

Chapter Four

1. D-DOY/A/1/1/20, 20 Apr 1916: 'Sanitation'; ibid., 14 Apr 1916, 3: 'Aerated Waters Ice cream &c.'
2. By Jessie Patrick Findlay (1857-1933), illustrated from photographs by John Patrick (Edinburgh: W. P. Nimmo, Hay & Mitchell, 1911).
3. E. L. Butcher, *Things Seen in Egypt* (London: Seeley, 1910).
4. This meant they remained in barracks, but ready to turn out immediately if required.
5. D-DOY/A/1/1/20, 24 May 1916: 'Public Property'.
6. The Rt Revd Rennie MacInnes, Bishop of Jerusalem, had been a missionary in Egypt since 1889.
7. As remembered from the first verse of Rudyard Kipling, 'The Love Song of Har Dyal': 'Alone upon the housetops to the North / I turn and watch the lightnings in the sky – / The glamour of thy footsteps in the North. / Come back to me, Beloved, or I die!'
8. Abbas Hilmi Pasha, former Khedive of Egypt.
9. *Western Gazette*, 15 May 1914, p. 5; 10 December 1915, p. 7; 7 January 1916, p. 4.

10. Attilio Serra, Italian Diplomatic Agent and Consul General at Cairo.

11. The QODY War Diary says 'Agricultural College, Ghezireh', meaning the Agricultural Society, Ghezireh, rather than the Agricultural College in the nearby suburb of Gizeh (D-DOY/A/6/5).

12. *Hansard*, 24 November 1936.

13. *Hansard*, 11 March 1954.

14. Louis W. Stickland, fisherman, South Egliston, Tyneham, died 13 May 1915 aged seventy-three. See diary entry for 28 July, and plate 13.

15. Poem XXXV in Stevenson's *Songs of Travel and Other Verses*: 'The tropics vanish, and meseems that I, / From Halkerside, from topmost Allermuir, / Or steep Caerketton, dreaming gaze again, / Far set in fields and woods, the town I see / Spring gallant from the shallows of her smoke, / Cragged, spired, and turreted, her virgin fort / Beflagged. About, on seaward-drooping hills, / New folds of city glitter.'

16. A copy held by State Library of Victoria is freely available online.

17. Firm of Sherborne solicitors, which had become Ffooks & Grimley in 1911.

18. 'Our Outlook', *Y.M., Egypt Number*, 1 September 1916, p. 815.

19. Marcel Clerget, *Le Caire: Etude de Géographie Urbaine et d'Histoire Economique* (Cairo: Schindler, 1934), Vol. II, p. 112; Karl Baedeker, *Egypt and the Sûdân: Handbook for Travellers* (7th edn, Leipzig: Baedeker, 1914), pp. 38-9.

20. American historical novelist, 1871-1947.

21. Gilbert & Sullivan's satire on feminism and women's education (1884).

22. Lviv/Lwow, Ukraine, recaptured by Austria from Russia.

23. 'Geographical Distribution of Students', *The Reading University College Review*, Vol. IV, No. 11, March 1912, p. 101.

24. Robert L. Tignor, *Modernization and British Colonial Rule in Egypt, 1882-1914* (Princeton University Press, 1966), pp. 339-40.

25. Robert Fergus McNeile was a Church Missionary Society missionary in Cairo, 1908-15 and a temporary chaplain to the forces, 1915-19.

26. See Christian, *Wyn George*, p. 86.

27. Lanchester was a British make of luxury car. The French firm Panhard & Levassor provided the official cars for their country's president at this time.

28. *Albizia lebbek*, the Lebbek Tree or East Indian Walnut, a member of the leguminosae (pea family).

29. 'My Old Shako', by Francis Barron and H. Trotère, 1907.

30. Cartoon by Leonard Raven-Hill, *Punch*, 30 June 1915, p. 503.

31. Rogan, *Fall of Ottomans*, pp. 125-7.

32. Ward, 'Dear Mother', p. 31.

33. Rowe, *2nd County of London Yeomanry*, p. 71.

34. *Collier's – The National Weekly*, Vol. 55, No. 8, 8 May 1915, pp. 8-9, 20-2, 24-6.

35. Stanley clearly wrote 'Spanish' sister, yet no Spanish ancestry has been traced via census and birth records. Maybe Kathleen had spent some time in Spain.

36. *Newnes' Handy Pocket Atlas of the World*: pre-war editions sold in Britain as *Handy Shilling Atlas*.

37. Untraced.

38. 'Les Pyramides' brewery was established by Belgian expatriates in Cairo in 1898.

39. 'Oh, the brave music of a *distant* drum!'. Edward Fitzgerald, *The Rubáiyát of Omar Khayyám*.

40. Christian, *Wyn George*, pp. 41, 75; Gwen Yarker, *Inquisitive Eyes: Slade Painters in Edwardian Wessex* (Bristol: Sansom, 2016).

41. Arthur Johnson, writing from Cairo in *Y.M.*, 30 June 1916, p. 599.

42. Leonard Cherry was one of three brothers of Leslie Cherry who served on the Western Front, and the only one of the three to survive. Kenneth was killed in 1915 and Douglas in 1917. Leonard was a close friend of the George brothers, and in March 1917 would become their brother-in-law after marrying their sister Dorothy. The Bee Hive Hotel was an inn close to Arnecliffe, in Sandbanks Road, Parkstone.

43. Of these two friends, at least one (Lockstone) was a fellow bank clerk. Lockstone's brother John married May Handover in 1926. Swatridge had not in fact been killed, but taken prisoner.

44. Kipling, 'Follow me 'ome'.

45. Part of the chorus of the music-hall song 'Row, Row, Row' by William Jerome and Jimmy V. Monaco, written for the Ziegfeld Follies in 1912.

Chapter Five

1. The Canadian Pacific steamship *Lake Michigan* (8,200 tons, built 1901) had started her career as a troop-ship in the Boer War.

2. J. R. Miller, DD, *The Blessing of Cheerfulness* (London: Hodder & Stoughton, 1895), one of Dr Miller's 'Silent Times' series.

3. Thompson, *Records 1914-1919*, p. 11; Mark Ward diary, 17 August 1915.

4. Day, *Cavalry Chaplain*, pp. 129-30.

5. Stanley clearly did not know the latter well and called him 'Oswell', but there was no one of this name.

6. Shephard, 'Two Gillingham Men at Gallipoli in 1915', p. 4.

7. Colonel Troyte-Bullock, quoted in Thompson, *Records 1914-1919*, pp. 23-4, where Sergeant Finlay is called 'Lance-Corporal', G. Parsons 'C. Parsons', and Corporal George 'C. George'.

8. D-DOY/A/2/1/2, No. 31, 4 Aug 1916, 1: 'Strength, Decrease'. (B.2090. C. War Office dated 19/7/16).

9. This will must have been lost, since the one that was executed dated back to 1912.

10. See Ward, 'Dear Mother', p. 6.

11. D-DOY/A/1/1/18, 1 Sep 1915, 1.

12. D-DOY/A/1/1/18, 4 Sep 1915, 1: 'Move'.

13. D-DOY/A/1/1/18, 12 Sep 1915 to 31 Oct 1915.

14. Total dead were: British, 27,054; French, about 8,000; Australian, 7,825; New Zealand, 2,445; Indian, 1,682. J. Macleod, *Gallipoli* (Oxford University Press, 2015), p. 67.

15. D-DOY/A/1/1/18, 30 Nov 1915: 'Sent to Hospl.'

Chapter Six

1. *Western Gazette*, Friday 10 March 1916, p. 5, '1st Dorset Yeomanry in Egypt. Interesting Letter.'
2. D-DOY/A/2/1/2, No. 15, 14 Apr 1916, 6: 'Promotions and Appointments taking effect from 8/2/16'; WO 339/70738.
3. D-DOY/A/1/1/20, 16 Apr 1916, 4: 'Command & Transfer'; ibid., 20 Apr 1916, 3: 'Command'.
4. Charles Reade, *The Cloister and the Hearth*, Chapter 54: 'They are sore troubled with the itch'.
5. The transcript says '33', perhaps a misreading of '32', but the manuscript letter is lost. There were thirty-one QODY dead, or thirty-two if one attached officer from another regiment is included.
6. D-DOY/A/2/1/2, No. 17, 28 Apr 1916, 1: 'Promotions and Appointments'; WO 339/70738.
7. D-DOY/A/1/1/20, 27 May 1916, 3: 'Hospital' and 4: 'Departure'.

Chapter Seven

1. D-DOY/A/2/1/2, No. 18, 5 May 1916, 4: 'Strength (detached)'.
2. One of the initial intake, Private W. Woolner, is listed in the regimental order book with the service number of another man (Private H. J. Hillier, who was apparently never in the ICC), but is missing from the otherwise identical list in Daily Orders Part II. D-DOY/A/1/1/20, 24 Apr 1916, 6: 'Strength'; D-DOY/A/2/1/2, No. 18, 5 May 1916, 4: 'Strength (detached)' (dated 24/4/16). Private Woolner is also present in plate 88 and is mentioned by Mark Ward in the ICC 'tent account' at the back of his diary, but no trace has been found in other army records.
3. Forth, *Fighting Colonel*, p. 91.
4. The many variant spellings include 'durra'. A generic term for grain.
5. Romantic play by Wilhelm Meyer-Förster, 1901.
6. Ward, 'Dear Mother', p. 32.
7. Kneeling, with legs folded in (plate 89). From Arabic word meaning to make kneel.
8. Probably *Notes on the Arabic Language, with Vocabulary of Words and Phrases*, section from *Murray's Handbook for Egypt and the Sudan* sold as a separate booklet.
9. 'I'll sing thee songs of Araby', by Frederic Clay.
10. Transcribed as 'Nancy', but this must be a misreading since their company used bull camels – something of which the typist was clearly unaware. See 'Archival Sources' on Stanley's handwriting.
11. Litter for carrying sick or wounded on a mule or camel.
12. See Chapter Four, note 42.
13. During the war, Blandford Camp became the base of the Royal Naval Division (the marines).
14. See note 4 above.
15. D-DOY/A/1/1/20, 11 Jul 1916: 'Notice'.
16. D-DOY/A/1/1/21, 22 Jul 1916, 3: 'Results of Courses'.

17. WO 339/70738.
18. Transcribed as 'Royal Garrison Artillery', but it is almost inconceivable that Bertram could have known his eventual posting this early. The lost original probably said 'Royal Artillery' or 'RFA', converted by the typist into 'RGA' with hindsight. The transcribed date of 3 June 1917 is a combination of misreading and guesswork.
19. D-DOY/A/2/1/2, No. 36, 9 Sep 1916, 5: 'Strength'; WO 339/70738.
20. Soldiers' slang for a meal of bread and tea.
21. *Bella Donna* (1909), sensational novel by Robert Hichens, partly set in Egypt.
22. *Four Indian Love Lyrics* by Amy Woodforde-Finden. These were favourites with the George family. See Christian, *Wyn George*, pp. 149 and 216 (note 92).
23. A reference to Gerard Manley Hopkins's short poem 'In the staring darkness'.
24. Probably misheard by Stanley and then mistranscribed. See 'Archival Sources' on his handwriting. The transcript has 'Dedonnis', certainly an error. Mandisha, one of the principal villages in the north of Baharia (nearer to Fayum), seems most likely, since it fits with Stanley's description and that of Inchbald, *Imperial Camel Corps*, p. 36.
25. See Ward, 'Dear Mother', p. 45.
26. There is increasing evidence that a coronavirus responsible for around 15 per cent of human common colds originated in camels. See V. M. Corman, et al., 'Link of a ubiquitous human coronavirus to dromedary camels', *PNAS*, 113 (2016), 9864-9.
27. Imam-Chafay, Moslem Necropolis near the Tombs of the Mamelukes.
28. Ashwell, *Modern Troubadours*, pp. 93-9; Leask, *Lena Ashwell*, pp. 129, 136-8; *Y.M.*, 6 October 1916, p. 937.
29. Another clear example of transcription error. The Herts Yeomanry and the Westminster Dragoons, in reserve on Chocolate Hill, took no part in the attack on Scimitar Hill.
30. Khedivial Mail Line ship, built 1890.
31. D-DOY/A/2/1/4, No. 19, 12 May 1917, 5: Punishments (Extract Part II Orders, No. 17, 28/4/17, No. 8 Coy. Imperial Camel Corps).
32. Recorded in D-DOY/A/2/1/4, No. 21, 26 May 1917: Strength (decrease); see also Ward, 'Dear Mother', pp. 38-9.
33. Northern English dialect for a washing dolly, perhaps picked up from north-country yeomen in Egypt.
34. See Ward, 'Dear Mother', p. 45.
35. D-DOY/A/1/1/26, 3 Feb 1918; ibid., 4 Feb 1918, 3: 'Salvage Work'.
36. From A. C. Swinburne's poem 'The Garden of Cymodoce': 'Our Master, over all our souls impends, / Imminent; we, with heart-enkindled eyes / Upwondering, search the music-moulded skies'.
37. Inchbald, *Imperial Camel Corps*, p. 106.
38. Bridge over the Stour, linking the villages of Child Okeford and Shillingstone, 5 miles NW of Blandford. Shillingstone station, adjacent to the bridge, was the first stop on the railway northwards from Blandford.
39. Kipling, 'Follow me 'ome'.
40. *A Brief Record of the Advance of the Egyptian Expeditionary Force, July 1917 to October 1918* (2nd edn, HMSO, 1919), page facing Plate 36.

41. Except for some troops who remained to defend the bridgehead at Ghoraniyeh, all the units who had taken part in the Amman raid had recrossed by the evening of 2 April. Stanley specifically mentions that it was 'night' and 'dark', so maybe his company crossed the previous night.
42. *The Open Road: A Little Book for Wayfarers*. Anthology of verse and prose edited by E. V. Lucas (enlarged edn, 1905).
43. Inchbald, *Imperial Camel Corps*, pp. 121-3; Rogan, *Fall of Ottomans*, pp. 367-9.
44. Ward, 'Dear Mother', p. 48. This account was written in the 1960s, and he slightly misremembered the date as being in the second week of May.

Chapter Eight

1. WO 339/70738.
2. *Statistics of the Military Effort of the British Empire during the Great War* (London: HMSO, 1922), pp. 162, 209-11.
3. WO 339/70738.
4. WO 95/5457, 2nd Reserve Heavy Battery, RGA, p. 1.
5. See, for example, WO 95/216/9, p. 47.
6. WO 95/394/1, pp. 76, 77, 79.
7. WO 95/394/1, p. 82. The entries for 19-21 August say '23 SB', but 23rd Siege Battery was not part of the group, and the same mistake later in the diary has been corrected.
8. WO 95/394/1, p. 83-5.
9. WO 95/539/3, p. 90.
10. WO 95/539/3, p. 99.
11. WO 95/539/3, p. 112.
12. WO 389/5/4, p. 364.
13. WO 389/5/4, p. 364; WO 95/539/3, p. 114.
14. WO 95/539/3, p. 113.
15. WO 95/5494, p. 378.
16. *London Gazette,* 19 November 1917, p. 11951; *Fourth Supplement to the London Gazette* of 19 March 1918, published 22 March 1918, p. 3600.
17. WO 95/216/8, p. 92.
18. Sixteen others from RGA were gazetted at the same time. Just over 37,000 MCs were awarded to British officers during the war.
19. Filipe Ribeiro de Meneses, *Portugal 1914-1926: From the First World War to Military Dictatorship* (Bristol: HiPLAM, 2004), pp. 50-8.
20. WO 95/216/8, p. 94.
21. WO 95/216/8, pp. 95, 107.
22. WO 95/216/8, p. 119.
23. WO 95/216/9, p. 11.
24. WO 95/216/8, pp. 119-28; WO 95/216/9, pp. 3-14, 21-2.
25. WO 339/70738.
26. WO 95/216/9, p. 25.
27. Lloyd, *Hundred Days*, pp. 18-19.
28. WO 95/216/9, p. 26.
29. WO 95/216/9, pp. 41, 43, 59, 63.

30. WO 95/223/1, p. 89.
31. WO 95/216/9, p. 99.
32. WO 95/211/5, pp. 46, 51.
33. WO 95/211/5, p. 58.
34. WO 95/211/5, p. 69.
35. WO 95/223/7, p. 28.
36. Lloyd, *Hundred Days*, pp. 254-62.
37. WO 95/211/5, p. 75.
38. WO 95/211/5, p. 81.
39. WO 95/211/5, p. 81.
40. WO 95/211/5, p. 82.
41. WO 95/211/5, pp. 85-95.
42. WO 95/211/5, p. 96; Ashwell, *Modern Troubadours*, pp. 197-209; WO 95/211/6, pp. 9, 10, 20.
43. WO 95/211/6, pp. 9-28.
44. WO 339/70738.

Epilogue

1. WO 339/70738.
2. See Kenneth C. Barnaby, *100 Years of Specialized Shipbuilding and Engineering: John I. Thornycroft Centenary 1964* (London: Hutchinson, 1964), pp. 78-80.

Archival Sources
and Bibliography

Archival Sources

George Family Papers

Stanley's 1915 journal is written in a Letts's pocket diary, 5½ inches by 3½ inches, one page per day. The entries are in copy pencil (made of graphite with an aniline dye, which turns mauve when water is added for copying purposes). Copy pencil was widely used in business, and Stanley may well have had a supply with him from Markwells or his bank when he left Blandford. The diary must at some time have been in a damp environment, because the writing has turned mauve to varying degrees. His surviving original letters are also in copy pencil.

Stanley acknowledged that his handwriting was 'too often illegible'. It ranges from neat, upright and highly legible to rapid, slanting and hard to decipher; for example, hastily written capital 'H' and 'N' can be difficult to distinguish, and the first half of 'M', rounded when slanting, can resemble 'D'. Lower case letters without tails or uprights become rows of squiggles, while those with tails or uprights often develop both, making 'h', 'p' and 'b' hard to tell apart. Several names of people and places are essentially illegible in isolation, but nearly all have been deciphered with the help of official records. When he had time, he drafted his letters first and then copied them neatly, but often there was not time.

Photocopies of transcripts of most of Stanley's and Bertram's letters and of one original Stanley letter are in the Imperial War Museum (Documents.6802). The photograph album 'With the Yeomen in Egypt' is now held with the QODY archive in the Keep Military Museum, Dorchester (DORMM 2011/1483). All other George family manuscripts and photographs (including many duplicated in the above album) are in private collections.

Dorset History Centre, Dorchester

I made use of the following QODY records:
D-DOY/A/1/1/15 Regimental order book, 1909–1914

D-DOY/A/1/1/16 Regimental order book, 1914 (at least partly written up in retrospect, judging by the fact that a series of dates in December 1914 is given erroneously as February 1915)

D-DOY/A/1/1/17 Regimental order book, 1914–1915

D-DOY/A/1/1/18 Regimental order book, 1915

D-DOY/A/1/1/20 Regimental order book, 1916

D-DOY/A/1/1/21 Regimental order book, 1916

D-DOY/A/1/1/22 Regimental order book, 1916–1917

D-DOY/A/1/1/26 Regimental order book, 1917

D-DOY/A/2/1/2 Part II orders, 1916

D-DOY/A/2/1/4 Part II orders, 1917

D-DOY/A/3/11/5 Duplicate telegram book, 1914

D-DOY/A/3/12/4 Correspondence of Colonel Colfox etc. (for 'England's Last Hope')

D-DOY/A/4/8 Muster roll of Squadron A, B, C and D, 1868–1914

D-DOY/A/4/10 Nominal roll of A (Dorchester), B (Sherborne), C (Blandford) and D (Gillingham) Squadrons on Mobilisation, 1914

D-DOY/A/4/11 Active Service Regiment register, 1915 (showing those who went to Gallipoli)

D-DOY/A/6/5 Papers including a War Diary showing the 1/1 Dorset Yeomanry actions 1915–1919, and a list of officers and men with addresses and whether killed in action

D-DOY/A/10/3 Detailed information regarding supply of horses purchased on mobilisation, 1914.

The National Archives

WO 95/211/5: 7 Brigade RGA, War Diary July – December 1918

WO 95/216/8: 16 Brigade RGA, War Diary May 1917 – April 1918

WO 95/216/9: 16 Brigade RGA, War Diary May – October 1918

WO 95/223/1: 40 Brigade RGA, War Diary January 1917 – July 1919

WO 95/223/7: 42 Brigade RGA, War Diary January 1918 – February 1919

WO 95/394/1: 60 Brigade RGA, War Diary September 1916 – July 1919

WO 95/539/3: 11 Brigade RGA, War Diary January – November 1918

WO 95/5457: Home Forces Historical Records

WO 95/5494, Folio C: Allocations of Heavy Batteries RGA

WO 339/70738: 2/Lieutenant Bertram Ilott George RGA

WO 389/5/4: DSO and MC Registers, 17 September 1917 – 23 April 1918. Book 5, Gazette of DSO and MC, pp. 342-432 (annotated with date and place of deed)

All page references for RGA War Diaries are to the digitised versions.

Other Unpublished Manuscripts

Shephard, John, 'Two Gillingham Men at Gallipoli in 1915'

Mark Ward papers:

(i) Diary for 1915. Partly written in retrospect, apparently while the author was in hospital in Malta, December 1915. Also contains 'tent account' from his time in the ICC. The Keep Military Museum, Dorchester, DORMM 2009/917/10.

(ii) 'Dear Mother: A Narrative of the First World War' (1963), based on his First World War letters to his mother. Copy held in The Keep Military Museum, Dorchester.

Select Bibliography

Ashwell, Lena, *Modern Troubadours: A Record of the Concerts at the Front* (London: Gyldendal, 1922)

Becke, A. F., *History of the Great War based on Official Documents. Order of Battle of Divisions, Part 2A. The Territorial Force Mounted Divisions and the 1st-Line Territorial Force Divisions (42–56)* (London: HMSO, 1936)

Christian, Jessica, *Wyn George: Traveller and Artist* (Stanbridge: Dovecote Press, 2013)

Day, Henry C., *A Cavalry Chaplain* (London: Heath Cranton, 1922)

Falls, Cyril and A. F. Becke, *History of the Great War based on Official Documents. Military Operations Egypt and Palestine from June 1917 to the End of the War. Part 1* (London: HMSO, 1930)

Farndale, Martin, *History of the Royal Regiment of Artillery: Western Front 1914–18* (London: Royal Artillery Institution, 1986)

Farndale, Martin, *History of the Royal Regiment of Artillery: The Forgotten Fronts and the Home Base, 1914–18* (London: Royal Artillery Institution, 1988)

Forth, Nevill de Rouen, *A Fighting Colonel of Camel Corps* (Braunton: Merlin, 1991)

Hounslow, E. J., *Fighting for the Bucks: the History of the Royal Bucks Hussars 1914–18* (Stroud: Spellmount, 2013)

Inchbald, Geoffrey, *Imperial Camel Corps* (London: Johnson, 1970)

James, Philip and Richard Wilson, *The Queen's Own Dorset Yeomanry and the Imperial Camel Corps 1916–1919* (Revised edn, Dorchester: The Keep Military Museum, 2010)

Leask, Margaret, *Lena Ashwell: Actress, Patriot, Pioneer* (Hatfield: University of Hertfordshire Press, 2012)

Lloyd, Nick, *Hundred Days: The End of the Great War* (London: Viking, 2013)

MacMunn, George and Cyril Falls, *History of the Great War based on Official Documents. Military Operations Egypt and Palestine from the Outbreak of War with Germany to June 1917* (London: HMSO, 1928)

Rogan, Eugene, *The Fall of the Ottomans: The Great War in the Middle East, 1914–1920* (London: Allen Lane, 2015)

Rowe, Edward, *2nd County of London Yeomanry (Westminster Dragoons): The First Twenty Years, a Summary* (Privately published, 1962)

Thompson, C. W., *Records of the Dorset Yeomanry (Queen's Own) 1914–1919* (Sherborne: Bennett, 1921)

Verey, Anthony, *The Berkshire Yeomanry: 200 Years of Yeoman Service* (Stroud: Alan Sutton, 1994)

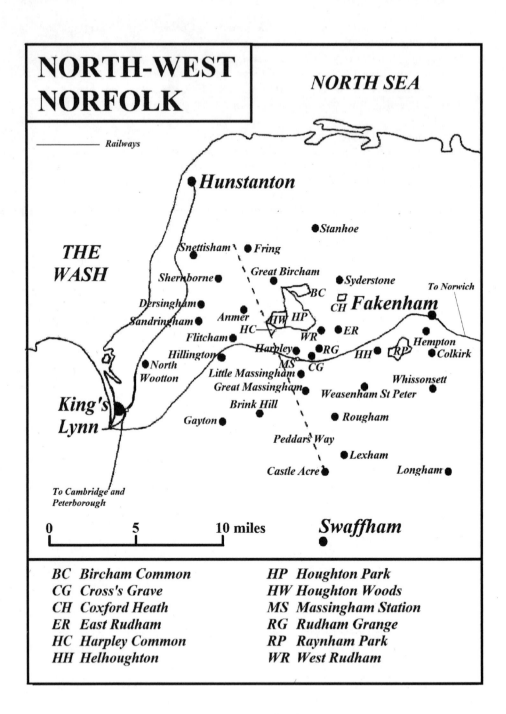

NORTH-WEST NORFOLK

NORTH SEA

———— Railways

● **Hunstanton**

●Stanhoe

THE WASH

Snettisham ● Fring

● Great Bircham

Shernborne ● Syderstone

BC

To Norwich

Dersingham●

CH ● **Fakenham**

Sandringham● Anmer

HW HP

HC●

Flitcham● WR ●ER

Harpley● RG Hempton

Hillington● MS HH● RP ●Colkirk

●North CG

Wootton Little Massingham

Great Massingham● Whissonsett

Brink Hill Weasenham St Peter

King's Lynn Gayton● ● Rougham

Peddars Way

●Lexham

Castle Acre● Longham●

To Cambridge and Peterborough

0 5 10 miles

Swaffham
●

BC Bircham Common	HP Houghton Park	
CG Cross's Grave	HW Houghton Woods	
CH Coxford Heath	MS Massingham Station	
ER East Rudham	RG Rudham Grange	
HC Harpley Common	RP Raynham Park	
HH Helhoughton	WR West Rudham	

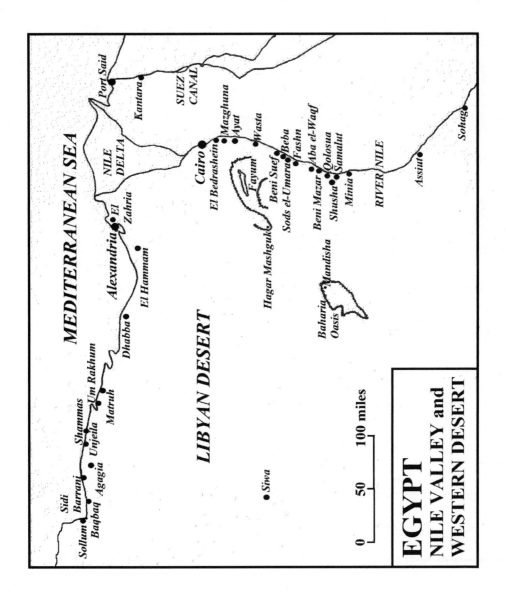

CAIRO (left) & ENVIRONS (above)

AAH	Anglo-American Hospital	GPH	Ghezireh Place (Hospital)
AHQ	British Army Headquarters	IC	Italian Consulate
B1	Kasr el-Nil Bridge	KN	Kasr el-Nil Barracks
B2	Bulaq Bridge	OH	Opera House
B3	Embaba Railway Bridge	PO	Post Office
B4	Zamalek Bridge	RAS	Royal Agricultural Society
B5	English Bridge	RC	Russian Consulate
B6	Abbas II Bridge	SH	Shepheard's Hotel
B7	Mohammed Ali Bridge	ShA	Shari Abdin
CH	Continental Hotel	ShB	Shari Bulaq
CMG	Convent of the Mother of God	ShKN	Shari Kasr el-Nil
EM	Egyptian Museum	ShMA	Shari Mohammed Ali
FC	French Consulate	VZ	Villa Zogheb

Cairo

To Alexandria
To Suez
Zeitun
Heliopolis
Abbasia
Citadel
Ghezireh
Bulaq el-Dakrur
Roda
Gizeh
Maadi
Tura
Helwan
El Bedrashein
Mena
Tramway
Gizeh Pyramids and Sphinx
To Upper Egypt and Khartoum
Railways

0 1 2 3 4 5 miles

Gizeh

Ismailiyeh Canal
City Walls
Ezbekiyeh Gardens
Muski
Central Station
Citadel
Mohammed Ali Mosque
Aqueduct (ruins)
Abdin Palace
Bab el-Luk
British High Commission
Kasr el-Aini Hospital
Old Cairo
Roda
River Nile
Ghezireh
Ghezireh Sporting Club
Zoological Gardens

0 1/2 1 mile

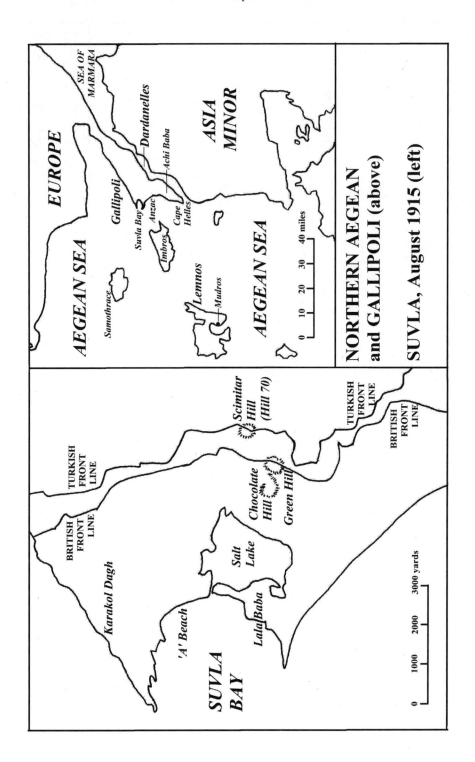

NORTHERN AEGEAN
and GALLIPOLI (above)

SUVLA, August 1915 (left)

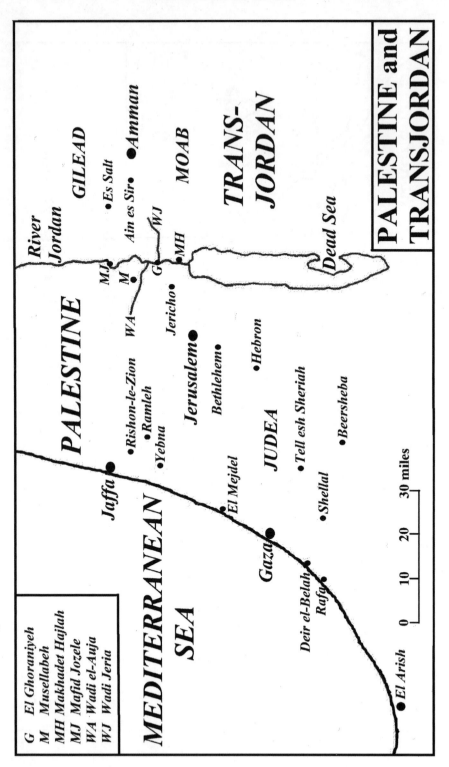

PALESTINE and TRANSJORDAN

GILEAD

River Jordan

• Es Salt

Ain es Sir • • Amman

MOAB

TRANS-JORDAN

WJ

MH

Dead Sea

PALESTINE

MJ

M

WA

G

Jericho •

Jerusalem ●

Bethlehem •

• Hebron

• Rishon-le-Zion

• Ramleh

• Yebna

JUDEA

• Tell esh Sheriah

• Beersheba

• El Mejdel

• Shellal

Jaffa ●

MEDITERRANEAN SEA

Gaza ●

Deir el-Belah ●

Rafa ●

0 10 20 30 miles

● El Arish

G El Ghoraniyeh
M Musellabeh
MH Makhadet Hajlah
MJ Mafid Jozele
WA Wadi el-Auja
WJ Wadi Jeria

192

NORTHERN FRANCE and
SOUTH-WEST BELGIUM (left)

THIRD BATTLE OF YPRES
(right)

ARRAS to MONS (below)

Biographical Index
of Service Personnel

This index gives dates of birth and death where known, with cause of death if while on active service; also regiment and rank at the relevant time (though promotion and transfer history outside ICC is incomplete, especially for Other Ranks). Address and occupation are as far as possible at the time of the outbreak of war or subsequent enlistment. Officers with no occupation stated were generally full-time professional soldiers pre-war.

Yeomanry officers who only appear in the group photographs (plates 23-4) are not included. Likewise seventeen soldiers appearing in the text or photographs who have proved unidentifiable or untraceable. These are (all QODY unless otherwise stated): Andrews, Cpl Carter (regiment unknown), Cook (Plymouth Battalion), Elsworth, Major Halstead (East Lancashire Regiment), Martin, Cpl Miller, Richards, Robinson (RFA), Sgt-Major Rochester (Essex Regiment), Saunders, Scott, Shepherd, Swatridge, Capt. Walford (Westminster Dragoons), Cpl Williams (regiment unknown), and Woolner (QODY and ICC, plate 88; see Ch. 7, n. 2).

Thomas ADLEM
23 Oct 1881 (Durweston) – 1963 (Dorset)
East Street, Stourpaine
Blacksmith
QODY, Farrier Sergeant 122
pp. 60, 71, 87, 91, 103

Sir Edward Henry Hynman ALLENBY
23 Apr 1861 (Southwell, Notts) – 14 May 1936 (London)
General; Commander, Third Army, 1915; Commander, EEF, 1917–19; later 1st Viscount
 Allenby of Megiddo and of Felixstowe
pp. 16, 150, 152, 155, 157, 161, 174

Charles Henry Paget, 6th Marquis of ANGLESEY
14 Apr 1885 (London) – 21 Feb 1947 (London)
Plas Newydd, Llanfairpwll, Anglesey
Royal Horse Guards, Captain; ADC to General Maxwell
p. 84

James Samuel (or Samuel James) ASHFORD
1890 (Tidworth) – 11 May 1925 (Wylye)
Little Bathampton, Wylye
Farmer's son, working on farm
QODY, Private 618
p. 80

Sir Randolf Littlehales BAKER
20 Jul 1879 (Iwerne Courtney) – 23 Jul 1959 (Ranston)
Ranston House, Iwerne Courtney, Blandford
MP (Unionist), North Dorset
QODY, Major, later Lieutenant Colonel
pp. 123, 125; plate 23

Frederick Charles BANFIELD
1 Oct 1897 (Ashington, near Ilchester) – 1969 (Somerset)
Ashington, near Ilchester
Farm worker
QODY, Private 1507/230756; ICC, Private
Plate 88

Prince Alexander Albert of BATTENBERG
(changed surname to Mountbatten and created Marquess of Carisbrooke, 1917)
23 Nov 1886 (Windsor) – 23 Feb 1960 (London)
Kensington Palace, London
Grenadier Guards, Lieutenant; ADC to General Maxwell
p. 84

Percy Hayden BEAMS
26 May 1897 (London) – 1978 (Wiltshire)
Bradpole, Bridport
Schoolmaster's son
QODY, Private 1523/230770; ICC, Private 50070
Plate 88

Bernard Charles BENNETT
Jan/Feb1890 (Chilmark, Tisbury) – 4 May 1917 (Egypt, died of wounds)
Manor Farm, Chilmark
Farmer
QODY, Corporal 469/230026 (promoted Sergeant Oct 1915)
pp. 29, 74, 84, 112-14

Robert Christie BENNETT
1887 (Weymouth) – 25 Sep 1928 (Weymouth)
The Lawns, Weymouth
Draper
QODY, Sergeant 313; later RA, Lieutenant
p. 75

Arthur Edward BOLT
1893 (Weymouth) – 1962/63 (Dorset)
Loders, Bridport
Butcher's assistant
QODY, Private 940/230300; ICC, Private 50018
Plates 88-9

Ralph BOWER
7 Jan 1893 (Blandford) – 10 Jan 1981 (Swanage)
Acton Field, Langton Matravers
Stone mason
QODY, Lance-Corporal 954/230314
pp. 45, 73, 83, 86, 112; plate 26

Edwin ('Ted', 'Teddy') BOWN
1872 (Sherborne) – Dec 1944 (Sherborne)
Higher Cheap Street, Sherborne
Cook with QODY
QODY, Private 810/230193
pp. 67, 77, 80, 105, 155

Alan A. BRABAZON
13 Oct 1895 (Mullingar, Co. Westmeath) – 8 Mar 1918 (Palestine, died of wounds)
Churchtown House, Mullingar, Co. Westmeath, Ireland
6th (Service) Bn, Prince of Wales's Leinster Regt (Royal Canadians), Lieutenant
p. 95

Frederick Joseph BRADLEY
23 Jan 1889 (Wimborne) – 3 Apr 1976 (Child Okeford)
Shillingstone
Farmer
QODY, Lance-Sergeant 143
pp. 23, 32, 34, 61, 77

Owen Charles BRAGGE
1876 (Wylye) – 13 Jul 1958 (Hawkchurch, Axminster)
Vicarage, Thorncombe, Chard
QODY, 2nd Lieutenant
pp. 66, 85, 109; plate 24

Harold Vernon BROWNE
25 Aug 1885 (Buckland Park, South Australia) – 7 Sep 1915 (Suvla Bay, Gallipoli; killed
 while acting as Landing Officer)
Preston House, Iwerne Minster, Blandford
QODY, Lieutenant (temporary Captain from 14 Aug 1915)
pp. 25-6, 37, 45, 53, 67, 80, 85-6, 107; plates 23-4

Sidney Earl BUCKLEY
1893/94 (Thrapston) – 20 Apr 1966 (Longborough, Gloucs)
Clopton Manor, Thrapston, Northants
Northamptonshire Regt, 2nd Lieut. (later Captain); attached RFC
p. 22; plate 7

Arthur William BUDDEN
21 Sep 1894 (Loders, Bridport) – 13 Oct 1969 (Montacute)
Post Office, Loders, Bridport
Shop assistant (had worked for Robert Sharp, Blandford florist)
QODY, Private 1478/230733; ICC, Private 50069
pp. 128, 133-5; plates 88-90, 95

Charles Ernest (known as Ernest) BUDDEN
1893/94 (West Lulworth) – 21 Aug 1915 (Gallipoli, KIA)
Burngate Farm, West Lulworth
Farmer's son
QODY, Private 1016
p. 71

John BURROW
7 Jul 1890 (Woolfardisworthy West, Devon) – 25 Aug 1926 (Chilhampton, Wilts)
Manor Farm, Steeple Langford, Wilts
Farmer
QODY, Sergeant 207
p. 83

Charles Edward CADIE
1881/82 (Holwell) – 26 Feb 1916 (Agagia, KIA)
Manor Farm, Longburton, Sherborne
Farm bailiff
QODY, Corporal 777
p. 71

Wallace Melvyn CALVERT
30 Nov 1890 (Sunderland) – 1 May 1918 (Palestine, KIA)
Preston [1911 census: 13 Imperial Terrace, Blackpool]
Draper's assistant
Bucks Yeomanry, Private 1987; ICC, Private 50034
p. 162

Edward William Fuidge CASTLEMAN
9 Sep 1870 (Chettle) – 19 Mar 1946 (Chettle)
Chettle House, Chettle, Blandford
Gentleman farmer
QODY, Major
pp. 15, 47, 84, 104, 123, 125; plate 24

Henry John Neville CHAMPION
1891 (Penzance) – 15 Dec 1928 (Penzance)
Penalverne, Wellington Road, Bishops Hull, Taunton
Assistant wine and spirit merchant
Herts Yeomanry, Private 1723.
pp. 67, 147

Alfred Douglas CHERRY
31 May 1889 (Blandford) – 9 Apr 1917 (France, KIA)
143 New Kings Road, Fulham, London SW
2nd Div. clerk, Board of Education
1 London Regt, Private 1734; later Dorsetshire Regt, 2nd Lieutenant, attd Somerset LI, Captain
pp. 137, 180 (Ch. 4, n. 42)

Kenneth Charles CHERRY
1893 (Blandford) – 21 Dec 1915 (Flanders, KIA)
143 New Kings Road, Fulham, London SW
Clerk, HMCS, Post Office
Civil Service Rifles, Private 3799
p. 180 (Ch. 4, n. 42)

Leonard CHERRY
27 Feb 1884 (London) – 29 Jul 1970 (Northiam, Sussex)
27 White Cliff Mill Street, Blandford
Draper and outfitter
3/ Royal Fusiliers, Lance-Corporal 2672; later Machine Gun Corps, Major
(Married Dorothy George, Lincolnshire, 1917)
pp. 99, 137, 180 (Ch. 4, n. 42)

Leslie John CHERRY
23 Jan 1891 (Blandford) – 12 Jan 1968 (Bournemouth)
27 White Cliff Mill Street, Blandford
Draper
QODY, Private 620; later Oxon & Bucks LI, Lieutenant
pp. 15, 17, 81, 85, 180 (Ch. 4, n. 42); plates 18-19

Sydney Albert CHURCHILL
1893 (Studland) – 1964/65 (Wiltshire)
Langton, Blandford
Farm labourer
QODY, Private 956/230316; ICC, Private 50071
pp. 84, 130; plate 88

Stanley Walter COOKE
5 Oct 1880 (Greenwich) – 23 Dec 1973 (North Walsham, Norfolk)
Naval Ordnance Department, Engineer Lieutenant Commander (retired as Engineer Rear
 Admiral)
pp. 106-7

George Horwood COSSINS
1888/89 (Pimperne) – 17 Apr 1945 (Wembley, Middlesex)
(Brother of H. J. Cossins)
42 Crystal Palace Park Road, Sydenham, London
Civil engineer
Westminster Dragoons, Private 1727/115148
pp. 102-3

Harry John COSSINS
16 Aug 1892 (Tarrant Rawston) – 20 Apr 1977 (Colehill, Wimborne)
(Brother of G. H. Cossins)
Luton Farm, Tarrant Rawston, Blandford
Farmer
QODY, Private 511
pp. 15, 23-4, 30, 32, 36, 38, 43, 46, 48-50, 73-5, 80-1, 102, 110; plates 18, 62

Sidney George COULTAS
1893 (London) – 27 Jun 1930 (Bovey Tracey)
3 Grand Parade, Archway Road, Highgate, London
'Electrical student', presumably electrical engineering
Berks Yeomanry, Private 1983/327165; ICC, Private
Plates 101-2

Percival Richard COURAGE
23 May 1886 (Stourpaine) – 24 Jan 1985 (Tarrant Keyneston)
High Street, Stourpaine, Blandford
Farm labourer
QODY, Private (later Corporal) 790/230178
pp. 73, 112-13

Henry Gerald CROSS
1889 (Mappowder) – 13 Jan 1955 (Eversley Centre, Hants)
Boywood Farm, Mappowder
Farmer
QODY, Private 307
p. 98

Frank J. CULLIS
1875/76 (Shrewsbury) – 20 May 1956 (Bridport)
Thorngrove, Gillingham
Butler
QODY, Private 804/230188; later Army Service Corps, Sergeant
p. 77

Cecil Francis CURTIS
18 Aug 1888 (Blandford) – 27 Mar 1942 (London)
18 Market Place, Blandford
Tailor
QODY, Corporal 355; Hants Yeomanry, 2nd Lieutenant (commissioned Jul 1916, later
 Lieutenant)
pp. 15, 17; plate 19

Percy CUTLER
11 Dec 1895 (West Parley) – 21 Mar 1971 (Hinton Martell)
Dean Farm, Witchampton
Farmer's son
QODY Private 654/230089
pp. 21, 42, 112; plate 26

George Murray DAMMERS
18 Aug 1879 (Symondsbury) – 28 Mar 1943 (Bridport)
Wykes Court, Bridport
Manufacturer of twines and lines
QODY, Lieutenant
pp. 103, 108, 114; plate 24

Frederick George DANIELLS
10 Oct 1894 (East Morden) – 1968/69 (Berkshire)
Langton Road, Langton Long
Mason's labourer
QODY, Private 802/230187
pp. 53, 77, 80, 84

Hon. George Seymour DAWSON-DAMER
30 Jul 1892 (London) – 12 Apr 1917 (Monchy, near Arras, died of wounds)
Buxted, Uckfield, Sussex
QODY, Lieutenant; re-gazetted 10th Hussars
p. 61; plates 23-4

DIGBY – see WINGFIELD DIGBY

Thomas DOGGRELL
11 Dec 1896 (Henstridge) – 13 Jan 1918 (Palestine, died of wounds while prisoner of war)
East End Farm, Semley, Shaftesbury
Farmer
QODY, Sergeant 649/230084
p. 32

Dr George Herbert DOMINY
29 May 1873 (Edinburgh) – 1 Jun 1946 (Marlborough)
Milton Abbas
Physician; Medical Officer, Milton Abbas Cottage Hospital; District Medical Officer, Blandford
RAMC, Captain; QODY, Medical Officer
p. 79

Francis DRAKE
May/Jun 1895 (Tarrant Crawford) – 1967/68 (Bournemouth)
Tarrant Abbey, Tarrant Crawford, Blandford
Farmer
QODY, Corporal (later Sergeant) 674/230101.
pp. 15, 32, 71, 74, 83, 112, 118, 125

Walter George DRUCE
16 Sep 1872 (London) – 8 Jan 1963 (Sherborne)
19A Wetherby Gardens, London SW
QODY, Captain
pp. 18, 34, 40

Frank Leslie DRURY
1890 (Tilmanstone, Kent) – ?
Newton Cottage, Swanage
Commercial manager
QODY Private 1479/230734; ICC, Private 50090
Plates 88-9

Alan James DUNN
Aug/Sep 1886 (Dorchester) – 13 Jan 1966 (Eastbourne)
39 Damory Street, Blandford
Post Office sorting clerk and telegraphist
QODY, Sergeant 443
pp. 23, 25

Basil Henry Applebee EAMES
2 Mar 1895 (Swindon) – 2 Jun 1975 (Woking)
Cedars, Shaftesbury
Bank clerk, National Provincial Bank, Shaftesbury
QODY, Private (later Corporal) 759/230158
pp. 69, 76, 87, 89, 91, 112

John Arthur FEARNSIDE
30 Nov 1879 (Mirfield, Yorkshire) – 25 Feb 1931 (Ballachulish)
RAVC, Captain; Regimental Veterinary Officer, QODY
pp. 52-3, 87; plate 24

Ernest Alfred FINCH
1894/95 (Hounslow, Middlesex) – 1 May 1918 (Palestine, KIA)
Hounslow, Middlesex
Butcher's son
Westminster Dragoons, Lance-Corporal 2341/115486; ICC, Lance-Corporal 50141
p. 162

Gerald Bertram FORD
12 May 1894 (Wimborne) – 6 May 1959 (Corfe Mullen)
Brookside, Canford Magna
Auctioneer's junior clerk
QODY, Corporal 865/230238
pp. 32, 34

Frederick James FOWLER
1873 (Melplash) – 4 Apr 1940 (Worgret)
Worgret Farm, Wareham
Farm labourer, formerly groom to Sir Henry Hoare, Stourhead
QODY, Private 778/230169, Lieut. Hoare's servant
pp. 23, 69, 73-4, 85

Percy John FOYLE
Aug/Sep 1896 (Kington Magna) – 18 Jun 1969 (Sutton Courtenay)
Greens Farm, Fontmell Magna, Shaftesbury
Farmer
QODY, Private 760/230159; ICC, Private
pp. 127-8, 133-4; plates 88, 114

John Denton Pinkstone FRENCH
28 Sep 1852 (Deal, Kent) – 22 May 1925 (Deal)
General; C-in-C BEF 1914–15; C-in-C Home Forces 1915; later Viscount French of Ypres
 and of High Lake, Co. Roscommon
p. 16

Mark William Wallis GENGE
May/Jun 1888 (Fonthill Gifford) – 6 Jan 1965 (Fonthill Gifford)
Stop Farm, Fonthill Gifford
Farmer
QODY, Private 993
pp. 32, 83

Bertram Ilott GEORGE
26 Jul 1881 (Blandford) – 7 Feb 1959 (Blandford)
85 Obelisk Road, Woolston, Southampton
Marine engineer
QODY, Private (later Sergeant) 1142/230457; 2nd Reserve Cavalry Regiment, Sergeant
 40086; RGA (Special Reserve), 2nd Lieutenant (later Lieutenant) 348565
pp. 14-15, 17-19, 23-4, 26-9, 31-2, 38, 41, 44, 47, 50, 64, 72-3, 83, 89, 96, 103-4, 107-
 8, 110-13, 115-17, 119, 120-2, 124, 138-9, 143, 156, 160, 164-75; front cover, and
 plates 1, 3, 5, 26, 32, 39, 50, 64, 67, 73, 76, 137-8

Harold Thomas Victor GEORGE
Mar/Apr 1897 (Port Albert, Victoria) – 1976 (Park, Victoria)
(Brother of H. I. George; first cousin of George brothers of Blandford)
Clerk, Victorian Railways
8 FA Brigade, 4 Reinforcement, Private
pp. 76, 142, 160; plate 87

Herbert Ilott GEORGE
May/Jun1884 (Dunolly, Victoria) – 25 Jul 1916 (Somme, France, KIA)
(Brother of H. T. V. George; first cousin of George brothers of Blandford)
Grocer
AIF 5 Battalion, Private 408
pp. 76, 142; plate 86

Justus Watts (known as Roy) GEORGE
6 Nov 1890 (Blandford) – 21 Aug 1915 (Gallipoli, KIA)
Efford Farm, Everton, Lymington, Hants
Farmer
QODY, Corporal 333
pp. 14-17, 19, 23, 25-7, 31, 33-4, 37-8, 41, 43-6, 48, 50, 56-7, 66, 72-3, 83, 85, 91, 100,
 103-4, 109-11, 113-14, 127, 174-5; front cover, and plates 1-2, 5, 8, 17-21, 25-6, 41,
 49, 67, 73

Stanley GEORGE
24 Apr 1889 (Blandford) – 1 May 1918 (Palestine, KIA)
Bridge House, Bemerton, Salisbury
Bank clerk
QODY, Private 862/230236; ICC, Private 50092
pp. 14-15, 17-18, 20-58, 60-115, 117-63, 174-5; front cover, and plates 1-2, 5-6, 20-1,
 26, 40, 73-4, 88, 92, 96, 105

Frederick John GOLLOP
31 Dec 1895 (Charminster) – 29 Jun 1957 (Broadstone)
16 Old Road, Wimborne
Clerk
QODY, Private 726/230137
pp. 29, 109

Sir Herbert de la Poer GOUGH
12 Aug 1870 (London) – 18 Mar 1963 (London)
Major-General; Commander, Fifth Army 1916
pp. 165-6

Albert George GOULD
1894 (Hardington Mandeville) – ?
Temperance House, Broadway, Dorchester
Farmer
QODY, Lance-Corporal 1362/230633; ICC, Lance-Corporal 50009
Plates 88-9

Walter Victor (known as Victor) GREENING
1894 (Braintree, Essex) – 29 Mar 1959 (Southampton)
29 Trinity Street, Dorchester
Accountant's clerk
QODY, Private 1311/230590; ICC, Private 50020
Plates 88-9

Charles Henry GREENWOOD
1893 (Belper, Derbyshire) – 2 Sep 1949 (Belper)
Kings Street, Belper
Draper
QODY, Sergeant 1352/230623; later transferred to Worcestershire Regt
p. 99

Sir James Moncrieff GRIERSON
27 Jan 1859 (Glasgow) – 17 Aug 1914 (near Amiens, heart aneurysm)
General; ADC to the King, 1911; Commander, II Corps, 1914
p. 16

Willie Reginald (known as William) GUPPY
1891 (Preston, Weymouth) – 18 Dec 1963 (Preston, Weymouth)
Preston, Weymouth
Lawyer's clerk
QODY, Corporal 1199/230497; ICC, Sergeant 50000 and CSM, No. 8 Company
pp. 131, 163; plates 88-9, 91

James Francis John (known as Francis) GUY
28 Feb 1899 (Shapwick) – May 1985 (Bromley, Kent)
Anchor Inn, Shapwick
Farmer
QODY, Private 794; ICC, Private; later Notts & Derby Rgt
Plates 88, 103

Douglas HAIG
19 Jun 1861 (Edinburgh) – 29 Jan 1928 (London)
General; Commander, I Corps 1911; Commander, First Army 1915; Commander BEF,
 1915–18; later Field Marshal and 1st Earl Haig
pp. 16, 41

Reginald Tom HAIM
21 Dec 1891 (Blandford) – 1971 (Dorset)
Durweston
Groom in Lord Portman's employ, Bryanston
QODY, Shoeing Smith 792/230180
pp. 23, 34, 78

Alfred Robert HALLETT
1 Oct 1892 (Symondsbury) – 4 Apr 1977 (Keynsham)
Wootton Fitzpayne, Charmouth
Post boy (livery stables)
QODY, Private 1269/230554; ICC, Private 50093
Plate 120

Sir Ian HAMILTON
16 Jun 1853 (Corfu) – 12 Oct 1947 (London)
General, Commander-in-Chief, Mediterranean Expeditionary Force
p. 105

John Sidney HANNAM
1 Apr 1881 (Liverpool) – 4 Jan 1960 (Vancouver, British Columbia)
Okanagan Falls, British Columbia; c/o 21 High Street, Wincanton
Farmer
QODY Private 850/230226
pp. 29, 102

Charles James (known as James) HARDING
20 Mar 1896 (Weymouth) – 1 May 1918 (Palestine, KIA)
1 Bath Street, Weymouth
Porter
QODY, Private 1466/230724; ICC, Private 50094
p. 163

George D. HARPER
Bucks Yeomanry, Private 808/205099; ICC, Private 50021
Plate 101

Harry Hodge HARROLD
30 May 1890 (Castle Cary) – 26 May 1979 (Sindlesham, Wokingham)
1 Grosvenor Road, Weymouth
Carpet Salesman
QODY, Private 881/230251
pp. 108-10

Cuthbert HARVEY
1893 (Maidstone) – 28 Mar 1918 (Palestine, died of wounds)
Walmer, Kent
Bank clerk's son
West Kent Yeomanry, Private 2003/270934; ICC, Private 50172.
p. 159

Frank Charles HARVEY
1890 (Piddletrenthide) – 1962 (Dorset)
West Street, Wimborne
Groom
QODY, Private 1085/230408
pp. 29, 40, 80, 113; plate 26

Arthur Humphrey HAYTER
9 Dec 1897 (Winterborne Kingston) – 21 Oct 1918 (Damascus, died of malaria)
Home Farm, Kingston Lacy
Farm bailiff's son
QODY, Private 731/230140
p. 42; plate 26

Gilbert Watkins HELLYAR
1879 (Thornford) – 26 Feb 1916 (Agagia, KIA)
Middle Farm, Thornford, Sherborne
Farmer
QODY, Sergeant 462
p. 88

George HEWLETT
54 Union Grove, Clapham, London SW
QODY, Private 1149/230462
pp. 88, 90

Arthur Alfred HIBBS
c.1892 (Bournemouth) – 28 Nov 1917 (Palestine, KIA)
12 Race Farm, Lytchett Matravers
General labourer
QODY, Private 1047/230380
p. 88

Reginald Henry HINE
1889/90 (Bishops Caundle) – 1948/49 (Dorset)
Stourton Caundle
Groom
QODY Private, 807/230191
Plate 26

Henry Colt Arthur HOARE
30 Jul 1888 (Wavendon, Bucks) – 19 Dec 1917 (Alexandria, Egypt, died of wounds)
Stourhead, Wilts
Land agent
QODY, Lieutenant; promoted to Captain 1916
pp. 23, 27, 65-6, 72, 80, 85; plate 24

Robert H. HOOKER
Berks Yeomanry, Private 1884; ICC, Private 50110
Plate 101

Maurice HOOPER
Aug/Sep1892 (Turners Puddle) – 13 Apr 1967 (Winterborne Tomson)
Langton Farm, Langton, Blandford
Farmer
QODY, Corporal 470
(Married Kathleen Cossins, Tarrant Rawston, 1921)
pp. 15, 23, 30-2, 38, 48, 50, 56, 83, 85, 87, 89, 101, 103, 106; plates 64, 67

Sir Henry Sinclair HORNE
19 Feb 1861 (Stirkoke, Wick) – 14 Aug 1929 (Stirkoke)
General; Commander, First Army 1916; later Baron Horne of Stirkoke
p. 172

Sydney Hubert HORSEY
1882/83 (Woking) – 11 Mar 1959 (Weymouth)
78 Cromwell Road, Weymouth
House painter
QODY, Lance-Sergeant 47/230006
p. 77

Victor Cornelius HUNT
Mar/Apr 1887 (Manston, Sturminster Newton) – 1956 (London)
Higher Farm, Manston, Sturminster Newton
Farmer
QODY, Sergeant 191
p. 32

Ernest George INGRAM
28 Jun 1882 (Wimborne) – 1972 (Southampton)
Bournemouth
Carman
QODY, Private 1123/230441
pp. 29, 41, 78; plate 26

Harold Douglas JEANS (or JEANES)
1887 (Buckhorn Weston) – 14 Dec 1968 (Winterslow, Wilts)
Writh Farm, Melbury Abbas
Farmer
QODY, Lance-Corporal 478
p. 34

Paul Aloysius KENNA
16 Aug 1862 (Liverpool) – 30 Aug 1915 (Gallipoli, KIA)
North Kilworth Hall, Leicestershire
Colonel (temp. Brigadier-General); ADC to the King
p. 113

Arthur Lewis KENNAWAY
16 Jun 1881 (Garboldisham, Norfolk) – 21 Aug 1915 (Gallipoli, KIA)
Spetisbury
Land agent
QODY, Lieutenant
pp. 39-40, 42-4, 46; plate 23

Frederick KERTON
1865 (Barrow, Suffolk) – 11 Jan 1939 (Weymouth)
14 Bridport Terrace, Dorchester
15th Hussars, Sergeant-Major 2347; attached QODY as Regimental Sergeant-Major;
 Commander, POW Camp, Cyprus, 31 May 1917
pp. 25, 33, 77, 83

Reginald KETTLE
1892/93 (Bournemouth) – 3 May 1964 (Corfe Mullen)
Wareham Road, Corfe Mullen
Market gardener
QODY, Lance-Corporal 612/230066
pp. 45, 78, 80, 110-11

Fred KNIGHT
Bucks Yeomanry, Private 2245; ICC, Private 50044
pp. 161-2

Herbert KNOTT
6 Nov 1891 (Sturminster Newton) – 25 Feb 1971 (Sturminster Newton)
(Brother of T. Knott)
The Commons, Sturminster Newton
Farmer
QODY, Private 484
p. 108

Tom KNOTT
1885/86 (Sturminster Newton) – 12 Mar 1964 (Stourton Caundle)
(Brother of H. Knott)
The Commons, Sturminster Newton
Farmer
QODY, Corporal 160
p. 32

Thomas Edward LAWRENCE ('Lawrence of Arabia')
16 Aug 1888 (Tremadoc) – 19 May 1935 (Bovington Camp)
Intelligence officer, later Colonel, EEF
p. 174

Arthur George (known as George) LEATON
5 Jan 1896 (Poole) – 29 Nov 1982 (Hamworthy, Poole)
Tolpuddle
Shoemaker
QODY, Private 1080/230404; later transferred to Royal Liverpool Regiment
pp. 38, 41, 83, 86; plate 26

Charles John LEE
1879 (Fenny Bridges, Ottery St Mary) – ?
Fairmills, Ottery St Mary
Groom
QODY, Private 1150/230463
p. 111

Bernard Percy Turnbull LEES
7 Aug 1891 (Sturminster Marshall) – 2 Sep 1922 (Kadune, Nigeria)
(Brother of Sir Thomas Lees)
Crawford House, Spetisbury
QODY, 2nd Lieutenant; temp. Lieutenant, 14 Aug 1915
pp. 39, 41, 46, 78; plates 23-4

Sir Thomas Evans Keith LEES
11 Apr 1886 (Wimborne) – 24 Aug 1915 (Gallipoli, died of wounds)
(Brother of Bernard Lees)
South Lytchett Manor, Poole
QODY, Lieutenant
pp. 24, 27; plate 23

Raymond LIMMER
7 Dec 1893 (London) – Feb 1991 (Dorset)
Selhurst, Lake Road, Parkstone
Accountant's son
QODY, Private 975/230329; POW 28 Nov 1917 – 2 Jan 1919
pp. 68, 78

Lestock Frederick Reid ('Sticky') LIVINGSTONE-LEARMONTH
1872 (Ercildoune, Victoria, Australia) – 16 Nov 1949 (Rimpton, Sherborne)
Manor House, Wootton Glanville, Sherborne
QODY, 2nd Lieutenant
pp. 53, 178 (Ch. 3, n. 1); plates 23-4

Nigel James Christian LIVINGSTONE-LEARMONTH
7 Mar 1878 (Woodlands, Hants) – 21 Aug 1915 (Gallipoli, KIA)
Limington, Ilminster
15th Hussars, Captain; QODY, Captain and Adjutant
p. 109; plates 23-4

Arthur Henry John LOADER
Feb/Mar 1894 (Leigh Common) – 16 Mar 1965 (Wimborne)
Leigh Common, Wimborne
Pig dealer's son; errand lad, fish trade
QODY, Private 727/230138
p. 83

Edward Sharland LOCKSTONE
1889/90 (Malmesbury) – 12 Mar 1915 (France, KIA)
Salisbury
Bank clerk
Duke of Edinburgh's (Wiltshire) Regt, Private 11134
pp. 100, 180 (Ch. 4, n. 43)

William Edward LONNEN
Jul/Aug 1883 (Dorset) – 22 Aug 1971 (Edmondsham, Cranborne)
Cranborne
Butcher
QODY, Lance-Corporal 1073
pp. 23, 30-1, 68, 73-4, 85, 88, 91

MacFARLANE – see MASON-MacFARLANE

Harry Challenger MAIDEN
1896/97 (Harlow, Essex) – 1967 (Huddersfield)
The Kennels, Bere Regis
Son of Huntsman of S. Dorset Foxhounds
QODY, Private 1173/230477; ICC, Private 50078
pp. 47, 83, 103; plates 26, 88, 103, 114

Frederick MAKIN
16 Sep 1894 (Bolton, Lancashire) – 15 Apr 1982 (North Elmham, Norfolk)
8 Grosvenor Terrace, Teignmouth
Farmer (formerly farm pupil at Marshwood, Charmouth)
QODY, Private 884/230253
p. 27

Noah F. MARSH
1895 (Weymouth) – 1968 (Weymouth)
Mina Villa, Chickerell, Weymouth
Farmer
QODY, Private 1460/230718; ICC, Private 50079
Plate 88

Walter George Edward MARSH
1880 (Stone Allerton, Somerset) – 1964/65 (Salisbury)
Ranston Stables, Blandford
Groom to Sir Randolf Baker
QODY, Private 789/230177; later Royal Tank Corps, Private 318293
pp. 73, 80; plate 26

Carlyon Will MASON-MacFARLANE
17 Jan 1891 (Maidenhead) – 5 Sep 1916 (Baharia, KIA)
Kindowie, Boyn Hill, Maidenhead; Craigdarroch, by Strathpeffer
7th (Queen's Own) Hussars, Captain; Commander, No.8 Company, ICC
pp. 126, 128, 140, 147; plate 97

Rt Hon. Sir John Grenfell MAXWELL
11 Jul 1859 (Liverpool) – 21 Feb 1929 (Newlands, Cape Colony, South Africa)
57 Cadogan Square, London SW1
Lieutenant General; GOC-in-C, Egyptian Expeditionary Force
pp. 73, 84, 86, 89, 93, 96, 100

Frederick John MEADEN
12 May 1894 (Okeford Fitzpaine) – 1970 (Dorset)
Park Farm, Tarrant Gunville
Farmer
QODY, Private 786/230174
p. 86

Harry Percival MEAKER
25 Dec 1892 (Woolavington, Somerset) – 10 Nov 1972 (Weymouth)
10 Bury Street, Weymouth
Club steward
QODY, Private 1424/230687; ICC, Private
p. 132; plates 88-9

William George MEECH
1887 (Charminster) – 26 Feb 1916 (Agagia, KIA)
(Half-brother of Bertie Taylor; same mother)
Tyneham
QODY, Private 996
pp. 97-8, 114

Stanley Derry Hamilton MERRETT
1895/96 (Box, Wiltshire) – 26 Oct 1941 (Exeter)
Sturminster Newton
Bank clerk
QODY, Private 721
pp. 23, 34, 42

Horace MILLER
1896 (Castleton, Dorset) – ?
Frome St Quintin, Dorchester
Farmer
QODY, Private 934/230296; later Machine Gun Corps, Private 115372; Tank Corps, 2nd
 Lieutenant
p. 113

Reginald Thomas W. MILLHOUSE
13 Apr 1896 (Kiveton Park, Yorkshire) – 1972 (Lincolnshire)
11 Church Street, Carlton, Notts
Office worker (wallpaper shop)
South Notts Hussars, Private 967; later Machine Gun Corps, Corporal 164774
pp. 96, 99

William Ernest Montague MINCHINTON
1893 (Ringwood) – 1949 (Salisbury)
Victoria Hotel, High Street, Cranborne
Engineering apprentice, son of hotel proprietor
QODY, Private 966/230321
pp. 21, 26, 57; plate 26

Harry John (known as John) MITCHELL
1883 (Lytchett Minster) – 21 Oct 1918 (Beirut, died of malaria)
The Yards, Dewlish
Labourer
QODY, Private 1070/230397
p. 98

Sidney Herbert MOORE
Sep/Oct 1886 (Durweston) – 11 Mar 1945 (Blandford)
Langton, Blandford
Blacksmith
QODY, Corporal Shoeing Smith 134
p. 101

George Douglas (known as Douglas) MUNCKTON
1890 (Wimborne) – 21 Aug 1915 (Gallipoli, KIA)
Honeybrook Farm, Colehill, Wimborne
Farmer (was pupil in agriculture at Tarrant Rawston, 1911)
QODY, Private 1024
p. 60

Sir Archibald James MURRAY
21 Apr 1860 (Woodhouse, Hants) – 23 Jan 1945 (Reigate)
General, Commander-in-Chief, EEF
p. 150

John P. MURRAY
Berks Yeomanry, Private 2822; ICC, Private 50932
Plates 101-2

Malcolm NAPIER
6 Oct 1889 (Southampton) – 11 Jan 1973 (Ringwood)
Exeter
Bank clerk
1st/1st Devonshire Battery, 4th Wessex Brigade, RFA, 2nd Lieutenant (Lieutenant, 29 Aug
 1914; Captain, 20 Feb 1917); to India, 1914; with Indian Army, 3rd (Lahore) Division,
 Mesopotamia, 1916–18; with EEF, Egypt and Palestine, 1918
(Married Iris George, Southampton, 1919)
p. 174

Leonard Ackland NETHERCOTT
12 Oct 1897 (Culmstock) – Jan 1989 (Devon)
The Cleve, Culmstock, near Wellington
Wool spinner
Royal Navy, Nov 1914 – Aug 1915, deserted and enlisted in the Army; QODY, Private
 1525/230772; ICC, Private 50081
Plate 88

Berkeley (known as Bert) Tom NORMAN
1886 (Bridport) – 9 Apr 1936 (Chippenham)
South Street, Bridport
Cabinet maker
QODY, Corporal 958; transferred to RFC
p. 80; plate 26

Francis Andrew William OLD
Feb/Mar 1894 (Charlton Marshall) – 21 Aug 1915 (Gallipoli, KIA)
Berkeley House, Pimperne
Farmer
QODY, Private 673
pp. 22, 30-2, 38, 46, 50, 62, 72, 86, 91, 103, 110; plates 32, 47, 62, 76

James Joseph (known as Pat) O'REILLY
c.1874 (Co. Fermanagh, Ireland) – 1940 (Dorset)
Newland, Sherborne
Publican
QODY, Private 1422; ICC, Private 50098
Plates 88, 109

Arthur William OSMOND
1893/94 (Child Okeford) – 18 Nov 1959 (Basingstoke)
Nether Cerne, Dorchester
Grocer's assistant
QODY, Private 827/230208
p. 108

Thomas William PARDY
Apr/May 1895 (Corfe Mullen) – May/Jun 1948 (Corfe Mullen)
Wareham Road, Corfe Mullen, Wimborne
Baker
QODY, Private 659/230092
pp. 29, 39-40, 86; plate 26

John Johnstone PATERSON
1886 (Edinburgh) – 29 Jan 1971 (Nairobi, Kenya)
Westminster Dragoons, Captain; ICC, Captain – took command of No. 8 Company on
 death of MASON-MacFARLANE
(Later Tai-Pan of Jardine Matheson)
p. 147

William Eliot PEYTON
7 May 1866 (India) – 14 Nov 1931 (London)
15th Hussars, Major-General. Divisional Commander, 2nd Mounted Division at
 Gallipoli. Appointed to command of Western Frontier Force, Egypt, January 1916
pp. 67, 88, 113

William Ernest PIKE
1896 (Motcombe) – 21 Nov 1917 (Palestine, KIA)
Waterlow Farm, Motcombe, Shaftesbury
Farmer's son
QODY, Lance-Corporal 716/230131
pp. 88, 94, 99, 103

Charles Thomas Evan PRIDDLE
3 May 1897 (Sherborne) – 10 Apr 1973 (Wyke Regis)
Portland Road, Wyke Regis
Laundress's son
QODY, Private 1584; ICC, Private 50083
Plates 106, 113-14

Frederick Arthur PURCHASE
1886 (Sherborne) – 1967/68 (Dorset)
Higher Newland, Sherborne
Farm labourer
QODY, Private 1295/230574; ICC, Private
Plate 88

Victor Charles Methuen REEVES
30 Nov 1886 (Ennismore, Co. Cork) – 26 Feb 1916 (Agagia, KIA)
Leitrim House, Kilworth, Co. Cork
QODY, Captain; temp. Major, 1 Jul 1915
p. 105; plates 23-4

Eustace Revell REYNOLDS
15 Apr 1890 (Heavitree, Exeter) – 11 Oct 1918 (Smyrna while POW)
28 Huron Road, Upper Tooting, Balham, London SW
Solicitor's clerk
Westminster Dragoons, Private 1610/115088; ICC, Private 50148, taken prisoner 1 May 1918
pp. 161-2

Edward George Upward RICHARDSON
4 Mar 1888 (Parkstone) – Jun 1984 (Dorset)
West Street, Stourpaine
Farm labourer in Lord Portman's employ
QODY, Private 816/230199
pp. 43, 73; plate 26

Dr Gerald Russell RICKETT
1878 (London) – 13 Aug 1953 (Crowmarsh Gifford)
The Cedars, Long Street, Sherborne
Physician; Medical Officer of Health, Sherborne Rural District; Medical Officer,
 Sherborne School
RAMC, Captain; QODY, Medical Officer; transferred to Citadel Hospital, Cairo, 1916;
 later commanded El Nazarieh Military Hospital, Cairo until the end of the war
pp. 38, 43, 77

Arthur Samuel ROBBERTS
26 Jan 1896 (Idmiston, Wilts) – 26 Feb 1990 (Bournemouth)
The White House, Porton, Salisbury
Farmer
QODY, Private 1023/230363
pp. 39, 42, 45, 73, 80, 110-11; plates 26, 63

Dudley ROBERTS
1892/93 (Bridport) – 5 Aug 1915 (Cairo, fractured skull following fall from balcony)
30 West Allington, Bridport
Mercantile clerk
QODY, Private 1165
pp. 100-1

Jack ROBSON
1898 (Wantage) – 6 Oct 1959 (Wallasey)
Stockham, Wantage
Son of racehorse trainer and farmer
Berks Yeomanry, Private 70445; ICC, Private 50128
pp. 50, 66, 72, 102; plate 42 (probably, but identity unverified)

F. ROSE
Pimperne
QODY, Private 729
p. 39; plate 26

Thomas Kirkbride ROUTLEDGE
Dec 1892 (Cotherstone, Yorkshire) – 9 Jun 1918 (Palestine, KIA)
The Mews, Parr Street, Parkstone
Groom
QODY, Trumpeter 660/230093
pp. 108-10

Warwick John Norwood RYAN
30 May 1890 (Kingston-upon-Thames) – 5 Sep 1916 (Baharia, KIA)
Beaufort Road, Kingston-upon-Thames
Schoolmaster
QODY, 2nd Lieutenant; ICC, Lieutenant
p. 140; plates 88-9

Sidney Albert SADLER
1884 (Corton Denham) – 11 Mar 1957 (Llantarnan, Mon)
Church Field House, Caldicot, Mon
Chauffeur
QODY, Private 1132/230449; ICC, Private 50085
Plate 88

Albert James SANSOM
1888 (Kimmeridge) – ?
South Lytchett Manor, Poole
Groom to Sir Thomas Lees
QODY, Private 798/230184
pp. 29, 73-4, 80

Carl Gustav SIELING
4 May 1879 (London) – 1970/71 (London)
45 Bernard Street, London WC
Jeweller
Westminster Dragoons, Private 980
pp. 89, 93

Arthur William Woodman SIMPSON
4 Apr 1873 (Northumberland) – 12 Jan 1955 (Lancaster)
Manchester Regiment, Captain
p. 100

Edward Mihill SLAUGHTER
16 Jul 1867 (Bristol) – 30 Dec 1936 (Sherborne)
9 Cleveland Row, Strand, London
Berks Yeomanry, Captain
p. 93

Edwin Churchill SMITH
8 May 1886 (Colehill, Dorset) – 1 Oct 1915 (19th General Hospital, Alexandria, enteric
 fever and fractured base of skull)
Wilksworth Farm, Wimborne
Farmer
QODY, Lance-Corporal 864
pp. 34, 37, 73

Tom Vine SNOW
Jan/Feb 1893 (Milborne St Andrew) – 24 Oct 1984 (Bere Regis)
Gould's Farm, Milborne St Andrew
Farmer
QODY, Private 474
pp. 72-4, 88, 103; plate 26

Hugh Maurice Wellesley SOUTER
30 Oct 1872 (Bombay, India) – 6 Aug 1941 (Sydney, New South Wales)
QODY, Major (second in command) Feb 1915, transferred from Indian Army, 14th
 Murray's Jat Lancers; Scottish Horse, Lieutenant Colonel, Jul 1915; QODY,
 Lieutenant Colonel (Commander), Jan 1916
pp. 86, 119-22; plate 24

Charles Laver STICKLAND
1892 (Bishops Caundle) – 11 Feb 1964 (Dorchester)
Dodge Cross, Sherborne
Groom
QODY, Private 1091/230412; ICC, Private 50087
Plate 88

Henry James STROUD
7 Apr 1889 (Sydling) – 10 May 1978 (Stalbridge)
Loscombe Farm, Sydling St Nicholas
Farmer's son, working on farm
QODY, Private 573/230048
p. 90

James Joseph STURMEY
1893 (East Lulworth) – 31 Dec 1917 (Alexandria, drowned after SS *Osmanieh* struck
 Turkish mine)
3 James Road, Branksome
Gardener
QODY, Private 1206/230504; later Machine Gun Corps, Private 101458
p. 26

Ralph SWATRIDGE
1888/89 (Maiden Newton) – 1963 (Dorset)
Salisbury
1/Dorset Regiment, Private 7738; taken prisoner
pp. 100, 180 (Ch. 4, n. 43)

Norris Jego SYMONDS
5 May 1888 (Sydling) – 13 Nov 1970 (Martinstown, Dorchester)
The Chantry, Martinstown (or Winterborne St Martin), Dorchester
Auctioneer and valuer
QODY, Private 1099/230419
p. 29

Reginald Bertie (known as Bertie) TAYLOR
1894 (Tincleton) – 21 Aug 1915 (Gallipoli, KIA)
(Half-brother of William Meech; same mother)
Tyneham
Farm labourer
QODY, Private 1019
pp. 73, 77, 97

Robert George TETT
1893 (Weymouth) – 20 May 1917 (near Sidi Barrani, accidentally drowned)
8 Queen Street, Weymouth
Electrician
QODY, Private 819/230202; ICC, Private (later Lance-Corporal)
pp. 148, 163; plates 88-9

Tom THORNE
Jun/Jul 1891 (Alderholt) – 1932/33 (Dorset)
18 The Terrace, Wimborne St Giles
Carter on farm, formerly groom
QODY, Lance-Corporal 677/230104
p. 61

Maurice Newton TORY
18 Feb 1880 (Sturminster Marshall) – 21 Jul 1951 (Spetisbury)
South Farm, Spetisbury
Farmer
QODY, Sergeant 858; commissioned Gloucs Yeomanry, 1916
pp. 18, 24, 29-31, 33, 38, 47, 50, 70, 80, 88; plate 9

Harry Walter TREDINNICK
1885/86 (Stokesay, Shropshire) – 1957 (Sussex)
South Africa
Farmer
Formerly Rhodesia Regiment, Private; Montgomeryshire Yeomanry, Captain;
 Commander, No.8 Company, ICC
p. 159

Edward George TROYTE-BULLOCK
17 Sep 1862 (Dorchester) – 29 Aug 1942 (Zeals)
Zeals House, Zeals
QODY, Lieutenant Colonel (Commander)
pp. 109, 139; plates 23-4

Robert Charles TUBBS
Aug/Sep 1887 (Woodlands) – 1968 (Hampshire)
Woodlands, Verwood
Farmer
QODY, Sergeant 177
pp. 23, 68

Albert John VYE
Jan 1886 (Bournemouth) – 29 Jan 1961 (Sturminster Marshall)
High Lea Farm, Hinton Martell
Farmer
QODY, SQMS 129
pp. 32-3, 80

James Walter VYE
1887 (Weymouth) – 1959 (Dorset)
49 Chickerell Road, Weymouth
2nd Dorset Regiment, Private; QODY, Corporal 1448/230707; ICC, Corporal (later
 Sergeant)
Plates 88-9

Mark Stark WARD
21 Jun 1896 (Nottington) – 6 Apr 1973 (Buckland Ripers)
South Buckland Farm, Buckland Ripers, Nottington
Farmer
QODY, Private 698/230116; ICC, Private (later Lance-Corporal) 50019
pp. 128, 131, 134, 148, 163, 177 (Ch. 2, n. 9), 179 (Ch. 4, n. 32), 180 (Ch. 5, n. 3, 10),
 181 (Ch. 7, n. 2), 182 (Ch. 7, n. 25, 34), 183 (Ch. 7, n. 44); plates 88-90

Louis Richard WAREHAM
1892/93 (Shroton) – 1961/62 (Dorset)
Shroton
Groom
QODY, Private 854/230230
p. 103

Jack Fitzroy WATERS
Jan/Feb 1890 (Charlton All Saints) – 26 Feb 1916 (Agagia, KIA)
Manor, West Woodyates, Handley
Farmer
QODY, Lance-Corporal 459
pp. 30, 73, 83

Edward Victor (known as Victor) WATKINS
2 Aug 1891 (Poole) – 6 Mar 1976 (Broadstone)
Blandford Road, Broadstone, Wimborne
Grocer
QODY, Private (later Corporal) 576/230049
pp. 29, 37, 73-4, 80, 86, 89

Wilfrid (known as Val) WATTS
14 Feb 1893 (Blandford) – 17 Jan 1916 (Belgium, KIA)
(First cousin of George brothers of Blandford)
Hill Crest, Salisbury Road, Pimperne
Wool-stapler, then flying instructor
QODY, Private 665; transferred Royal Flying Corps, temp. 2nd Lieutenant
pp. 15, 17, 20; plates 19, 22

Tom Arthur WEBB
26 Sep 1889 (Uxbridge) – 25 Oct 1949 (Dorchester)
Colthelstone, Westham, Weymouth
Timber merchant's manager
QODY, Private (later Lance-Corporal) 818/230201; ICC, Private
Plates 88-9

William Henry (otherwise William John) WELLS
29 Mar 1891 (Wimborne) – 5 Aug 1971 (Wimborne)
Corn Market, Wimborne
Coal merchant
QODY, Private 730/230139; ICC Private 50089
Plate 88

William Ernest WHITE
1893 (Weymouth) – 1955/56 (Dorset)
Bovington, Wool
Grocer's assistant
QODY, Private 1001
p. 23

Charles Herbert WHITTINGHAM
1872 (Rhyl) – 24 Aug 1932 (Vichy, France)
Durham Light Infantry, Colonel (Reserve); Director-General of State Prisons, Egypt;
 previously organised and commanded Egyptian Camel Transport Corps
p. 90

Frederick James Bosworth Digby WINGFIELD DIGBY
22 Aug 1885 (London) – 23 Nov 1952 (Sherborne)
Sherborne Castle, Sherborne
QODY, Captain (later Major)
p. 113; plate 24

William John WOODROW
Feb/Mar 1884 (Dorset) – ?
2 Richmond Road, Upper Parkstone
Smith
QODY, Shoeing Smith 1133
p. 28

Philip George Best, 6th Baron WYNFORD
27 Aug 1871 (Weyhill, Hants) – 15 Dec 1940 (Somerset West, South Africa)
Warmwell House, Warmwell, Dorchester
QODY, Major; transferred to Royal Artillery, June 1915
pp. 52-3, 77; plate 24

General Index

Aba el-Waqf, 133
Acheson Hospital for Officers, London, 170
Agagia, Battle of, 120, 122, 140; mass grave at, 122, 124, 139, 150, plate 85
Ain es Sir, 159
Alexandria, 58-63, 105-6, 115, 122-6, 138, 146, 147; Sidi Bishr Camp at, 123-5
Amman, 157-8, 161, 182 (Ch. 7, n. 41)
Anmer, 23-4, 34, 42, 44
Anzac (Australian and New Zealand Army Corps), 58-9, 76, 93, 117
Arish, El, 149-51, plate 126; Wadi el-Arish, 150, plate 127
Arnecliffe, 81-2, 85, 91, 99, 136, 138, plate 12
Arras, 168-9, 171-2
Ashwell, Lena (1872-1957), 146; Concert Parties, 145-6, 173, plate 112
Asquith, Herbert Henry (1852-1928), Prime Minister, 37, 70, 74
Auja, Wadi el-, 158, plate 132
Australian Imperial Force, 58, 71, 75-6, 79, 82, 85, 89, 98, 100, 102, 120, 126, 142, 180 (Ch. 5, n. 14)
Austria-Hungary, 17, 72, 98, 179 (Ch. 4, n. 22)
Avington Park Camp, Winchester, 164, 166, 171
Avonmouth, 18, 48-9, 50-1, 55
Ayat, 129

Baharia Oasis, 140, 142-3, 182 (Ch. 7, n. 24)
Baldock, 16, plate 16

Baqbaq, 123, 125, 147
Beatty-Wright School of Flying, 20, plate 22
Beba, 130-1, 134
Beck, the Revd Henry Edward (c.1855-1935), 26, 35, 39-41
Bedrashein, El, 128
Beersheba, 151, 157, plate 128
Belgium, 69, 143, 165-8, 172, 179 (Ch. 4, n. 38), plates 139-44
Bemerton, 15, 47, 57, 84, 88, 160
Beni Mazar, 134
Beni Suef, 130-1
Bernhardi, Fredrich von (1849-1930), 38, 94
Bethlehem, 157, 158
Betty, Dorothy (c.1895-1984), 21-2, 32, 42, 50, 62, 81, 85, 87, 110, plates 7, 20-1
Beveridge, Albert J. (1862-1927), 94
Bingham's Melcombe, 71
Bircham Common, 47
Bircham, Great, 32-3
Blandford Camp, 28, 75, 137, 181 (Ch. 7, n. 13)
Blandford Forum, 14-16, 45, 47, 83, 94, 97, 118, 128-30, 137, 140, 158, 171; Laurels, The (later The Cedars), 14, 72, 118, 147, 149, plate 1
Boulogne, 170, 173
Brazil, 174
Brink Hill, 39, 43
British Army
 Higher formations:
 First Army, 16, 41, 171-2

Second Army, 16
Fifth Army, 165
New Army (Kitchener's Army), 92-3, 103, 105
Canadian Corps, 68, 168, 170, 172
II Corps, 165
X Corps, 166
XIII Corps, 169-70
Egyptian Expeditionary Force, 126, 150-1, 157
Mediterranean Expeditionary Force, 48-9, 58, 105
Western Frontier Force, 118-25, 137
Artillery:
Royal Field Artillery, 91, 139
Royal Garrison Artillery, 164-73, plates 139-43; 2nd Canadian Brigade, 171; 7th Heavy Artillery Group/Brigade, 171-3; 11th Heavy Artillery Group/ Brigade, 166-7; 16th Heavy Artillery Group/Brigade, 168-71; 42nd Heavy Artillery Group/Brigade, 172; 60th Heavy Artillery Group/Brigade, 165-6; 23rd Heavy Battery, 164-72; 115th Heavy Battery, 171-3; 2nd Reserve Brigade for Heavy Batteries/2nd Reserve Battery, 164, 171
Infantry:
Dublin Fusiliers, Royal, 113
Essex Regiment, 69, 90
Inniskilling Fusiliers, Royal, 113
Lancashire Fusiliers, 88-9, 99
Manchester Regiment, 88-9
Cavalry:
2nd Mounted Division, 18-20, 40, 48-9, 78, 105, 108, 110
Notts and Derby Mounted Brigade, 19
2nd South Midland Mounted Brigade, 18-20, 24-5, 27, 34, 36, 48-9, 63, 76, 81, 101, 106, 108-11, 115
1st South-Western Mounted Brigade, 15-16, 18
Berkshire Yeomanry, 19, 24, 50, 62, 72-3, 85, 87, 93, 101-2, 106-10, 114, 126-7, plate 42
Buckinghamshire Yeomanry (Royal Bucks Hussars), 18-19, 93, 101, 106-7, 110, 114, 126-7
Derbyshire Yeomanry, 19, 81
Dorset Yeomanry (Queen's Own), 15-58, 60-127, 138-9, 155, 164, plates 8-11, 17-19, 23-6, 29
Duke of Lancaster's Own Yeomanry, 71, 89-90, 95, 97, 100-3

Hampshire Yeomanry (Carabiniers), 15-17
Hertfordshire Yeomanry, 67, 87-9, 99-103, 105, 147
North Somerset Yeomanry, 17
Scottish Horse, 86, 114
South Notts Hussars, 19, 95-6, 99-100
West Kent Yeomanry, 159
Westminster Dragoons (2nd County of London Yeomanry), 19, 87-90, 93, 97, 100-3, 105, 114, 126, 147
Wiltshire Yeomanry, Royal, 16-17
Worcestershire Yeomanry (Queen's Own Worcestershire Hussars), 18
2nd Reserve Cavalry Regiment, 164
Other formations:
Imperial Camel Corps, 126-63, 174, plates 128, 134-5; No. 8 Company, 2nd Battalion, 126-63, plates 88-93, 95, 97, 99-106, 108-11, 113-14, 117-22, 130; Memorial, London, 174
Light Car Patrols, 148, plate 116
Remount Department, 18, 73; Avonmouth depot, 18
Royal Army Medical Corps, 27-8, 53, 62
Royal Flying Corps, 20, 22, 165
Buckley, Joan (b.1896), 22, 28, 38, 40-3, 85-7, plate 7
Burden, Catherine (Aunt Kate, 1858-1950), 85-6

Cairo and environs, 63-105, 116-18, 126-8, 144-6, plates 31-64, 73-6, 83, 88-9, 108, 111
Abbasia, 66, 71-2, 76, 78, 81, 83, 86, 88-9, 99, 118, plates 88-9, 108, 111; Abbas Hilmi Barracks, 94, 96, 100-3, 126-7, 129, 134, 137, 144, 147, plates 45-7, 73-6
Ali Pasha (Mohammed Ali) Mosque, 66, 69, plate 51
Bab el-Luk, 88, 91, 100
British Army HQ, 63, 69, plate 33
British High Commission, 59, 63, 84
Bulaq Bridge, 65, 67, 79, plate 58
Bulaq el-Dakrur, hospital in former khedival palace, 116
Cafés and restaurants, 66-7, 69, 71, 73, 75-6, 79, 81, 140
Cinemas, 73
Citadel, 66, 69, 92, plate 51; Citadel Barracks, 98, 100-1
Ezbekiyeh Gardens, 69, 78-9, 81, 98, 100, 145

French Consulate, 63, plates 31, 32
Ghezireh, 65, 67, 73-7, 79, 85, 87;
 Convent of the Mother of God, 87;
 Ghezireh Palace Hospital (formerly
 hotel), 76, 85; Royal Agricultural
 Society grounds and buildings, 75-6,
 78-81, 85, 91, 101, plates 61-4;
 Sporting Club, 73
Gizeh, 65, 68, 76, 81, 127; Bridge
 (English Bridge), 76, plate 59; Gardens
 and Zoological Gardens, 69, 76, 81,
 84, 87, 91, plate 60; Pyramids, 69, 72,
 76, 79-80, 83, 87, 91-2, 127, plates
 48-50, 83; Sphinx, 76, 83
Italian Consulate, 69
Kasr el-Aini Hospital, 75, 83
Kasr el-Nil, 68-9, 71-3, 75-6, 86, plate
 34; Barracks, 64, 75, 78-9, 81, 87-8,
 91, 94, plates 24, 35-41, 43; Bridge,
 64-5, 127, plates 37, 57
Kursaal variety theatre, 77
Maadi, 71, 88-92, 98; Prisoner of War
 Camp, 86, 88-101, 128; Bord du Nil
 Café, 88, 95
Mena, 76, 80, 83, 117; Camp, 98, 115,
 117-18, plate 83
Muski, 145; Police Station, 63, 71, 78,
 81
Opera House, 71, 145-6
Roda Island, 67
Russian Consulate, 63, 68, 77
Shepheard's Hotel, 81
Shops, 67-9, 73, 76, 145
Cambrai, Battle of, 172
Cattistock, 98
Churchill, Winston Spencer (1874-1965),
 First Lord of the Admiralty, 74, 82
Churn Camp, Berkshire Downs, 18-19
Circassians, 159
Congregationalism, 10, 26, 150
Coope, Kathleen (1886-1976), 24, 142
Cossins, Ernest (1890-1972), plate 18
Cossins, John (1860-1929), 15
Cranborne Chase, 17
Cromer, 22-3

Daily Telegraph Shilling Fund, The, 143
Dardanelles, 35, 37, 40, 58, 69, 74-5, 77,
 81-2, 92-3, 99-100, 103, 105; see also
 Gallipoli
Dead Sea, 157, 159, plate 133
Deir el-Belah, 153, 155
Demobilisation, 173-4
Dhabba, 119-20, 124, 147-8, plate 123
Dorchester, 14-17; Maiden Castle, 16-17,
 plate 19

Dorset, 14-17, 19, 71, 77, 81-2, 91, 97-8,
 118-19, 122, 128, 147, 153, 155, 158,
 166, plates 10, 12-14, 17-21
Dorset Men, Society of, 72

Efford Farm, Everton, 15, 104, plate 15
Egliston, 77, 97, plate 14
Egypt, 40, 44, 49, 58-106, 109, 112, 115-
 51, 154, 160-1, 174, plates 30-76, 83-5,
 88-96, 98-127
Egyptian Army Camel Corps, 102-3, 133
Everett, John (Herbert Barnard John,
 1876-1949), 97

Fakenham, 24, 28-9, 48-50
Farbus, 169-70
Fashn, 133
Fayum, 129, 140-3, plates 99-102
Flanders, 69, 165-8, plates 139-44
France, 14-15, 17, 19-20, 35, 40, 44, 46,
 58, 74, 84, 86, 91, 95, 100, 105, 137,
 142-3, 160-1, 168-73

Gallipoli, 9, 21, 58, 76, 85, 87, 93, 104-
 19, 124, 142, 174, 180 (Ch. 5, n. 14),
 plates 78-82
 'A' Beach, 107-10, plate 78
 Achi Baba, 85, 91-3, 105
 Chocolate Hill, 108-12, 114
 Helles, Cape, 118; Memorial, 174
 Karakol Dagh, 108
 Lala Baba, 108, 115, plate 81
 Salt Lake, 108, 110
 Scimitar Hill, 109
 Suvla Bay, 105, 107-8, 115, 118, 142,
 plates 78-81
Gass, Irene (1885-1968), 26, 31, 37, 62-3,
 66, 70, 78, 81-2, 85-7, 100, 102, 113
Gayton, 32, 38
Gaza, 150-3, 155, 158
Genly, 172
George, Dorothy (Dolly, 1887-1980), 14,
 81, 137, 180 (Ch. 4, n. 42), plate 1
George, Dray (Thomas Edward Dray,
 1885-1965), 9, 14, 33, 42, 49, 56, 67,
 70, 78, 91, 99, 102, 117, 127, 139-40,
 144, 149-50, 155, 158, 175, plates 1,
 4-5
George, Iris (Muriel Iris, 1894-1973), 14,
 17, 21-2, 27-8, 42, 66, 72, 79-80, 85,
 94, 97, 104, 153-4, 176 (Ch. 1, n. 1),
 210 (Napier), plates 1, 13, 20-1, 131
George, Louisa Anna Maria (1857-1945),
 14, 25, 27-8, 39-40, 44-5, 66, 72, 76,
 79-80, 86, 89, 91, 97, 103, 112, 117-

18, 120, 132, 137, 140, 142-3, 147-8, 151-2, 156-7, 161, plate 1

George, Margaret (Helen Margaret (Margot), 1883-1982), 9, 14, 47, 78, 91, 127, 137, 144, 147, 175, plate 1

George, Thomas (1848-1935), 14-15, 27, 41, 44, 66, 70, 76, 81, 85-6, 89, 118-19, 142-3, 150, 158-61, plate 1

George, William (1850-1928), 44, 76, 142

George, Wyn (Winifred Ruby, 1880-1951), 14, 44, 46, 56, 97, 112, 176 (Ch. 1, n. 1), plate 1

George V, King, 72, 76, 96, 171

Ghoraniyeh, El, 157, 161, 182 (Ch. 7, n. 41), plate 135

Gibraltar, 54-6, 143

Gillingham, 15

Greece, 35; see also Lemnos

Hagar Mashguk, 141, plate 94

Hammam, El, 118-19

Handover, May (1893-1958), 31, 33, 45, 77, 81, 180 (Ch. 4, n. 43)

Harnham, 15, 20-1, 41

Harpley, 20-49, plate 27; Harpley Lodge, 28, 39-41, 43-5, 48; Lower Farm (Murfet's), 37, 39-40, 46, 48; Rose and Crown, 21, 23, 26-7, 29, 32-3, 44, 46-7

Hebron, 157

Helhoughton, 34, 49

Heliopolis, 88, 105

Helwan, 91, 96, 128

Hendon Airfield, 20, plate 22

Hillington, 22, 37

Hindenburg Line, 172

Houghton Hall and Estate, 20, 23, 25, 29-31, 33, 40, 43, 47, plates 25-6, 28

Indian Army, 58, 59, 93, 110, 117; Gurkha Rifles, 117; Mule Corps, 110

Influenza pandemic ('Spanish Fever'), 171

Irwin, Will (1873-1948), 38

Jaffa, 151-4, 159, 162

Jeria, Wadi, 160

Jericho, 157-8, 160, plate 133

Jersey, 70-1, 77, 95, plate 6

Jerusalem, 150, 152, 157-8, 160; Memorial, 174

Jordan, River and Valley, 157-61, plates 132-5

Judea, 153, 157, 160, plates 129-30, 132-5

Kantara, 148-9

King's Lynn, 20, 22, 31, 33, 36, 50

Kitchener, Horatio Herbert, Earl Kitchener of Khartoum (1850-1916), Secretary of State for War, 19, 35, 58, 74-5, 132, 136, 138

La Bassée, 38

Le Lacheur, Elsie (b.1885), 70, 95, 100, 102, plate 6

Le Lacheur, Emily (b.1883), 70-1, 77, 95, 100, 102, plate 6

Lemnos, 35, 87, 106-8, 115, 117-18

Libya, 35, 118, 122

Lloyds Bank, Salisbury (Wilts & Dorset pre-1914), 15, 27, 160

Lodder, Hannah (1877-1957), 15, 81, 88

Loos, Battle of, 20, 105

McNeile, Revd Robert Fergus (1877-1971), 84, 87, 179 (Ch. 4, n. 25)

Mafid Jozele, 161-2

Mahmudiyeh Canal, 60, 62-3

Makhadet Hajlah, 157, plate 134

Maktil, Wadi, 120

Malta, 49, 56-8, 66, 109, 143

Marchiennes, 172-3

Markwell & Co., 14, 129, 140

Marne, Second Battle of the, 171

Massingham, Great, 22-4, 28, 34, 36-8, 40; Little, 25, 29, 33, 40; Railway Inn, 34, 39, 42, 46; Station, 30, 34, 42, 46

Matruh, 119-22, 147, plate 124

Mazghuna, 128

Mejdel, El, 155

Menzies, Eveline Emma (1881-1962), 15, 21, 24-5, 29, 37, 41-2, 44, 63, 77, 87, 94-5

Menzies, John Stewart (c.1880-1940), 15, 21, 41

Milton Abbas Grammar School, 14

Mina, Shafik Fahmy, 83-4, 146, plates 65, 68

Minia, 83-4, 134, 136, 146, plates 65-8

Moab, Mountains of, 157, 159-60, plate 133

Mons, 38, 172

Mordey, Carney & Co. shipyard (later Thornycrofts), 15

Musellabeh, 158

Neuve Chapelle, 41

Nile, River and Valley, 64-7, 69, 73, 75-6, 83, 88, 90-3, 95-6, 98-9, 127-40, 143-4, 146, 149, plates 37, 57-9

Norfolk, 16, 20-50, 103, plates 25-8

Operation Michael, 170

Ottoman Empire, 35, 59, 70, 78, 82, 93, 119, 140; see also Dardanelles, Gallipoli, Palestine, Transjordan, Turkish prisoners

Palestine, 78, 149, 151-63, 174, plates 128-30, 132-5
Pankhurst, Sylvia (1882-1960), 85
Passchendaele – see Ypres
Peddar's Way, 32-3, 38, 40, 44
Perham Down, Salisbury Plain, 16, plate 11
Poole Harbour, 17, 81-2, 91, 166, plate 12
Porter, Agnes (1859-1945), 20, 22, 39, 41, 48-9, 63
Porter, Robert (1834-1921), 20, 39, 41, 44-5, 47
Portland, 17
Portugal, 54, 168-9; Expeditionary Corps, 169

Qolosua, 135-6
Quévy-le-Petit, 172
Quiévrechain, 172

Radnor, Sister (Salisbury Infirmary), 21, 26, 72, 84
Rafa, 153-6
Ramleh, 154
Raynham Park, 25, 34
Reading University College, 15, 83-4
Rishon-le-Zion, 151, 154, plate 129
Roclincourt, 169-70
Rossiter, Dorothy Julia (1892-1914), 21, 24-5, 47, 77, 94-5, 114
Rossiter, Kathleen (1895-1980), 94-5
Rudham, East, 20; Rudham Grange, 39, 49; Rudham, West, 20, 25-7, 32, 34, 36, 40, 45-6

Salisbury, 15, 17-19, 21, 24-5, 27, 41-2, 47, 57, 94-5, 100
Salisbury Plain, 16, plate 11
Salt, Es, 161, plate 133
Samalut, 129, 136
Sandringham, 24, 44-6
Senussi, 118-23, 136-7, 140, 143-4, 147-9
Shammas, 120-1, 147
Shellal, 152
Shellaleh, Esh, 156
Sherborne, 15, 17, 19, 31, 45, 50, 78, 100, 142
Shernborne, 24, 38
Ships:
 Agamemnon, HMS, 106
 Bacchante, HMS, 107
 Borulos, 147-8

Canopus, HMS, 107
Commodore, 49-58, 60, plate 29
Cornwall, HMS, 106-7
Cornwallis, HMS, 106
Doris, HMS, 107
Enchantress, HMS, 81-2
Gleneagles, 57
Hannibal, HMS, 115, 117
Karoa, 49-51, 56, 58, plate 30
Lake Michigan, 106, 180 (Ch. 5, n. 1)
Lusitania, 66, 72, 78
Royal George, 139
Sarnia, 107, plate 77
Swiftsure, HMS, 107
Venerable, HMS, 108
Shittler, Owen (*c*.1870-?), 25-6, 32, 41, 44, 63, 75, 77, 84, 90-1, 160
Shusha, 127, 134, 136-7, 140, 142-3
Sidi Barrani, 122, 147-8, 163
Sinai, 149-51, plates 125-7; Sinai Police, 151
Siwa, 144, 147
Sods el-Umara, 131-2
Sohag, 138-9
Sollum, 122-4, 140, 144, 147-8, 150, plates 113-19
South African Army, 1st Infantry Brigade, 119, 121-2
Southampton, 15, 174; Hartley University College, 15
Spain, 54, 56
Spring Offensive(s), German (1918), 161, 170
Stickland, Louis (*c*.1841-1915), 77, 97, 179 (Ch. 4, n. 14), plate 13
Styles, Charles A. (*c*.1872-?), 29, 31
Styles, Daisy, 29, 31
Suez Canal, 59, 82, 88, 146, 148-9
Suffrage/Women's Suffrage, 41-3, 85, 146; see also Pankhurst, Sylvia

Tarrant Rawston, 15
Tell esh Sheriah, 153
Thélus, 168-71
Thornycroft, John I., & Co. Ltd. (formerly Mordey, Carney), 15, 173-5
Topsham Barracks, Exeter, 164
Transjordan, 157-61, plates 133-5
Tunis, 55-6
Tura, 88
Turkey – see Ottoman Empire
Turkish prisoners, 89-92, 95-6, 98
Tyneham, 77, 97

Um Rakhum, 120, 147, plates 84, 122
Unjeila, 120-2, 147, plate 121

Valenciennes, Battle of, 172
Vest Pocket Kodak, 10, 156
Villers-au-Bois, 170-1
Villers-en-Cauchies, 172

Walters, William George (*c.*1879-1957), 147
Wantage, 19-20, 50, 66, 78
Wasta, 129
Watts, Bertha Theodora (1859-1925), 45, 48, 62-3, 97, 137, 155
Watts, Madonna Agnes (Aunt Don, 1864-1937), 45, 85-6, 88, 104
Watts, Miss (Nurse Watts, Salisbury Infirmary), 24-6, 72
Weasenham St Peter, 27, 29
Wilts & Dorset Bank, Salisbury, 15; see also Lloyds Bank

Wimborne St Giles, 17, plates 17-18
Wimereux, 170
Worbarrow, 77, 97
Wright, Jasper J., 43, 45, plates 25-6

Yebna, 151-2, plate 130
YMCA, 79, 85, 146, 173; *Camp Song Book*, 23, 98; Recreation Huts, 98, 138, 146
Ypres, 20; First Battle of, 38; Second Battle of, 68; Third Battle of, 165-8, plates 139, 141-4

Zahria, El, 60, 63
Zeppelins, 22-4, 40, 44
Zillebeke, 166-7, plate 142